INDONESIAN TEXTILES
AT THE TROPENMUSEUM

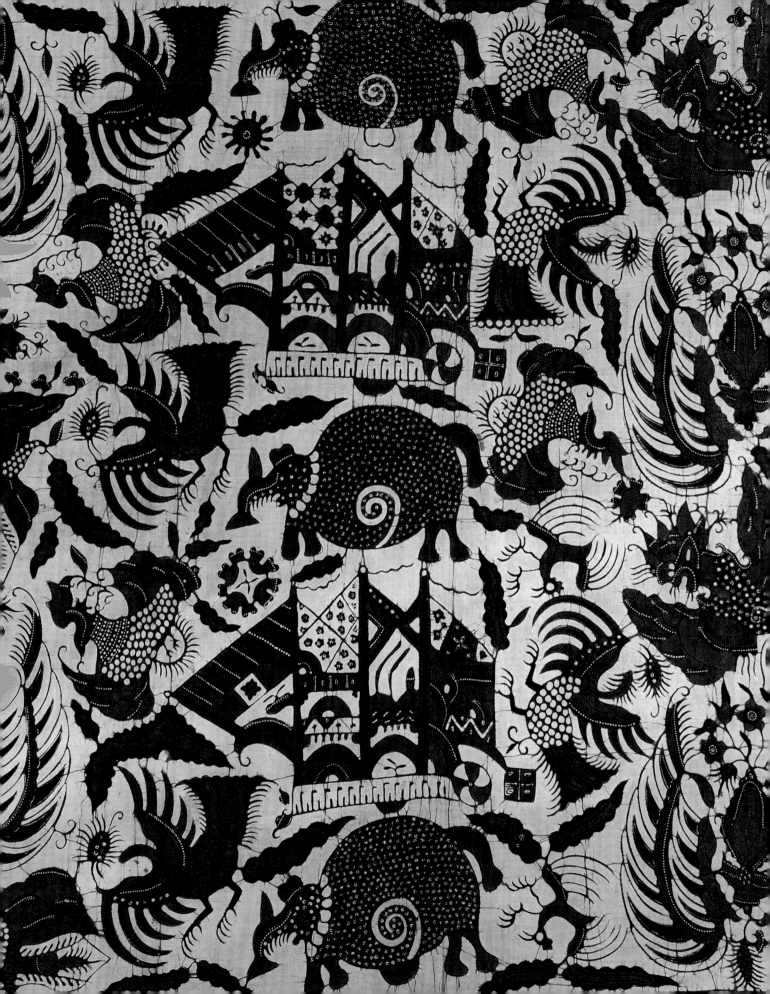

INDONESIAN TEXTILES

at the Tropenmuseum

ITIE VAN HOUT

SONJA WIJS

CONTENTS

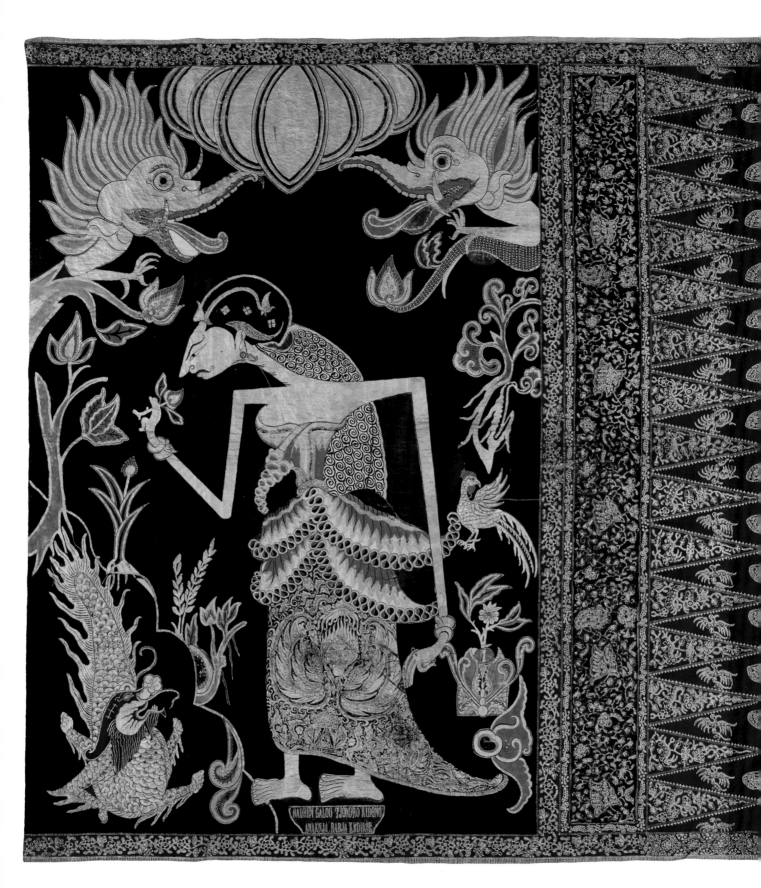

RADHEN GALOO TJONDRO KLRONO
ANAKNJA RADJA KEDIRIE

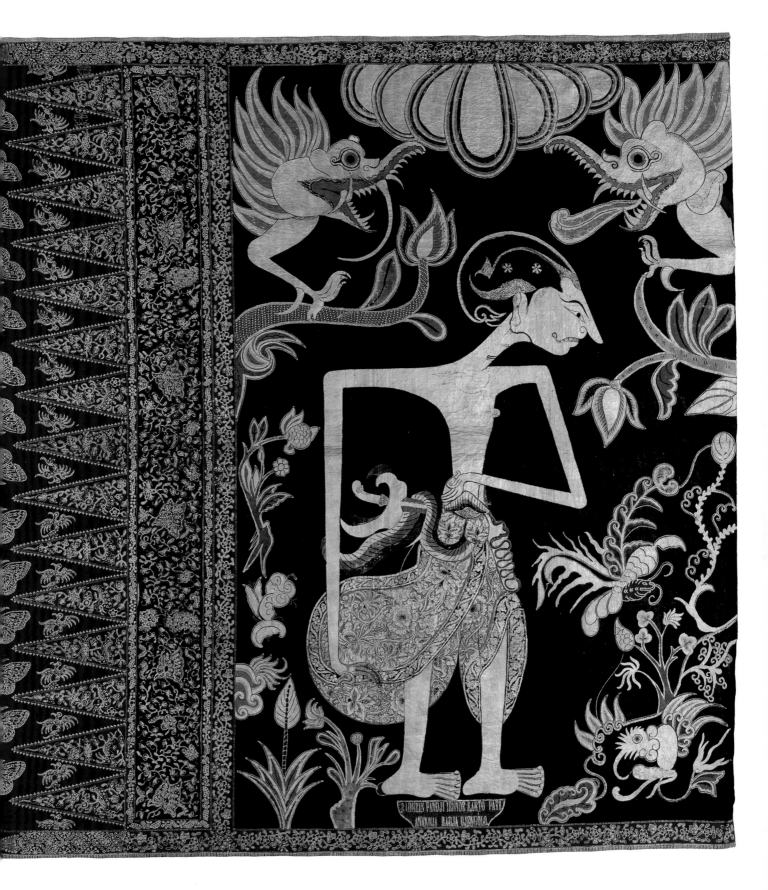

RADHEIN PANDJI IBRROS KARTO PATI
ANAKNJA RADJA DJENGGOLA

FOREWORD

Indonesian Textiles at the Tropenmuseum is the sixth and final publication in a series on the Tropenmuseum's collections. This series explores the broad-ranging histories of collecting, study and display at the museum, framed regionally or thematically.

The Tropenmuseum has a long tradition of 'collecting cultures'. Tracing its history back to the second half of the 19th century with collections from the Colonial Museum in Haarlem and the Ethnographic Museum of the Amsterdam Zoo Artis, the museum's early years are closely bound up with Europe's expansionist and scientific ideals and traditions. Such collecting and representational practices would change over time, reflecting different moments in (Dutch) political and scientific history. At the beginning of the 20th century, the collections moved to their current, purpose-built location in Amsterdam. After this, the museum widened its remit beyond a narrow focus on the Dutch colonies and by the mid-20th century started to collect, study and present objects from other regions around the world. Today the Tropenmuseum is experiencing the latest phase in its dynamic history. Having merged in 2014 with the National Museum of Ethnology in Leiden and the Africa Museum in Berg en Dal to form the Nationaal Museum van Wereldculturen, the Tropenmuseum is now part of a mission-driven institution, committed to utilising its collections to address contemporary societal issues.

At the end of the 16th century when Dutch travellers, scientists, colonialists and collectors first encountered the art of weaving in Indonesia, they were impressed by the high quality and intricate techniques of what they saw, especially on Sumatra and Bali. Since then, Indonesian weaving traditions have gained an international reputation, appealing to researchers, collectors and audiences across the world. As these textiles and knowledge about them became more widespread, Indonesian terms for decorative techniques such as batik, *ikat* and *plangi* also travelled.

These have become commonplace terms, due in part to the work of museums, even if the textiles themselves are in no way 'common'.

The close connection between the museum and the Dutch state lends a unique character to the textile collection at the Tropenmuseum. Beyond telling stories about textile techniques, or about the lifeworlds of the peoples who made and used them, they are also embedded in the entangled relationship between the Netherlands and Indonesia, first as coloniser/colonised, later in development corporation and finally in the ongoing and ever-changing postcolonial relations. Our work at the museum has been to uncover these different stories and this is what we present to you in this publication. These stories emerge from objects of exceptional quality, especially those acquired from collectors such as Johan Ernst Jasper and Georg Tillmann. All together these collections have placed the Tropenmuseum on the international map of Indonesian textiles, sought after for numerous national and international exhibitions and publications.

As director, I recommend *Indonesian Textiles at the Tropenmuseum* to you, our reader, hoping that you will enjoy this selection of objects from our collections and the multiple and diverse stories they embody. I want to thank everyone who made this book possible, especially Itie van Hout, former curator of the textile collection at the Tropenmuseum. To conclude, I want to thank the BankGiro Loterij and the Prins Bernhard Cultuurfonds, without whose support this publication would not have been possible.

Stijn Schoonderwoerd
General Director

<<

Hipcloth – *kain panjang*
Made for the 1883
International Colonial
and Export Exhibition in
Amsterdam. The Ministry
of Colonial Affairs donated
this cloth to the municipality
of Delft.
Cotton, batik
249 x 106 cm
Tegal, Java
Before 1883
TM-2335-15
Exchange: Stedelijk Museum
Ethnological Collection,
'Het Prinsenhof' (The Royal
Court), Delft, 1954

<

Tubular skirt – *sarung*
Cotton, gold leaf, batik,
painted
208 x 114 cm
Semarang, Java
19th century
TM-903-16
Bequest: Maurits Enschedé,
1934

PREFACE

This publication describes the formation, growth and character of the Indonesian textile collection in the Tropenmuseum. Important regional sub-collections that did not fit within this historical structure are discussed in the last chapter. The more than 12,000 fabrics and weaving tools form an archive of tangible and intangible heritage. This collection of objects contains information about the colonial relationship between the Netherlands and the Netherlands East Indies and various Indonesian cultures and peoples. It is also a rich archive of materials, techniques and skills of several Indonesian weaving traditions.

The various chapters reflect the policy of the Dutch government towards the arts and crafts industry in the Netherlands East Indies and the activities of collectors, researchers and museum staff. Motivated by personal preferences, most of them approached their work in their own individual way. However, this freedom was always linked to the prevailing political and museum policies and scientific schools of thought at various junctures. For example, the investigation of materials and weaving and decorative techniques and general anthropological research were for a long time regarded as separate disciplines. However, in recent decades, social scientists, field researchers and theorists have united these specialised fields. The resulting studies have demonstrated the essential value of knowledge of materials and techniques in the understanding of Indonesian textile traditions.

The collection of Indonesian textiles at the Tropenmuseum gained international fame while Rita Bolland was the curator of textiles (1947–84). Rita Bolland studied manufacturing and decorative techniques and became a nationally and internationally recognised expert in this field. She recorded her knowledge in numerous publications, shared it with researchers and colleagues from home and abroad who visited the Tropenmuseum, and urged students to research textile techniques. Reason enough to dedicate this book to Rita Bolland (1919–2006) for her contribution to textile research, her inspiration, and as a highly valued colleague.

This book would not have been possible without the help of many people. First I want to thank Pauline Kruseman, former managing director of the Tropenmuseum and now supervisor at the Nationaal Museum van Wereldculturen. This project would not have been possible without Pauline's determination and tireless support. I would like to thank Sonja Wijs for her contribution about textile exhibitions. I am grateful to Ruth Barnes, Miriam Hoijtink, Wayne Modest, Pieter ter Keurs and Nico de Jonge for their advice, as well as Reimar Schefold, Susan Legêne, Wonu Veys, Koos van Brakel, Thomas Murray, Hester Poppinga, Tony Lith, David van Duuren, Daan van Dartel en Pim Westerkamp. The work of Jacqueline Boerkamp, Irene de Groot, Richard van Alphen and Ingeborg Eggink in selecting and photographing the collection in storage was of great importance. I wish to thank Jowa Imre Kis Novak for his help in obtaining images of some of the exhibitions.

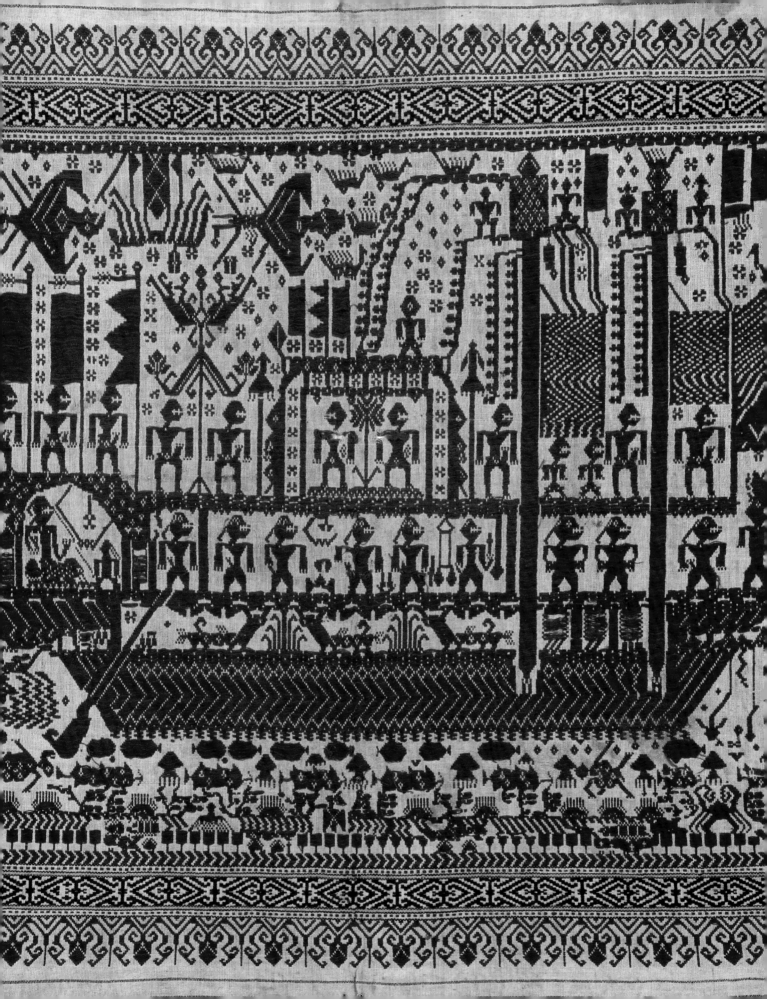

MUSEUMS, SCIENCE AND MATERIAL CULTURE

This ceremonial cloth unifies virtuoso weaving skills, religious iconography, social cohesion, trade, politics, the passion for collecting, and research. It was made in the distant past by a skilled and experienced weaver from the Lampung region in South Sumatra. The boat is the world, with mankind as the crew, floating on the sea with aquatic creatures, under the heavenly realm where the gods live with the birds as their messengers. The cloth belonged to a category of ritual gifts exchanged at weddings where they regulated the relationships between families. The boat is also a seaworthy vessel that was used to trade along the shores of the archipelago and beyond. This textile would never have come to the Netherlands were it not for the fact that the Dutch had colonised the archipelago and Georg Tillmann had to flee to the Netherlands to escape from German National Socialism (Nazism). It was part of the collection of this passionate collector who was also one of the first people to conduct a serious study of these textiles and publish his findings.

*Through making, using, exchanging,
consuming, interacting and living with things,
people make themselves in the process.*[1]

Introduction

The textile collection at the Tropenmuseum is a unique material archive in which historical and anthropological knowledge relating to Indonesian art and culture as well as political, economic and museological knowledge is preserved.[2] The collection is comprised of everyday and ceremonial clothing, ritual textiles and tools used to produce the textiles. The nearly 12,000 textiles from Indonesia were collected over a period spanning more than 160 years. The majority were brought to the Netherlands when the Indonesian archipelago was a Dutch colony, the former Netherlands East Indies.[3] This colonial relationship has determined the composition and character of the collection. The textiles and garments in the Tropenmuseum collection come from cultures throughout the Indonesian archipelago, from Aceh on Sumatra in the west to Tanimbar, located far in the east. A small part of the collection consists of textiles that were made in the Netherlands for commercial and/or artistic reasons.

Indonesia's population includes approximately 350 ethnic groups distributed over a large number of islands. Despite a great diversity in peoples and geography, weaving is arguably one of the traditions that unify them, as it is practiced throughout the archipelago. It is unquestionably its most famous and impressive art form. Over the centuries, traders, religious leaders and colonisers from Asia, the Middle East and Europe have to varying degrees left their traces in the archipelago. Different weaving traditions with a wide variety of textile techniques, patterns and colours arose from the interplay of climatic conditions, the availability of materials, innovation, from interaction within their own and with other cultures, and their prevailing ideologies and religions. In Indonesia textiles were not only used for clothing: their role in social and religious life was of crucial importance. James Fox wrote powerfully and concisely in 1977 about the Indonesian weaving tradition: 'Cloth swaddles the newly born, wraps

and heals the sick, embraces and unites bride and groom, encloses the wedding bed and, in the end, enshrouds the dead.'[4] Probably since prehistoric times, textiles in this region have been a binding element in socio-cultural life and despite significant social and religious changes still play a meaningful role in the lives of many people.

This rich variety and history made textiles from Indonesia a collectible item for many Europeans. Scientists, colonial administrators, Catholic and Protestant missionaries, soldiers, entrepreneurs and private collectors took textiles, manageable and relatively easy to transport, back to the Netherlands. Packed in a suitcase or trunk, on this journey the textiles lost the function they had in their original context. Once unpacked in Europe, many ended up in museums where, just as in their cultures of origin, they were handled with care as objects to study, admire and preserve for future generations. The textiles acquired a new meaning in these museum institutions, both as representatives of distant, often unknown cultures, and of the Netherlands as a colonial empire. In the museum, the garments are no longer worn, the waxy fragrance of the cloths decorated with the batik technique has been replaced by the smell of mothballs, and the rhythmic ringing of the bells sewn onto the clothing is no longer heard. They have become museum objects, studied and exhibited according to the changing views of social scientists and curators over the course of time.

From its onset in the 16th century, the presence of the Dutch in the Indonesian archipelago was mainly focused on the economic interests of the Netherlands. Within the context of these commercial interests in the 19th century scholarly and artistic interest arose in the cultural traditions of the archipelago, especially in the batik industry. The attitude of the Dutch colonial administration towards Indonesian handicrafts would have major consequences for the economic development of the textile industry in the Netherlands as well as on Java. Administrative officials and researchers recognised that gathering knowledge about materials and techniques would benefit Dutch economic interests and safeguard the cultural and artistic values of this form of applied art. Some of the studies that were carried out resulted in publications which are still considered as definitive works in their field.[5]

In this book the origins and the growth of the Tropenmuseum's textile collection are presented together with the ideas and motivations of the collectors, their positions within the colonial system, their encounters with the local population and those who were involved in researching and exhibiting the collection in the museum and beyond.

The history of this collection and of the Tropenmuseum itself is inextricably linked to Dutch political – and especially Dutch colonial – history, but even after the colonial era, political developments strongly influenced the fortunes of the Tropenmuseum. In the second half of the 20th century the interest in colonial history and its relation to ethnographic museums and ethnographic collections was addressed in the Tropenmuseum by defining and studying a new collection category *koloniale collecties* (colonial collections), referring to the material culture and the associated ideas of people who were close to the Dutch colonial community.[6] These subjects and the backgrounds of the Indonesian weaving traditions are discussed in the following chapters, culminating in a presentation of highlights from the Tropenmuseum collection.

This chapter continues with an overview of developments in anthropology insofar as these relate to the study of material culture in general and to textiles in particular. Despite a long, though sometimes sporadic interest in objects as sites for anthropological study, material culture studies remain an important nesting field. The history of anthropology is closely aligned with that of ethnographic museums. This began in the 19th century with the acquisition and study of artefacts thought to represent the lifeworlds of primitive or traditional societies.

Museums, science and material culture

In the Indonesian archipelago the most experienced weavers created textiles that were essential to rituals that were performed to structure and maintain the interaction between humans and the world of their ancestors, and the interpersonal relationships among the living. As early as the 16th century, the beauty and luxuriance of the textiles, of the 'fine cottons with gold thread', aroused the curiosity of the first Dutch travellers to 'the East',[7] and in the subsequent centuries also that of colonial administrators, scholars and others who expressed an interest in Indonesian weaving traditions. Many of them took back textiles to the Netherlands. The textiles, made of cotton or silk, the latter richly decorated with patterns in gold thread, or produced using the ornamentation techniques 'batik' and 'ikat' – unknown in Europe at that time – were exhibited in the Netherlands to testify to the country's stature as a colonial power and demonstrate the cultural wealth of its Overseas Territories.[8] The Netherlands basked in other

1
Shoulder cloth – *kain limar*
Silk, gold thread
Weft, supplementary weft
200 x 88 cm
Palembang, Sumatra
Early 20th century
TM-6207-34
Long-term loan: Gerardus
van der Leeuw Museum
Collected by A.Tj. Van
der Meulen, 1862–1934

2
Headcloth – *iket*
Cotton
Batik
118 x 113 cm
Cirebon, Java
19th century
TM-2210-1
Gift: C.Tj. Bertling, 1952

people's glory, though many at that time would have thought that this glory belonged to the Netherlands. Yet, compared to other forms of what was called 'primitive' art in Europe, art lovers and art dealers discovered this technically skilled and rich iconographic textile art relatively late after the Second World War. Nowadays these textiles are treasured by collectors and aficionados alike and are preserved as works of art and precious heritage (figs. 1–3).

These textiles had a different meaning for each of these respective parties: the weaver, the colonial civil servant, and the art collector. In each context a different value was assigned to the textile and the textile became part of a distinct story. To gain insight into these stories, into the history of an object, Arjun Appadurai wrote: 'follow the things themselves in order to grasp the meanings that are inscribed in their forms, their uses, their trajectories'.[9] Every piece of textile, but also collections that could be considered as a cohesive entity, have their own story to tell.[10]

Within anthropology, interest in textiles has not always been consistent. Even though clothing and textiles were desirable collectibles, it was only in the course of the 20th century that people realised that too little research had been conducted into this field. Starting in the middle of the 20th century, social scientists began emphasising the social and cultural connotations of clothing and textiles and as a result, research into textiles has been given a permanent place in anthropology.[11] *Dress, Adornment and the Social Order*, edited by Mary Ellen Roach and Joanne Eicher Bubolz, and published in 1965, examined the relationship between dress and adornment and the social environment.[12] Ronald A. Schwarz, however, came to the conclusion years later in 1979 that: 'Clothing is a subject about which anthropologists should have much to say, yet remain mysteriously silent […]. Indeed, descriptions of clothing are so rare in social anthropology that the casual reader might easily conclude the natives go naked.'[13] This is striking because it is not easy to find a human in time and space who does not 'dress' in the broadest sense of the word, 'To be human is to dress, to dress is to be human.'[14] In *Cloth and the Human Experience*, Annette B. Weiner and Jane Schneider suggested a relationship between the marginal attention to textiles in the social sciences and the possible lack of interest of male anthropologists in the activities of women, or in textile techniques and their products, or a lack of interest in both.[15] The situation was slightly different in the Netherlands because of the colonial situation. Several male researchers had already expressed an interest in Indonesian textiles at the end of the 19th century.[16]

This limited intrinsic interest in clothes is also apparent from the information provided with the photographs in the Tropenmuseum collection. At the beginning of the 20th century, it was often members of the aristocracy who were photographed wearing precious clothes. The photographer, whether professional or not, would in most cases note the place where the photograph was taken, and sometimes the ethnic group and the social positions of the people depicted. Details about the meaning of the richly decorated clothes were rarely given and descriptions were usually cursory, for example, the photograph of the 'village head of Galoempang (Central Sulawesi) with his wife and sister dressed in festive attire', or 'studio portrait of the Crown Prince of Deli' (figs. 4, 5).

3
Shroud, ceremonial
hanging – *papori to noling*
The cloth was purchased in
1936 by C.M.A. Groenevelt
on Georg Tillmann's behalf.
The wife of missionary and
linguist N. Adriani collected
the cloth in Galumpang.
Cotton
Warp *ikat*
175 x 131 cm
Toraja, Galumpang, Sulawesi
19th century
TM-1772-713
Gift: W.G. Tillman, 1994

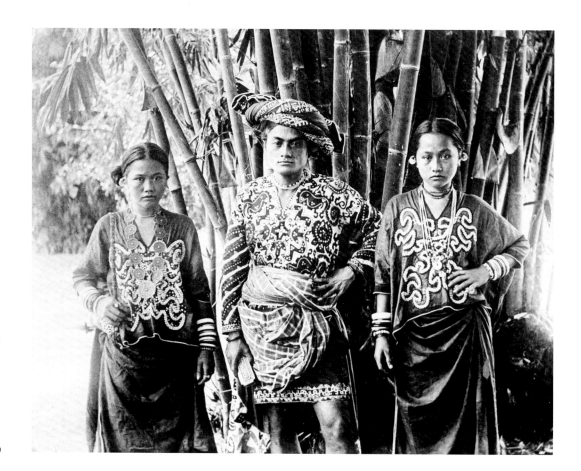

4
Headman of Galumpang
with his wife and sister
in ceremonial attire
Photographer unknown
29.1 x 23.2 cm
Galumpang, Sulawesi
c. 1920
TM-60041774
Provenence: H. Wolvekamp

The growing interest in clothes and textiles in the second half of the 20th century, also manifested in large-scale anthropological fieldwork, was not an isolated development but part of a renewed interest in expressions of material culture. Because these ideas have influenced developments in the study of ethnographic textiles, some paradigms are outlined briefly here.

Collecting and studying

Members of the nobility, wealthy bankers and entrepreneurs in Germany compiled the first methodical collections of ethnographic objects in the 16th century. Their reasons for bringing objects from other cultures to Europe and displaying them in their so-called cabinets of curiosities were, in addition to gathering knowledge, a way to show off their wealth, influence and power.[17] These motives did not differ much from the objectives of the European colonial powers that assembled collections of ethnographic objects from

the 18th to the 20th centuries. The objects the Dutch brought with them from foreign countries early in the 19th century were housed in the Museum van Oudheden (Museum of Antiquities, 1818) in Leiden, and the Koninklijk Kabinet van Zeldzaamheden (Royal Cabinet of Curiosities, 1816) in The Hague.[18] In the decades that followed, ethnographic museums were founded for these collections, such as the first ethnographic museum in Europe, 's Rijks Ethnographisch Museum (National Ethnographic Museum) in Leiden (1837), the Koloniaal Museum (Colonial Museum) in Haarlem (1864) and the Ethnographisch Museum van Artis (Artis Ethnographic Museum) in Amsterdam (1871). The collecting activities were driven by scientific ideals and economic and political objectives. Scholars set themselves the goal of bringing together collections, including from cultures that were seen in the first half of the 19th century as belonging to the 'the artistic canon of universal history', such as the Hindu–Buddhist civilisation on Java and Sumatra.[19] Influenced by Charles Darwin's 1859

publication, *On the Origin of Species*, and the birth of ethnography as a social science, this attitude underwent changes. The cultures were now regarded as the only remaining representatives of early primitive societies, '[...] before they were either transformed, or made extinct by the relentless march of "civilization" in the form of Western colonialism'.[20]

The bringing together of collections occurred in the colonial context of an unequal division of power. However, in daily practice the colonial collector was at the whim of happenstance: which objects could be acquired was determined by chance encounters and what the local population provided. Systematic

collecting was usually not an option, as certain precious and often sacred textiles that had often been kept in families for generations, were seldom proffered. The idea that ethnographic collections would be representative of their cultures of origin has long been abandoned.[21] With a few exceptions, it was only from the 1970s that textiles belonging to a family heritage found their way to Western collectors and museums. At that time the Tropenmuseum did not have an active acquisition policy, possibly because of the flagging political relationship after the independence of the young state of Indonesia. Some important types of textiles are therefore under-represented in this collection. The collection tells us as much about the contacts between the locals and the Dutch both during and after the colonial era as it does about the different cultures in Indonesia.[22]

The study of objects in ethnographic museums in the 19th century led to the emergence of anthropology as an academic discipline. At the end of that century the first ever anthropology professors often combined their position at a university with a function in a museum.[23] The focus was on the technological prowess of the cultures that made and used the objects. This interest was in keeping with the prevailing theory of evolution, which maintained that mankind progressed through several fixed stages of development (from hunter-gatherer to city dweller). The stages were identified by the relevant culture's level of technological development. In comparison to the civilised West, the living cultures where the ethnographic objects came from were considered as societies in an earlier, still uncivilised, stage of development. This object-oriented research '[...] organized by measures of technological progress, provided the empirical basis for grand schemes of social evolution, diffusion, acculturation and change'.[24]

In addition to bringing together collections, a core function of museums was to classify and document the objects. A scientific classification model was developed in the National Ethnographic Museum, the forerunner of the Rijksmuseum voor Volkenkunde (National Museum of Ethnology), which arranged the collection in twelve functional categories (Groups). The collections were divided into 'place of origin', 'type of material' and 'production technique'; the twelfth and final category was

5
Studio portrait of the
Crown Prince of Deli
Photographer: Asahi & Co.
28.2 x 16.5 cm
Deli, Sumatra
1915–25
TM-60006770

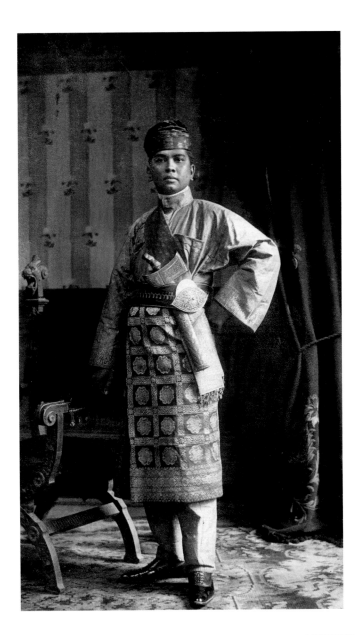

'science, religion, ceremonies'.[25] This way of organising was possibly grounded in practicality. The documentalist at the museum would (physically) hold the object and begin the description logically using the information provided by its shape, material and production method. Only after that were the 'abstract' characteristics, the function and meaning of the object for its culture of origin, considered. This knowledge was still very limited at that time because the people who purchased the objects mostly did so for reasons unrelated to ethnography as a social science. This method of classification resulted in an intrinsic division of cultural components in the documentation. The objects' concrete and abstract, material and social/spiritual aspects were separated in this system, a distinction that did not exist for the creators and users of the objects in their cultures of origin.

At the end of the 19th century, Franz Boas in America defined a holistic approach to the study of non-Western cultures. Boas, a fierce opponent of the theory of scientific racism and socio-cultural evolution, opined that a culture had to be studied as an 'integrated spiritual totality' from the standpoint of four sub-disciplines, namely archaeology, physical anthropology, linguistics and cultural anthropology. He considered knowledge of the material culture as key to understanding a culture. However, it was not sufficient to examine only the objects in museums, as was initially the case: objects should be examined in the socio-cultural context in which they are made and used. After gaining experience in fieldwork, Boas saw that problems could arise in analysing and interpreting the data because as a 'Western' anthropologist, he studied the collected material with an outsider's understanding. He concluded that the researcher and the researched perceive reality in different ways.[26] Others shared this view. Anthony Shelton wrote a century later in his study of the aesthetic appreciation of objects by the Huichol in Mexico:

[…] the real world, for the Huichol, is not the world that we perceive. […] aesthetics is not concerned with passive reflection, but with an active attitude to maintain or adjust a system of ethics inherited from their ancestral deities, which organises the world and define appropriate activities and relations within it. Material cultural

artefacts are essential ritual tools within such belief systems. […] Huichol aesthetics, unlike its Western counterpart, does not appear to make any distinction between signified and signifier. Its art is iconic in that it not only represents the deities but also becomes a manifestation of them and shares identical sacred qualities. […] It is necessary to examine the fundamental ontological categories of their (Huichol) thought.[27]

In 19th-century England, scientific developments followed a different route than in America. The British developed the aforementioned archaeology, linguistics, physical anthropology and social anthropology as independent disciplines. Henry Balfour, the first curator of the Pitt Rivers Museum in Oxford, used an interesting metaphor in 1938 to illustrate the different approaches within anthropology. In his lecture 'Spinners and Weavers in Anthropological Research', he called the specialists who study a culture from one particular discipline, 'the spinners'. They collect the material, process it, and spin the thread. In contrast, the generalists – who analyse all the material collected from a broader perspective – are 'the weavers'. They make connections and weave the threads into a whole, the fabric, the theory: 'they will create not only a fabric but a pattern as well, by interlacing the "warp" of facts with the "weft" of argument'.[28] From the 1920s the focus on objects and collections diminished in universities. New schools of thought – functionalism and structural functionalism – arose, which studied social phenomena and their interrelationships. The significance of objects was reduced to instruments that gave form to everyday life or were passive references to wealth or poverty, dominance or oppression. The emphasis was placed on social, political and economic aspects of culture and not on the material aspects, or as W.H.R. Rivers had already described in 1914: 'the whole movement of interest in anthropology is away from the physical and material towards the psychological and social'.[29] The contrast between the 'concrete' and 'abstract', the 'material' and 'social', 'objectivity' and 'subjectivity' now also played a role in academia.[30] Although material culture did not vanish from the picture entirely for the simple reason that humans cannot be separated from their material world, academia by and large stopped studying objects and collections and, as had been the case in the early

years, this research was undertaken within the confines of museums.[31]

Starting the 1920s, in the Netherlands Willem Huibert Rassers, initially a curator and later the director of the National Museum of Ethnology in Leiden, and Jan Petrus Benjamin de Josselin de Jong, also a curator and later a professor of ethnology in Leiden, collaborated closely in the field of Indonesia's material culture and ethnography in the role of Balfour's 'weavers'. Rassers' interest was not primarily in the objects that would provide insights into their cultures of origin, but the opposite: knowledge of these cultures would provide insights into the significance of the objects for the respective cultures.[32] In the 1930s De Josselin de Jong introduced the idea that certain regions on earth with sufficiently homogeneous and unique cultures (for example, the Indonesian archipelago) could be approached as distinct areas of ethnological study. At the same time these cultures should reveal differences that could facilitate comparative research. This theory became known as the Field of Anthropological Studies (FAS).[33] The study of material culture was one aspect of De Josselin de Jong's holistic approach. He and Rassers are considered founding fathers of structuralism in Leiden (de Leidse School).

With the introduction of symbolic anthropology in the 1960s, material culture was cast again in a central role. The distinction between 'material culture studies' and 'anthropology' could potentially be removed. As Peter Ucko put it, material culture was no longer seen as 'the poor handmaiden of other aspects of anthropology'. In his research he demonstrated how a particular category of objects could open up 'many areas of investigation of interest to a wide range of anthropological enquiry', and that 'the study of human artefacts can act as a bridge between most other aspects of anthropology'.[34]

In England this development originated from a renewed interest in technology, an interest that grew into a broad, multidisciplinary approach to material culture. In the Netherlands, Adriaan Alexander Gerbrands, professor of cultural anthropology at Leiden, expanded upon his theory of ethno-communication in which he ascribed a central role in the study of cultures to the objects made by humans: 'For there is no doubt that whoever has come to understand the language of things, has

thereby also discovered a key that provides access to the culture.'[35] Research into material culture became a permanent part of the anthropological curriculum in Leiden. In the late 1960s, Hetty Nooy-Palm and Reimar Schefold manifested their interest in and involvement with material culture studies by developing the course Museum Studies and Knowledge of Material Culture within the Cultural Anthropology course at the University of Amsterdam. This they did with the Afdeling Sociaal Wetenschappelijk Onderzoek (SWO, Department of Social Studies) of the KIT/Tropenmuseum. In 1969 Nooy-Palm, working at the SWO, taught this subject at the Tropenmuseum with Rita Bolland, the curator of textiles.

In England Daniel Miller, Susanne Küchler, Christopher Tilley and others broadened the field of material culture studies into an interdisciplinary field of study in the 1980s and 1990s. They considered 'materiality' as an essential part of culture, and advocated an approach in which, among other disciplines, archaeology, (art) history, architecture and geography are all applied when examining how objects affect the 'construction, maintenance and transformation' of humans in a socio-cultural context.[36] Miller investigated the relationship between subject and object and found that there is no fundamental distinction between humanity and materiality:

[...] everything we are and do arises out of the reflection upon ourselves given by the mirror image of the process by which we create form and are created by this same process. [...] We cannot know who we are, or become what we are, except by looking in a material mirror, which is the historical world created by those who lived before us and confronts us as material culture, and that continues to evolve through us.[37]

At the root of this lies the process of objectification that can be defined as the process by which forms of human expression, consciously or unconsciously, in groups or individually, obtain concrete form. Mankind, the subject, should be able to see objects as embodying intrinsic aspects of itself.[38] People and material culture, writes Tilley, are two sides of the same coin: 'Persons and things, in dynamic relation, are constitutive of human culture in general, societies and communities in particular, and in the agency of groups and individuals.'[39]

The subject-object and material-immaterial dichotomy also influenced the study of ethnographic textiles. The importance of information about the physical and technical characteristics of textiles was acknowledged, yet only a few researchers studied materials and techniques, while others focused on examining the socio-cultural significance of textiles for society.[40] The analysis and study of textiles in relation to material, technique and form, however could not be separated from the study of the textiles' social and religious significance; they form a whole, as articulated by Küchler and Miller: 'When fibres, fabrics and ways of wearing are the medium for one's relationship to other people and to the gods, we cannot have "cloth" and "religion"; we can only have the materiality of cosmology.'[41]

A new generation of textile researchers embraced this holistic approach. In the 1970s, Mattiebelle Gittinger initiated and promoted research into textile traditions from Indonesia, among other places. In 1979 she organised the groundbreaking exhibition 'Splendid Symbols: Textiles and Tradition in Indonesia' and wrote the eponymous publication.[42] At the same time the first of a series of high-profile conferences was organised that not only stimulated research, but also resulted in publications that made the results of the research available to a wider readership.[43] Attention was paid to both the socio-cultural aspects of the textiles in their cultures of origin and to analysing the materials and applied techniques. They were, however, still largely treated as separate areas of study.[44]

At the same time an interdisciplinary cross-fertilisation took place in the Tropenmuseum, led by textile curator Rita Bolland, which has contributed to the recognition that knowledge of and understanding the techniques, the 'material', were essential for gaining insight into the 'social' function of the textiles in their respective societies. Field research in Indonesia also showed that technological aspects were inseparable from the roles textiles played. In the early 1970s, Marie Jeanne Adams was one of the first people who, through her study of a weaving tradition on Sumba, described how each stage in the production of a textile was associated with the successive stages in the lives of the Sumbanese, 'In myth, ritual and social rules on Sumba, the stages of textile work are consistently linked to the progressive development of individual human life. These stages provide an overarching metaphor for the phases of the Sumbanese life cycle.'[45] The materials, the weaving and decorative techniques, and the choice of patterns and motifs determined how a textile looked, and influenced its significance within the community, 'In asking what is the cultural component of technology, we are also asking what can technology tell us about culture?'[46] Besides Adams, Ruth Barnes, James Fox, Danielle Geirnaert, Rens Heringa and others also stressed the importance of researching the relationship between the techniques and the social and religious aspects of the textiles in the cultures that made them.[47]

After the publication in 1986 of *The Social Life of Things* by Arjun Appadurai, which concluded that not only individuals but also the objects they create and use have a life story and a life cycle, the next step was to examine the mutual engagement of man and object and the effect that objects have on humans.[48] With regard to the study of material culture, Pieter ter Keurs wrote: '[…] many quests for the spiritual, the supernatural, are also encounters with the material', and '[…] the materiality of things is crucial to the functioning of people. It makes social relationships visible, often in the form of exchanges – it bestows status and prestige in the political arena, but also in everyday life – and it makes tangible what is incomprehensible.'[49]

In his book *Art and Agency*, published in the 1990s, Alfred Gell formulated an 'anthropology of art', which he defines as the theoretical study of 'social relations in the vicinity of objects mediating social agency'.[50] He considers art, and also ethnographic objects as a special form of technology and extrapolated how objects contribute to the formation of society: through their production, the way they circulate in society, and how society reacts to them. He calls this the 'technology of enchantment'.[51] Although Gell's work has been criticised by diverse scholars,[52] his ideas remain valuable for the study of Indonesian textiles. He attributes an active role, 'agency', to objects in social interaction and proposed that objects 'affect' those who look at, possess or desire to possess them. Human beings, the makers and users of the objects, are, however, always the primary agents and the objects can only be agents in a secondary or indirect sense. Objects act as the vehicle through which people manifest and realise their intentions.[53] Gell argues that certain features

of objects, such as ornamentation, result in a personal attachment to things, and hence to social processes in which these objects play a role. Decorations are part of the 'technology of enchantment', which Gell defines as a 'psychological technology [which] encourages and sustains the motivations necessitated by social life'.[54] In the case of Indonesian textiles this also applies to the materials they are made of and their technological aspects. As for technology, Gell does establish a link between the ability of the object to enchant and the way it was made. He suggests a relationship between the perfect mastery of a technique, the form the object takes, and the effect the object has on people and their relationships: 'the captivation, fascination, demoralization, produced by the spectacle of unimaginable virtuosity ensues from the spectator becoming trapped within the index [object] because the index embodies agency which is essentially indecipherable'.[55] He thus concurred with Boas, who identified the same relationships in the confluence of perfect technique, the emotions and convictions of the creators, and the reactions of others, the users, to these objects.[56] Gell concluded that objects may have an 'enchanting effect' resulting from the ability of these 'perfect' objects to touch the senses of man: '[T]he power of art objects stems from the technical processes they objectively embody: the technology of enchantment is founded on the enchantment of technology.'[57] He concluded that objects affect the contexts in which they are used, the effect of the 'material' on the 'spiritual'. The form that objects have been given due to the mastery of a technique influences the way people think about their world. Keeping in mind that ethnographic objects are often the representations or materialisation of social values, it is no wonder that Indonesian ceremonial textiles and their production processes have become important to anthropological study.

The Tropenmuseum now

The current collection at the Tropenmuseum originated in the 19th century at the Koninklijk Zoölogisch Genootschap Natura Artis Magistra (NAM, Royal Zoological Society Natura Artis Magistra) in Amsterdam and the Colonial Museum in Haarlem, where objects from the former Dutch colonies were collected and exhibited from 1838 and 1864 respectively. These collections consisted of indigenous natural products as well as expressions of material culture, namely, objects that were crafted and used by the inhabitants of the Indonesian archipelago and other Overseas Territories.

The Vereeniging Koloniaal Instituut (Colonial Institute Association) was founded in Amsterdam in 1910. To house the institute and the museum affiliated with it, a large and lavishly decorated building was constructed on the Mauritskade. During the 20th and 21st century, the institute and the museum have undergone many name and policy changes because of politics. After the Proclamation of Indonesian Independence (1945), in 1950 the name of the institute changed to Koninklijk Instituut voor de Tropen (KIT, Royal Tropical Institute) and the museum acquired its present name, the Tropenmuseum. The Ministry of Foreign Affairs funded the museum until 2012, when the ministry announced that it would no longer support the Tropenmuseum. On 1 April 2014 the Tropenmuseum was detached from the Royal Tropical Institute in order to form the Nationaal Museum van Wereldculturen together with the National Museum of Ethnology in Leiden and the Afrika Museum in Berg en Dal. Its 150-year relationship with the Ministry of Foreign Affairs and its predecessors, including the Ministry of Colonies, had ended; thenceforth / the Tropenmuseum fell under the auspices of the Ministry of Education, Culture and Science.

The Nationaal Museum van Wereldculturen now manages one of the world's largest collections of Indonesian textiles. People are still fascinated by the beauty and vibrancy of Indonesian textiles as an expression of a unique cultural tradition. It is hoped that this important collection will continue to attract visitors to exhibitions and inspire new generations of researchers who, under the auspices of the Rita Bolland Fellowship for Textile Research programme, can study the collection and continue to contribute to this important field of material culture studies.

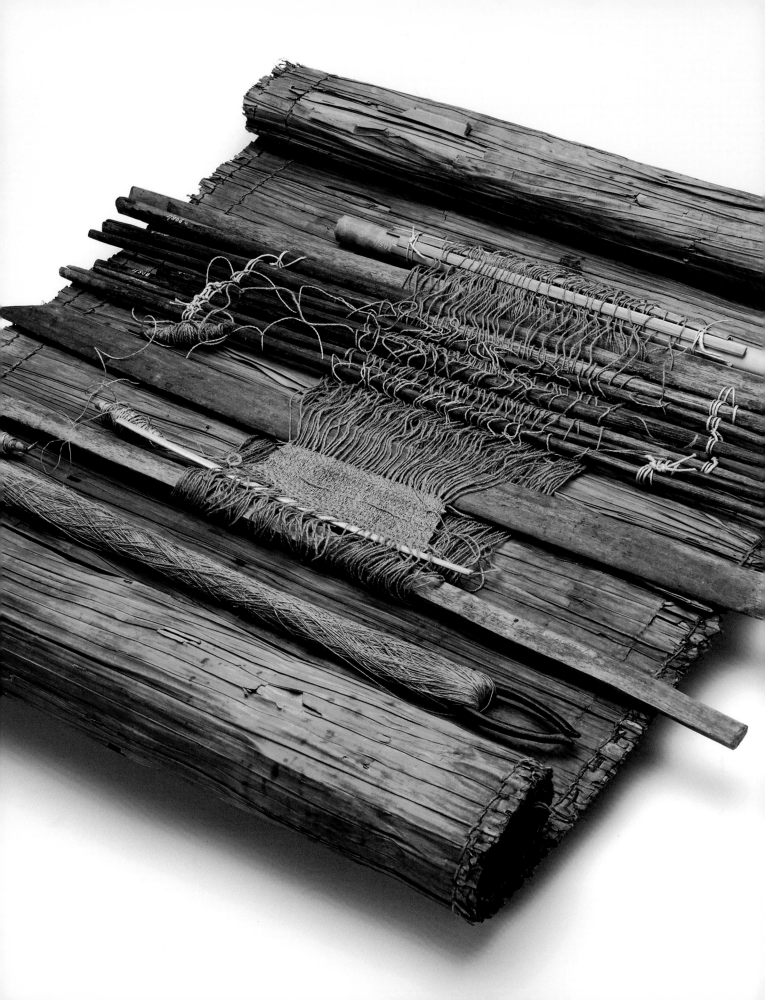

TEXTILES
IN INDONESIA

<
Model of a backstrap
loom with twill weave
See fig. 20

Although the broad variety of weaving traditions that have developed over thousands of years in the Indonesian archipelago is widely divergent, they share a common origin. Weavers in Indonesia drew on a broad palette of weaving and decorative techniques. Some may even date back to the birth of weaving. The textile on this model of a loom from Central Borneo is executed in a twill technique. The pattern of small diamonds is related to Neolithic motifs on basketry and mats.

Textiles played a unique and significant role in the lives of the various Indonesian communities, and are a binding element in socio-cultural life and despite great social and religious changes still play an important role in the lives of many people.

'She found there was a rhythm to the shuttle and the sword which took the place of prayer. Every movement was a repetition, every repetition was a word. The warp, the weft and the tools took on new meanings.'[58]

Many anthropological studies have been conducted and wonderful books have been published about the textile traditions in Indonesia. Some discuss traditions from a number of islands; others focus on one particular island, or on one ethnic group.[59] This chapter contains a brief description of the backgrounds of the various Indonesian weaving traditions, followed by a survey of techniques and materials.

Foundations and influences

Over the course of time foreign influences and the local responses to these resulted in a diversity of textile traditions in the Indonesian archipelago. Different scholars have situated the origin of the practice of weaving outside Indonesia. Chris Buckley studied the spread of what he calls 'the warp-faced tradition' on the Asian mainland and Insular Southeast Asia on the basis of three prominent characteristics of this weaving tradition: a. the type of loom; b. *ikat* decorative technique; and c. the tubular skirt as a garment. Archaeological and

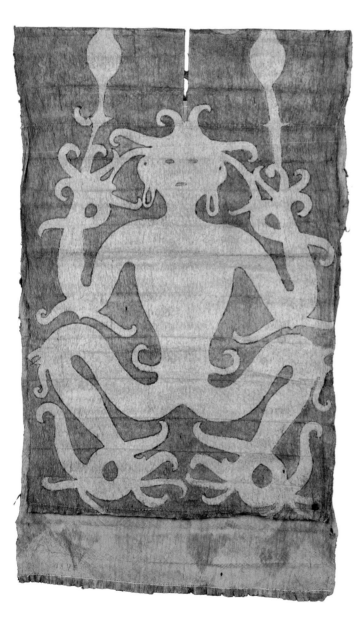
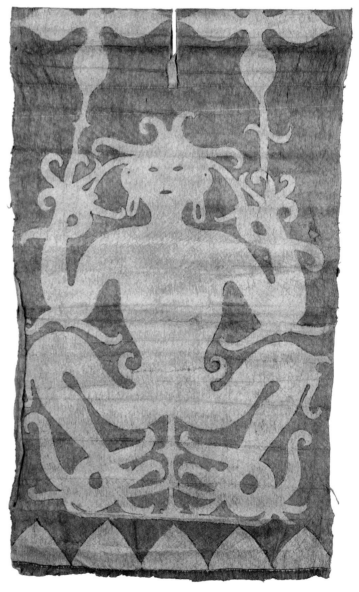

linguistic evidence and the distribution of these characteristics point to the conclusion that migrating peoples, belonging to the Austronesian language family and related to ethnic groups in the southeastern coastal region of China, introduced weaving to Insular Southeast Asia around 2500 BCE.[60]

The cultures of the majority of the ethnic groups living on the Indonesian islands prior to the Austronesians' arrival were either displaced by these migrants, or merged with the culture of the newcomers. The Austronesians brought changes in lifestyle and ideology, including, in addition to weaving, new farming techniques, the construction of wooden houses and seaworthy ships, and possibly also the technique of creating garments from barkcloth (fig. 6).[61] Until today, the terms used in Indonesia for objects or activities relating to weaving are derived from the Austronesian language family. The type of loom – a backstrap loom with circular warp, which was used in this early tradition – was of the same type that has been used for centuries, and indeed still is today on several islands (fig. 7).[62] Inextricably linked to this loom is the application of decorations and patterns on the warp threads, such as stripes in varying colours and patterns in the *ikat* technique.[63]

The introduction of weaving, the loom and the *ikat* technique marked the beginning of a textile tradition about which Mattiebelle Gittinger wrote:

[...] the Austronesians of Insular Southeast Asia endowed textiles with a worth that seems distinct from virtually all other peoples. This was not a monetary assessment, but a societal investment that gave to textiles a meaning that empowered them to enter into all aspects of life and to be viewed on many different layers of interpretation. In some instances the power of cloth extends beyond worldly social structures to relationships with the dead and even to cosmological levels.[64]

Living in a state of continual instability in a threatening environment, the early inhabitants sought a transcendental reality to rationalise emotional concerns such as fear of the unknown and the need for protection, fertility and continuity. People saw themselves and the world around them as parts of a dual universal entity, an entity outside which nothing else existed. Fundamental to this ancient belief system is the importance of notions concerning 'status' and 'fertility'.[65] Known as cosmic dualism, this system of thought divided the universe into two orders. Consequently, everything surrounding humans, including nature and all human activities were ordered into two opposing but complementary parts defined as either male or female: the upperworld and the underworld, sky and water, hot and cool, light and dark, headhunting and weaving, metal and textiles. The way to ensure the all-important

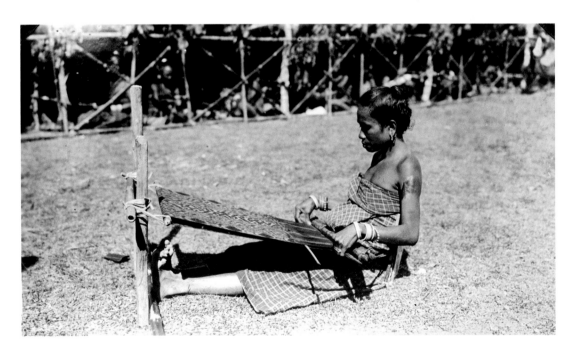

8
**Ceremonial textile
– *fut atoni***
The pattern consists of large
and small interlocking human
figures, *atoni*. Birds are
depicted on their ears, hands,
elbows, knees and feet, and
may represent souls that leave
the body after death in the
form of a bird.[2]
Cotton
Warp *ikat*
218 x 133 cm
Niki Niki region,
Amanuban, Timor
Late 19th/early 20th century
TM-2071-14
Purchase: E.B.
Geertsema-Beckering, 1951

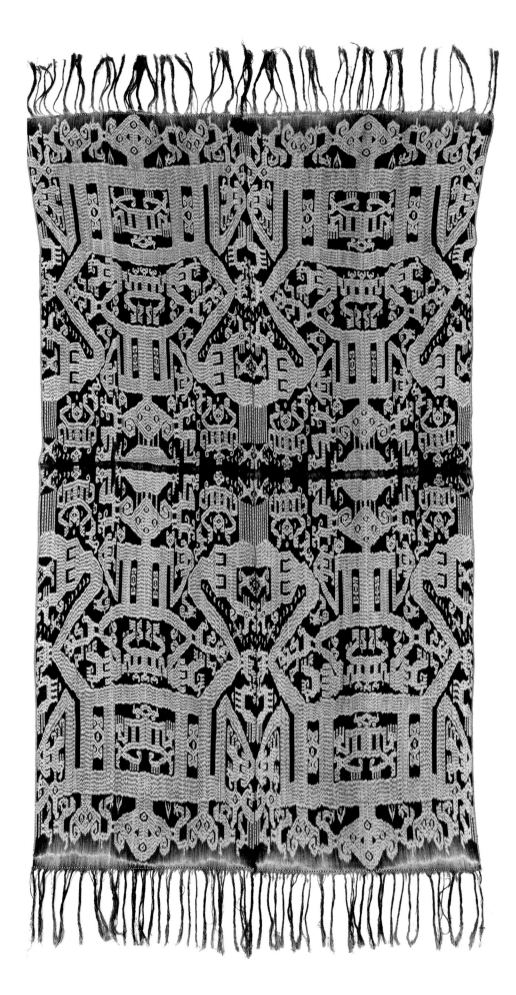

9
Ceremonial cloth
– pua kombu
Cotton
Warp *ikat*
180 x 116 cm
Batang Lupar Dayak, Borneo
19th century
TM-3892-7
Purchase: M.C.M. van
Oordt-Reinders, 1970

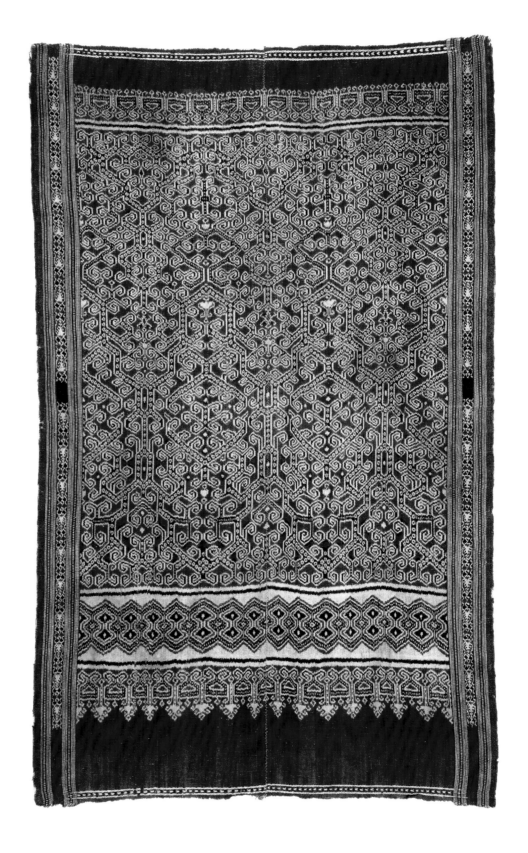

continuity of existence was to keep these polarities in balance. Also crucial to life was the worshipping of the ancestors, the creators of the earth, the discoverers of new territories, and the founders of the communities (fig. 8).[66]

In the Indonesian textile tradition the women are the weavers, and men participate in the production of textiles by making the weaving tools. The emphasis on the human values of continuity and stability were expressed through activities in the domain of textile production – in the preparation of cotton, the spinning of threads, the dyeing process, the working with a circular, continuous warp on a loom, in the creation of patterns and the ritual use of clothing. On the loom the circular warp without a beginning or an end is the basis from which a cloth emerges. The circular threads were associated with the continuity of life, with the succession of generations, and therefore with the ancestors and the supernatural. The entire process, from preparing the cotton to completing the cloth, is considered a metaphor for the human life cycle.[67]

Human life and its interactions with the worlds of ancestors, gods and spirits were regulated by *adat*, the customary laws laid down by the ancestors and kept alive by oral tradition. *Adat* rules prescribed behaviour in daily and ritual life to maintain the desired balance. Textiles were indispensable attributes in the cycle of agricultural rituals and rites of passage, i.e., birth, puberty, marriage and death. One of the major activities defining these ceremonies was the exchange of goods, which represented the male and female aspects of the cosmic whole. For example, textiles, ivory and pigs belonged to the female domain, while gold, weapons and buffaloes were part of the male sphere. Objects were the tangible means by which shape was given to the ritual behaviour required by the *adat* rules. They contributed to the ordering of communal life, and thus to certainty in the complexity of existence. Textiles also indicated clan affiliation, wealth, status and age. Throughout the archipelago rank depended on descent from the founding ancestors and on personal achievement. On Borneo headhunting and weaving were considered complementary activities. In the egalitarian Iban society a marriage ideally could only occur when a woman had achieved a certain status by weaving a *pua*, a sacred cloth, and a man by taking a head. After a headhunting raid, *pua* with powerful patterns were used to receive the

10

Ceremonial cloth
– *geringsing wayang*

Only on Bali cloths are woven with *ikat* motifs that are applied on both the warp and the weft, i.e. double *ikat*. The technique is similar to the one employed for the silk double *ikat* cloths from India, *patola*. The human figures on the cloth are reminiscent of the representations on reliefs of East Javanese temples dating from the 13th and 14th centuries.
Cotton
Double *ikat*
221 x 51 cm
Tenganan Pageringsingan, Bali
19th century
TM-1799-1
Exchange: Kunsthandel Lemaire, 1948

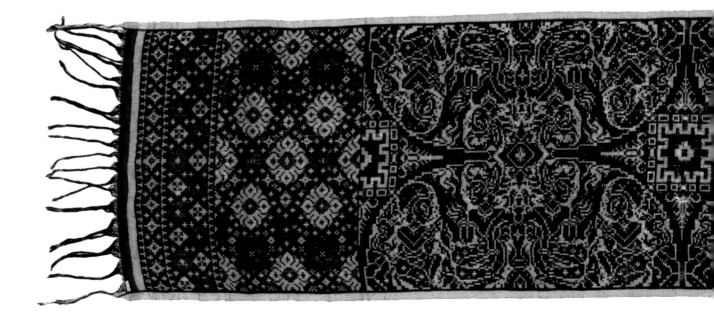

trophy heads.[68] Status and fertility were the values that were materialised when trophy heads and sacred textiles were displayed at various ritually important occasions (fig. 9).

In the last centuries BCE, new ideas and facets of the associated material culture spread over a number of islands once again, this time from a bronze culture (Dong Son 700–500 BCE to 100 CE) in North Vietnam. Representations and motifs on Dong Son artefacts, including the famous kettledrums, are redolent of depictions of boats and human figures on Indonesian textiles. Decorations on ceremonial skirts from the Lampung region in South Sumatra are an example (see fig. 166).

From the first millennium CE the archipelago was influenced by cultures from different directions. From Asia, the Middle East and Europe, merchants, religious scholars, representatives of imperial courts, explorers and colonial authorities visited the region once, came back several times, or decided to make the archipelago their home. Attracted by the abundance of natural resources and the opportunities offered by new markets, visitors from India and China were the first to arrive. Contacts between India and Sumatra

are thought to have been established in the first and second centuries CE by representatives of Indian rulers and Brahman scholars invited by the regional dynasties, who brought aspects of Indian religion and statecraft with them. In subsequent centuries the relationship with India was confined to the western half of the archipelago. Aspects of Hindu–Buddhism were steadily assimilated, facilitated by the fact that the Indian religious concept of the universe seems to have merged easily with local ideas on cosmology (fig. 10). From the 7th century, important kingdoms were developing in South Sumatra (Srivijaya, 7th–14th centuries) and in central Java (Sailendra, 8th–11th centuries). In these kingdoms with larger and more formal social organisations than the previous small-scale Austronesian societies, the function of clothing and textiles changed profoundly and weavers started using new materials and techniques. Silk garments embellished with gold thread and also precious beads came to symbolise and legitimise the power of the ruling class. In order to weave these textiles a different kind of loom with a flat warp and a reed came into use (fig. 11).[69]

Although Indian philosophy had a negligible influence on the cultures on the islands in the east

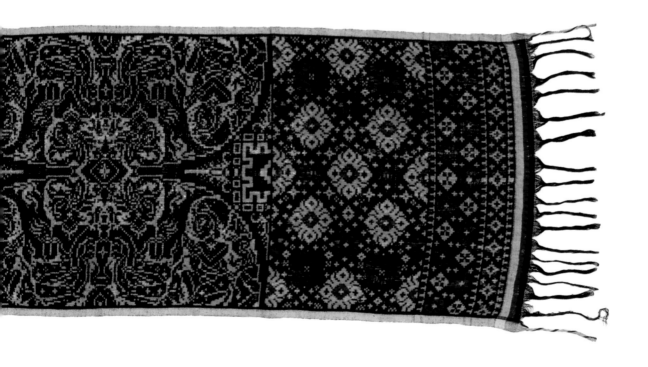

11
Loom with comb and
discontinuous warp
Wood, bamboo, cotton
128 x 104 x 13 cm
Sulawesi
19th/20th century
TM-48-2a
Purchase: J.E. Jasper, 1912

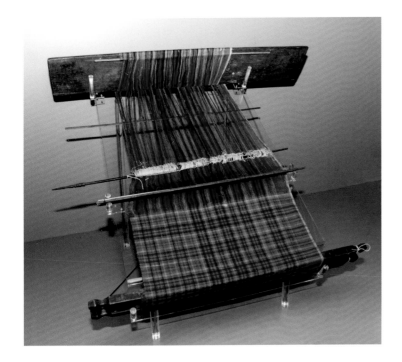

of the archipelago, the imported Indian tradecloths did affect the choice of patterns and the arrangement of designs on locally produced cotton *ikat* textiles. Indian textiles, the double *ikat* silk *patola* and printed cotton cloths, were treasured for centuries throughout the archipelago as sacred heirlooms, and represented the status and wealth of a village or family (fig. 12).

The Srivijaya court maintained trade connections with China, as did the later east Javanese kingdom of Majapahit (1293–c. 1500), a dynasty that also had connections to the Indianised world, but with strong local cultural characteristics. In the first centuries of the second millennium, alliances with royal families in China and the arrival of Chinese settlers brought Chinese valuables such as ceramics and silks to the archipelago. New techniques such as embroidery and couching with silk thread, as well as the striking Chinese imagery on clothing and on the imported and highly valued porcelain, influenced the appearance of locally produced textiles. Alongside these trade goods the Chinese merchants also brought large quantities of coins with a square hole in the centre. In Bali and Lombok these coins came to be regarded as having magical powers and were sometimes woven into sacred textiles (fig. 13). In the 19th century the Chinese community played an important role in the development of the commercial batik

12
Tubular skirt
– *kewatek nai telo*
Cotton
Warp *ikat*
146 x 143 cm
Lembata
19th century
TM-1772-1179
Gift: W.G. Tillman, 1994

13
Ceremonial cloth with Chinese coins – *kekombong*
Powers that could protect and preserve the efficacy of sacred textiles were attributed to Chinese coins, *kepeng*, on Lombok and Bali.[3] The manufacture of such a cloth is often a time-consuming affair, because the cloth must be woven from threads of which none can be broken during the weaving process. If a thread breaks the weaver has to start all over again.[4]
Cotton, metal
220 x 36 cm
Lombok
20th century
TM-1354-6
Gift: Prof. Dr. J.P. Kleiweg de Zwaan, 1940

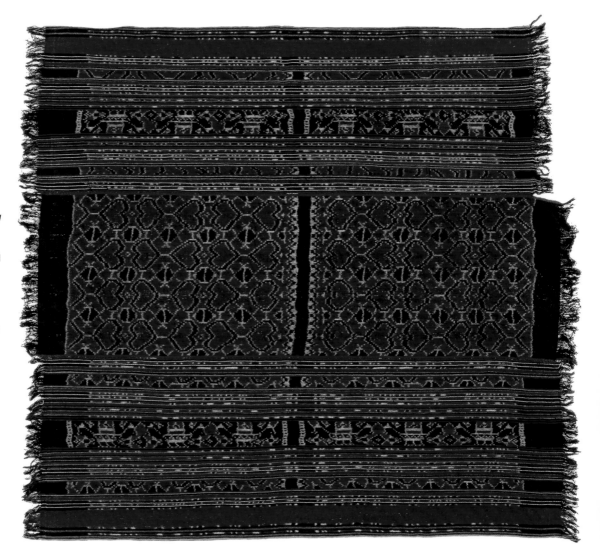

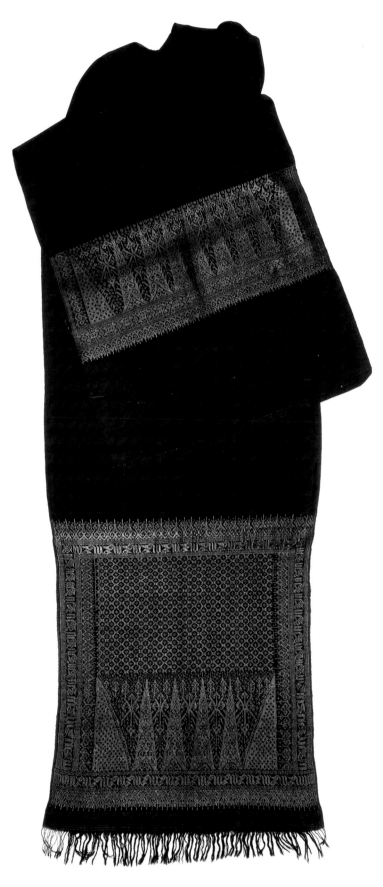

industry on Java, both as entrepreneurs and traders, and in the development of the Peranakan batik style (see figs. 179, 180).[70]

Travellers from all points along the trade route from China to as far as Europe introduced new religious and cultural elements to the archipelago, as did Muslim traders from the Middle East, China and India. The inhabitants of coastal kingdoms in the west of the archipelago converted to Islam around the 14th and 15th century. The mystical and spiritual elements in Islam enabled a coalescence of the newly introduced religion and the older religious beliefs.[71] Islamic influence spread unevenly through the region, but was prevalent on the western islands.
Clothing and textiles remained integral to ceremonial life and symbolised hereditary rights to power and the wealth of the aristocracy. In former times traditional clothing consisted of rectangular cloths that were wrapped around the body; these are still worn at ceremonial occasions in several parts of the archipelago. With Islam came alternative textile patterning techniques and motifs, new ideas about modesty, and tailored blouses, jackets, robes and trousers came into use. Representations of living creatures, characteristic of the ancient tradition, transformed under Islamic influence into geometric designs and highly stylised figurative motifs (fig. 14).
The first European involvement with the archipelago occurred in the early 16th century. After defeating the Portuguese, who were the first Europeans to travel to the archipelago, the Dutch colonised the region for more than 300 years. Dutch traders, drawn to the lucrative spice trade, founded an influential trading company, the Vereenigde Oostindische Compagnie (VOC, Dutch East India Company, 1602–1799). Although the Netherlands East Indies declared its independence from the Netherlands in 1945, the Dutch government only acknowledged the sovereignty of the Republic of Indonesia in 1949 (fig. 15).

< 14

Shoulder cloth

A cloth with Islamic calligraphy executed as a border decoration in silver thread. Prominent people wore these cloths during the pacification of Aceh as silent protest against the Dutch presence in their region.[5]
Silk, silver thread
Supplementary weft
459 x 84 cm
Aceh, Sumatra
20th century
TM-1772-1258
Gift: W. Tillman, 1994
Collected by C.M.A. Groenevelt

15

Tubular skirt – *tais*

A football game is depicted on the lower half of this tubular skirt. The teams are on the field; the ball is on the centre spot. The linesmen are standing on both sides of the goals, flags in hand. One of the winners holds the cup; a second person wears a huge crown on his head. The upper part of the skirt is decorated with a design inspired by motifs from Indian *patola*.
According to the collector this was a *pusaka* cloth, a sacred cloth that belonged to the family heritage. The identities of the teams are unknown; the match was supposedly organised when a high-ranking Dutch government official visited Tanimbar.
Cotton
Warp *ikat*
149 x 130 cm
Tanimbar
20th century
TM-1862-32
Exchange: J. Langewis, 1948

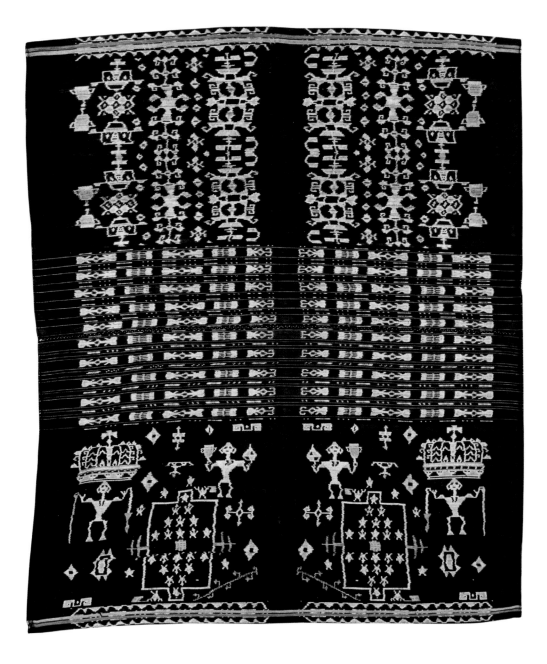

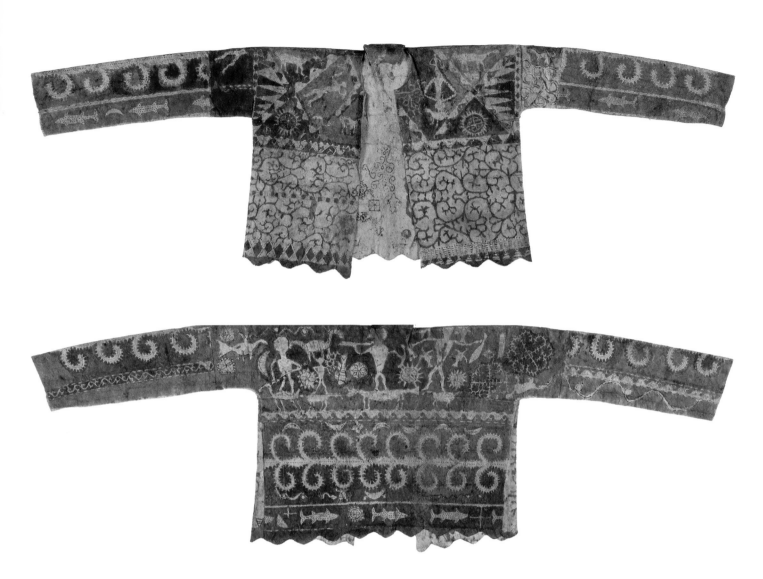

Materials and techniques

Before weaving was known, leaves, plant fibres and possibly barkcloth were used to make clothing.[72] (fig. 16) The peoples in the archipelago mastered a broad range of techniques to produce and decorate their clothes and ritual textiles. One of the oldest Neolithic techniques is twining, which, like plaiting, is considered a forerunner of weaving (figs. 17, 18). In the Late Neolithic period (2500 BCE) – when it is thought the weaving technique was introduced to the region – textiles were woven from bark and leaf fibres from plants such as the wild pineapple and wild banana. The fibres were prepared for the weaving process by knotting or twisting them using

a spindle to make threads long enough to weave. After its introduction from India, cotton was grown in the archipelago and became the most widely used material in Indonesian textile production. In the east of the archipelago the drop-spindle was the traditional tool used to spin the cotton into thread. The spinning wheel was introduced from the Indian subcontinent and was implemented in the coastal regions. Different types of looms are used in the archipelago. Although technically advanced looms now produce most of Indonesia's textiles, the oldest known type, the back-strap loom with circular warp, is still used in more isolated regions. The name refers to the technique whereby the weaver controls the tension of the warp threads with her back.[73]

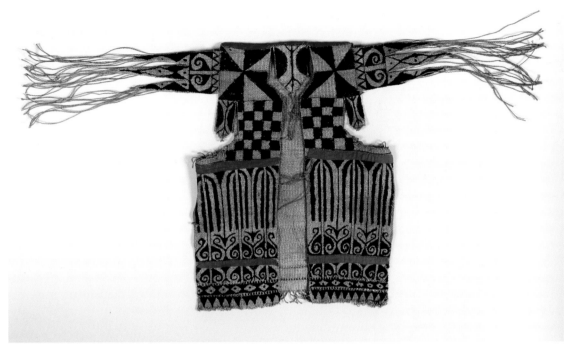

< 16
Ceremonial jacket
In Galela, barkcloth garments for everyday use were decorated with black charcoal; motifs on ceremonial clothing were applied in reddish brown or yellow. The upper part of the jacket is decorated with representations of people, buffalo heads, birds, suns, fish and snakes in the natural shade of the barkcloth.
On the inside are depictions of human beings, a turtle, some abstract motifs and an Arabic text: 'this jacket belongs to a person from Galela'.
Barkcloth
Painted
78 x 60 cm
Galela, Halmahera
Before 1887
TM-A-3330
Gift: Artis

17
Warrior's jacket
Vegetable fibre
Twined, painted
52 x 35 cm
Tebidah Dayak, Borneo
H-1687
Gift: Colonial Museum
Collected by Dr. Van der Weerd, 1900

18
Dayak family
Book illustration from a wood engraving
15 x 11 cm
TM-3219-42
Gift: unknown

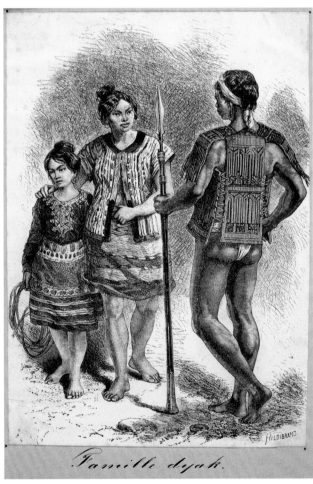

Famille dyak.

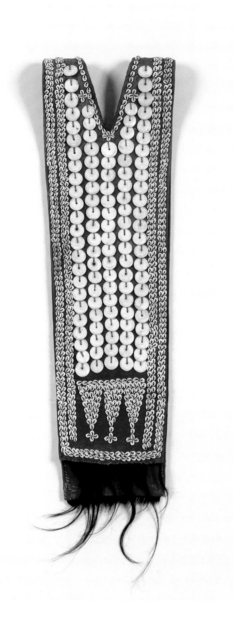

In the western part of the archipelago, in the regions where Hindu–Buddhist courts were established, a 'weft-based' weaving tradition developed that used a more sophisticated loom with a flat warp and a reed. According to Buckley this loom also originated in Southern China.[75] The reed, made of bamboo slivers, separated and spaced the individual warp threads, facilitating weft-faced patterning on cotton and imported silk. These textile decoration techniques remained in use when Islam became the dominant religion, and still do today.

To produce a coloured textile, a variety of natural dyes obtained from the leaves, bark or roots of plants and trees were and still are employed. Before dyeing cotton, either in the form of yarn or as a finished textile, the material is tanned, oiled and treated with a mordant (a substance that fixes dyes in fabric). The main natural colours were the natural white of the cotton; brown/black, obtained from mud or created by combining blue and red; blue from several varieties of indigo; and red from the bark and roots of the *Morinda citrifolia* tree. Other dyes included turmeric for yellow, and the resin named 'dragon's blood', produced from the rattan palm, for bright red. European chemical dyes, introduced in the second half of the 19th century, gradually replaced natural dyes, but vegetal dyes are still used on a limited scale. Patterns can be created by using different materials, techniques and colours. Seeds and shells have likely been used as ornamentation since Neolithic times, and from the moment they were imported glass beads were a prized material for decorating clothing and other objects (figs. 19, 200).[76]

Indonesian weavers mastered a broad range of decorative techniques. Depending on the type of loom, patterns were made by manipulating the warp and/or the weft while weaving; by adding supplementary weft or warp threads; by creating a motif on the threads before weaving, resulting in a pattern during the weaving process; or by adding patterns to the surface of the finished textile. Examples of the first technique are the small geometric motifs on fibre and cotton twill weaves from Central Borneo. Small diamond and chevron patterns, related to Neolithic motifs on basketry and mats, were created during the weaving process. This technique is practised in only a few isolated regions in the archipelago (figs. 20–22).

19
Mourning garment for men
Barkcloth, wool, human hair, cone shells, *nassa* shells
134 x 21 cm
Dayak, Borneo
Before 1887
TM-A-2897
Gift: Artis

As a result the textiles are warp-faced, meaning that only the warp threads are visible. The width of the cloth woven on this loom is to a certain extent limited to the width of the weaver's body (see fig. 2).[74] The circular warp results in a textile which, when removed from the loom, is a circular piece of cloth. As a rule, the remaining unwoven section of the warp threads is then cut to create a rectangular cloth. Two or sometimes three panels are joined to create a larger cloth for a tubular skirt, a hip- or a shoulder cloth. This 'warp-based' tradition is still widespread in the east of the archipelago.

TWILL WEAVE ON AN APO KAYAN LOOM

The photographer Jean Demmeni accompanied the Dutch explorer A.W. Nieuwenhuis on his expeditions through Central Borneo between 1893 and 1900. Demmeni returned with a loom (\TM-87-1) about which Nieuwenhuis wrote in 1904: 'The Dayak weave with this ordinary, simple apparatus, which is widespread throughout the Indonesian archipelago. With this loom they produce only simple kinds of things.

They do not understand weaving in patterns, they can only produce diamond shapes which are repeated in all sorts of variations in the different tribes.'[6]
Here, Nieuwenhuis was referring to the oldest and historically most used loom in Indonesia, the backstrap loom with circular warp, and the 'diamond shapes' that emerge refer to the twill weaving technique. The loom has additional components that make

it possible to produce a twill weave, whereby lozenge or herringbone patterns are created. By employing this way of weaving, motifs are created that are akin to plaiting patterns. The fact that this is an ancient weaving technique is demonstrated by the discovery of vegetable-fibre fragments of twill weave in the Niah Caves on Borneo (1600–400 BCE).[7]

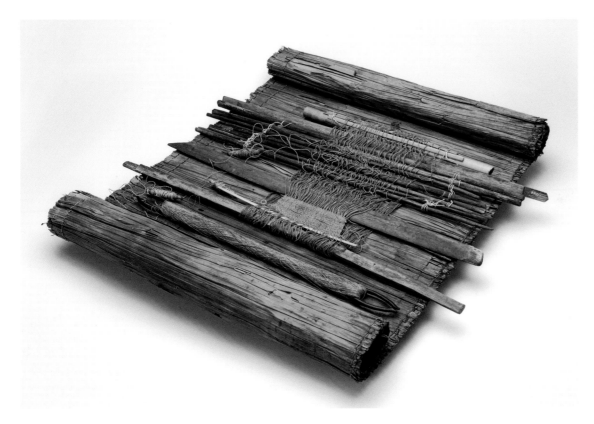

20
Model of a backstrap loom with twill weave
Cotton, vegetable fibre, wood, bamboo
64 x 63 x 8 cm
Apo Kayan, Borneo
TM-805-1
20th century
Gift: De Rooij, 1933

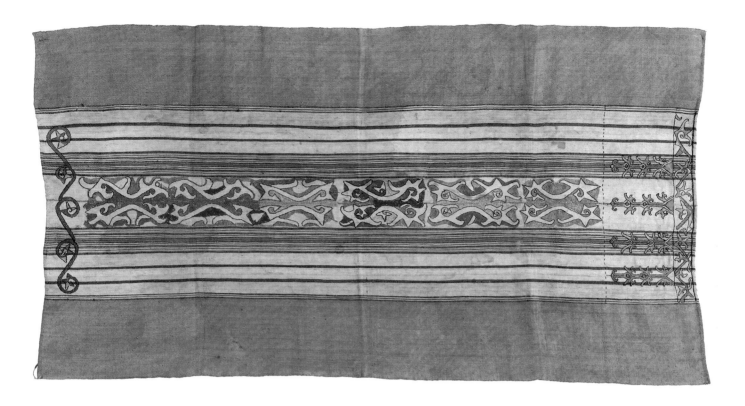

21
Women's skirt
Cotton, vegetable fibre
Twill weave, embroidery
110 x 59 cm
Apo Kayan, Borneo
TM-5166-1
19th century
Gift: L.H. van der
Kruk-Bodeman, 1988

22
Women's skirt (detail)
Cotton, vegetable fibre
Twill weave
128 x 64 cm
Apo Kayan, Borneo
TM-1798-1
19th century
Exchange: C.Tj. Bertling,
1848

Indonesian textiles became known worldwide for their patterns created with resist dye methods such as *ikat*, *batik*, *pelangi* and *tritik*. Other decorative techniques are striping, complementary- and supplementary warp- and weft weaving, supplementary weft wrapping, painting, embroidery, beadwork and appliqué. Because the backstrap loom with circular warp produced a warp-faced textile, the earliest decoration on textiles comprised striped or patterned warp-oriented decorations. This type of decoration was created with complementary- and supplementary warp weaving and warp *ikat*. Patterning on the weft, executed on a backstrap loom with a reed, was created with techniques such as weft *ikat*, complementary- and supplementary weft weaving, and supplementary weft wrapping. Supplementary weft weaving is called *songket* when done with metallic thread (see fig. 1). *Sungkit* (needle) is a term used in Borneo for discontinuous supplementary weft wrapping, and *pilih* (to choose) is used for continuous supplementary weft weaving (fig. 23).

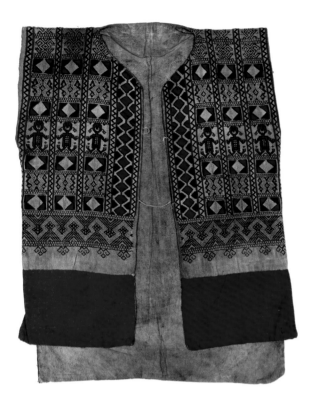
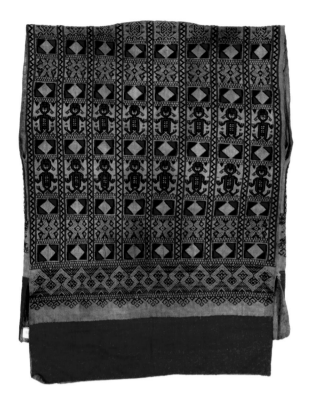

23
Jacket – *kelambi*
Cotton
Sungkit and *pilih*
60 x 44 cm
Dayak, West Borneo
19th century
TM-1772-1013
Gift: W.G. Tillman, 1994

For the purpose of patterning, resist-dye techniques use dye-resistant materials to prevent the dyes from penetrating selected areas of the threads or the fabric. *Ikat* creates a pattern on the threads before weaving. *Ikat* comes from the Indonesian word *mengikat* meaning 'to wrap' or 'to bind'. Designs are reserved by tying off small bundles of thread with strips of palm leaf or a similar material to prevent the dye penetrating those areas in the dye bath. The reserved areas stay white; to obtain a multi-coloured cloth new resists are added and old resists can be removed before the cloth is immersed in the next dye. After dyeing, all resists are removed, leaving patterned threads ready for weaving. This can be done to either the warp or weft threads, or to both of them, to create a textile with a pattern in double *ikat*. The *ikat* technique and more specifically warp *ikat* probably has the same origin as the prehistoric backstrap loom with circular warp and is most likely one of the oldest decorative techniques. It is possible that weavers throughout the archipelago once employed this decorative technique, even if we do not see it being used today. It is now associated with cultures in eastern Indonesia and in remote

regions in the interior of Sumatra, Kalimantan and Sulawesi (see figs. 3, 9, and 143). *Ikat* on the weft threads came into vogue with the introduction of silk thread (figs. 1, 24). Nonetheless, for the complex double-*ikat* technique, known only on Bali in Indonesia, cotton thread is used (see fig. 10). The batik, *pelangi* and *tritik* techniques are used to create designs on woven fabric.[77] In brief batik is a resist-dye process in which a resist, for instance, hot wax or another substance, is applied in patterns to the surface of a cloth to isolate areas from the dye. This is done with a wax pen (*canting*) or a metal stamp (*cap*), although in the past other devices were also used. When the *canting* or *cap* is used the wax is applied to both sides of the cloth. After dyeing, the resist is removed by boiling, melting or scraping. This process can be repeated several times with different colours to produce multicoloured cloths. Java became famous for clothing with elaborate *batik* patterns; this technique is also known on Madura and Sumatra, and in the past also on Sulawesi (fig. 25; also see figs. 84, 197, 203). To produce *pelangi*, certain areas of a cloth are reserved from the dye by being bound off with dye-resistant fibres before the

24
Textile fragment
Cotton, silk, silver thread
Weft *ikat*
148 x 91 cm
Sumatra
Date unknown
TM-1772-1328
Gift: W.G. Tillman, 1994

25
Tubular skirt, *sarung*
Cotton
Batik
242 x 133 cm
Java
19th century
TM-2899-29
Gift: A.C.A.J. Clifford, 1960

dyes are applied. *Tritik* is a process in which the cloth is stitched, gathered and tightly tucked before dyeing so that dye cannot penetrate the reserved areas (fig. 26).

Other decorative techniques include embroidery, couching, appliqué, beading, and *prada*, the application of gold leaf or gold dust with glue to the surface of the textile (fig. 27).

Cultures are in constant flux: there have been many major transformations since ancient times. Over the past century, again much has changed in Indonesia, the art of weaving has been lost in some regions, while in others it has managed to survive or has been revived. New materials and techniques are used, but mainly because they are less time-consuming, and commerce exerts a greater influence than before. Yet down to the present day, in many regions textiles are vital to enacting rituals. When making these ceremonial textiles, the weavers wholly or partly revert to traditional production methods.

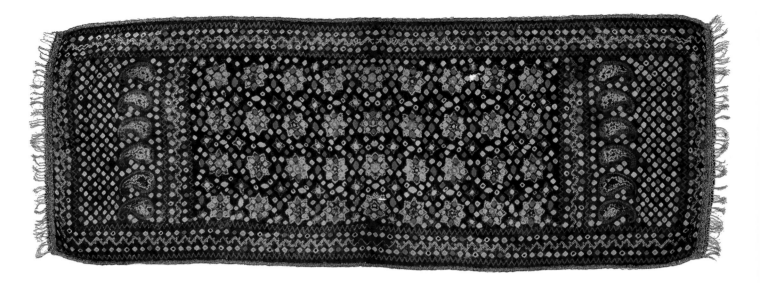

26
Shoulder cloth
Silk, gold gallon
Plangi, *tritik*, crochet
214 x 78 cm
Bali
20th century
TM-2246-2
Loan: Dienst van 's Rijks
Verspreide Kunstvoorwerpen,[8]
1953

27
Ceremonial cloth,
part of a dance costume
Silk, gold leaf
Prada
134 x 102 cm
Bali
Early 20th century
TM-1243-41
Purchase: Assistant Resident,
Bali, 1938

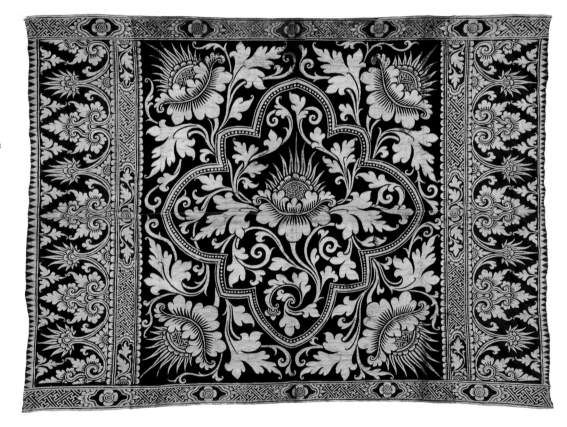

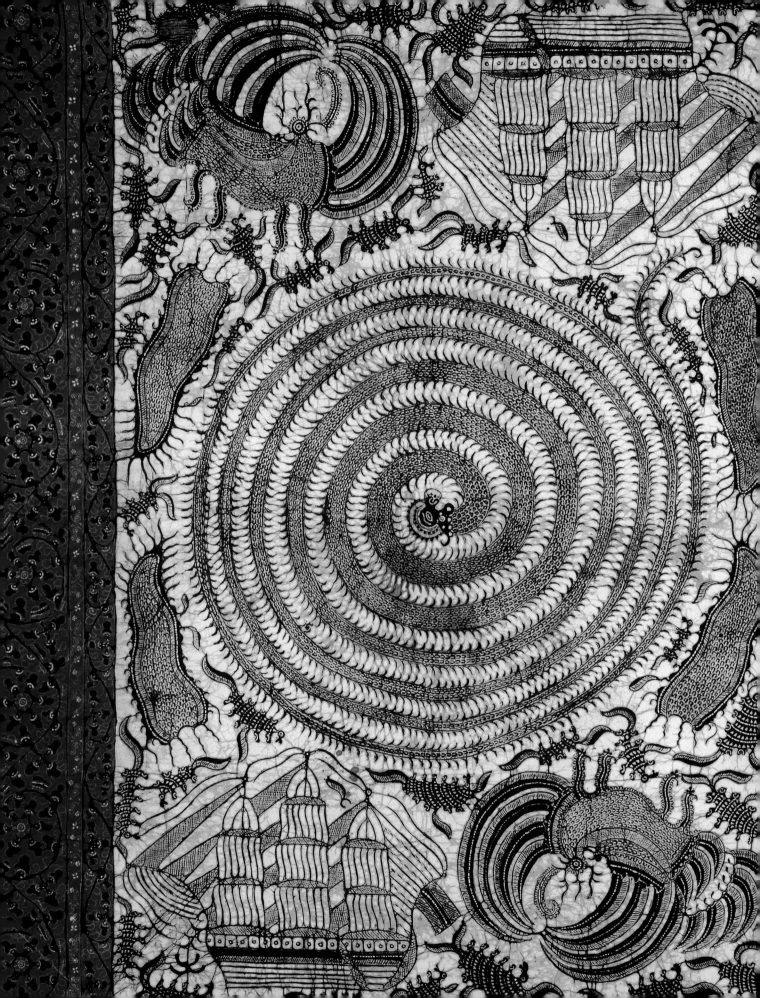

THE COLONIAL ADMINISTRATION AND THE ARTS AND CRAFTS INDUSTRY

<
Tubular skirt – *sarung*
See fig. 183

This batik tubular skirt was made around 1870 in Lasem on the North Coast of Java at a time when it was a bustling port with an emerging batik industry. Some of the batiks produced there were destined for the Sumatran market. The combination of the colours red, blue and cream is characteristic of Lasem. The deep red colour and the circular motifs on the centre panel are redolent of Indian tradecloths that were so highly prized on Sumatra. On the side panels winged mythical creatures, centipedes and ships stand out in blue against a white background. The vessels are European three-masters depicted with the wind in their sails and a row of gunports. The Dutch came to the East to trade. The Dutch East India Company (VOC) successfully traded Indian textiles for spices in the archipelago.

In the centuries preceding Dutch colonial rule, textiles from India were one of the most important commercial products for the Dutch East India Company (VOC). In the 17th century the VOC strove to achieve a monopoly on the spice trade for the Netherlands to the detriment of other European countries, including England. Indian textiles produced in Gujarat and on the Coromandel Coast were shipped in massive quantities by the VOC to Java, from where they were traded and distributed throughout the archipelago (see figs. 63, 194). The commercial value of Indian fabrics may also have influenced the emergence of economic interest in the Netherlands in the Javanese textile industry and especially the batik industry. This interest was driven by industrial developments in the textile industry in England and to changes on the political map of the world at the beginning of the 19th century. When France annexed the Netherlands in 1810 during the Napoleonic Wars (1804–15), the English seized their chance in 1811 and occupied the island of Java. Sir Thomas Stamford Raffles (1781–1826) was appointed governor general of Java. At the Convention of London in 1814 the archipelago was allocated to the Netherlands and in 1816 the British

left Java again. Raffles' presence on Java was short-lived, but his influence was permanent. His great interest in and study of the Javanese language and culture led to him being appointed president of the Bataviaasch Genootschap van Kunsten en Weten-schappen (Batavian Society of Arts and Sciences) in 1813. Dutch government officials in Batavia (Jakarta) founded this society – the first scientific institute in Asia – in 1778. The society was to focus primarily on issues such as natural history, archaeology and ethnology, and only secondarily on agriculture, trade and prosperity.[78] Although the Dutch founded this society, it was the Englishman Raffles who conducted the first comprehensive study of Java's culture. He did however also accumulate knowledge for his research from Dutch officials present on the island, who proved to be an important source of information for him.[79] His research culminated in 1817 in the publication of *The History of Java*, which was translated into Dutch in 1836.[80] This translation however omitted the chapter 'Antiquities on Java', 'because the translator considered antiquities to be "objects of entertainment and diversion" and the subject to be "unnecessary". Thus was the Dutch public deprived of an introduction to Hindu–Buddhist art and the accompanying illustrations.'[81] In the Netherlands this chapter was apparently considered to be of little value for the development of colonial commercial activities. Raffles had previously criticised the Dutch for their disinterest in art and culture, and for focusing only on their trading activities, although in his book he also expresses interest in the commercial potential of the batik industry for the English cotton and textile printing industry. The successful English textile production for the Indian market had not gone unnoticed by the Dutch and the opportunities that the Javanese textile industry could offer Dutch textile companies became ever more apparent. The Dutch government started to appreciate the importance of assimilating knowledge about Indonesian languages and cultures.

After the bankruptcy and dissolution of the VOC in 1799 and the allocation of the archipelago to the Netherlands in 1814, King Willem I (1772–1843) gradually changed the colonial system. From one that focused on trade, it was transformed into a system of direct colonial rule and control over more and more regions and islands.

28
Memorial coin
The text 'De vestiging van het Nederlands gezag in Indië herdacht' ('Commemorating the establishment of Dutch authority in the Indies') is on the obverse in a temple complex above the image of the Dutch Lion. On the reverse are a Javanese woman at her batik frame and a farmer with a buffalo with the text 'Visitatione Tua Pace & Praeposits Tus Justice, 1602–1902'.
Design: J.M. Faddegon
Bronze
6.2 cm
The Netherlands
1902
TM-H-2189
Gift: A.O. van Kerkwijk, 1904

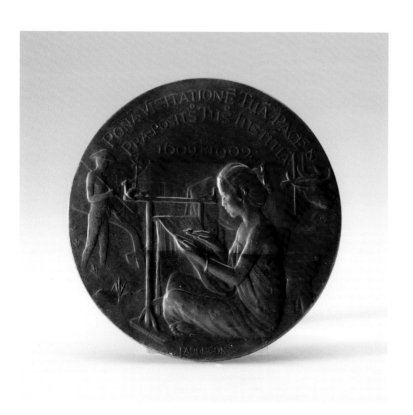

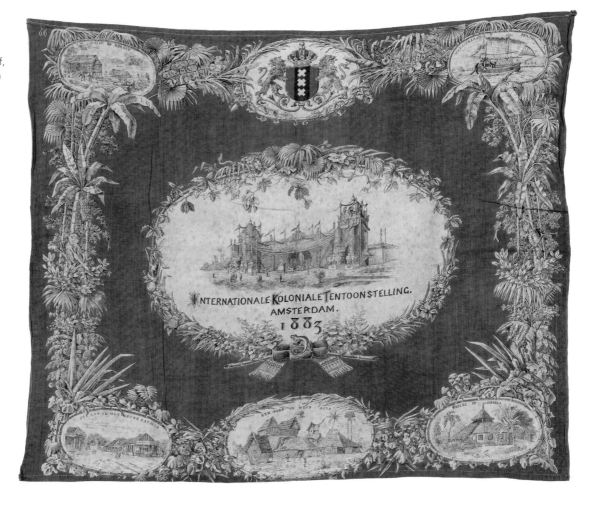

29
Commemorative cloth
The cloth, in the style of
a Dutch farmer's handkerchief,
was printed by Van Vlissingen
& Co. in Helmond for the
1883 International Colonial
and Export Exhibition in
Amsterdam. The cartouche
in the centre depicts the
entrance to the exhibition.
Around the border are
(clockwise): the arms of
Amsterdam, a canoe from
Makassar, a mosque in
Ambon, a village in West
Java, a street in Batavia
(Jakarta) and a house on
Borneo. These images are
connected by the tendrils
of native plants.
Printed cotton
46 x 68 cm
Helmond, the Netherlands
1883
TM-5707-1
Gift: D. Demper, 1997

In the 19th century the Javanese batik industry and
the Dutch cotton industry grew to become important
tools of political and economic relations between the
Netherlands and the Netherlands East Indies, 'Soon
batik and its newly emerging Dutch counterpart of
white and printed cotton cloth would become instru-
mental in the growing interweaving of economic
developments in the Netherlands and the Dutch East
Indies' (see Chapter 'Colonial Collections').[82]
A memorial coin was issued in 1902 commemorating
the 300-year-long relationship between the archi-
pelago and the Netherlands. On the coin is the image
of a woman preparing a batik cloth. Batik art was one
of the best-known forms of Indonesian handicrafts
in the Netherlands, and was possibly seen as repre-
sentative of Javanese culture, yet at the same time
this image also expresses the commercial potential
of the batik industry (fig. 28).

World fairs

The importance of colonial trade and the Indonesian
craft-production system for the Dutch government
and industry was manifested in the establishment
of the Colonial Museum in Haarlem in 1864 (see
Chapters 'Collecting' and 'Presentation'). The
objective of this museum was to stimulate trade
and accumulate and disseminate knowledge about
the colonies. To this end, the museum organised
exhibitions and conventions both on Java and in the
Netherlands, which displayed local crafts products
that were made from raw materials and natural
produce from the archipelago. The Dutch government
also organised activities outside the museums that
helped to foster interest in arts and crafts from
Indonesia. A new phenomenon, world fairs, organised
by national authorities, debuted in Europe.

30
Model of a sedan chair
Made for the 1883
International Colonial
and Export Exhibition in
Amsterdam. As is also the
case with full-scale sedan
chairs, the model has
a curtain around it made
from an Indian *patolu*.
Patola are Indian silk textiles
that were imported to the
Indonesian archipelago
(see fig. 63).
Wood, bamboo, silk
Double *ikat*
29 x 58 x 19 cm
Java, India
Before 1883
TM-A-3679
Gift: Artis

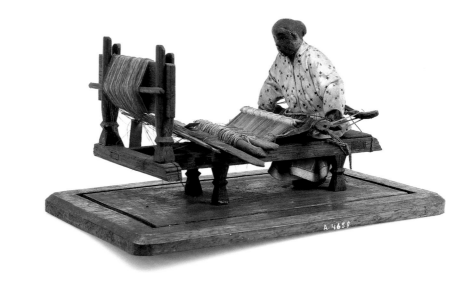

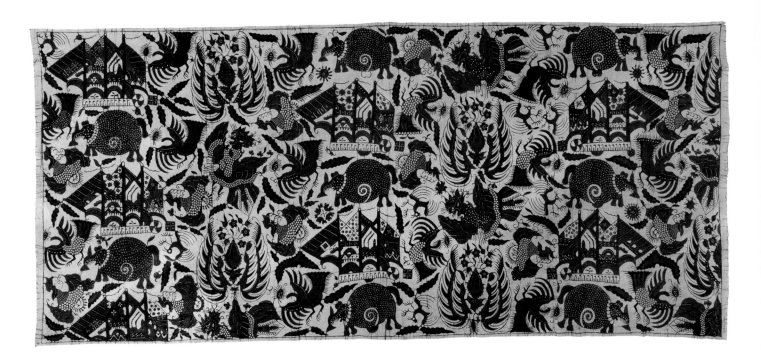

World fairs were grand events in which countries could display their progress in political, economic, technical and cultural fields to each other and to an international audience. That the Netherlands chose 'Overseas Territories' as the central theme for the only world fair ever to be held in the Netherlands came as no surprise. The Netherlands presented itself at the Internationale Koloniale en Uitvoerhandeltentoonstelling (International Colonial and Export Exhibition) held in Amsterdam in 1883 as 'a ruler of a vast and ancient colonial empire', thus positioning itself as deserving a place among the modern and industrialised nations of Europe.[83] The Helmond-based textile company Van Vlissingen & Co. (now Vlisco) printed a commemorative cloth in the shape of a Dutch farmer's handkerchief to commemorate this world fair (fig. 29).

For this exhibition the government commissioned a collection of 'ethnographic objects, raw materials and colonial goods' from the Netherlands East Indies. A section devoted exclusively to arts and crafts generated interest among the general public as well as artists and art lovers. Various handicrafts were presented in addition to the displays of 'indigenous' objects. The organisation brought Indonesian artisans to the Netherlands to demonstrate their skills, including batik and weaving, to the public.

In the Netherlands this presentation initiated a debate on the ethical implications of displaying living people. Some of those involved in the organisation expressed their concern for the well-being of the artisans, others spoke of 'their vicarious shame' when the sound of the Javanese gong announced the start of the show and many visitors rushed to see how humans from an 'uncivilised' culture were put on display.[84]

The multitude and diversity of trades in the archipelago made it impossible to present all handicrafts in such a 'realistic' way. Miniature models and tableaux were therefore created especially for this exhibition (figs. 30, 31).

Besides the economic importance for the Netherlands and the pride with which the products from the colonised territories were displayed, this was the first exhibition to assign an artistic value to the sophisticated 'Oriental' ornamentation of Indonesian crafts (fig. 32).[85]

Interest in Indonesian decorative arts grew in the Netherlands after the world fair in Amsterdam.[86] The director of the Colonial Museum, Willem Frederik van Eeden, made a significant contribution to this by discussing the indigenous art industry in lectures and essays. He highlighted the 'personal uniqueness' of Oriental decorative arts, which he

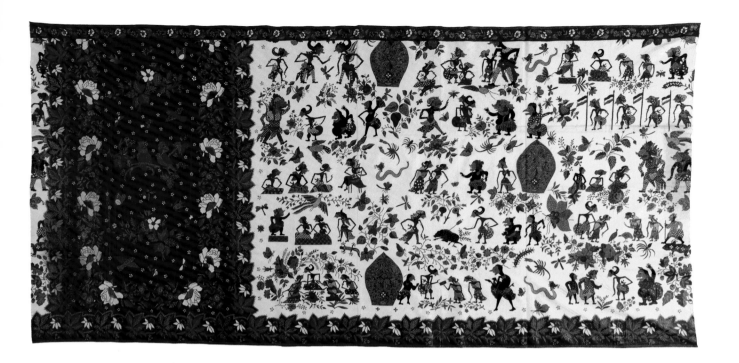

believed had disappeared from Dutch arts and crafts because of industrial developments in the 19th century. He admired the ability of the Javanese to 'transform natural products into decorative patterns so that only a nuance of the original remains and the figures together form a harmonious whole'.[87] Van Eeden not only pointed to the wealth of motifs; he also emphasised the soft and harmoniously juxtaposed colours obtained from natural dyes and compared them to the harsh European synthetic colours (see figs. 33, 34).

A world fair was organised in Brussels in 1910. The committee responsible for the Dutch contribution found the colonial theme so important that it was allocated a third of the total space available to the Netherlands. In addition to the committee in the Netherlands, an exhibition committee was also appointed in the Netherlands East Indies, which proposed organising an 'indigenous crafts show'. Handicrafts from the Netherlands East Indies were given a place of honour in the centre of this section as the 'crowning glory *and* commercial product' (fig. 35).[88]

An important contribution to this world fair came from Johan Ernst Jasper, a leading researcher in the field of Indonesian arts and crafts. He had acquired the objects for this contribution together with a fellow researcher Gerret Pieter Rouffaer at the fifth annual fair in Surabaya in 1909. Part of the collection of textiles and looms that Jasper sent to Belgium entered into the collection of the Colonial Museum in 1912 (which is now included in the Tropenmuseum collection, Series H); the Koloniaal Instituut (Colonial Institute) in Amsterdam bought another part of this collection in 1916 (Series 48).

Lack of knowledge

The increasing interest of the colonial administration and entrepreneurs in the materials, manufacturing techniques and handicrafts from Indonesia revealed a lack of knowledge among the parties involved, which in 1884 led to the Haarlem museum director's decision to initiate a survey of the state of the applied art industry in the Netherlands East Indies. At the same time Van Eerden wanted to explore ways to strengthen this sector in order to protect it from decline. G.P. Rouffaer arrived in Batavia around the same time. Rouffaer travelled through a significant part of the archipelago and developed a keen interest in its cultural heritage. He was a researcher who not only wanted to serve science; he was also concerned with the social position of the craftspeople in the colony. His publication in collaboration with J.J. Juynbol, *De Batikkunst in Nederlandsch-Indië en haar Geschiedenis* ('Batik Art in the Netherlands East Indies and its History'), appeared in 1900 and is still considered a standard work. Their research is characterised by a multi-faceted approach in which the techniques, history, the meanings of the patterns and the significance of batik art for Indonesia and Europe are discussed. Rouffaer also consulted studies by various government officials and scientists into the economic and social conditions in the batik industry on Java. He conducted his in-depth study of batik art as an independent researcher and not on behalf of the government, although his work did influence their attitude towards the batik industry. Following Rouffaer's initiative the Dutch government commissioned two studies at the start of the 20th century. J.E. Jasper made a thorough study

of the various disciplines within the arts and crafts sector, and Cornelis Marinus Pleyte, at the time the curator of the Artis Ethnographic Museum (see Chapter 'Collecting'), studied the cultural and socio-economic aspects of the industry in West Java.

J.E. Jasper (1874–1945) made an important contribution to the field of Indonesian crafts and the creation of ethnographic collections in the Netherlands, including the textile collection in the Tropenmuseum, not only as a representative of the Dutch government, but also because of his own personal commitment to the subject.
Jasper was born in Surabaya in 1874 into an East Indies family who had lived in the archipelago for many generations. He chose a career in the colonial administration and was educated at the Koning Willem III Gymnasium in Batavia. In a career spanning more than 30 years he rose from *controleur* (district commissioner), to governor of Yogyakarta. He died in 1945 in a Japanese internment camp.
Jasper was a versatile man with a great regard for culture, and a passionate and prolific writer of novels, stories and articles on the most diverse subjects. Jasper admired the beauty of East Indies decorative art and was fascinated by the various arts and crafts techniques. Like others, he feared that Western influence would result in the disappearance of craftsmanship in the Netherlands East Indies. To prevent this, he considered knowledge of the different techniques to be essential. It was also necessary to adapt the craft production system and constantly modernise it so that it could become a profitable industry. In 1901 Jasper made several study trips through Europe where he visited museums and exhibitions. Ideas about conducting research into East Indies weaving and decorative arts were born during a visit to an exhibition on Indonesian arts and crafts in The Hague. In 1902, the colonial administration commissioned Jasper to evaluate the school curriculum for Javanese children in Surabaya, and in his report he advocated establishing special vocational schools with a focus on arts and crafts. This goal was fully in line with the then prevailing *Ethische Politiek* (Ethical Policy) to improve the economic standing of the population by encouraging cottage industries. The colonial administration came to the conclusion that, in order

to execute this policy effectively, more knowledge was required about the field of crafts. As a result Jasper was asked in 1906 to initiate technical and artistic research into various branches of the local traditional crafts. To this end, he travelled with the Javanese artist Mas Pirngadie (1875–1936) through the archipelago. As part of this research, he organised annual fairs in several Javanese cities with the aim of increasing awareness of various arts and crafts products, and thus the market for them. Jasper asked government officials in remote regions to encourage the locals to send their products to these annual fairs. To ensure that he received enough submissions he awarded prizes for the technically most refined products. This approach ensured that textiles, selected by people from remote regions, also became available for acquisition. After these events Jasper would often purchase the best exhibits.

Jasper's research resulted in a five-volume publication, *De Inlandsche kunstnijverheid in Nederlandsch Indië* ('The Native Arts and Crafts in the Netherlands East Indies'), illustrated by Mas Pirngadie. To this day researchers and others interested in Indonesian arts and crafts consult this standard work.[89] Jasper devoted two volumes to textile art. In *De Weefkunst* ('The Art of Weaving', 1912) and *De Batikkunst* ('The Art of Batik', 1916) he provides descriptions of materials, production techniques and the motifs and patterns on the textiles. The emphasis in these publications is placed on the technical aspects of 'what was made, what it was made of, and how it was made'. This integrated Jaspers' research with the then prevailing interest in materials and production techniques. This focus also influenced the content policy of the Colonial Museum in Haarlem and later the museum in Amsterdam. Given the results of these studies and the reports of government officials in the Netherlands East Indies, it appears that the focus was no longer just on the commercial possibilities but, under the influence

36
Test cloth
This cloth was produced in 1901 by Meta Weerman in the Colonial Museum's Laboratory. She was a student at the School for Applied Arts, which was adjacent to the museum. Weerman succeeded the director, H.A.J. Baanders, in 1901. This test cloth is an example of dyeing in six colours (see fig. 54).
Cotton
Batik
38 x 35 cm
Haarlem
1901
TM-H-3335

of the Ethical Policy, also on improving the working conditions of workers in the various industries.[90]

In his 1931 'Batik Report', civil servant P. de Kat Angelino describes the appalling conditions for workers, particularly female workers, in the batik industry.[91] The colonial administration considered it worthwhile to try to improve these conditions. In practice, however, it amounted to next to nothing.

In addition to the studies that were conducted in the Netherlands East Indies, initiatives were also taken in the Colonial Museum in Haarlem to increase knowledge of products and technical processes and thereby serve the commercial interests of the Dutch market. The dye indigo was, just as coffee, tea and sugar, a 'government product', which meant that during the time of the *Cultuurstelsel* (Cultivation System) the local population was obliged to cede a portion of their production to the colonial administration. In order to improve the dye's quality, tests were conducted in the Colonial Museum's Laboratory (Afdeling Onderzoek en Proefneming; Research and Experimentation department) (see Chapters 'Colonial Collections' and 'Collecting'). The results of this research not only served an economic purpose, but also benefited a group of Dutch artists who around 1900 began to experiment with both the batik process and dyeing techniques in order to gain more insight into the complex decorative techniques used on textiles.

An example of these tests is preserved in the Tropenmuseum collection. Meta Weerman made

it in the Colonial Museum's Laboratory in 1901. The batik cloth has an image of a rising sun and nutmeg kernels that have just burst open and the words: '*Het daghet in den Oosten*' (literally, 'It is dawning in the East'), the motto of the Colonial Museum at the time (fig. 36).[92] The textile appears to represent both the political and artistic ideas about the relationship between the Netherlands and its East Indies colony at the time: artistically because of the use of batik, a technique for which there was fascination and admiration from both artists and the general public in the Netherlands; and commercially because the nutmeg refers to the lucrative spice trade. The text possibly indicated the ambivalent attitude that existed in the Netherlands with regard to the colony. Although the Dutch had always been in the East Indies for profit, in some circles at the end of the 19th century there was growing concern for the living conditions of different ethnic groups and increasing appreciation for their crafts.

In the Netherlands, the prevailing opinion was that the population of the Netherlands East Indies or 'the East' was undeveloped and uncivilised. The archipelago, it was argued, was 'shrouded in darkness' and it was up to the 'enlightened' colonial power, the Dutch government, to kindle the light of modern civilisation in Indonesia.[93] Hence the motto: '*Het daghet in den Oosten*'. However, this motto also gave rise to other interpretations. In a number of essays, Van Eeden, the director of the museum, praised the exceptional artistic abilities of the Netherlands East Indies population as expressed

37
Commemorative cloth
Cotton
Batik
132 x 42 cm
North coast of Java
1921
TM-5437-4
Gift: F.E. Douwes Dekker

through their decorated silk and cotton fabrics in soft colours, and their gold and silver thread ornamentation. He compared these lyrically with the 'silver edges around the clouds'. His admiration went so far that he no longer talked about 'the dawning in the East' ('*het daghet in den Oosten*') but about 'the dawning *from* the East' ('*het daghet "uit" den Oosten*'). According to him, the situation was reversed. The Dutch should draw inspiration from the refined artistic expressions of the ancient cultures of the Hindu kingdoms in Asia. The 'East' would benefit the Netherlands not only economically: the Dutch also needed the East Indies to 'initiate a beneficial broadening of the mind' in their homeland.[94] Van Eeden's regard for Indonesian decorative arts influenced both the policy of the Colonial Museum and more broadly, the policy relating to Dutch arts (see Chapter 'Colonial Collections').

Regardless of Van Eeden's admiration, he among others, scientists and government officials in the Netherlands East Indies included, developed an ambivalent attitude towards the arts and crafts industry. A tension arose between the desire to preserve the prized 'authentic' traditions and the obligation they felt to protect those traditions from decline and extinction by reforming and adapting them to Western tastes, as a result of which the products would become more attractive for international trade.[95] At the same time the conviction grew in prominent circles in the Netherlands that the Dutch should no longer simply consider the colony as a conquered land; the colonial administration also had a moral obligation to serve the interests of the indigenous people. These views were also influenced by the novel *Max Havelaar*, published in 1860, by Multatuli ('I have endured much'), the pseudonym of Eduard Douwes Dekker (1820–87). In *Max Havelaar*, former Assistant Resident Eduard Douwes Dekker exposed the abuses suffered by the Indonesian population as a result of the Cultivation System. In 2002 *Max Havelaar* was proclaimed to be the most important Dutch-language literary work of all time by the Maatschappij der Nederlandse Letterkunde (Society of Dutch Literature).

In 1992 the Tropenmuseum acquired a batik cloth that was made for C.H. Douwes Dekker, Eduard's brother's great grandson. The Javanese text on the textile, *Bewijs van sympathie aan uw familie, aangeboden aan de hooggeschatte bevriende familie*

C.H. Douwes Dekker, Pamalang. 1921 ('A token of our sympathy to your family, offered to our highly esteemed friends, the family of C.H. Douwes Dekker, Pamalang. 1921'), expressed the extent of the appreciation for the Douwes Dekker family. Camille Hugo Douwes Dekker (1877–1933) worked as *controleur* and assistant resident in Pekalongan and Purwokerto in the Netherlands East Indies from 1918 to 1928. Unfortunately the identity of the person who commissioned this fascinating cloth is unknown (fig. 37).

The Dutch government's interest in Javanese batik art helped to shape the character of the textile collection in the Tropenmuseum. The concentration of the colonial administrative apparatus on Java, the work of private collectors, and the research and resulting publications created the conditions that led to the Tropenmuseum now owning a large and important batik collection (see Chapters 'Colonial Collections' and Catalogue).

COLONIAL COLLECTIONS

<
Dolls representing
a Christian Ambonese
wedding couple
See fig. 58

In the 19th century, ethnographic museums were established and a major international fair was organised to familiarise the Dutch population with the cultures of the Overseas Territories. Because it was impossible to display everything in full scale, models and miniatures were used instead.

Clothing is a form of material culture that manifests themes such as identity and colonial power relations, both in everyday life and at ceremonies. These dolls, dressed as a Moluccan bridal couple around 1880, who had converted to Christianity, are part of the 'colonial collection'. A century later, this collection was part of the reassessment of the entangled relations between coloniser and colonised.

38
Robe
Cotton, gold leaf
Mordant-dyed, resist-dyed,
painted
116 x 57 cm
Palembang, Sumatra
(imported from the
Coromandel Coast, India)
19th century
TM-1698-358
Gift: F.J. Vattier Kraane-
Daendels, 1946

In the 1980s ethnographic museums began exploring the colonial basis of their collections and the role of these objects within the post-colonial societies where they are preserved in museums and private collections. This was partly in response to the rise of institutional criticism from various academic quarters, as well as increasing public disapproval. In the Tropenmuseum one response was the establishment of a category of objects called 'colonial collections' as a subject of study. The term 'colonial collections' was used to designate the material culture and the associated intellectual legacy of specific groups of people who formed part of or who were closely allied with colonial communities in the Netherlands East Indies. This category also includes various forms of art and material culture that arose in the Netherlands as a result of the entangled relations with the cultures in the archipelago.[96]

This chapter discusses four topics: a. The clothing worn by the different social classes and ethnic groups as one way to express the relationship between the culture of the coloniser and the colonised; b. Dutch textile companies tried early in the 19th century to secure a place on the Indonesian textile market with imitation batiks and unbleached cotton; c. at the end of the 19th century a group of Dutch artists became interested in batik art and applied the decorative techniques to their art in innovative ways; d. to disseminate knowledge in Europe about the Overseas Territories, the colony was reproduced in miniature for museums and world fairs in the form of models of houses, ships, bridges and representations of ethnic and social groups in the Netherlands East Indies.

Clothing in pre-colonial and colonial society

'Outward appearance was a central and heavily regulated issue under the colonial state and authority always had to be visible.'[97]

Since the arrival of the Europeans in the 16th century, changing dress codes have altered Indonesian society both visibly and invisibly. Adopting, adapting or rejecting dress codes from

other cultures was not a new phenomenon in the
Indonesian archipelago. Long before the arrival
of Europeans the archipelago traded with cultures
in South and East Asia and the Middle East.
This interaction brought new religions, forms
of government, art forms, materials, and weaving and
decorative techniques which resulted in changes
to clothing and clothing habits. A fundamental
change consisted of covering the bare upper body,
a form of modesty introduced by Islam and later
also encouraged by Christianity. Religious and
administrative institutions in these foreign cultures
associated nudity with paganism and barbarism.[98]
In regions strongly influenced by Islam the dress
conventions introduced from India and the Middle
East consisted of long robes and coats that were
made from Indian fabrics or locally produced
textiles (fig. 38). These garments were reserved for
aristocratic men and women, who when wearing
one, replaced the traditional hipcloth with a pair
of trousers.[99]
Feudal societies in the Indonesian archipelago had
long regulated apparel, and restricting the free choice

of clothing as a means to exert control over the
population was quickly recognised by the Dutch
in the 17th century. The VOC and later the Dutch
colonial administration elaborated on these rules
and tried to enhance and maintain their position
by regulating dress conventions. Bernard S. Cohn
wrote about the importance of clothing in the British
colonial society: 'Clothes are not just body coverings
and adornments, nor can they be understood only
as metaphors of power and authority, nor as symbols;
in many contexts, clothes literally *are* authority.'[100]
In 1658 the VOC issued an edict stipulating that
wearing Western clothing was an exclusive privilege
of the Dutch and Indonesians who had converted
to Christianity. The vast majority of the population
who did not belong to this group and ethnic groups
such as the Chinese and the Arabs had to wear their
'national' dress. These rules were intended to make
the social hierarchy clear and transparent: each
individual and every group could be identified by
their apparel (fig. 39).
The choice for certain clothing is generally deter-
mined by the location, time and occasion when the

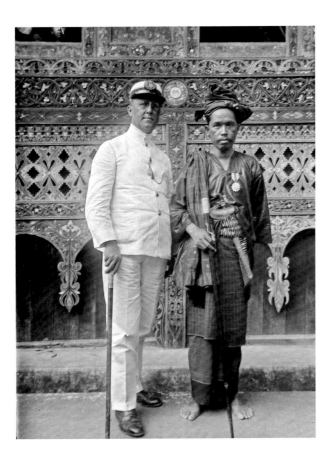

40
Portrait of Assistant
Resident J. Jongejans
wearing a *jas tutup*
and an indigenous
government official
wearing in local dress
Photographer unknown
Gelatin glass negative
9 x 12 cm
Solok, West Sumatra
1929
TM-10001825
Gift: J. Jongemans

determined their apparel: Javanese dress etiquette was followed for ceremonial matters at court; at formal meetings between Javanese aristocracy and Dutch authorities the regents wore a combination of Javanese and Western clothing, and when they interacted with the modern world they wore Western-style suits.[103]

Around 1850 formal dress codes outside the royal courts in the cities on Java also changed, thereby changing the everyday streetscape as well. Among the first to make this change were male servants employed by the Dutch who combined Javanese and Western styles in their work uniforms. As with gaining access to Western education, affluence was an important factor when deciding to wear Western clothes. Education and clothing opened doors to the world of the Europeans, which was considered new and modern. Van Dijk states that different motives could underlie this choice. The choice for Western attire could indicate a preference for and a desire to be part of European culture, or it could point to the wearer's rejection of the customs and strict etiquette of his or her own feudal culture.[104] With men wearing Western clothing such as trousers and shoes, traditional customs and rules changed and so did behaviour. The tradition of kissing a highly placed person's foot, the feudal foot kiss, was replaced with the Western handshake, and instead of humbly sitting on the floor, modern Indonesians sat on chairs at the same height as the Westerners. Western clothing brought new manners and a new self-image along with it. Naturally, there were those who opposed the wearing of Western clothes because adopting the culture of the oppressor was to the detriment of their own ethnic identity.[105] With the introduction in the 19th century of direct rule by the Dutch government, the employees of the colonial administration were expected to dress according to the rules of their employer. In the tropical climate these employees, who belonged to the new middle class, wore a modified version of the Western suit, consisting of white trousers, a white jacket (*jas tutup*, a high-collared jacket) and a flat cap (fig. 40). High-ranking government officials wore a white Western-style suit, which had 'military' epaulettes, and a white pith helmet. At official occasions high-ranking government officials wore a black jacket richly embroidered with gold thread.[106]

clothes would be worn. This applied during the colonial period in the Netherlands East Indies, both to the locals and the Dutch. However, the prescribed rules had limited reach and did not extend much further than Batavia on Java and the immediate surroundings. The regulations did not apply to the aristocracy, like the rulers of Central Java and other islands who maintained strong links with the VOC. As early as the 17th century, they chose to appear entirely or partly in European dress, '[…] if Western intruders had shown themselves to be powerful, why not copy their dress in an effort to absorb that power which had proven to be superior?'[101] Sultan Mangkurat II sought an alliance with the VOC in his struggle for the throne of the kingdom of Mataram (late 16th c. – early 18th c.) and on certain occasions chose Western clothing instead of Javanese dress. A comment about him in a Javanese text stated that by wearing European clothes he had renounced his Javanese identity.[102] More than a century later, Western garments were commonplace among the aristocracy. For the Javanese rulers the occasion

41

Dutch family with servant on the verandah
Photographer unknown
After 1870, increasing numbers of Europeans came to Indonesia, including women. Photographs were taken for the family 'back home'. The man is wearing batik trousers, *celana*, and a *badjoe tjina*, a variation on a Chinese jacket. The Dutch woman wears a white *kebaya* and a *sarung*. The *baboe*, the child's nanny, wears a coloured *kebaya* and a *kain panjang*.
Silver gelatin developing-out paper
16 x 12 cm
Location unknown
1890–1900
TM-60008795

42

Cloth used to make indoor trousers – *celana*
Trousers were initially made from batik hipcloths; later, batik cloths were made especially for these trousers, which also included the braiding depicting crowned *nagas* on the sides of the trouser legs.[1]
Cotton
Batik
156 x 105 cm
Surakarta, Java
TM-38-9
Early 20th century
Gift: Jhr. H. C. van der Wijck, 1916

Initially only unmarried men came to the Netherlands East Indies from Europe. They entered into relationships with local women and sometimes married them, but mostly they lived as common law man and wife. Through these women Indonesian customs and traditions, such as cuisine and clothing habits, made their entry into the European households. These relationships with local women produced offspring, an Indo-European population, which was designated by the term 'Indisch'.[107] From the mid-19th century to circa 1915, when at home in an informal atmosphere Western men wore either so-called pyjamas, a shirt and trousers of striped cotton, or a collarless jacket and a hipcloth or trousers made from batik textile. Neither the jacket nor the batik trousers were traditional Indonesian garments, but Dutch inventions (figs. 41, 42).[108]

J.W. van Lansberge, governor general of the Netherlands East Indies from 1875 to 1881, donated a unique woven pineapple fibre, batik tubular skirt (*sarung*) to the museum (fig. 43). Although pineapple fibre was traditional material for weaving, applying motifs using the batik technique to this material was unusual. Traditionally cotton cloth was used for batik. The letter 'L' has been applied to the so-called

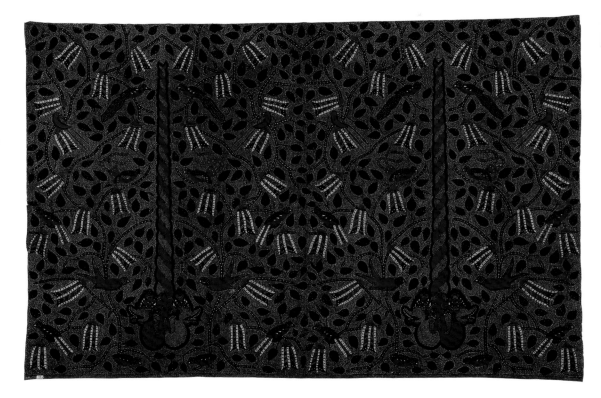

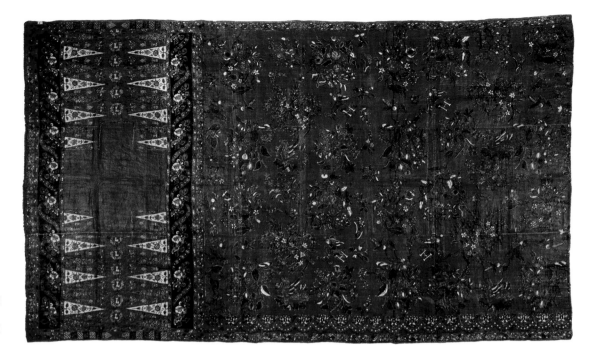

kepala, the 'head' of the tubular skirt and surrounded by floral borders. The *badan*, the 'body' of the skirt, has elf-like figures sitting on the letter 'H', surrounded by anchors, a Christian symbol of hope, faith and fortitude. The tubular skirt is made in a batik style called *batik belanda* (*belanda* = the Netherlands).[109] In addition to the material and the images, the dimensions of this tubular skirt also differ from the conventional tubular skirt. Given the letter 'L' on the cloth and the generous proportions, it is likely that it was specially made for Van Lansberge, a 'large European', who would have worn it at home.

Women's dress codes followed their own course. Until the early 19th century wearing batik clothing was a privilege reserved for the Javanese elite. Only women within the sphere of influence of the royal courts mastered the batik technique. With the establishment of Dutch authority this privilege disappeared and ordinary Javanese, Indo-European and Dutch women started wearing batiks. This resulted in the commercialisation of the technique and entrepreneurs opened batik workshops in different regions of Java. Regardless of their background, in the 19th century women wore a batik hipcloth (*kain panjang*), or a tubular skirt (*sarung*)

and a *kebaya*, a blouse with long sleeves of flowered cotton, white batiste or velvet. Over time, the *kebaya* changed from a long blouse reaching to the ankles into a shorter one that fell to the hips (fig. 44). However, with so many women wearing the *sarung kebaya*, as this combination was called, it did not mean that the existing class differences had become invisible.[110] Different ethnic groups wore different batik styles and a corresponding *kebaya*. The vast majority of women, especially on Java, wore the coloured, often floral *kebaya*, made of fabric imported from India, England and the Netherlands. Aristocratic ladies preferred velvet *kebaya* and Dutch and Indo-European women a white *kebaya* made of cotton batiste.

The Central Javanese aristocracy wore batiks, and were bound by strict rules when it came to wearing certain motifs. For the Dutch women and the growing Indo-European and Chinese middle class who did not have to adhere to these rules, a commercial batik industry began developing on Java's north coast around 1840. This industry, in which Chinese and Arab traders played an important role, was initiated by women of Indo-European origin who were unmarried or who, after their Dutch husbands had died, had to generate income for their families.

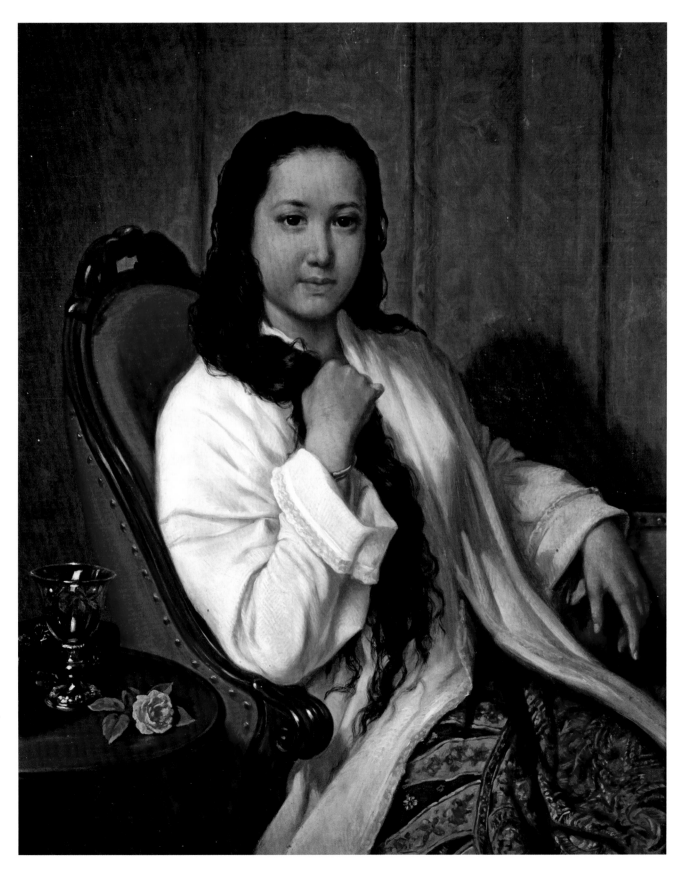

A BATIK 'PRANKEMON'

This tubular skirt with the image of a nutmeg tree was probably made in the workshop of Carolina von Franquemont (1817–67), an Indo-European woman who established a batik workshop in Surabaya in 1840. In 1845 she moved to Mount Ungaran near the port of Semarang. Here she was closer to her clientele, which consisted of wealthy European, Indo-European and Chinese women. Von Franquemont created new 'modern' design elements and produced, among others, batiks with scenes from fairy tales and *wayang* figures. The local term for the cloths was *kain Prankemon*. By experimenting with natural dyes she managed to imitate the rich hues of Indian chintz. She created a blue-green colour which became one of the characteristics of her work.

A nutmeg tree is depicted on this tubular skirt at the moment when the nuts have just burst open and the costly mace and nut are visible. The initials 'E.N.' in the middle of the 'head' of the skirt, the *kepala*, could be those of the person who commissioned it.

Von Franquemont died during the eruption of Mount Ungaran in 1867, which also destroyed her workshop.[2]

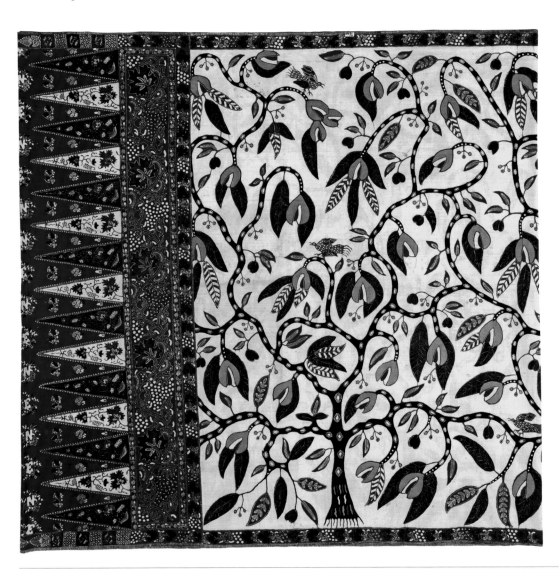

45
Tubular skirt – *sarung*
Cotton
Batik
114 x 110 cm
Semarang, Java
c. 1850
TM-1585-4
Gift: P.H.Q. Bouman, 1942

> 46
Tubular skirt – *sarung*
Cotton
Batik
214 x 107 cm
Banyumas, Java
Workshop: Carolina
van Oosterom
c. 1878
TM-5319-1
Gift: J.A.W. van Solkema,
1990

A BATIK 'PANASTROMAN'

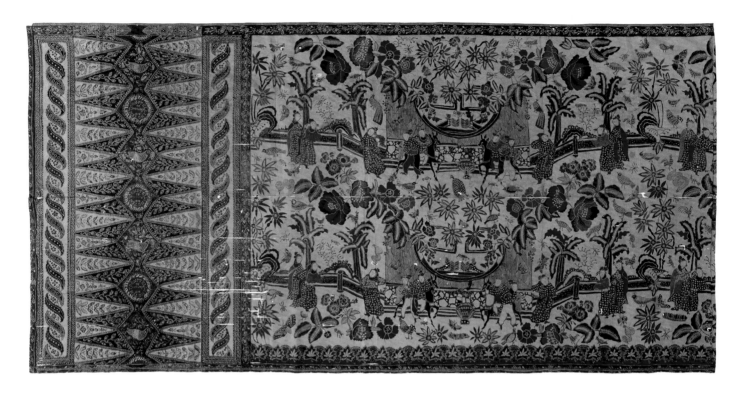

This cloth was made for the exhibition that was organised for the Derde Indische Landbouw Congres (Third East Indies Agricultural Congress) in Surabaya in 1878 (see also fig. 79). A scene from the opera Madam Butterfly is depicted on the tubular skirt. The tubular skirt may be a *kain Panastroman*, the name used for batiks made in Catharina van Oosterom's workshop. Van Oosterom, who was commissioned to make many unique objects, did not sign her batiks, but her work contains a number of characteristic stylistic elements. Carolina Catharina van Oosterom was born in Salatiga in 1816 as Catharina Philips. At the age of 16 she married the 34-year-old W.J. van Oosterom, a clerk in the service of the colonial government in the Netherlands East Indies. His last station was in Semarang, where he left his wife with a small pension after he died in 1844. To maintain her status, Catharina opened a batik workshop on Mount Ungaran near Semarang around the same time as Carolina von Franquemont. A devout Christian, she moved to Banyumas to preach in the Protestant church and propagate her faith. She and her sister-in-law were among the first missionaries on Java.[3] Carolina van Oosterom also sent batiks to the annual fairs organised by J.E. Jasper.

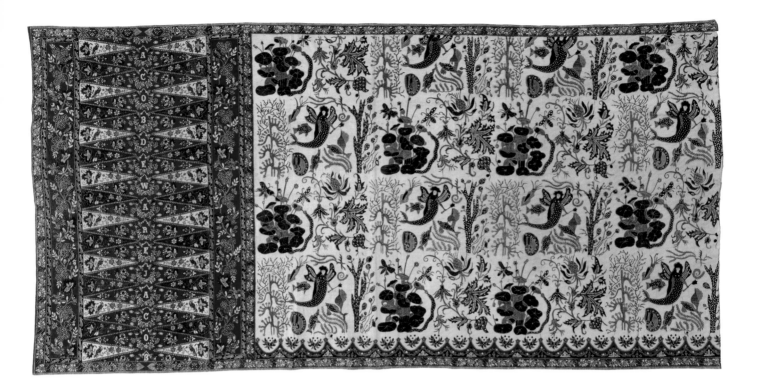

47

Tubular skirt – *sarung*
This tubular skirt was owned
by Christina Jeanette (Tientje)
van Bloemen Waanders (1892–
ca. 1938). Her father was
Major of Infantry and director
of the prison in Batavia. It is
possible that Tientje received
the precious *batik belanda* with
the text '*De Ware Jacob*'
('My True Love') as a gift on
her engagement and marriage
to Karel August van den Bos in
1912. The motifs on the textile,
specially designed for and by
affluent East Indies women,
refer to fertility, prosperity and
love. The tubular skirt has
remained in Tientje's family
ever since, travelling with
them to Sulawesi, to the
Netherlands, to America,
to Canada, and finally back
to the Netherlands.[2]
Cotton
Batik
219 x 110 cm
Semarang, Java
Early 20th century
TM-6374-1
Gift: S.G. Bruckel-Land 2010

They opened batik workshops where they employed
workers.[111] Known batik entrepreneurs were Carolina
Josephina von Franquemont, Carolina Catharina
van Oosterom, A.J.F. Jans, Lien Metzelaar and Eliza
van Zuylen.[112]

The differences between the *batik belanda* style and
batiks from the principalities included a different
arrangement of designs, a free choice of motifs
and, after the introduction of synthetic dyes, much
brighter colours (see the Catalogue). The Indo-
European batik entrepreneurs borrowed the motifs
for their batiks from Western embroidery patterns
of flower bouquets or motifs on Indian chintz.
The choice was unrestricted and they designed
batiks with hunting scenes, ceremonial parades,
scenes from Western operas, and Javanese *wayang*
performances. Batiks with special representations
were commissioned for occasions like engagements
and weddings (figs. 45–47, also see Chapter 'Collect-
ing' and the Catalogue). All these representations
not only adorned the wearer, they also indicated
that she was open to modernity.

Dutch women came to Indonesia in increasing
numbers after the Suez Canal opened in 1869.
Alongside the different ethnic groups now also
households consisting of European families arose

in the East Indies. As a result, the attitude changed
towards the Indonesian *sarung kebaya*, which came
to be seen as only suitable for the morning hours in
and around the house. Towards the end of the 19th
century, it too was replaced in the home by other
clothes. The Dutch woman whose duties until then
had mainly been domestic, ventured outdoors to play
a public role wearing fashionable Western clothes.
She became exemplary of the modern, civilised West
at official meetings. Young Indo-European women
were the first to adopt this fashion, followed by
well-educated Indonesian women who also wanted
to participate in modern life.[113]

Batik in the Netherlands

Trade and *Javaanse katoentjes*

Textiles were an important commodity from the
moment Dutch traders arrived in the Indonesian
archipelago. In the 17th and 18th centuries fabrics
from India were the most sought after items to
trade for the spices that were so highly prized
in Europe. At the beginning of the 19th century,
new opportunities opened up for the European
textile industry. During the short-lived British

administration of Java (1811–15), Sir Thomas Stamford Raffles recognised the prospects of creating a market in Indonesia for cheap English printed cotton fabrics along similar lines to one that had already been established in then British India. Raffles also initiated the production of 'imitation batiks' in England for the Javanese market and the surrounding islands. After the British ceded the colony to the Netherlands under the terms of the Anglo-Dutch Treaty of 1814, calico-printing companies in the Netherlands copied this initiative. Most of these textile companies were located in Flanders. King Willem I also recognised the commercial potential of the Overseas Territories, and to encourage Dutch industry, in 1824, he founded the Nederlandsche Handel-Maatschappij (NHM, Netherlands Trading Society). This society granted Dutch textile companies guaranteed contracts and tax breaks. Initially it was mainly the textile industry in Flanders that benefited from this. After the separation of Belgium from the United Kingdom of the Netherlands in 1930, a new textile industry had to be started in the northern Netherlands. King Willem I and the NHM actively supported this project. Part of the Dutch textile industry was located in Twente in the east, where cotton was woven into a finished product to be used by the batik industry on Java. In other provinces, textile enterprises focused on the dyeing and printing of cotton fabric. Because of the lack of know-how in the northern Netherlands, Flemish cotton printers were brought to the Netherlands under favourable terms.[114] The cotton-printing industry also started developing methods to produce imitation batiks. Because bleached and unbleached cotton fabrics from Twente became the preferred choice in the increasingly commercialised Javanese batik industry, this commodity would in the course of time become the Dutch textile companies' most lucrative product for the Netherlands East Indies.

The imitation batiks produced in the Netherlands were called *Javaanse katoentjes* (Javanese cottons), indicating that Java was their place of destination, and that they were produced in a style that was seen in the Netherlands as being typically Javanese.[115] Traders hoped that from Java the textiles would be distributed to the rest of the archipelago. When producing these imitation batiks the Dutch knew that they had to allow for the quality demands of their prospective customers – no simple task in batik production. To mimic the Javanese style as closely as possible, samples of batik cloths were sent to the Netherlands. The textile entrepreneurs could obtain these from the Departement van Koloniën (Ministry of Colonial Affairs), which had compiled a pattern book of the most popular designs. Information for this book probably came from the 'Nota om te dienen tot inlichting van de Monsters der Lijwaten' ('Memorandum to provide information about the Samples of Cottons'), written in 1819 by the Javanese linguist C.F. Winter.[116] In his annual report of 1822, Adriaan Cornets de Groot, an administrator in Gresik, East Java, included a description of the batik process in this region along with drawings of 36 different motifs.

The most important textile companies producing imitation batiks – J.B.T. Prévinaire and De Heyder, originally from Flanders – established factories in Haarlem (1834) and in Leiden (1836) respectively. Pieter Fentener van Vlissingen founded a textile company in Helmond in 1843. Besides the batiks, other textiles were also produced for the Netherlands East Indies market such as imitation chintzes and mignonettes, textiles with multicoloured floral and striped designs. These were used to make blouses, *kebaya*, or also as linings for jackets. The last two products, imitations of the highly prized Indian tradecloths, were produced by machine. The companies had to continue to use a manual process to imitate the technically complicated batik process. The Dutch companies attempted to develop a mechanical method to manufacture batiks with the same quality as the Javanese batiks, but failed to do so. However, the firm Prévinaire managed in 1854 to develop a machine, 'La Javanaise', with which the hot reserve (a mixture of resin and wax) could be applied to both sides of the cloth, as happened with Javanese batiks. This product was no longer marketed as 'imitation batik' but as 'wax batik' because the method somewhat resembled the authentic batik technique. Prévinaire also managed to infuse the textiles with the recognisable Javanese wax aroma.[117] The firm Van Vlissingen & Co. (now Vlisco) in Helmond, which produced cheap imitation batiks from 1852, also began selling wax batiks in 1866. 'Uncle Frits', a relative who owned a sugar plantation on Java, provided this company with information on patterns and motifs. In his time

on Java, Uncle Frits had developed an interest in the batik industry and sent batik samples with the most prized motifs in the archipelago to support the family business in the Netherlands.[118]

The main markets for the imitation batiks were Java, Sumatra and the Malay Peninsula. The producers knew that their product did not have the quality of Javanese batiks, but as the Belgian textile entrepreneur François Voortman said: 'Our industrial civilisation does not make better products than the hand-made works of the past, but it allows the poorest classes of society to obtain in a lesser quality, objects that formerly belonged to the privilege of the upper classes.'[119] On Java it was indeed the poorer segment of the population that purchased the – when compared with the original Javanese batiks – lower quality Dutch products. On Sumatra less importance was attached to the delicacy of the motifs and more to the quality of the cotton and the arrangement of the motifs and the colour scheme. There, these imitation batiks still functioned in a similar way to the textiles from India or the copies made of them on Java (figs. 48, 49).[120] The textiles for Sumatra were therefore strongly reminiscent of certain types of textiles produced on India's Coromandel Coast. Mr. S.C.I.W. van Musschenbroek (1827–83) also actively tried to expand upon the knowledge about the batik process and motifs in the Netherlands. Van Musschenbroek studied law in Leiden and the Javanese language in Delft, where he graduated from the training institute for civil servants in 1854. He left for the Netherlands East Indies in 1855. He was a government official but his true interests lay in physics, biology and the art and culture of the archipelago. He was a member of the Bataviaasch Genootschap voor Kunsten en Wetenschappen (Batavian Society of Arts and Sciences), and during his leave in the Netherlands in 1860, became an honorary member of the Maatschappij tot Bevordering van Nijverheid (Society for the Advancement of Industry), which initiated the establishment of the Colonial Museum in Haarlem (see Chapters 'Collecting' and 'Presentation'). He returned to Java in 1862, and held various positions on different islands and in different regions. During his tenure in 1866 in Temanggung, Central Java, he commissioned a collection of cardboard cards with wax batik motifs (figs. 50, 51). According to G.P. Rouffaer some of these cards were made by Raden Aju, the

wife of the regent of Temanggung, and some by F.H. van Vuurden-Winter, the daughter of the linguist C.F. Winter, who lived in Ambarawa. The collection was made on behalf of the Society for the Promotion of Industry in the Netherlands. Van Musschenbroek donated the cards to the Colonial Museum in Haarlem in 1873. Van Musschenbroek published a book in 1878 in which he described the motifs and provided a translation of an anonymous manuscript from Surakarta that was printed in Semarang in 1872.[121] With this, Van Musschenbroek's intention was to describe the batik process, but Rouffaer noted that the manuscript contained descriptions of several different textile decorative techniques like batik, *plangi* and *tritik*. The latter was used to make the 'flowered cloths', *kain kembangan*, ceremonial textiles that were used at the Central Javanese courts (see figs. 71–73).[122]

In 1882 Van Musschenbroek became a member of the organising committee of the International Colonial and Export Exhibition that was held in Amsterdam in 1883. In the same year he was involved in founding the Nederlandse Koloniale Vereniging (NKV, Netherlands Colonial Association), which aimed to establish a colonial museum and library in Amsterdam as a place to 'organise lectures and conferences also for the less educated middle class to generate and maintain interest in the colonies in the provinces'.[123] The collection this society brought together, including objects from the 1883 World Fair, came to the Tropenmuseum via the collection of the Aardrijkskundig Genootschap Artis (Artis Geographical Association) (see Chapter 'Collecting').

Despite all efforts to improve the product, the market share of the Dutch imitation batiks remained very modest. In the meantime, a cheaper production method had also been developed on Java, in which the wax was applied with a copper stamp (*cap*) instead of the much more labour-intensive wax pen (*canting*). This made the Dutch products even less competitive and in the 1860s the imitation batik market collapsed completely. Thereafter the Dutch textile printing industry focused on the West African market, where there was no local competition. To this day the company Vlisco in Helmond still produces 'Real Dutch Wax and Java prints' for this market.

< 50
A collection of batik patterns
Rouffaer was convinced that the information on the labels that were attached to the backs of the cards around 1878 by Van Musschenbroek was incorrect. He asked the director of the Colonial Museum in Haarlem for permission to change them. All the labels were soaked off, and stuck back on with his appended comments.
Cardboard, Chinese paper, wax
c. 25 x 25 cm
Yogyakarta, Java
1873
H-637-33/34/66/79
Gift: S.C.I.W. van Musschenbroek
A collection of 86 batik patterns on 83 sheets of cardboard (Series 637-1/83)

51
Reverse with Rouffaer's notes
TM-H-637-34

Dutch artists

Exhibits at the world fairs and the attention paid to Netherlands East Indies craftsmanship by the museums in Haarlem and Amsterdam generated an interest in batik art among a group of Dutch artists at the end of the 19th century.

The Industrial Revolution in Europe and the increasing Western influence on the lives of the people in the colony made researchers and other interested parties fearful of the demise of technical knowledge, both in the Netherlands and the Netherlands East Indies. The love that Van Eeden, director of the Colonial Museum in Haarlem, developed for objects made by the local art and crafts industry has already been mentioned. In his publications he also discussed Dutch artistic traditions, which he thought were succumbing to superficiality and alienation as a result of industrialisation. He therefore warmly welcomed the growing awareness in different circles in the Netherlands of the Arts and Crafts movement in England and Scotland. Followers of this movement turned their backs on industrialisation, mechanisation and mass production, which would only produce cheap and ugly products. The Arts

and Crafts movement propagated a re-appreciation of craftsmanship and of the beauty and simplicity of the products.

In the Netherlands, the need arose for a dedicated tuition programme for decorative artists to counter this superficiality. Van Eeden was aware of initiatives in this field in England and decided to assess the situation at the South Kensington Museum (now the Victoria & Albert Museum) in London. An arts and crafts school that was connected to the museum focused on studying the arts and their associated techniques. On the advice of Van Eeden, the Nederlandse Maatschappij van Nijverheid (Dutch Society for Industry), the founder of the Colonial Museum in Haarlem, also decided to establish a Museum van Kunstnijverheid (Museum of Applied Arts) with an affiliated School voor Kunstnijverheid (School of Applied Arts). The Museum of Applied Arts, which was located in the same building as the Colonial Museum in Haarlem, opened in 1877. The school was housed in the adjacent buildings. The objective of both institutions was to: "'Refine the handicrafts through art", with the aim of saving our craftsmen from a dull state to which the *Indiër* [Indonesian] has not yet sunk, and it is our bounden duty to prevent this.'[124] Leading artists such as Michel Duco Crop and Chris Lebeau taught theoretical and practical courses at the School of Applied Arts. The intention was to revitalise various handicrafts, so that commodities would once again be the result of a unique creative process involving artistry and skill: Dutch craftsmanship would be elevated to a higher artistic level. At the school a new 'more individual and original' drawing method was developed, in which the study of nature and the stylisation of natural forms had an important place.[125] These drawing lessons attracted a lot of interest at training colleges, including in the Netherlands East Indies. The method was introduced partly due to the influence of Van Eeden, who had expressed his admiration for the ornamentation inspired by nature in Indonesian arts and crafts. Not only craftspeople and artists but also the general public would acquire a better taste and artistic sense if exposed to examples of craftsmanship and art from the past and from other cultures. It was hoped that this would lead to improvements in the artistic quality of Dutch industrial products.[126]

Inspired by the Arts and Crafts movement, in the Netherlands a new art movement arose called *Nieuwe Kunst* (Art Nouveau). Galvanised by the focus on applied arts in exhibitions such as the International Colonial and Export Exhibition in 1883 in Amsterdam, the 'Nationale Tentoonstelling van Vrouwenarbeid' (National Exhibition of Women's Labour) in 1898 in The Hague, and in the permanent exhibitions at the Colonial Museum in Haarlem and the Artis Ethnographic Museum in Amsterdam, in the late 19th century a group of Dutch artists became interested in various forms of Javanese art: music, dance and theatre, but also manifestations of the textile industry such as batik art. They were inspired by the technical and aesthetic qualities of Oriental ornamentation. Articles and lectures by G.P. Rouffaer were an important source of information on batik art; furthermore, H.A.J. Baanders, who was connected to the Colonial Museum's Laboratory, brought greater prominence to this decorative textile technique. Rouffaer saw batik art as 'the fusion of the aesthetic and practical value, animating industry with the harmonious spirit of the artistic'.[127] Some artists began experimenting with the batik technique, which they considered particularly suited for interior design and other applied arts. Carel Lion Cachet (1864–1945) was the first Dutch artist to work with it. He first saw batik art in the Artis Ethnographic Museum when he visited it with his teacher from the college. He experimented with the batik technique with the intention of ultimately 'making very large pieces of linen with flat solid colours, so they could serve as wall coverings'.[128] Earlier, Oriental rugs that were used as wall decorations had been the inspiration for wall coverings and wallpaper, and now Lion Cachet recognised the potential of using batik art for this purpose too. However, over time he realised that making such large pieces was technically so complex that he downscaled his ambitions and started making smaller textiles.[129]

The first presentation of Dutch batik art took place in 1892 in an art shop in Amsterdam, with works by Dijsselhof, Lion Cachet and Theo Nieuwenhuis.[130] For these artists, the batik technique proved to be an ideal method to demonstrate their technical prowess in a unique and personal way, 'Two pieces of hand-decorated batik textiles could be similar, but never identical.'[131] At the same time 'batik' represented an exotic artistic tradition that resonated with the appeal of and appreciation for all that was foreign and eccentric in the Art Nouveau movement. Not only artists in the Netherlands were inspired by Javanese batiks: Dutch artists and teachers in the Netherlands East Indies also introduced Western stylistic influences to their pupils there (fig. 52). Several factors, however, constrained the development of an artistic batik industry in the Netherlands. There was a constant lack of raw materials from the colony and if they were available, problems arose due to the disparities in climatic conditions on Java and in the Netherlands and how the waxes and dyes reacted to the differences in temperature and humidity.

In addition to collecting, exhibiting and sharing knowledge, the Colonial Museum in Haarlem was also tasked with conducting research relating to the development of products for trade. To this end, the Research and Experimentation department was established and equipped with a modern laboratory. Combining science and practice meant that entrepreneurs, researchers as well as artists came to the museum and this department for information.[132] The department also conducted tests on behalf of the Dutch cotton printing industry and also to find ways to process waxes and dyes of Indonesian origin in order to simplify for Dutch artists what was referred to as the 'cumbersome' batik process. It was also commissioned to prove the superiority of an important Dutch trade product, a natural Indonesian crop, the dye indigo. This was essential because of the competition that had resulted from the production of synthetic indigo elsewhere in Europe. In 1900 the architect H.A.J. Baanders, an enthusiastic practitioner of batik art, performed a series of tests at the Laboratory to solve the problems that arose when making batiks in Europe. Spurred by personal curiosity, he had immersed himself in G.P. Rouffaer's research into Javanese batik techniques. Baanders conducted his research in collaboration with Meta Weerman (figs. 36, 53). They experimented with different waxes and natural dyes, each test with a different combination of ingredients. The goal was to obtain an optimum colour-fastness. In his report Baanders describes 258 tests in detail, including of different waxes and dyes such as indigo for blue, catechu for brown and madder for red. In particular,

52

Book with drawings,
including batik motifs,
made by students of
the training college in
Bandung on the occasion
of J. Lameijn's retirement
in 1921.

In 1903 Justinus Lameijn
went to work as a teacher
in the Netherlands East Indies.
In 1913 he became director
of the training college
in Bandung. He returned to the
Netherlands in 1920 for health
reasons. At his farewell party
in Bandung his students
presented him with two books
in which they displayed their
skills in drawing and painting
examples from nature.
In these books, characteristic
elements of Javanese
ornamentation that form the
basis of numerous batik motifs
merge with stylistic aspects of
European Art Nouveau. While
visiting Queen Wilhelmina in
1921, Lameijn gave her one
of these books. In 2013,
the Lameijn family donated
the other one to the
Tropenmuseum.[3]
After his retirement in 1927
Lameijn remained committed
to the East Indies education
system from The Hague.
He has written a series of
reading books entitled
*Matahari Terbit: Kitab batjaan
melajoe* ('The Sun is Rising:
A Malay Reader'), which were
used until the 1970s.
46 x 33 x 5 cm
Bandung, Java
1921
TM-6494-1
Gift: R. Lameijn, 2013

53
Test cloth made by Meta Weerman
Satin, wax
70 x 54 cm
Haarlem
c. 1900
TM-H-3338
Gift: Colonial Museum

> 54
Experiments with indigo by H.A.J. Baanders
The composition of the wax and the number of immersions in the indigo vat were recorded with each test. A card recording the dyeing method and type of wax.
Cotton
Batik
30 x 30 cm
Haarlem
TM-H-3324/3328/3332/3333
Gift: Colonial Museum

the tests with madder yielded poor results because of having to work with low temperatures (the wax would otherwise melt). After much experimentation, a successful dying process was finally developed for the European context (fig. 54).

After Baanders left the Laboratory in 1901, Weerman started to perform tests with alizarin and aniline dyes that she obtained through a German company. The poor results meant that this company modified the composition of the dyes so that they could be used at low temperatures.[133]

The Laboratory employees visited major national and international exhibitions where they distributed a free bulletin describing their work, with a complete overview of the batik tests. Through this bulletin the museum hoped 'to inspire many [people] to practise batik in this way as independent workers, and thereby permanently enrich Dutch crafts with a new branch, which has already proven itself capable of bearing fruit as beautiful as Javanese batik art'.[134]

At the beginning of the 20th century, the Laboratory began working closely with several Dutch artists, including Carel Lion Cachet and Johan Thorn Prikker.[135] They pooled their findings relating to the batik technique, the knowledge was disseminated in publications in different languages, and their art was exhibited at home and abroad. Through this the

Laboratory became the preeminent institute in Europe where the public, both in the Netherlands and abroad, was introduced to the batik technique.[136] It goes without saying that the collection of the Colonial Museum in Haarlem was enriched with a collection of batiks made by Dutch artists. The collection includes works by Johan Thorn Prikker, Chris Lebeau, H. Grabijn-Reeser, J. de Wilde and Meta Weerman, all of whom, Thorn Prikker excepted, had been involved in the Laboratory at the Colonial Museum.

Johan Thorn Prikker (1868–1932) studied painting at the Koninklijke Academie voor Beeldende Kunsten (Royal Academy of Art) in The Hague (fig. 55). He may have become acquainted with batik art in 1896 when he visited his friend, the Belgian artist Henry van de Velde, in Brussels. Van de Velde, an important representative of the Art Nouveau movement, had the opportunity to admire Javanese batiks in the Dutch colonial section at the 1894 World Fair in Antwerp. Thorn Prikker was immediately enthusiastic and believed that the batik process would produce a better and more authentic result than printing fabrics. In 1897 he wrote an essay 'Einiges über das Batiken' ('Some Things About the Batik Process'), in German, in which he indicated that he derived a lot of his information from the work

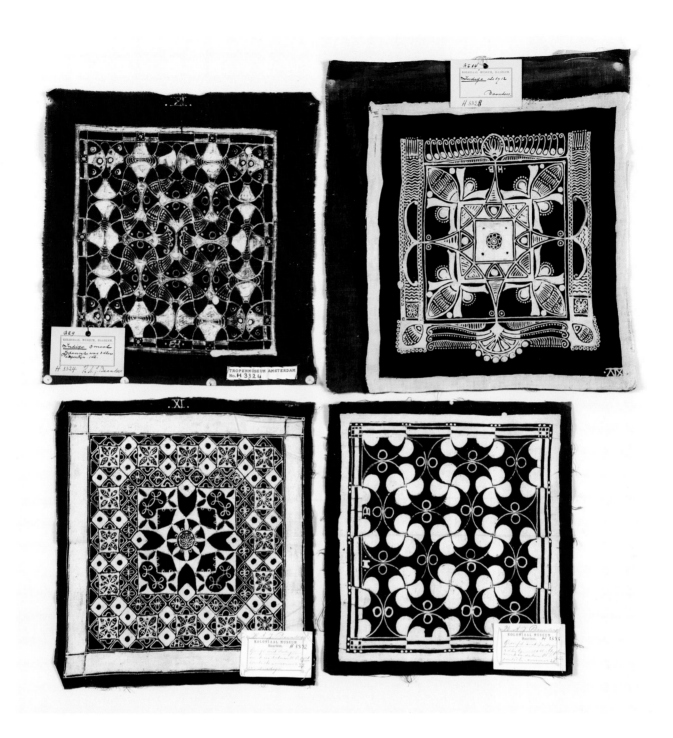

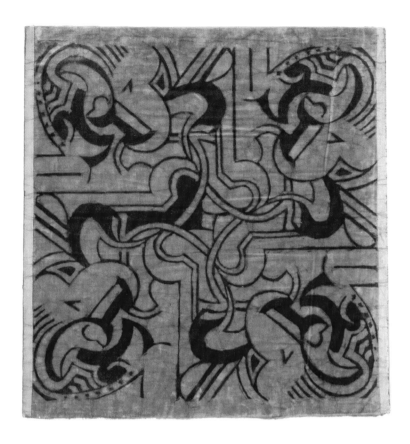

55
Cushion cover
Design: Johan Thorn Prikker
Velvet
Batik
49 x 46 cm
The Netherlands
1902/1903
TM-H-3315
Gift: Colonial Museum

of the aforementioned S.C.I.W. van Musschenbroek. In 1898, the 'Arts and Crafts' shop was set up in The Hague with Thorn Prikker as artistic director. The shop was described as a space with a batik-decorated room, batik curtains, drapes, pillows, piano covers, etc., that will do nothing but satisfy the most demanding aesthetic, and we are certain that our art-loving public will wish to decorate their drawing rooms and boudoirs with this, in Holland, reborn art. Thorn Prikker's batik tablecloths, cushion covers and book covers were among the items this shop sold. His work is very different from traditional Javanese batik. It was made in the Agathe Wegerif-Gravestein batik workshop in Apeldoorn where for his designs the wax was applied with brushes instead of a wax pen (*canting*). Besides cotton he also used silk, linen, velvet, leather and parchment as a base material.[137] The Colonial Museum purchased his batiks on cotton, silk and velvet from 'Arts and Crafts' in 1899, and they are now part of the Tropenmuseum collection.

In 1900, Chris Lebeau (1878–1945) briefly took over running the 'Arts and Crafts' shop from Thorn Prikker. Not long afterwards, Lebeau decided to work with H.A.J. Baanders in the Colonial Museum's Laboratory on resolving the technical issues surrounding the batik process. At that time he combined the ornamentation of the Central Javanese batik tradition with the Art Nouveau decorative style (fig. 56). He enjoyed working with the colours of the Javanese principalities: dark blue, brown and white. His work is characterised by flowing lines that emerge from rows of countless dots. The Javanese batik technique, *nitik*, must have been the source of inspiration.[138] His meticulous way of working and his appealing decorative programme ensured that his work was widely exhibited at home and abroad. In 1904 Lebeau started teaching at the School of Applied Arts attached to the Museum of Applied Arts in Haarlem.[139] A student of Lebeau's, Bertha Bake, became a famous Dutch female batik artist. Like her teacher, Bertha Bake became closely involved in arts and crafts education in the Netherlands. Batik art had become very popular in the Netherlands, and was now seen as a technique that could also be practised at home. Aware of the complexity of the technique, however, Bertha Bake warned: 'Do not venture into batik art! Don't do it, because it will lead to nothing. Batik is – at least in the West – an ART that requires excellent training and a special talent.'[140]
The techniques that were developed in Dutch batik art were internationally acclaimed. Dutch artists taught abroad, and foreigners came to the Netherlands to learn the technique, among them the Frenchwoman Madame Pangon, who took lessons in Haarlem. She opened a studio in Paris in 1912 where the fashion designer Paul Poiret, known for his Neoclassical and Oriental styles, expressed great interest in her batiks.[141]

Dutch artists also practiced batik art in the Netherlands East Indies. The artist couple Quirien A.A. Krijnen and Petronella M.H. (Nellie) Krijnen-Surie moved there in 1915. Quirien A.A. Krijnen (1883–1945) attended the Royal Academy of Art in The Hague in 1898, where he took classes in decorative arts, drawing and art history, and qualified as a technical draftsman. Krijnen became acquainted with batik art at the academy, and also in the 'Arts and Crafts' shop and at the National Exhibition of Women's Labour.[142] In 1911 he started his own design

56
Cushion cover
Design and production:
Chris Lebeau
Silk
Batik
63 x 61 cm
1904
TM-H-3341
Gift: Colonial Museum

office called Emulation, with a training department that offered a complete package of drawing classes. Several Emulation students came from families who maintained close ties with the Netherlands East Indies, such as B. Zorab, who later sold a few masterpieces from the Lampung region in South Sumatra to the Colonial Institute in Amsterdam (see figs. 156, 160). Nellie Surie (1897–1965) registered as a student at Emulation in 1912, and she and Quirien Krijnen married in 1915. The couple settled in Batavia and in 1918 founded Emulation – Ateliers ter bevordering van Kunst-nijverheid en Huiselijke Kunst (Emulation –

Workshops for the Promotion of Arts and Crafts and the Domestic Arts). Their goal was to promote various forms of handicrafts in the Netherlands East Indies, particularly in the domestic sphere of the Dutch women who lived there. The couple recognised the complexity of the batik process and developed a specially adapted and simpler method that was deemed more suitable for the amateur batik enthusiast. However, this technique was very different from the traditional Javanese one. Nellie started a batik workshop from where the 'batik on silk using the Quirien A.A. Krijnen method' was distributed (fig. 57). They offered ready-to-use

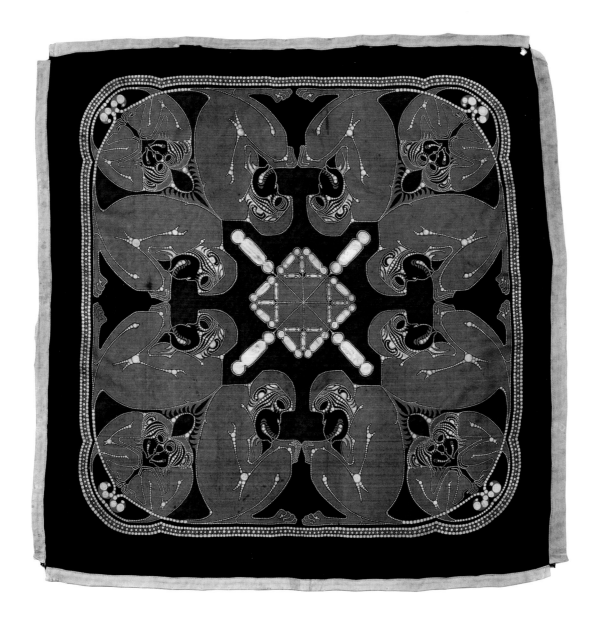

57
Nellie Krijnen-Surie
in her studio
Photograph: Gamelan
Magazine, year unknown

'batik kits' with all the necessities, including bottles of aniline dye, the wax, and samples designed by Nellie. She made designs in Art Nouveau style as well as representations of Javanese dancers and playful scenes of everyday life. With her desire to promote domestic arts and crafts, Nellie was acting in the spirit of the women's association Tesselschade – Arbeid Adelt ('Tesselschade – Labour Ennobles'), founded in 1871). This association encouraged women to improve their economic situation by producing and selling handcrafted objects. Tesselschade – Arbeid Adelt was also the initiator of the National Exhibition of Women's Labour, in 1898.

In Batavia, Emulation grew into a company that managed seventeen agencies that sold the batik kits on various islands. An ethnographic museum, an antiques shop and a publisher of several magazines were also established under the same name.

The company published the magazines *Emulation – Guide to Promote Homely Arts and Crafts* and *Huiselijke Kunst* ('Homely Arts') with manuals describing its self-developed batik technique and the designs created for it. *Huiselijke Kunst* was printed in colour in five languages, including Indonesian. Because Nellie Krijnen was dissatisfied with the printing quality in Batavia, she travelled to the Netherlands in 1921 to have the colour plates made for one of the issues. To ensure that Emulation's work reached the widest possible audience Nellie travelled to Australia, South Africa and England, where she organised exhibitions, as she had done in several cities in the Netherlands. She held exhibitions on various islands in the Netherlands East Indies and also tried to reach out to women in Batavia who were not Dutch or Indo-European by extending a 'Special invitation to visit this exhibition to all Indonesian and Chinese Women and Young Ladies'.

The Second World War brought an end to their business. The couple was interned in a Japanese camp where Quirien Krijnen died in 1945. In 1948 Nellie returned to the Netherlands, where she passed away in 1965.[143]

The colony in miniature

Life-size mannequins dressed in ethnic clothing
(see Chapter 'Presentation'), models and miniatures
representing different ethnic groups and identities
form part of the Tropenmuseum category of 'colonial
collections'.

Besides the work of permanent institutions like
the Colonial Museum in Haarlem and the Artis
Ethnographic Museum in Amsterdam, temporary
exhibitions and world fairs were organised to
promote Dutch industry as well as familiarise people
in the Netherlands with life in the distant colonial
territories. A vast majority of the objects collected
for the aforementioned colonial exhibition in the
Netherlands in 1883 were made and used in their
cultures of origin.[144] But not everything that played
out in the colony could be displayed life-size by
means of original objects. To provide an impression
of life in the colony the exhibition committees in
both the Netherlands and the Netherlands East
Indies commissioned Indonesian artisans to make
scale models of houses, boats and bridges and
people attending ceremonial events or practising
their handicraft (see figs. 30, 31).

In Indonesia J.E. Jasper organised annual fairs in
Surabaya and Yogyakarta.[145] Most models in the
Tropenmuseum collection are from Java. A small
collection of dolls portrays people from other islands.
These models, often a man and a woman, portrayed
different ethnic groups in traditional clothing. One
doll couple is notable for not wearing traditional
clothing (fig. 58). They represent a Christian bridal
couple from Ambon in the Moluccas. The spice trade
brought different Europeans to the region, and
values changed with the arrival of the Portuguese
who introduced Christianity at the beginning of the
16th century.[146] The Dutch arrived in the early 17th
century, and with them came Protestant mission-
aries. Christian values and attitudes towards the
body forever changed the dress conventions of those
Ambonese who converted to Christianity. A hybrid
clothing style arose that combined local and
European elements. Essential components such
as the *mustisa*, the decorated chest piece; the *manset*,
the dark-coloured cuffs; the red *cenela*, slippers; and
accessories like the silk handkerchief were all part
of the bride's costume. The groom's attire consisted
of a European three-piece suit with hat, leather shoes
and gloves, all of them black. During the period of
Dutch domination this wedding attire was seen as
the epitome of fashion and modernity.[147]

Another bridal couple from Aceh in the north of
Sumatra was donated by Françoise Jacoba Vattier
Kraane-Daendels (fig. 59). These dolls were probably
also made to be exhibited in Europe. They wear bridal
costumes with all the corresponding accessories.
The donation included detailed descriptions of all
elements of both costumes.

The Tropenmuseum has two dolls from the Toraja on
Sulawesi that are documented as 'original inhabitants
of the islands'. This pair of dolls is reminiscent of *tau
tau*, but were not made to function in this context.
Tau tau are wooden or bamboo effigies representing
deceased persons. They were placed in front of the
tombstones carved into the rocks to protect both
the dead and the living. This doll couple was probably
made for a (world) fair in Europe as representatives
of the local people. They are dressed in traditional
barkcloth, and are provided with baskets and bags
to suggest a long journey (fig. 60).

Batik belanda, Dutch batik art, imitation batik,
models, miniatures and dolls are the result of

58
Dolls representing
a Christian Ambonese
wedding couple
c. 40 cm
Ambon, Moluccas
Before 1887
TM-A-5372a/b
Gift: Artis

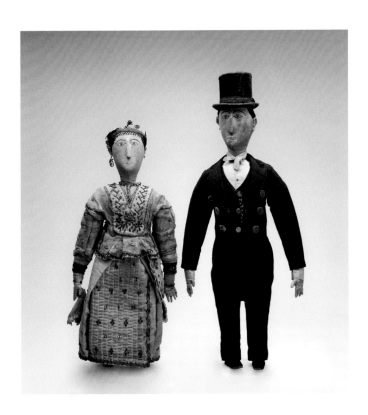

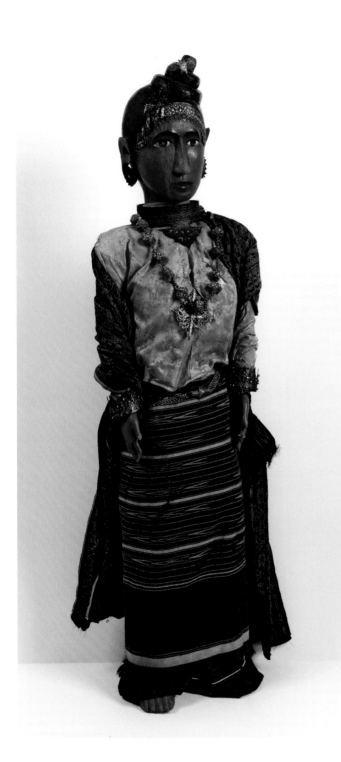
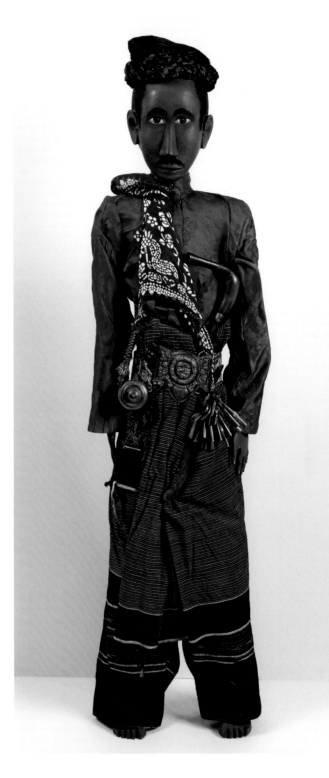

< 59
**Dolls representing
a wedding couple
from Aceh, Sumatra**
c. 70 cm
Aceh, Sumatra
Early 20th century
(TM-1698-445/443
Gift: F.J. Vattier
Kraane-Daendels, 1946

60
**Dolls representing
inhabitants of Rongkong,
Sulawesi**
c. 73 cm
Late 19th/early 20th century
TM-6-1a/b
Gift: D. Breedtveld-Boer, 1914

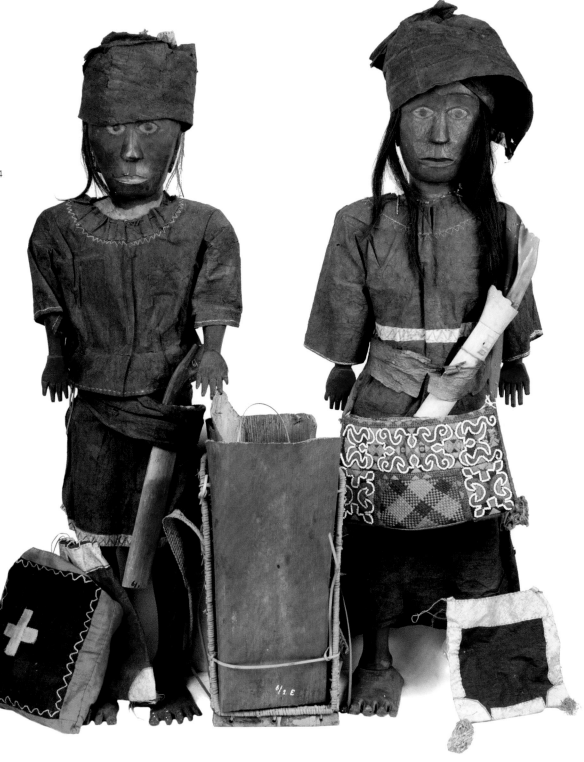

encounters between the colonised and the coloniser. Another example is a narrative painting made at the beginning of the 20th century (fig. 61). This object was purchased in 2002, at a time when the Tropenmuseum itself had begun to explore the relationship between ethnographic collections and the state of affairs in the colonial society. This wall hanging shows these social relationships as seen through the eyes of a colonised Indonesian.[148]

The wall hanging was made around 1920 by Sitisiwan (1865–1948), an artist who worked in Gegesik in northwestern Java. Gegesik was a famous art centre at that time. These large cloths were commissioned by local entrepreneurs who rented them to people to decorate the walls at ceremonial events. Traditionally, they only served a decorative function and had depictions of animals, plants and people, without there being a coherent story to bind them. Sitisiwan was an artist who depicted historical events. This was at a time when local resistance to colonial oppression was on the rise.

The nine-metre-long cloth is divided into nine scenes on two levels. The representation can be read as a graphic novel, but the sequence is not entirely clear. The painting depicts the arrest, trial and execution of a group of Javanese men. Names, occupations and sometimes family relationships are mentioned

61
Wall hanging (+ details)
Artist: Sitisiwan (1865–1945)
Painted cotton
703 x 145 cm
Gegesik, Java
Early 20th century
TM-5910-1
Purchase: T. Murray, 2000

alongside them. The portrayals of Dutch civil servants and Javanese officials in Dutch service are also accompanied by descriptions of their positions. All the characters are dressed according to their ethnic group or their position within the colonial government.

The story probably begins in the bottom right hand corner with a court session that was held in Arjawinangun, a village near Gegesik. The *wedana* (district head) of Arjawinangun sits behind a table on which the stolen goods, a rifle, copper vases and bowls, are on display. Opposite him are a group of standing and seated Javanese, some with a rope around their neck. The parents of one of the defendants named Marsiti, *Marsiti biyang* (mother) and *Marsiti bapa* (father), are also present. In the scenes that follow, the defendants, tied to each other with a rope, are escorted away by Javanese officials. They carry the stolen goods with them. In the next image a Dutch government official, a *kentola* or *controleur* (district commissioner), is dictating a letter and the group of chained men are being led away by a policeman called Sawinyar from Gegesik Kidul. They are preceded by a white buffalo. Above this scene a group of Dutch soldiers march beside a Javanese administrator and a Dutchman, the resident, who then travels by car to the place of

execution. The hanging is attended by two Dutch men, a bailiff, a resident councillor who is smoking a cigar, and a Javanese soldier. The final scene at upper right resembles the first one below, and again shows a trial with defendants. At far right, covering the entire width of the cloth, a large mythical animal that resembles a tiger attacks a white buffalo, while two Dutch men shoot at the tiger. This painting by Sitisiwan probably shows an historic lawsuit in Arjawinangun and is meant as an indictment of Dutch colonial rule. He transformed a cloth usually used as decoration into a denunciation of the colonial oppressors and a call for social change.[149]

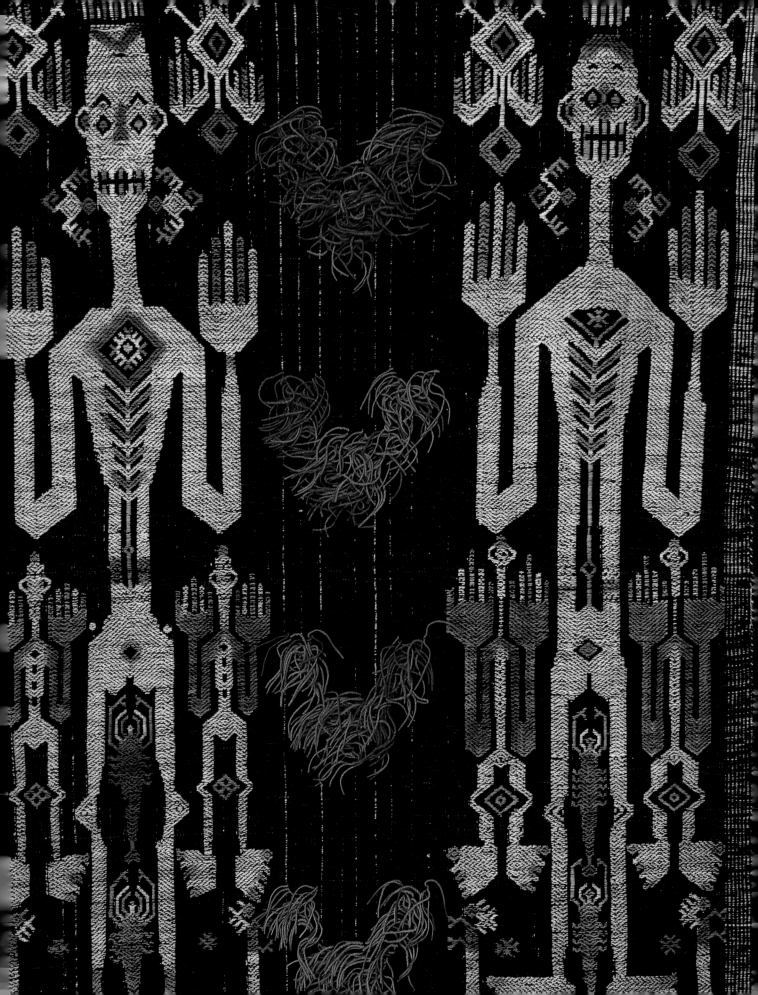

COLLECTING

Government officials, scientists, entrepreneurs, soldiers and
missionaries collected numerous textiles and garments during
their stay in the Netherlands East Indies. While those who brought
the objects to the Netherlands are often known, the names of the
makers of the objects were not recorded – they were and remain
anonymous citizens of the Dutch colonial empire. But there are
some exceptions.

H.C. Humme (1826–92), Resident of Timor and its Dependencies,
donated a rare tubular skirt to the Artis Ethnology Museum.
He acquired it during his trip to Sumba between 1873 and 1875.
He described it as 'a fine garment embroidered by a Sumbanese
princess'. He even names her: Princess Amal Oekoe, daughter
of the Raja of Kapedoe on Sumba Island. Humme recognised the
importance of providing this information about the skirt which
he purchased or possibly received as a gift.

'The peculiar Dutch mixture of religion, science, enterprise and commerce is reflected in the many sculptures and ornamental details [….]. These icons of Western thought and industry were mirrored in essential images from the East and the West, which refer to religions and rituals, to various peoples, to agriculture and industry, to knowledge, beauty and pleasure in various cultures.' [150]

The collection of the Tropenmuseum in Amsterdam is housed in a large and imposing building. The building and the museum are inextricably linked to the political history of the Netherlands, especially its colonial history. The above quote refers to the richly decorated building that was constructed at the beginning of the 20th century in the heyday of Dutch colonial rule in Southeast Asia. The entire building is enriched with decorations that represent the commercial interests of the Netherlands in the colonies and the preoccupation with foreign cultures by different scientific disciplines. Representations of the earliest contacts between the Netherlands and Indonesia are visualised in the *Lichthal* (Atrium), the central hall of the museum. Events that occurred during the so-called *Eerste Schipvaart* (First Voyage) led by Cornelis de Houtman

are brought to life in relief on the capitals of the pillars. De Houtman left Amsterdam for 'the East' with a small fleet of ships in early 1595 to evaluate the potential of the spice trade. At the end of that year, he became the first Dutchman to step ashore on what is now Indonesia. Willem Lodewycksz, *onderkommies* of the fleet, had been commissioned to document the journey in detail. His report recounting the experiences and observations of the Dutch on their way to and in the archipelago served as a basis for the reliefs in the museum. He describes encounters with local governments and foreign traders such as the Portuguese and Chinese. He says very little about culture, and even less about expressions of material culture, with one exception: he describes a Sumatran sultan's clothing, ornamented with gold thread, and weaving on Bali, '[...] where the inhabitants are primarily busy with weaving cotton textiles, at which they are very talented, and the creation of various works, and the colours'. [151] Unfortunately Lodewycksz provides no further details, but around 1920 the Haarlem sculptor J.L. Vreugde, who was commissioned to portray this journey in the new institute, translated the comment on Bali into a sculpture of two women weaving. Vreugde must have studied the type of loom that was used on Bali because several details of the loom – a type still used today – are reproduced accurately (fig. 62). Lodewycksz was one of the first Dutch people to praise weaving in Indonesia and expressed his admiration in his report on his return to the Netherlands. Was this the beginning of a fascination for Indonesian textiles that would for centuries thereafter blossom in the Netherlands and far beyond?

The Dutch East India Company (VOC) was founded in 1602 to exploit the spice trade as effectively as possible. VOC traders knew that dealing in spices was part of a larger Asian trade network, and that, for example, silver and textiles from India were highly prized trade products in the Indonesian archipelago. In 1618, 23 years after Cornelis de Houtman's trip, Jan Pieterszoon Coen, the first governor general of the Netherlands East Indies and founder of Batavia (Jakarta), also recognised the profitability of Indian fabrics 'Piece goods from Gujarat we can barter for pepper and gold on the coast of Sumatra, rials and cottons from the coast for pepper in Bantam, […] piece goods from the Coromandel coast in exchange

62
Relief, Balinese weavers
J.L Vreugde, inspired by Willem Lodewycksz's report on the 'First Voyage' in 1595, led by Cornelis de Houtman. On a pillar in the Tropenmuseum's Atrium.
c. 1920

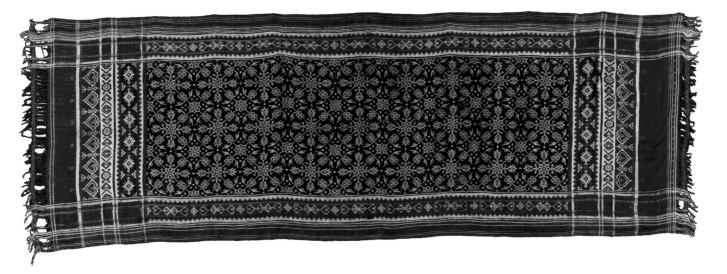

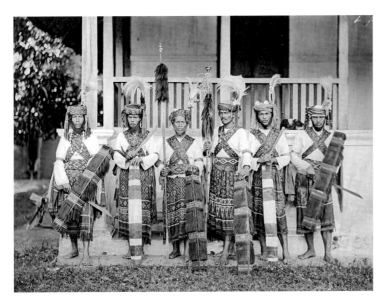

for spices, other goods and gold from China, piece goods from Surat for spices [...] one thing leads to the other'.[152] The fabrics, called *Javaensche cleeden* (Javanese cloths) by the VOC merchants, were shipped to Batavia, where they were stored in large warehouses. Trade was extensive: around 1750 the number of cloths in storage fluctuated between 500,000 and 1 million pieces.[153] A significant proportion of the textiles were produced to cater to the specific requirements of different markets. Price and quality were decisive for the segment of society in which they were traded. Silk fabrics from Gujarat with motifs in double-*ikat*, *patola*, were most in demand in aristocratic circles (figs. 63, 64). J.B. Tavernier,

a French explorer who made several trips to India, wrote in 1677: 'The *patola* are one of the good international trade products for the Dutch, who only allow the *Compagnie* (VOC) to trade them, as opposed to private traders, and they transport them to the Philippines, Borneo, Java, Sumatra and other neighbouring islands.'[154] These precious textiles are part of the costumes that dancers wore at the Yogyakarta court, but they were also fashioned into trousers for the local rulers (fig. 71). The dancers were a favourite subject for Dutch artists. J.C. van Eerde, director of the Koloniaal Museum (Colonial Museum) in Amsterdam, welcomed this attention because 'the Javanese dance will thereby gain international recognition'. In this way he expressed his conviction that the Dutch could learn from the 'richness of form, the monumental greatness and expressive power' of this art form (fig. 65).[155] However it were not the silk *patola* that made up the bulk of trade, but cotton fabrics. Printed and unprinted cotton fabrics were produced for the Indonesian market in Gujarat and on the Coromandel Coast.

VOC traders brought Indian tradecloths to the Netherlands already in the 17th century, and Indonesian textiles arrived in Europe in the first decades of the 19th century. The first organised acquisition activities that laid the foundations for the Tropenmuseum's current textile collection took place in the mid-19th century. Textiles from Indonesia were acquired by the Colonial Museum in Haarlem, the Artis Ethnographic Museum, and

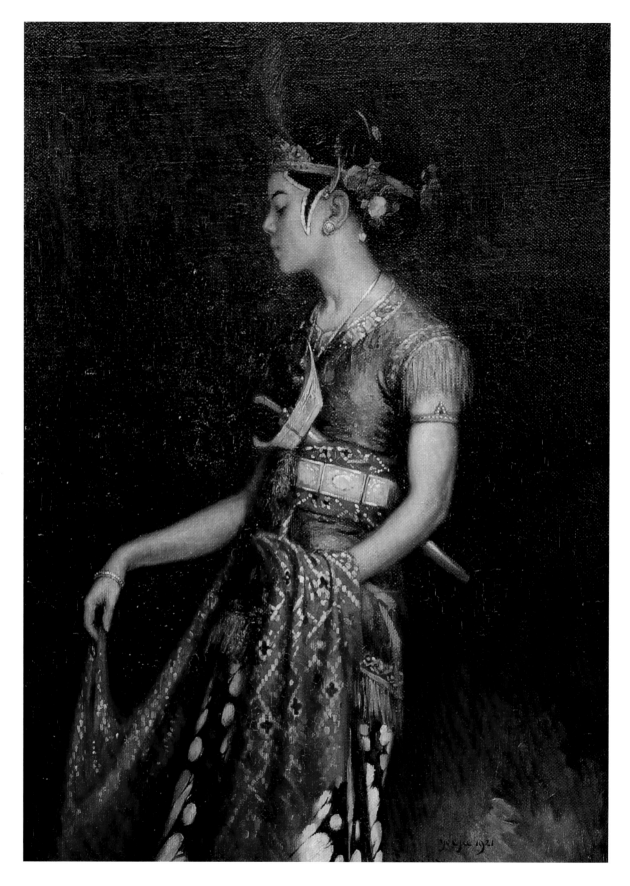

INDONESIAN TEXTILES

others. These collections were combined in 1923, and became the core collection of the museum of the Colonial Institute, now the Tropenmuseum in Amsterdam.

This chapter describes the various institutions where the collections were housed, managed and studied, as well as the changing political, economic and art-historical views that over time played a role in the development, growth and study of the collection of Indonesian textiles. As part of the entire collection of ethnographic objects, the textile collection has long held a special position in the Tropenmuseum. The museum had a staff function for its textile collections from the 1920s until 2014. What is the reason behind this special position of 'textiles' in the Tropenmuseum and how was it shaped over time?

Haarlem
The Colonial Museum, 1864–1923

In 1864, the world's first colonial museum was established in Haarlem. The museum was an initiative of the Nederlandsche Maatschappij ter Bevordering van Nijverheid (Dutch Association for the Advancement of Industry), founded in 1836.[156] This association gave impetus to assembling one of the first public collections of ethnographic objects in the Netherlands. The botanist Frederik Willem van Eeden (1829–1901) joined the association in 1859. When the association proposed establishing a museum of raw materials, natural products and arts and crafts from the Dutch Overseas Territories and colonies, Van Eeden dedicated himself to compiling various collections. The shared interest of this association and the aforementioned Netherlands Trading Society (NHM) in the production of textiles would have a major impact on the Dutch textile industry, especially in Twente. The Colonial Museum was officially opened in 1871 and Van Eeden was appointed director. The aim of this museum was to study and exhibit raw materials and arts and crafts from the colonial territories, both to promote the exploitation of the colonies and to stimulate Dutch industry. According to the articles of association, the knowledge acquired was to be shared with the Dutch public in a clear and systematic manner through exhibitions and publications (fig. 66).

From 1870, after the lifting of the NHM's trade monopoly in the Netherlands East Indies, the archipelago became an attractive region for private entrepreneurs. Increasing commercial activity in the colony and growing prosperity in the Netherlands resulted in the emergence of a new well-to-do middle class in the homeland. The entrepreneurs brought home objects from the colonies and these, together with items collected by government officials, scientists and others, constituted the beginning of the Haarlem museum's collection.

The museum was in line with the *zeitgeist*, a transition from cabinets of curiosities to a museum with a more scientific approach. The collection was classified into a number of categories, including the Vezel-stoffen (Fibres), and the Indische Nijverheid en Kunst (East Indies Arts and Crafts) departments (see figs. 104, 105).

A documentation system was established to increase accessibility to the collection for scientists, entrepreneurs and the general public. The extent to which science and commercial practices were inseparable for Van Eeden is apparent from what he wrote in 1884 for the 12-and-a-half year celebration of the museum's existence: '[…] scientific research for the prosperity of commerce, industry and shipping is as important as the air we breathe is for our existence'.[158]

Despite a variety of collections, including stuffed animals, plant specimens and ethnographic objects, the museum in Haarlem was mainly a 'products museum' that focused on the acquisition, identification and study of raw materials, natural products and their applications: garments produced from fibres were collected to acquaint the public not only with the material and its potential commercial uses, but also with the exquisite artistry employed in their manufacture. In those days there was little interest in the museum in the people in the cultures of origin or in the meanings and functions of the objects for the society in which they were made and used. This viewpoint changed at the beginning of the 20th century when the exhibitions started emphasising the cultural context of the objects in the regions of origin. It also led in 1912 to the renaming of the East Indies Arts and Crafts department as the Afdeling Volkenkunde (Ethnology department).[159] Because the initial interest was in crops, materials

66

Tubular skirt – *sarung* (2x)
These cloths were probably part of a larger series consisting of all stages of the batik process. The card attached to the waxed cloth has the text: 'No. 10a *sarong* batik, *Ngereng taroesan*. Pattern: *Merak kesiempir*, *Latar putih* (white background). Manufactured by Mrs. Lawick van Pabst in Yogyakarta. *Museum v. Kunstnijverheid Haarlem!* [Museum of Applied Arts Haarlem!]'. G.P. Rouffaer translated '*Merak kasimpir*' as 'peacock with drooping wings'. W.F. Lawick van Pabst in Yogyakarta manufactured batiks on behalf of C.M. Pleyte, curator at the Artis Ethnographic Museum in Amsterdam, and for K.P.A. Koesoemodinigrat, son of *Susuhunan* (Sultan) Pakubuwono IX and older brother of *Susuhunan* Pakubuwono X. Samples of the different stages of the batik process were specially made for the world fairs in Amsterdam, Paris and Brussels.
Stages of the batik process
Cotton, wax
Batik
217 x 106 cm
Yogyakarta, Java
Late 19th/early 20th century
TM-932-62/932-64
Loan: Dutch Society for Industry and Commerce, the successor to the Dutch Association for the Advancement of Industry, 1935

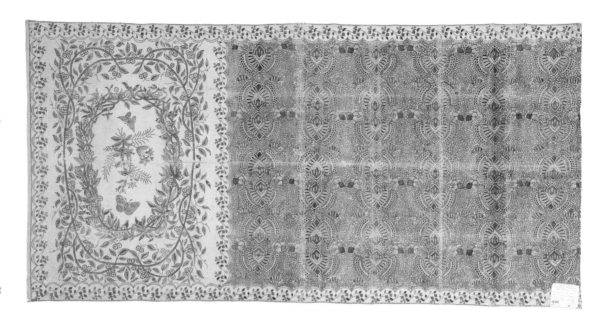

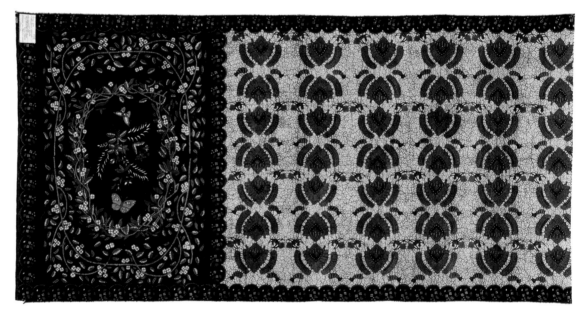

and the products that could be made from them, the Haarlem collection contains examples of everyday clothing of people who are not frequently represented in collections. Daily encounters between 'coloniser' and 'colonised' in the context of the production of commercial crops such as indigo and tobacco lent the Haarlem collection its own character. H. Cremer, a tobacco planter in Deli, Sumatra, brought Chinese-made clothing from Chinese contract labourers who worked on the plantation to the Netherlands. He was the brother

of Jacob Theodoor Cremer, co-founder of the Colonial Institute in Amsterdam (figs. 67, 68).

Despite the interest in the artistic qualities and the technical virtuosity of indigenous crafts, economic and political interests remained the priority at the museum in Haarlem, as seen in the collecting and exhibiting of raw materials and crops. Various fibres were presented as being suitable for cottage industry, as evidenced by garments and textiles made from fibres such as *agel*, *lemba*, pineapple fibre, *koffo*,

Mauritius hemp and fan palm. But fibrous materials were also collected for other purposes: *kapok* to stuff mattresses and pillows, and the '*gemoetie* fibre', which appeared to have useful properties for insulating underwater telegraph cables.[160] The fibre clothing, including a complete outfit made of fan palm fibre, must have enhanced the raw material and product displays in the museum (fig. 69).

A number of textiles came into the museum's collection via colonial administration officials. Civil servants acquired textiles as gifts from the local population on the occasion of a visit or a special event. These encounters occurred in an atmosphere of colonial dominance and suppression; however, it is customary in the archipelago to present a textile as a gift to a stranger, which is

67
Jacket – *baju Cina*
Clothing of a Chinese contract labourer from the Deli tobacco plantation on Sumatra. The collector H. Cremer was a brother of J.T. Cremer, one of the founders of the Colonial Institute in Amsterdam.
Cotton
146 x 75 cm
Deli, Sumatra
Before 1886
TM-H-1408b
Gift: H. Cremer

68
Chinese contract labourers in a tobacco shed; the leaves are sorted by colour and quality on the left and by length on the right.
Photographer: unknown
Albumen print
Sumatra
26 x 36 cm
1885
TM-60010553
Provenance: unknown

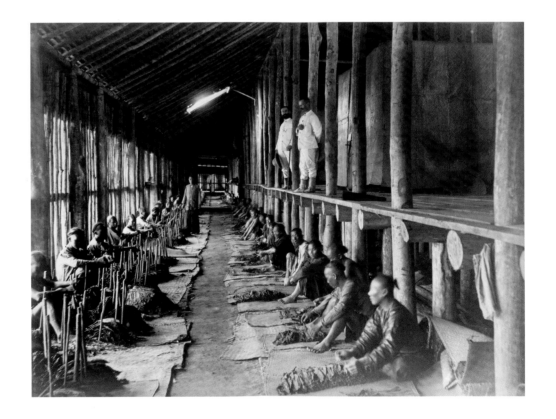

69

Jacket
Fan palm fibre
52 x 50 cm
Java, Salatiga
c. 1880
TM-H-3168
Collected by H.I. van Swieten
for the 1883 International
Colonial and Export Exhibition
in Amsterdam.

70

**Kanjeng Pangeran Arya
Koesoemodiningrat
(1862–?)**
Gift: Constance van Leeuwen,
Kanjeng Pangeran Arya
Koesoemodiningrat's great
granddaughter.

a way to begin a relationship in which a certain reciprocity is expected. Civil servants were also tasked with actively collecting. J.E. Jasper was one of the most influential officials in this area. Part of the large collection he acquired for the Dutch pavilion at the 1910 Brussels World Fair is included in the Tropenmuseum (see Chapter 'The Colonial Administration and the Arts and Crafts Industry').

Pursuing the *Ethische Politiek* (Ethical Policy) formulated at the end of the 19th century, besides government officials, members of the Javanese elite also committed to spreading information about Javanese crafts and improving the economic conditions of the craftsmen. Kanjeng Pangeran Arya Koesoemodiningrat (1862–?), a prince at the Surakarta court, contributed to this process in different ways.[161] Like J.E. Jasper, he was a member of the East Indies exhibition committee that was responsible for compiling the exhibits for the 1910 Brussels World Fair (fig. 70).

K.P.A. Koesoemodiningrat, the son of *Susuhunan* (Sultan) Pakubuwono IX (1830–93) and the elder brother of Pakubuwono X (1866–1939), was a respected member of the royal family at the Surakarta court. He had the freedom to pursue his own interests alongside his military career in the Koninklijk Nederlandsch Indisch Leger (KNIL, Royal Netherlands East Indies Army), where he held the titular rank of lieutenant colonel. He grew up at a time when the *Cultuurstelsel* (Cultivation System) regulated economic conditions in the Netherlands East Indies. As a grown man he experienced the rise of the Ethical Policy,

which greatly appealed to him. The development of arts and crafts was close to his heart, not only for artistic reasons, but also because of the potential to improve the living conditions and economic situations of the local artisans. Foreign scholars and artists who visited the Surakarta court influenced Koesoemodiningrat's life philosophy and although he was raised in the Islamic tradition, he did not consider himself as just a Muslim. He was strongly attracted to theosophy and was friends with the Orientalist D. van Hinloopen Labberton, a board member of the Theosophical Society in the Netherlands East Indies. A portrait of Annie Besant, a leading member of the Theosophical Society, hung in the veranda of his house. Koesoemodiningrat's ideas on both the artistic value and the economic importance of the crafts sector concurred with the views of Van Eeden and batik researcher G.P. Rouffaer in the Netherlands. Rouffaer had published an article about the Dutch 'artistic' debt of honour after the appearance of the article by C.Th. Deventer on the economic debt of honour the Netherlands owed the Netherlands East

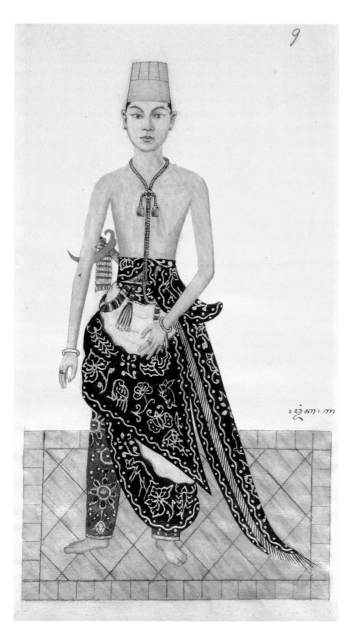
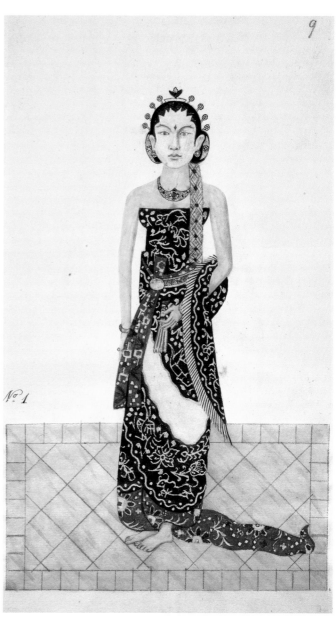

<<
> 71

Manuscript with
a description and illustrations of *kain kembangan*,
a category of ceremonial
cloths that were worn
at the Surakarta court.
K.P.A. Koesoemodiningrat
compiled the book at the
request of G.F. van Wijk,
the Resident in Surakarta.
This type of *kain kembangan*,
with the *alas-alasan* motif
applied in gold leaf, was worn
by the bride and groom on
the fifth day of the wedding
ceremonies.[1]
35 x 22 cm
Surakarta, Java
c. 18 95
TM-H-336
Gift: Colonial Museum, 1900

> 72

Breastcloth – *kemben alas
alasan*
Exhibited at the 1900 Paris
World Fair.
Cotton
Tritik, batik, *prada*
348 x 51 cm
Java
19th century
TM-15-196
Gift: Association for the
Foundation of a Museum
of Southeast and Caribbean
Studies in Amsterdam, 1912

> 73

Hipcloth – *dodot alas alasan*
Exhibited at the 1900 Paris
World Fair.
Cotton
Tritik, batik, *prada*
210 x 184 cm
Java
19th century
TM-15-18
Gift: Association for the
Foundation of a Museum
of Southeast and Caribbean
Studies in Amsterdam), 1912

Indies.[162] The Boedi Oetomo (The Noble Cause)
association was founded on Java in 1908. This
association for Javanese officials, of which Koesoe-
modiningrat was a member, sought to improve the
living conditions of the Javanese people by providing
more education and exerting more influence on the
colonial administration. The position people held
in society should not be determined by rank or birth
but on their own merits. However, the association
gradually shifted its focus to nationalist activities,
and after its influence rapidly declined, it merged
with Indië Weerbaar ('Resilient East Indies'),
which, alongside improvements to the 'ethical
atmosphere', deemed military resilience as impor-
tant. Koesoemodiningrat and Van Hinloopen
Labberton, a strong supporter of the emancipation
of the Netherlands East Indies – under the watchful
eye of the Netherlands, in military, intellectual and
economic terms – were sent to the Netherlands
as representatives of this movement to explain its
objectives. G.F. van Wijk, the resident in Surakarta,
was also part of this group.[163] Queen Wilhelmina,
the government and parliament received the
delegation in March 1917.

K.P.A. Koesoemodiningrat had a deep affection
for the textile industry in his country. A special
manuscript in the Haarlem collection contains
a description and illustrations of clothing worn at
the Surakarta court. Koesoemodiningrat compiled
the manuscript at the request of G.F. van Wijk
(fig. 71). The handwritten text in Javanese and Dutch
is dedicated to J. Dekker, director of the museum
in Haarlem from 1910–12. The manuscript contains
45 hand-painted images of a specific type of textile,
the *kain kembangan*. Alongside every image is
a description of the colour combinations and dyes
in both Javanese and Dutch. How the aristocracy
wore these textiles is documented in depictions
of couples at wedding ceremonies.
Kain kembangan or 'flowered cloths' (*kembang* =
flower) are ceremonial garments that were worn
as a hip-, breast-, or headcloth and as a belt.
The decoration on these textiles is applied using
the *tritik* technique. *Kain kembangan* produced and
worn at Central Javanese courts belong to an old
Javanese tradition. As early as 1577, during his visit
to Java, the English explorer Sir Francis Drake
(c. 1540–96) described cloths of 'blue on reserved

white'.[164] In the middle of the 17th century Rijckloff van Goens, who as VOC envoy visited the regent of Mataram on several occasions between 1648 and 1654, discussed these textiles. About the clothing of the court dancers he wrote: '[...] both breasts covered with a silk cloth two hands wide, green and red in colour, black and green, white and red or white and green [...]'.[165] This description matches the colours of the *kain kembangan* in the manuscript. The most important *kain kembangan* is the *bangun tulak*, a dark blue or dark green cloth with a white centre panel. The dark-light combination represents the Javanese philosophical concept of the 'material' and 'spiritual', or life and death.[166] The *alas-alasan* pattern is applied on the dark part in gold leaf, and consists of depictions of animals such as deer, the poisonous centipede and birds, the inhabitants of the earth and

sky. Protective powers are attributed to the cloths due to the dark-light combination and the representation of certain animals (figs. 72, 73).[167]

With the aim of raising international awareness about the Javanese batik industry, Koesoemodiningrat designed and commissioned batiks for the 1910 Brussels World Fair. Some of his textiles came to the Colonial Institute in Amsterdam via the Dutch Association for the Advancement of Industry (Series 932) (see fig. 34). In 2012, nearly a century later, the relationship between the Tropenmuseum and this royal family was revived. A great-granddaughter of K.P.A. Koesoemodiningrat donated two textiles from the family heritage to the museum in 2012. Both batiks were produced in the Surakarta court by her mother, Koesoemodiningrat's granddaughter.[168]

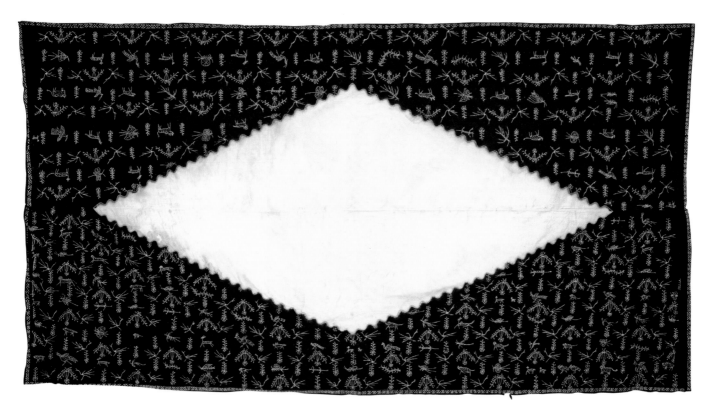

Amsterdam
Natura Artis Magistra (Artis), 1838–1920

When the Royal Zoological Society Natura Artis Magistra (NAM) was founded in 1838 its focus was on natural history in general and on conducting research in the Dutch colonial territories in particular. The Society was initially only open to representatives from the worlds of science, the arts and business. The membership reflected the social and intellectual developments that had taken place in society: 'The zoological society became a source of civic and national pride for its supporters who were motivated, in part, by a sense of nationalism.'[169] Dr. Gerardus Frederik Westerman, co-founder and director of Artis from 1838 to 1890, believed that Artis had to gather and share knowledge about peoples and cultures as well as the animal kingdom. His views were described as follows in the *Indische Gids*: 'He – a man of action – will as director of Artis create space for the most highly organised creature in the animal kingdom.'[170] As a result, in Artis it was no longer just live exotic animals, zoological material such as skeletons, and preparations and minerals that were collected and studied, but also objects from the cultures that Artis members visited. Thus precious silk robes from Sumatra were donated to 'create an impression of the artistic skills brought to life by Oriental opulence'. From the many donations it received, the board of Artis concluded in 1859 that

'the establishment of an Ethnographic Museum was more than desirable in the capital city of a colonial power'.[171] The Artis Ethnographic Museum opened in 1871. A foreign magazine described this cultural-historical collection as 'the pearl in Artis' crown'.[172] Artis grew into a renowned cultural and scientific institution, where not only scholars but also entrepreneurs and interested parties were able to develop and share their knowledge. Artis had an active acquisition policy: employees asked travellers to the colonies to collect objects and donate them to Artis, regardless of whether they were scientists, merchants, government officials or missionaries. In return they received honorary membership with all the associated privileges, such as access to 'exotic, ethnological exhibitions' and classical music concerts in the garden. On a scientific level, Artis employees sought contact with experts abroad to enhance the position of Dutch science. With this policy, Artis put Amsterdam on the 'scientific' map as the capital of a large European colonial nation.[173] People responded positively to the request for objects, and Artis soon had a very varied ethnographic collection, with clothing and fabrics from a large number of Indonesian islands. An important part consists of batiks, including some rare textiles attributed to Carolina Josefina von Franquemont. Von Franquemont was one of the first Indo-European batik entrepreneurs who, working on the north coast of Java, introduced a drastic style change compared

74
Tubular skirt – *sarung*
The floral motifs are reminiscent of the motifs on chintzes brought from India to the Netherlands by the VOC. In order to satisfy Dutch tastes as closely as possible, in 1686 the VOC sent the painter and textile merchant Gerrit Claeszoon Clinck to Bengal and Coromandel to design new patterns to be manufactured there. According to the prevailing European fashion, the motifs on the chintz had to be freer, lighter and not painted in tight rows. The new type of chintz was a success; imports to Amsterdam increased twofold. In the late 18th century the demand for chintz in Europe and in Indonesia decreased, around which time the batik industry began to grow strongly.[4]
For Carolina von Franquemont, (see fig. 45).
Cotton
Batik
223 x 111 cm
Semarang, Java
Workshop: Carolina Josephina von Franquemont
Before 1867
TM-A-4956

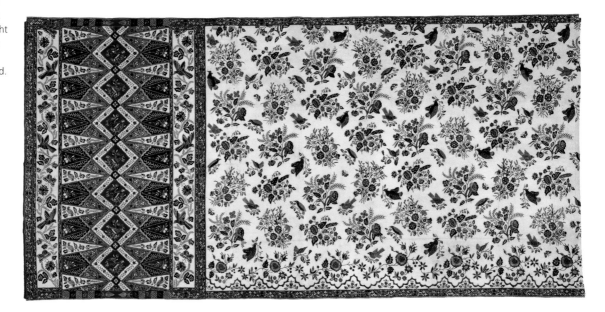

with the batik style of Central Java (fig. 74) (see Chapter 'Colonial Collections' and the Catalogue). A major acquisition consisted of a collection of 150 batik patterns from Probolinggo on Java that had been commissioned for the 1883 International Colonial and Export Exhibition in Amsterdam. This collection was donated to Artis by the Nederlandsche Koloniale Vereniging (NKV, Netherlands Colonial Association), which had striven for the establishment of a colonial museum and library in Amsterdam after the exhibition in 1883. G.P. Rouffaer would later write that because it included a list of pattern names and a brief description of the batik process, this pattern collection was of great importance to his study of batik art in the Netherlands East Indies (fig. 75).

Major acquisitions by Artis consisted of donations from physicists, biologists and geologists who visited the Overseas Territories for their research. Although these scientists expressed interest in the people and

their cultures, the collected ethnographic objects and the accompanying documentation were to be considered more or less as an added bonus. Gathering knowledge about peoples and cultures was not their primary goal. This was only partly true in the case of the linguist Herman Neubronner van der Tuuk (1824–94), who in 1861 donated a collection of North Sumatran Batak objects to Artis. Van der Tuuk, born in Malacca (then Dutch territory), studied in the Netherlands, but spent most of his life in the Netherlands East Indies. He was a brilliant researcher and a passionate scholar of various Indonesian languages. Van der Tuuk remained in the Batak region from 1849 to 1857, and was the first scholar to study the spoken and written Batak language. He was employed by the Dutch Bible Society to study this language with the goal of translating the Bible. He settled on the west coast and from there travelled inland where he collected songs, stories and objects. Van der Tuuk made the

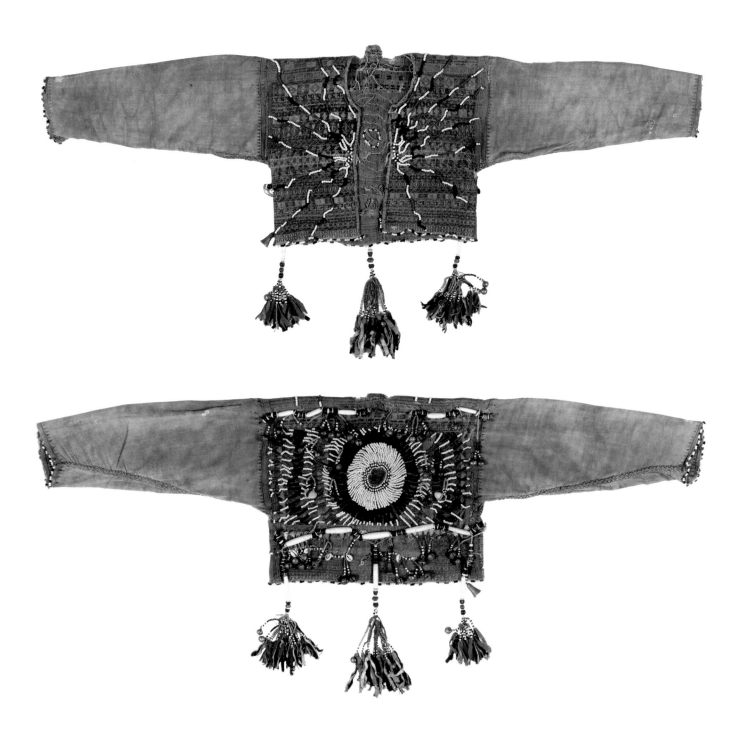

Batak language his own through intensive contact with, for example, priests who he invited to come and live in his house. With his striking personality and outspoken ideas he ultimately felt more at home with the Batak than with his Dutch employers. Within him grew a great appreciation for the people and their culture and in time he relinquished his mission to translate the Bible, fearing that the Bible's influence would lead to irreversible changes to the Batak religion and culture. He was also concerned about the growing influence of Islam and the spread of the Malay language, which, he noted, were to the detriment of the local languages. He published a dictionary, the *Bataksch-Nederduitsch Woordenboek*, in 1861: to this day it is still the definitive work on the Batak language.

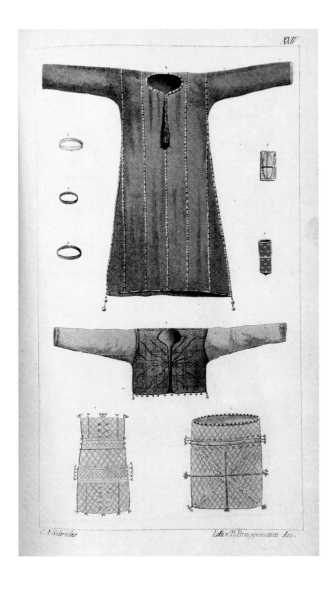

< 76

Bridal jacket – *baju omon*
Cotton, glass beads, shell,
metal bells
Supplementary weft,
beadwork
45 x 35 cm
Mandailing Batak, Sumatra
c. 1854
TM-A-3318
Gift: Herman Neubronner
van der Tuuk

77

Drawing of a bridal jacket
in Herman Neubronner
van der Tuuk's dictionary,
the *Bataksch-Nederduitsch
Woordenboek*.[6]

Van der Tuuk collected objects for his scientific-linguistic goal. Many words in the Batak language had no Dutch equivalent. To clarify the meaning of some words he collected the objects they described and illustrated them in his dictionary. His collection of over 200 objects includes 'divination books', amulets, and also a shuttle with a text that was documented as being a love poem. He also gathered a special collection of clothing and textiles, of which he added more than 30 pages of illustrations to his text (figs. 76, 77) (see the Catalogue).[174]

The ethnographic collection at Artis continued to grow, and space became an issue after a large number of objects from the International Colonial and Export Exhibition was incorporated into the Artis

collection in 1883. A new Ethnographisch Museum (Museum of Ethnology), led by curator C.H.M. Pleyte, opened on 1 May 1888 on the occasion of the 50th anniversary of the Amsterdam Society Natura Artis Magistra. The description of the purpose and exhibits in this museum expressed the prevailing attitude in the Netherlands towards ethnographica: 'The first requisite for the success of negotiations with foreign cultures is knowing their habits and customs and their language. These two points are of the utmost importance, especially for the merchant.'[175] An article about the new museum in the *Nieuwe Rotterdamsche Courant* stated that it would be better if it no longer focused on commercial interests alone, but instead looked to ethnography as a 'starting point'. About the entrance hall of the museum it was said that it was 'most pleasant, as it should be, for were there one scientific discipline liable to be popularised, it would be ethnography'.[176] Clothing and textiles barely featured, but the permanent exhibition did include batik art, which was already in the limelight at that time. Around 1900 this exhibition was visited regularly by Dutch artists, Carel Lion Cachet among them, who applied the batik technique to his work (see Chapter 'Colonial Collections'). Pleyte compiled a documentation system with descriptions of the objects. He made the collection more accessible for the public by allowing interested parties to consult the collection register. He wrote three visitor guides in which major acquisitions were noted, such as a donation of clothing and fabrics from Borneo. This collection was compiled by G.A.F. Molengraaff (1860–1942) who joined several scientific expeditions as a physicist and geologist, including the first expedition to Borneo in 1893, led by A.W. Nieuwenhuis. In 1901 Molengraaff visited Celebes (Sulawesi) and in 1910 organised expeditions to Timor, Wetar, Roti and Savu. His research was in the field of geology, but the more than 170 items he collected also testify to his interest in the material cultures of the people he encountered, especially their clothing and textiles (fig. 78).

As at the Colonial Museum in Haarlem, the Artis museum also expressed a special interest in the different types of fibres and the products that could be made from them. Exhibitions and conferences were organised both on Java and in the Netherlands

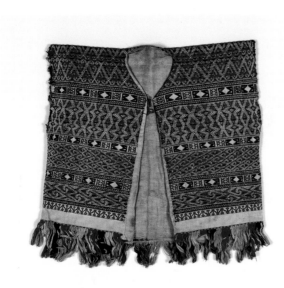

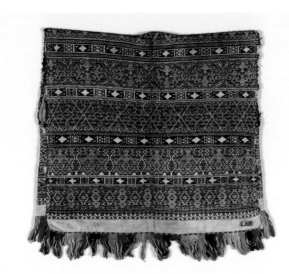

to enhance and spread knowledge about the fibre
industry (fig. 79). The 'Congres en Tentoonstelling
ten dienste van de Cultuur en de Bereiding van
Vezelstoffen' ('Congress and Exhibition on the
Cultivation and Production of Fibres') organised
in 1911 in Surabaya focused entirely on commerce,
as was made clear in the report of the president
of the organising committee in Surabaya, J.E. Jasper.
He opined that the knowledge incorporated in the
'native' sector of the fibre processing industry was
useful for the planters and European entrepreneurs.
Increasing such knowledge could initiate strong
economic growth in the motherland. At the same
time the committee wanted to encourage local

people from Surabaya to participate in the growing
and processing of fibre plants in order to stimulate
the nascent fibre industry in the Netherlands East
Indies, which was also considered of national impor-
tance.[177] Although an independent market in fibrous
materials already existed in London and Hamburg,
the committee hoped to establish a relationship
between Amsterdam and manufacturers in the
colony. The conference and exhibition in Surabaya
were so successful that a 'post-exhibition' was
organised in the Koningszaal (King's Hall) in Artis,
which was realised in close cooperation with the
Colonial Museum in Haarlem. The materials and
objects exhibited in Surabaya were shipped to the
Netherlands for this purpose.

During this exhibition, the ambivalent attitude of
the Dutch towards the population of the Netherlands
East Indies also became apparent. How could one
reconcile the 'technical brilliance', the reason why
the objects were so highly praised, with the notion
that those who made the objects were considered
to be 'primitive' and 'uncivilised'?[178] The organisers
stressed both the trade aspects of the fibre industry
and the fusion of the abundant tropical nature
and the artistry of the population, as the objects
themselves demonstrated (fig. 80). The captions
accompanying them contained as much information
about the materials from which they were created,
as about the people who made and worn the clothing.
For example, it was noted about jackets made from
a particular type of fibre that they were water-
repellent, and served as fishermen's clothing. In this
regard, the Artis Ethnographic Museum was a real
ethnological museum that wanted to illustrate the
daily life of people in the colony. After the exhibition
at Artis, the entire collection of fibre samples and
objects made from them was housed in the Colonial
Museum in Haarlem and not in the Artis museum.
Both museums wanted to serve the economic
interests of the Netherlands, yet it seems that the
Haarlem museum was seen to be more the 'products
and trade museum' than the Artis museum, and
that it was more fitting to place the fibre collection
there.[179] Different goals and acquisition policies led
to a broader and more varied collection in Haarlem
than in Artis.

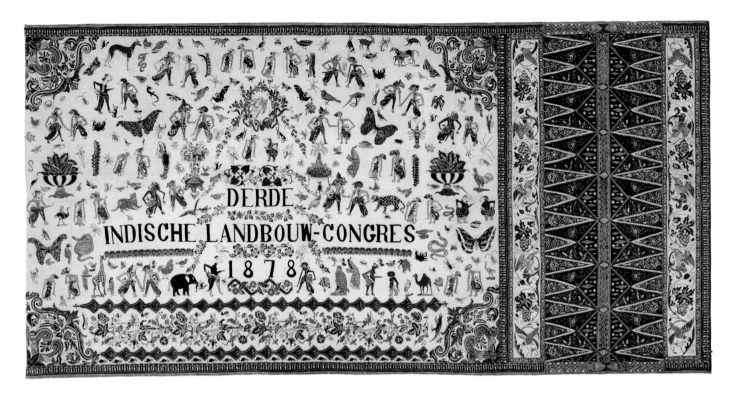

was probably made in
Catharina van Oosterom's
workshop in Banyumas,
or by Ms. Willemse or Mrs.
Matheron, who took over
the batik workshop after her
death in 1877. Since the cloth
was used in 1878, it is possible
that Van Oosterom supervised
its production (see fig. 46).
Cotton
Batik
223 x 112 cm
Banymas, Java
Before 1878
TM-A-5032
Gift: Artis, 1921

80
**Ceremonial textile
– *tawit'ng doyo***
Lemba fibre
Warp *ikat*
108 x 82 cm
Benuaq Dayak, East
Kalimantan
Late 19th/early 20th century
TM-48-121
Purchase: J.E. Jasper, 1912

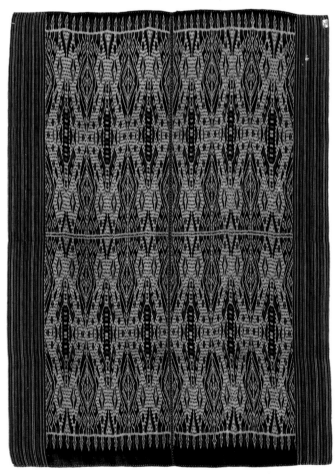

Colonial Institute Association, 1910–45

A chronic lack of space arose at the end of the 19th century in the Haarlem and Artis museums. By 1900, a plan was conceived to create a new, larger and more comprehensive institute in Amsterdam where both collections would find a new home. The Colonial Institute Association, initiated by J.T. Cremer, a former Minister of Colonial Affairs and honorary chairman of the board of the Colonial Museum in Haarlem, was founded in Amsterdam in 1910. It was intended as a central colonial institution for science, education, trade and industry, where practical knowledge in the colonial economic field was linked to scientific research.[180] The aim was to collect and disseminate knowledge about the Overseas Territories and to support the colonial interests of both the Netherlands and the colonies. The institute focused on economics, ethnology and hygiene, for which three separate departments were created: a Handelsmuseum (Trade Museum), an Ethnology department and a Tropische Hygiëne

(Tropical Hygiene) department. The Trade Museum was intended to represent the 'material interests' and the Ethnology department the 'spiritual interests'.[181] Raw materials and products were transferred to the Trade Museum; the ethnographic collections of the Haarlem and Artis museums went to the Ethnology department. The building where the new institute was to be housed was completed after many delays in 1926. The grand opening by Queen Wilhelmina took place in the same year. For this occasion the galleries of the main exhibition space, the Atrium, were decorated with textiles from the collection (fig. 81). Even though the collection was housed, and exhibitions were organised, at various locations in the city while the building was being constructed, after 1913 the study of the textile collection began in earnest.

In the period 1910 to 2014 the collection of Indonesian garments and textiles continued to expand through donations and purchases. Whereas in Haarlem and in the Artis museum the focus was primarily on batik art, in the new museum the

81
Opening of the Colonial Institute in Amsterdam by H.M. Queen Wilhelmina on 9 October 1926.
Photographer unknown
Gelatin glass negative
23.5 x 30 cm
TM-10020669

time had come to study other parts of the textile collection. Just as the Colonial Museum in Haarlem had been an important knowledge centre for Javanese batik techniques, over the years the museum in Amsterdam adopted the same role for textiles and weaving- and decorative techniques from the entire archipelago. This was due to the fact that during almost the entire period a staff member was tasked with specifically focusing on the textile collection.[182]

The Colonial Museum, 1910–45

The Tropenmuseum's textile collection was enriched in this period with a number of important acquisitions from the collections of associations and foundations, and private individual such as scientists, entrepreneurs, artists, clergymen and soldiers. Some of them, after their stay in the colony, were affiliated to the museum in different positions. Two foundations that witnessed the birth of the Colonial Institute also made important contributions to the creation of the collection of Indonesian textiles: the Nederlandsche Maatschappij voor Nijverheid en Handel (Dutch Society for Industry and Commerce) (Series 932), established in 1836, and the Vereniging voor de Stichting van een Museum voor Taal-, Land- en Volkenkunde (Association for the Foundation of a Museum of Southeast and Caribbean Studies) in Amsterdam, founded in 1903 (Series 15) (see figs. 72, 73). Besides a series of 68 batik patterns, the collection of the Dutch Society for Industry and Commerce contained some batiks with remarkable designs featuring Javanese texts. These textiles were made on commission in the workshop of W.F. Lawick van Pabst in Yogyakarta. C.H.M. Pleyte, curator at Artis Ethnographic Museum, and the previously mentioned Javanese prince, K.P.A. Koesoemodiningrat, commissioned textiles from this workshop for museums and world fairs. The K.P.A. Koesoemodiningrat collection consists of several hipcloths, a headcloth and a breastcloth. As the text on the headcloth confirms, Koesoemodiningrat also commissioned these and the other textiles (fig. 82).

The first director of the Colonial Museum in Amsterdam, the professor of ethnology and Indologist, J.C. van Eerde (1871–1936), appointed in 1913, steered the new museum in a direction that was modern for the time. Whereas other museums tried to display their entire collections, Van Eerde wanted to depict the life of the peoples in the colonies through a strict selection of objects. Like Van Eeden in Haarlem and Jasper in Indonesia, Van Eerde was concerned that artistic traditions in Indonesia would be lost. He therefore decided to go on an acquisition and research trip to gather as much information and as many objects as he could before it was too late. In 1929 he left for Indonesia with concrete plans and a long list of gaps in the collection, including some in the field of textiles.

During its early years, the museum in Amsterdam laid the foundations for fundamental research into the field of weaving and decorative techniques that would later earn it international renown. The focus on technology was in a way a logical extension of the Haarlem museum's activities, but without the passion for textiles of some of the staff members and the research they conducted the collection would not have received this recognition. Although the position did not exist at that time, the first 'textile curator' was B.M. Goslings, who after a military career in the Netherlands East Indies became a curator at the Ethnology department at the Colonial Museum in 1913. His prevailing interest was in textiles, the associated technology, the looms, and the fabrics, of which he acquired a number for the museum. After making an inventory of the collection he came to the conclusion that it contained too few complete looms. The looms in the collection that he wanted to document had arrived in the Netherlands disassembled, which seriously impeded their study.[183] Goslings informed Van Eerde of this fact while he was preparing for his trip. When he arrived in Batavia, Van Eerde visited an exhibition of looms from different regions that was organised by the Batavian Society of Arts and Sciences. During the exhibition, weavers gave demonstrations on these looms. After the exhibition ended, Van Eerde managed to purchase a few looms, convinced that they were complete and that the parts were all in the right place. He also acquired the various types of textiles that could be woven on the looms. In May 1929 the colonial administration on Java organised the fourth 'Pacific Science Congress'. Van Eerde attended and was able to purchase a second important collection from Borneo, Sumba, Sulawesi, and the Zuidwester Islands. He returned with 250 textiles and nine looms (Series 556).

A BATIK FOR THE BRUSSELS WORLD FAIR 1910

This cloth has the dimensions of a headcloth, but was never intended to be used as such. It was made in W.F. Lawick Pabst's workshop in Yogyakarta as part of a series to raise awareness of the sophisticated Javanese batik art among the general public at the 1910 Brussels World Fair. A Javanese text on the cloth, referring to different types of garments is surrounded by a number of decorative borders. The text reads:

Batik pattern, also a headcloth, modang, *in the style of the* semoe-kirang *pattern. One white and one black* latar *(background) breastcloth with* oempak-oempakan *pattern, supplemented with* seret, *featuring different* oempak *patterns. Pattern of forbidden* parang *in addition to some* semen *patterns. Moreover four* tjeplok tjeplokan, *the grand total amounting to six (pieces).*

All this comes from Kandjeng Pangeran Arya Koesoema di Ningrat, Captain of the General Staff, nobleman in the august realm of Surakarta. The objective of his Lordship is to promote the Javanese craft industry in the field of batik as soon as possible; thus the patterns that are distributed can be distinguished from the coarser batik work. Also to promote the execution of orders that differ from the general Javanese produce, such as cloth for pyjamas, tablecloths and chairs as used by Europeans. But in such cases the desired dimensions must be specified. May this come to the attention of readers, and hopefully motivate them to make a purchase. Completed in the month of Sura, year Bé Ao. 1840 (1910 AD).

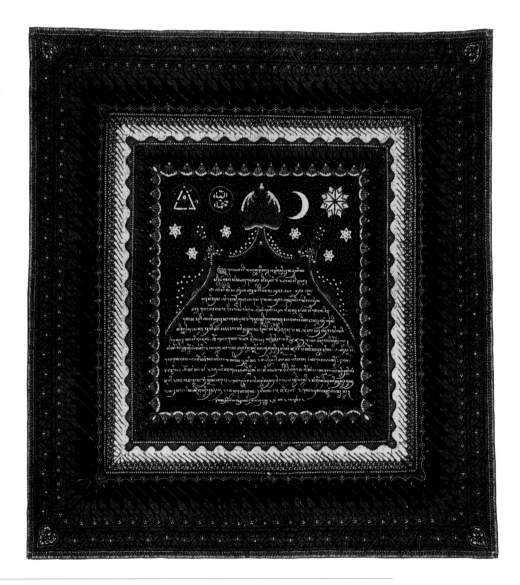

< 82
Headcloth – *iket*
Design: K.P.A.
Koesoemodiningrat
Lawick van Papst's workshop
Cotton
Batik
107 x 104 cm
Yogyakarta, Java
Early 20th century
TM-932-70
Gift: Dutch Society for Industry
and Commerce, 1934

83
**A description of cloth
347-2 by B.M. Goslings**
Photograph: Zettel Goslings

84
**Headcloth – *slendang
bersidang***
Cotton
Batik
82 x 189 cm
Jambi, Sumatra
Early 20th century
TM-347-2
Acquisition: Tassilo Adam,
1927

85
Tubular skirt – *sarung*
Cotton
Batik
113 x 103 cm
Jambi, Sumatra
Early 20th century
TM-556-19
Acquisition: J.C. van Eerde,
1929

Goslings documented this collection with great care, just as he did the collections from the 1900 World Fair in Paris and from J.E. Jasper and Tassilo Adam. He not only described the objects in detail; he also examined the relationship between the type of loom and the structure of the fabric that was made on it. He developed a classification system in which he categorised the looms based on the way the warp threads are positioned on the loom. He recorded the results of his research on the museum's documentation cards and in various publications (fig. 83).[184]

Goslings was fascinated by a batik cloth that was acquired in Jambi on Sumatra. Until the collector and photographer Tassilo Adam donated the cloth

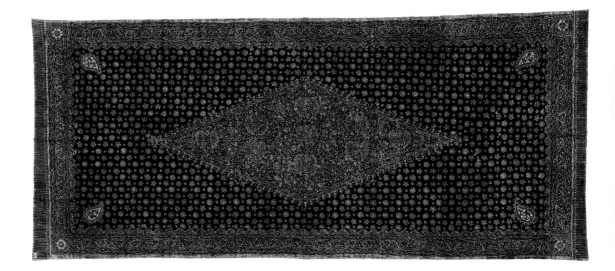

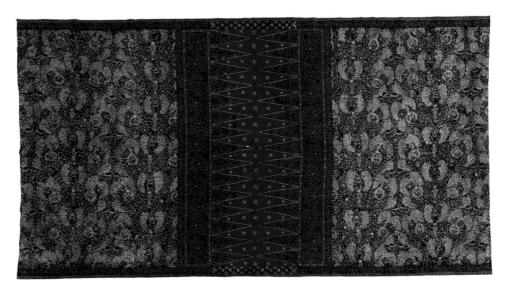

Pa Mbelgah and family
Tassilo Adam regarded this photograph as the most remarkable he ever made. Pictured are Pa Mbelgah, the local ruler of Kabanjahe (Karo, Sumatra), and his family. The skulls of their ancestors and the most valuable textiles and jewellery are displayed in front of them. The skulls were specially taken from the skull house for this photograph. Gaining your subject's confidence is not a prerequisite to becoming a good photographer, but it certainly helps. German planter Tassilo Adam (1878–1955) was a master at diplomacy, opening the way for him to capture many facets of the life of the Batak.
Photographer: Tassilo Adam
Silver gelatin developing-out paper
Karo Batak, Sumatra
50 x 65 cm
1919
TM-FC-2008-069
Acquisition: Tassilo Adam

to the Colonial Institute in 1927, people in the Netherlands were unaware that the batik technique was also practised on Sumatra. Goslings decided to investigate this and contacted government officials on Sumatra to obtain information from them. The result was that nine cloths were sent and added to the collection. All the cloths known to Goslings were dyed with indigo, but he had read in Tassilo Adam's notes that in Jambi both blue and red cloths were made. Officials in Jambi confirmed this. Despite this information the conviction existed in the Netherlands that the red-dyed cloths could not possibly come from Jambi, until 1930, when Van Eerde brought back a 'red' Jambi cloth from his acquisition and research trip (figs. 84, 85).[185]

Tassilo Adam (1878–1955) assembled an important collection of objects, including textiles (Series 347). Adam was born in Munich in 1878 as the son of a German/Italian couple. When he was sixteen, he went to Vienna to continue studying. A book he read in Vienna about the Batak people of Sumatra piqued his curiosity for this ethnic group and in 1899, at the age of 21, he left for Deli on Sumatra. There he found work as an assistant on a tobacco plantation. In addition to his activities in the tobacco sector on Sumatra's eastern coast, he collected objects on commission from Swiss and German museums. Adam proceeded systematically and strove to obtain an example of every type of fabric that was used at that time. From 1914 he also concentrated on photography and film. As a photographer he documented the daily and ceremonial life of the Karo Batak. Both the objects and photographs from Adam's collection are irreplaceable records of this culture (fig. 86). He recognised the importance of documenting different stages in the textile production process. The various techniques and the associated tools were documented in the museums, but actions are often difficult to describe in words alone. Drawings did offer a solution, but the way Adam's image material documented processes *in situ* is invaluable. His material contains unique information that cannot be conveyed even in the best descriptions.[186]

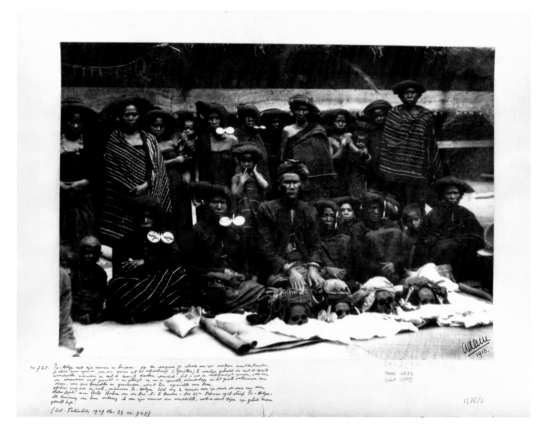

87
Teuku Umar's jacket
Wool, gold braid
63 x 42 cm
Aceh, Sumatra
19th century
TM-674-722
Gift: F.W. Stammeshaus,
1931

Besides scientists and entrepreneurs, military personnel also donated objects to the museum. Repression and violence were key to the display of power of Dutch colonialism, and war trophies – often in the form of weaponry – were brought back to the Netherlands; textiles were mostly overlooked. However, it is known that some local rulers were forced by the Dutch military at the time of their capture to discard their clothing, thereby robbing them of their social and cultural identity. Two objects in the Tropenmuseum's textile collection bear witness to two bitter and brutal colonial wars, the Java War (1825–30) and the Aceh War (1873–1914). F.W. Stammeshaus (1881–1957) was a soldier in the Royal Netherlands Indies Army (KNIL) stationed in Aceh in Sumatra. After his military career he worked first as a government official and then from 1929 to 1933 as curator at the Aceh Museum. On his return to the Netherlands he became a curator at the Ethnology department of the Colonial Institute. Stammeshaus was a great enthusiast and collector of ethnographica and on his appointment as curator donated his collection of objects to the institute.[187] In 1930, the coat of one of the most famous resistance

heroes in the history of Indonesia, Tekoe Umar Djohan ('Johan the Brave', 1840–99) came into his possession. Tekoe Umar fought in the Aceh War (1873–1914) against the Dutch. After Dutch soldiers bribed him with money, opium and weapons, he and some fellow fighters joined the colonial army in 1893. In 1896, however, he returned to the Acehnese resistance to fight the Dutch again. Tekoe Umar was slain on the night of 10/11 February 1899 in a Dutch ambush. The jacket was in possession of Tekoe Umar's son, who gave it to Stammeshaus (fig. 87). A very different witness to the Java War is a large, red silk cloth with text in both Chinese and Malay characters in gold leaf (fig. 89). The memorial cloth, created in 1830, was a gift from the heads of the Chinese community in Semarang to H.M. Baron de Kock on his departure to the Netherlands. As commander from 1825 to 1830, Lieutenant General De Kock led the battle against the Indonesian resistance fighter Diponegoro during the Java War. The Chinese expressed their gratitude for the restoration of peace and security in Central Java in the writing on the cloth. The text glorifies De Kock's abilities in grandiose terms and how he wholeheartedly devoted himself to the country:

[...] My Lordship, the General, has been located here for over twenty-six years, your Most Worthy Gentleman's work has consisted of the management of the land of Java, to the great joy of all segments of the population [...]. In 1825 there was great unrest among the masses and those who work expected a lot from your most worthy self, everyone said that if Mr. General would come in person, the whole country would without a doubt be at peace again.[188]

This is followed by a glorification of De Kock's conquests and battles. At the end of the text the author, a 'Chinese inventory master', wishes De Kock 'favourable winds' on his voyage to the Netherlands.[189] This text possibly refers to events at the beginning of the Java War in which Javanese fighters killed numerous Chinese. The Chinese population lived in separate neighbourhoods where their own leaders, including the writer of the above text, enjoyed great respect and were responsible for collecting taxes. The Chinese earned money for both the Dutch and the Javanese rulers as tenants and toll collectors. This meant that they often enjoyed good relations

Amboe Tooan, Mayoor Capitein Luitenant, oid Liutenant dan Boedelmeester tjina die Samarang, maaloemken Samba, pada Kebawa Penetee Tooan
raal De Kock njang ada die dalm negrie Betawie dengan Sejee-etranja. Koomoodian darie itoe ada la Saja orang mace kata kaloe negrie me
die baek njeng tantoe dapet darie pada orang njang pegang pekerdjahan arif bijaksana, Serta akil njang Sampoorna, misken Kapoedjian tampe die mana mi
Sebagie Kaija Tooan Generaal De Kock poonja soongoe soongoe attie darie pada negrie. Tooan Generaal poonja day
Radoedoean Soeda lebie doewa poeloe anem Taoon, bagenda poonja pekerdjahan pegang negrie Tana Sawa Segala orang Ketjil besar Sak
lianja uda Sooka attie, darie Tooan Generaal poenje kabaikkan pegang Talan negrie itoe, lagie negrie Ketjil mara
Tooan Generaal pergie die Sitoe Samoeanja toondook Soeka attie. Darie tana Sawah Taoon 1825 geger, roeboe
Sekalian orang Ketjil, dan orang pegang pekerdjahan Sekalianja ada arep kapada bagenda, Sekalian perkata Sa
toe Tooan Generaal datang Sendirie tantoe bole liggra tentrem Seneng negrie, bilah bagenda perang Sana Sinie bagenda
Kool benteng brandal, poekool die atas oetan dengan Soesa naik goenoeng, toeroen goenoeng die dalm Segala Kasoesahan itoe p
bagenda perang, apa billah Tooan Generaal lahrentie perang kireja baik Sekalianja orang Ketjil, pegiemana kaija orang alim, itoe keratas
Kook Keblakangan tiada oesah die tangker, die teloehnja Sendirie. tetapie Saija orang tiada kira bagenda Kaki tangan njang amat besar, pada tan
28 boelan december Tetapie Tooan Allah Soeda tamtoeken orang poonja oemoor tetapie die dalm hattie bagenda ada maskool die loearnja bagenda
pegiemana lama kereja baik negrie poor dapet poonja hormat, dan bole liat Tooan Generaal poonja kapinteran arif bijaksana. Tooan Soosoehoenan maliate Tooan
Generaal mace peelang die negrie Ollanda. Tooan Soosoehoenan Sandirie toeroen die Samarang kasee selamat Sama Tooan Generaal. inie kabaikan perang die liat amboee Sakoti
orang Ketjil Sooka attie. orang dagang dan orang njang kereja Sawah Sekalianja jalannja die poenja pekerdjahan dapet dirinja poonja oentoeng.
Saija orang Soeda dapet kenal Sama Tooan Generaal Soeda doewa poeloe taoon itoe, misken blakangan arie Sekalian poodjie Sama Tooan Generaal poony
baik Sama orang Ketjil.
Sekarang Saija orang mintak Sama Tooan Allah biar pandjang oemoor, redjikie bole besar Tooan Generaal boole dapet angin baik
Kas tanjee die ollanda, dapet njang die Pertooan Radjee Ollanda njang mahamulie, per Sooka attie kasee hormat Tooan Generaal, dan katie manaeck Kadoedoean Saija orang
Sekalian Soongoe Soongoe attie mangadep Sama Tooan Generaal, lagie Saija orang harep Tooan Generaal dapet Segala kaboikan darie Tooan Allah.

仁

蓋聞國家將興必得賢臣恭惟
得勞緱力略忠貞義氣專心為公無
暇反私明智而忠信寬厚而愛民勞
上而全下也教化亞地以德服人嘗
但小埠頭所遇亞地自和辮各處擾
亞地自和辮曰
引領而望所仰望今果順應民心功成名
之間進則攻城野戰退則備首誠服向仁
駕親征必然掃平及遂巡畏縮綢首誠服于
制敵如神自非智勇兼善茲全經籌謀畫策
見仁得勞緱力略孫蘭開風親
何以成此大功也
然示體率之情此誠千古罕見之盛
事也莫不踴躍歡欣耕商各盡感知天威
仍然興起有利於埠頭長耆等於
之恩二十餘年一旦復幸觀天皇天威明
恐尺頌德仁得勞緱力略壽福無疆
黙庇仁得勞緱力略
並日月揭報祈皇
大王喜意重賞爵位高堂子子孫孫
世襲簪纓

祖家
和蘭壹千八百三十年五月

胡雷珍蘭　許丹生
雷珍蘭
陳潘海　蔡朝萬　魏盈郡
　　　　王君樣　武道
魏先武
陳忠祐　朱萬然　陳久本
馬腰陳長青
甲必丹陳蜂煙全錦賀

< 89
Commemorative cloth
Silk, gold paint
210 x 186 cm
Java, Semarang
1830
TM-624-1
Gift: Baronesse de
Kock-Jacob, 1930

90
**Uniform with the
inscription 'Salvation Army'**
Cotton
Embroidery
146 x 74 cm
Java
20th century
TM-H-2128a/b
'Bala Keslamatan' ('Salvation
Army') is embroidered on
the jacket in Javanese script.[1]

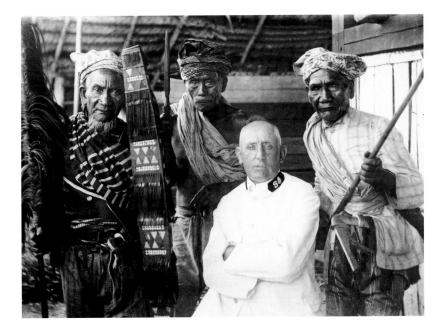

91
A Salvation Army
commander with
Toraja men
Photographer unknown
Sulawesi
11 x 15 cm
c. 1930
TM-60011683
Provenance unknown

with the colonial administration but were hated by the locals.[190] The writing on this cloth expresses the feelings of this inventory master for this general, but the cloth itself contains more information. It is made of red silk, and the text is written in gold leaf. Red and gold stand for good fortune, prosperity and abundance in Chinese culture, and from the words and the materiality of the object it can be concluded that the people who gave it to the Dutchman wished him all of these.

Colonial encounters of an entirely different calibre occurred under the auspices of the Salvation Army. The organisation first established posts on Java, and a missionary post was established on Sulawesi in 1910. Over time, 300 Dutch and Indonesian Salvationists settled in this region (figs. 90, 91).[191] In 1861, the Vereinigte Evangelische Mission (United Evangelical Mission) established a presence in the Batak region in North Sumatra. The missionaries exerted their influence on religious, social and cultural fields. Like Islam several centuries earlier, the mission introduced different clothing habits. Women who had converted to Christianity wore the Malaysian *kebaya* or the longer *baju kurung* to cover the upper body, men stopped wearing a headscarf, and children were expected to no longer walk around naked.[192] The mission engaged in numerous activities that impacted on society, one of which was the foundation of schools. The traditional skills that women were expected to possess were taught at special girls' schools. In Laguboti a school was established where deaconesses taught the girls how to be good mothers and housewives; the curriculum included lessons in local and European textile techniques. Mastering the traditional weaving techniques was considered important because women were expected to be able to provide the clothes for the family. The mission also wanted to promote weaving to prevent this tradition from disappearing. One textile in the Tropenmuseum

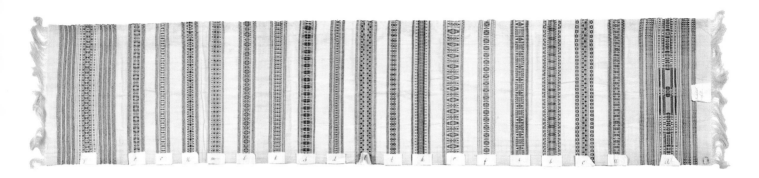

92
Pattern cloth
Cotton
Supplementary weft
200 x 41 cm
Laguboti, Batak, Sumatra
Late 19th/early 20th century
TM-83-1
Gift: Trade Museum
department, Colonial Institute,
1919

93
Loom with circular warp
Wood, bamboo, cotton
97 x 68 x 10 cm
Tanimbar, Fordata
1925
TM-329-1 a/k
Purchase: P. Drabbe, 1926

is historically important: a sampler of popular motifs that could be the only surviving example that was created at this school (fig. 92).[193]

In 1911, Petrus Drabbe (1887–1970) was ordained as a priest in the Congregation of the Missionaries of the Sacred Heart of Jesus in Tilburg. In 1915 he was posted to the Tanimbar archipelago in the southern part of the Moluccas, where he remained until 1935. In addition to his missionary work he was interested in the languages and cultures of the local population. His activities served both spiritual and commercial purposes. Besides translating Bible stories and prayers into the local languages, he also translated his interest in Tanimbar's material culture into economic opportunities for the population. He approached the Colonial Museum and suggested that it commission some textiles so that the locals could earn from their

production. On 10 August 1925 he wrote: 'I could also have *Tanimbareesche* textiles made; a *sarung* costs 10 to 15 guilders. Furthermore, I could even have looms made with unfinished work on them, together with all the names of the components.' Among the items the museum ordered from him were 'a complete loom, with all components packaged in such a way that nothing can detach itself during transportation, preferably with a partially woven *ikat*-decorated cotton warp; also *ikat* cotton textiles, barkcloth pubic belts and a buffalo skin war costume'.[194]

In October 1926 the Colonial Museum purchased a collection of fabrics and tools from Drabbe. More orders for other tools that were used to prepare threads and woven textiles followed later. The order and the correspondence demonstrate that the focus was wholly on the processing of cotton and yarns

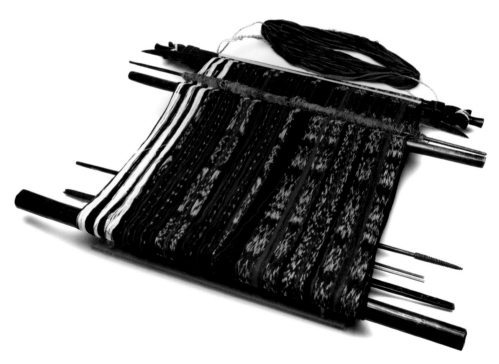

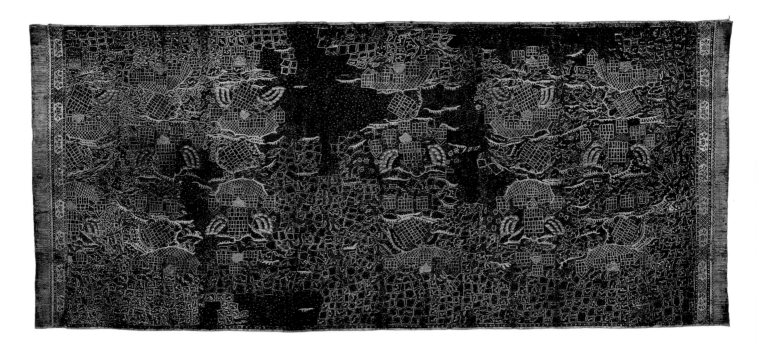

94
Temple cloth – *lamak perada*, or shoulder cloth – *senteng perada*
Cotton, gold leaf
Batik, *prada*
223 x 93 cm
Bali
20th century
TM-809-215
Purchase: O. Sayers-Stern, 1950

and weaving techniques. The documents from the museum are carbon copies of typewritten letters that are unsigned, so the person who placed this order is unknown. It is likely that B.M. Goslings formulated these detailed instructions in order to supplement the museum's textile collection with looms and textiles from the east of the archipelago. Father Drabbe delivered the objects and provided precise descriptions and terms, sometimes in three local languages; he also wrote a monograph about the Tanimbar people and culture (fig. 93).[195]

When considering the aforementioned professionals and interested parties who contributed to the steady growth of the Tropenmuseum collection, the role artists played should not be forgotten. One of them was Charles Eugene Henry Sayers, who was born on 14 October 1901 in Central Java. He was sent to the Netherlands to study and attended the Rijksacademie voor Beeldende Kunsten (National Academy of Visual Arts) in Amsterdam from 1920 to 1923. He was taught by Roland Holst, Derkinderen, Jurres and Van der Waay. After spending time in Paris, where he attended the Académie des Beaux Arts, and a trip through Egypt, he returned to Java. In the 1930s he travelled to Europe where he was asked to paint three large murals for the large reception hall of the

Netherlands East Indies Pavilion at the 1931 International Colonial Exhibition in Paris. Unfortunately, these paintings were lost in the fire that completely destroyed the pavilion. In 1934 he moved back to his country of birth. Sayers was interned in 1942 during the Japanese occupation of the Netherlands East Indies and put to work on the Burma railway as a prisoner-of-war. Weakened by malnutrition and malaria, he died on 15 November 1943, only 41 years old, in Camp Km 114 Thanbyazajat, Burma (Myanmar). In 1950 the Tropenmuseum acquired the large collection of ethnographic objects that Charles Sayers had assembled (fig. 94).

A special acquisition was made at the beginning of the 20th century by P.Th. Galestin (1907–80). Batavia-born Galestin was educated in Leiden and his professional life began as a curator at Museum Sonobudoyo in Yogyakarta. From 1938 to 1945 he was curator of the Ethnology department at the Colonial Institute in Amsterdam, and then professor of the archaeology and ancient history of South and Southeast Asia in Amsterdam and Leiden. Through his good contacts in Javanese aristocratic circles he came into possession of a *staatsiejas* (ceremonial jacket), which was worn by various sultans, including Hamengku Buwono VII (1877–1921) (figs. 95, 96).

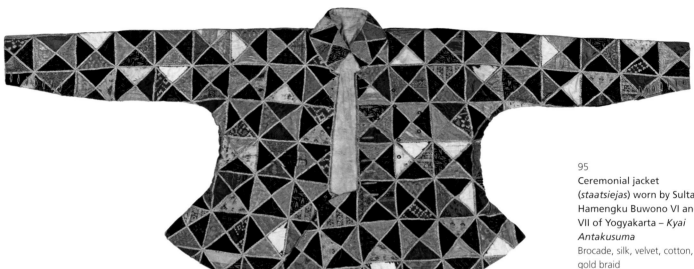

This royal jacket was worn by Z.H. Hamengku Buwono VI (1855–77) and Z.H. Hamengku Buwono VII (1877–1921), both sultans of the Central Javanese principality of Yogyakarta. The jacket belonged to the ceremonial costume that was worn during the great parade of Garebeg Mulud. Hamengku Buwono VIII (1880–1939) broke with this tradition and started wearing a black velvet jacket. The jacket and possibly its prototype were part of the royal family's sacred heirlooms, *pusaka*. Z.H. Hamengku Buwono V (1822–55) is portrayed in a painting wearing such a multi-coloured jacket (*staasiejas*).[2] Treasured heirlooms such as these can possess special powers and bear a title. The title of this jacket is *Kyai Antakusuma*, which translates

as 'Lord of the Infinite Number of Flowers' or 'the Honourable Many-Flowered'.
R.S. Tirtokusumo, a translator in Yogyakarta, wrote: 'The late Sultan VII wore on this occasion a special ceremonial jacket, *Kjahi Ontro Kusumo*, an heirloom of great value, consisting of thick pieces of printed cotton, *soop*, sewn together, that was offered to the Sultan VI by a certain Mrs. Wieseman as a tribute. The prototype, however, must have belonged to Sultan I (1717–92) and is now preserved as a sacred heirloom along with the second *Kjahi Ontro Koesoemo*.'[3] The same translator assumed that both garments were located in the *kraton* (Javanese palace) until 1931. In 1895 the Dutch *kraton* physician, Dr. Groneman,

also mentioned a garment, an heirloom of high value, made up of multi-coloured silk triangles that was worn by Z.H. Hamengku Buwono VII. He also stated that the prototype jacket in the Surakarta *kraton* is 'held in honour'.[4] In his study of the Javanese *kris*, W.H. Rassers discussed such a garment that played a role in a Javanese creation myth. He characterised the mythical ancestral parents of the Javanese as the union of heaven and earth, but 'above all it is the union of the garment *Onta Kusuma* with the *kris Braja Sungkuh* […]'.[5] The origins of the jacket are recounted in old Javanese manuscripts. It was said to have originally been made from the skin of the serpent Ananta, the

> 96

Hamengku Buwono VI (1855–77)
This photograph is from an album in the Tropenmuseum's collection of studio portraits of the Sultan of Yogyakarta and his family. Such court albums were given as keepsakes to administrators departing from Yogya, and to other representatives of the European elite. This album was owned by J. Mullemeister (1838–1926), Resident from 1889 to 1891 The sultan wears a patchwork ceremonial jacket, the divine origin of which lent additional religious weight to the sultans' authority. His status is also reflected in the size of his loincloth, *dodot*, and the size of the *parang rusak* motif. He wears ear jewellery and a headdress appropriate to his status. The sultan sits on a golden throne with

god of all snakes and mount of the Indian god Vishnu.[6] According to Gericke and Roorda's dictionary,[7] *Antakusuma* is the name of a jacket given by Batoro Endro (Indra, the god of war, the sky, thunder and rain) to Arjuna, a jacket that enabled him to fly. A jacket mentioned in the Old Javanese poem, *Arjunawihaha*, a story that dates back to the early 11th century and the reign of King Airlangga, gives the wearer the power of flight.[8] The prototype of this *Kyai Antakusuma* is said to have been donated by the Prophet Muhammad on the completion of the Demak mosque at the end of the 15th century to Sunan Kalijaga (1460–?), also known as Lepen, one of the nine holy disseminators of Islam. During a meeting of a group of preachers, a bundle fell from the sky consisting of the Prophet's prayer mat and shawl wrapped in a goatskin. Sunan Kalijaga made a jacket from the goatskin, which was named *Antakusuma*.[9] It was the devout Kalijaga who, in order to facilitate the rapid spread of Islam, incorporated the habits and customs of the former Hindu Majapahit Empire (1293–1500) into the body of Islamic practices. Kalijaga saw local traditions, and art and culture as a means to convert people to Islam. He linked the sacrificial meal that was held during the first month of the year in Majapahit times to Muslim celebrations like Garebeg Mulud, the feast commemorating the birthday of the Prophet

Muhammad. In later centuries, Kalijaga's 'jacket', the *Kyai Antakusuma*, was only worn during Garebeg Mulud. Interestingly, this garment was given to Kalijaga, who had a special interest in clothing. For Muslims he advocated the wearing of tailored clothing such as *baju takwa* rather than the traditional untailored cloths. Thereafter, Kalijaga's jacket was worn by the chiefs of the Central Javanese kingdom of Mataram (1584–1749).[10]

The patchwork pattern of the *Antekusuma* jacket is considered sacred in Central Java. This pattern, executed in batik, was worn by the highest officials, members of the Tamtama *corps d'élite* and the jesters in the *kraton*. The pattern is also referred to as *tambal* or *tambalan* when in batik form. *Tambal* means 'small fragment of cloth'.[11] It consists of an assemblage of motifs, the whole thus forming an overview of batik motifs that were valued in court circles (see fig. 185). Older examples of *tambal* batiks display motifs reminiscent of those on Indian tradecloths.

There are various stories about the origin of this pattern. Its magical powers can be traced to patchwork clothing worn by Mongolian shamans. In the past Hindu priests in Tengger in East Java also wore jackets made of old pieces of cloth that they called *Ontokusumo* and, in more recent times, batiks with *tambal* patterns. They did this to demonstrate their

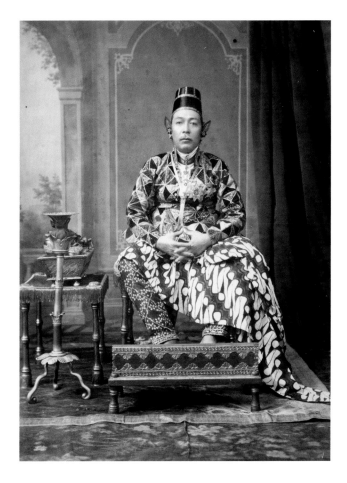

disavowing of all worldly luxuries. This is comparable with the clothing of Sufi followers who, after three years of initiation, wore multicoloured patchwork, also to emphasise the notion of living in poverty.[12]

The jacket was possibly made by Geertruida Louisa Wieseman-Dom (1833–1909) for Hamengku Buwono VI (1855–77). She was a descendant of an East Indies family; the family of her husband, Frederik Wilhelm Wieseman, a plantation owner in Java, maintained very good ties with members of the court.

a footstool. All these attributes indicate that this is an official state portrait.
Photographer: Cephas, court photographer from 1871
Albumen print
Yogyakarta
21.5 x 15.5 cm
1880–91
TM-60001455
Loan: J. Mullemeister

He bought the garment from a Javanese noble at the court in Yogyakarta. Galestin suspected that he had acquired a sacred heirloom, so he showed the jacket to the son of Hamengku Buwono VII, who recognised it as his father's and decreed that it was no longer an heirloom because his brother Hamengku Buwono VIII no longer wished to wear it. Galestin as a museum professional recognised the importance of documenting such an acquisition in detail when it came into his possession.

The new museum in Amsterdam was well and truly on track and the collections were housed in the various depots, when the threat of war loomed in the late 1930s. Measures had to be taken to store the collection as safely as possible. German hostility also had other consequences. In this uncertain time, private individuals entrusted their collections to the museum. Georg Tillmann's extensive and important collection was housed in the museum's depots in 1939 (Series 1772). As the war progressed other collections followed, including a collection of textiles from Sumatra (Series 1689). After the occupation of the Netherlands in May 1940, the Germans commandeered parts of the Colonial Institute from October 1940 to May 1945 to house over 300 members of the *Ordnungspolizei* (Order Police). With the advance of the Allied Forces in the winter of 1944, measures had to be taken again to protect the collection that had grown during the war years. A large part of the textile collection, including the 670 textiles from the Tillmann collection, was packed in crates and placed in vaults at several bank buildings in Amsterdam.[196] The Tillmann collection, having survived the war, was written into the museum's registry as a loan in 1947. Wolf Tillman, son of Georg, donated the collection to the museum in 1994. This donation was celebrated with the exhibition 'Woven Documents' (see Chapter 'Presentation'). Georg Tillmann and his collection are discussed below and in the Catalogue.
The war changed everything. Despite dramatic shifts in international relations, the Dutch government was still convinced that the pre-war relationship with the Netherlands East Indies could be restored. Even after Sukarno's proclamation of Indonesia's independence in 1945 'those in charge of the Colonial Institute and its Colonial Museum were unable to part with the message they had built in stone in Amsterdam'.[197]

What was clear was that the term 'colonial' in the institute's name had too many negative connotations, so the institute was renamed the Indies Institute, and the museum the Indisch Museum (Indies Museum). Even though the political ties with Indonesia had been broken, it was hoped that the relationship would continue in the cultural field.
After the Dutch recognition of Indonesia's independence in 1949, the institute chose a new name and a new direction in 1950. The Indies Institute became the Koninklijk Instituut voor de Tropen (KIT, Royal Tropical Institute) and the Indies Museum was named the Tropenmuseum. The institute and the museum expanded the scope of their activities to include the entire tropical world.

The Tropenmuseum, The Royal Tropical Institute, 1950–2014

The aim of this institute was the same as that of its predecessors: 'gathering and propagating knowledge'. The deteriorating relations between the Netherlands and Indonesia actually had little impact on the way in which the textile collection was studied in the museum; however, the museum no longer organised study and acquisition trips.
B.M. Gosling's focus on textile techniques was reinvigorated with great enthusiasm and expertise when Joop Jager Gerlings and Rita Bolland were employed by the museum. Coincidence or not, Jager Gerlings and Bolland both joined the museum in early 1947 and, despite their different positions, shared a room. As a museum assistant Rita would take groups on guided tours; Jager Gerlings was a curator. It must have been in that room that their shared interest in textiles and especially the Indonesian textile tradition became evident. Rita Bolland (1919–2006) made a major contribution to the field of textile technology. Her interest was sparked during her childhood in Indonesia, her birthplace. Upon returning to the Netherlands she obtained the Akte van Bekwaamheid voor het Vak Fraaie Handwerken en het Kunstnaaldwerk' ('Certificate of Competence in the Subjects Fine Needlework and Art Needlework') in 1942. Inspired by the work of her predecessor Goslings, the museum's rich collection and the stimulating interaction with Jager Gerlings, from the very onset

of her career at the museum, Bolland dedicated herself to researching weaving and decorative techniques. Their combined efforts resulted in 1952 in Jager Gerlings' dissertation, 'Sprekende Weefsels – Studie over het ontstaan en betekenis van weefsels van enige Indonesische eilanden' ('Telling Textiles – Study on the Origin and Meaning of Textiles from Some Indonesian Islands').[198] This research became known for Jager Gerlings' quest for a 'unity in diversity' in Indonesian ornamentation.[199] Although Rita Bolland's name is not mentioned in this publication, there is no doubt that her contribution must have been significant (fig. 97). Jager Gerlings writes in the introduction that the weaving traditions chosen for the study represent '[...] virtually all weaving and decorative techniques used in Indonesia'.[200] The distinction between technical and anthropological research, which is referred to in the chapter 'Museums, Science and Material Culture' also applied here. Jager Gerlings: 'In addition to the museum material I naturally consulted the literature on the ethnic groups I studied. Only with regard to the use of textiles did this yield a reasonably satisfactory amount of data. As for information about the technical aspects of weaving, the published work contains hardly anything that is of value.'[201] The reason, according to Jager Gerlings was that anthropologists lack expertise on weaving techniques.

In a handwritten report about her time at the museum, Bolland wrote how delighted she was that after Goslings' retirement, 'the museum had another member of staff who concentrated on the collection of textiles and looms'.[202] She was referring to Jager Gerlings and with her characteristic modesty concealed her own role.[203] The first two chapters of *Sprekende Weefsels* were almost certainly based on Bolland's research. They are devoted to materials, looms, weaving and decorative techniques, which are described in detail and examined for similarities and differences. In the chapters that follow Jager Gerlings examines the ornamentation, and the uses and meanings of the textiles in their respective cultures of origin. He was one of the first to study the similarities and differences between weaving traditions in the various regions of the Indonesian archipelago. This publication addresses the gaps in knowledge about weaving techniques previously

97
Rita Bolland teaching schoolchildren at the Tropenmuseum in Amsterdam
Photographer unknown
Silver gelatin developing-out paper
7.5 x 11 cm
c. 1950
TM-60052335
Provenance: Bolland family archive

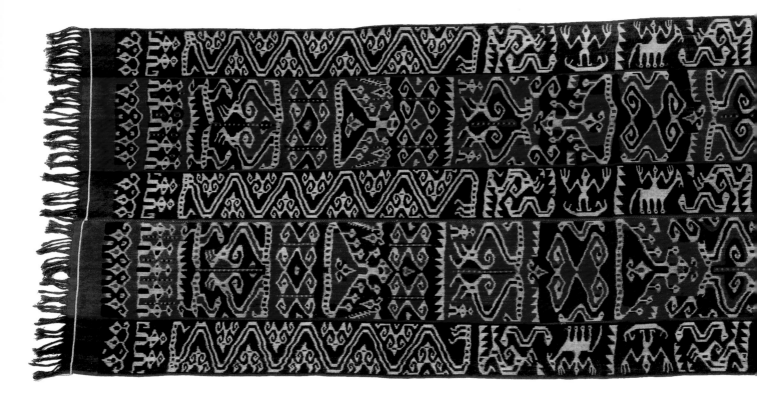

98
Ceremonial textile
Cotton
Warp *ikat*, painted
327 x 105 cm
Kisar
20th century
TM-2246-13
Exchange: Cultural Heritage
Agency of the Netherlands
(RCE), 1953
Collected by J. Langewis

> 99
Georg Tillmann
Courtesy of: Hugo Tillman

determined by Jager Gerlings in relation to anthro-pological data, but the content remains strictly divided between materials and techniques on the one hand and context on the other.[204] After filling various positions in the museum in which she concentrated intensively on the textile collection, Bolland was appointed curator of textiles in 1972. She documented collections that had been donated to the museum during and after the war, such as the collection of the Vattier Kraane-Daendels family. In addition to an important collection of works by Dutch masters, Françoise Jacoba Daendels, a descendant of the family of H.W. Daendels, governor general of the Netherlands East Indies from 1807 to 1810, and Cornelis George Vattier Kraane, also accumulated a large collection of ethnografica, which included textiles from Sumatra. Subsequent years saw a growing international interest in the Tropenmuseum collection due to Bolland's and Jager Gerlings' work and the rise in scientific interest in America in Indonesian weaving. The work of Dutch researchers such as Rouffaer, Loebèr and Jasper, and publications by Goslings, Tillmann, Bolland, Langewis and Wagner brought researchers, curators and collectors from around

the world to the Netherlands to study the Tropen-museum's collections of Indonesian textiles. Moreover, Rita Bolland shared her knowledge of various techniques with anyone who showed genuine interest. She was at that time one of the few people in the field who were completely focused on the study of textile technology.[205] Her passion and dedication were obvious from what she wrote in a publication that was issued after a textile conference in Cologne. She opened the essay 'You Need a Loom to Produce a Textile' with the sentence: 'The study of the loom is as important as the study of the textile that is made on it.'[206] She made vital contributions to the fields of weaving and decorative techniques and to garnering international appreciation for the Tropenmuseum collection.[207]

Bolland collaborated closely with the twin brothers Jaap and Lourens Langewis who, after working in the Netherlands East Indies for twenty years, returned to the Netherlands in 1947. The Colonial Institute employed them both in 1948: Lourens in the Ethnology department and Jaap in the Trade Museum. After several years Jaap returned to Indonesia. Lourens became a passionate collector and textile expert. Together with Frits A. Wagner

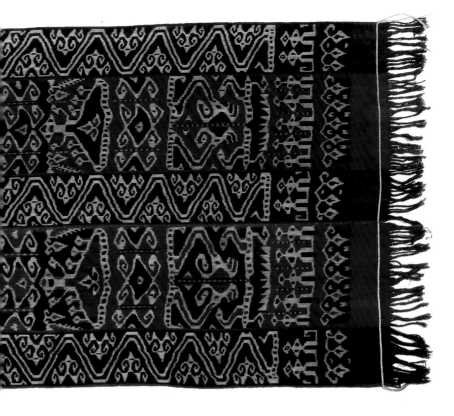

he published an important reference work *Decorative Art in Indonesian Textiles* in 1964, which featured a large number of textiles from the Tropenmuseum collection.[208] A major contribution to the renown of Indonesian textile art, this book also enhanced the reputation of the Tropenmuseum abroad. The museum was able to acquire a number of important textiles through their mediation (fig. 98).

In the same year that Rita Bolland started working at the museum, the Georg Tillmann collection was officially entered into the Tropenmuseum register as a loan. This extremely valuable collection, which was safely housed in the museum during the war, could from that moment on officially be studied and documented. Thankfully, use could be made of the data and information that Tillmann himself had arranged in a card system on which he had also recorded each acquisition.

Georg Tillmann (1882–1941) was the son of a Jewish banker in Hamburg (fig. 99). He inherited his interest in art and culture from his mother's family, the Baers. Tillmann was a passionate and gifted collector. He himself admitted: 'The Baer bacillus of collectivitus that in my mother produced the harmless attack of stamp interest, in me reached its highest degree of virulence on the nutrient medium of a certain Tillmann thoroughness of methods'.[209] He collected a wide variety of objects from an early age, ranging from stamps and gold coins to engravings by Dürer, Rembrandt and Lucas van Leyden, and the porcelain objects he collected are still displayed in prominent museums around the world. The family bank in Hamburg was closed in 1930 in anticipation of the growing threat to Jewish families in Germany. A year later Tillmann rented a house on the Prinsengracht in Amsterdam, and he and his family moved there in 1932. When, in 1939, war – and the Netherlands' involvement in it – seemed inevitable, the Tillmann family travelled via London to the United States. How much the collection meant to him is evidenced by letters he wrote from America in which he describes how hard it was to leave his collection behind and how he longed to see the objects again.[210] However, soon after arriving in America, Georg Tillmann became ill and he died there in November 1941.

Tillmann became acquainted with Indonesian art shortly after his arrival in Amsterdam in 1932. After his wife purchased two *krisses* from a dealer in the

> 100 (+ detail)
**Ceremonial cloth
– *pua kumbu* (+ detail)**
During his visit to this region
around 1915, Loth saw this
pua kumbu hanging behind
the seats of honour reserved
for the aristocracy.[13]
Cotton
Warp *ikat*
260 x 160 cm
Batang Lupar, Sembala River,
Central Kapuas
19th century
TM-1772-708
Collected by Mr. Loth,
an engineer at the
Department of Mining
Gift: W.G. Tillman, 1994

> 101
**Detail of cloth used
to cover tents**
Palm fibre
Warp *ikat*
366 x 57cm
Madagascar
19th/20th century
TM-1772-1492 (detail)
Gift: W.G. Tillman, 1994

neighbourhood, the 'bacillus of collectivitus' reared its head again and a new fascination was born. It was not only the artistic value of the objects that appealed to him; they also aroused an interest in the cultures and the people who created and used them: 'All objects of this art and craft in whatever material and from whatever period for me have the same meaning as being inseparably connected with the rites, traditions and inner lives of their makers, sometimes obviously, mostly so mysteriously that access to their understanding is possible only with the help of intense ethnological and even psychoanalytical research work.'[211] By 1939 his collection had grown to approximately 2000 objects, including 670 textiles and garments from Indonesia. The extensive and high-quality Georg Tillmann collection is the most important part of the Tropenmuseum textile collection, and it has brought many visitors and researchers to the museum from around the world. Tillmann acquired the textiles from art dealers in Amsterdam and The Hague, and from private individuals such as the artist W.O.J. Nieuwenkamp and the scientist and missionary N. Adriani. C.M.A. Groenevelt purchased the major part of Tillmann's collection on his behalf in Indonesia. The entire collection was dear to Tillmann's heart, but his special interest and love was for his collection of Indonesian textiles. Tillmann's scientific interest in the textiles brought him into contact with researchers and curators from museums in Europe and America. He examined and compared as many cloths as possible, consulted the literature, and held discussions with colleagues.[212] He befriended the Indologist Bep Schrieke who, after a long stay in the Netherlands East Indies where he held administrative and scientific positions, became director of the Ethnology department in the Colonial Museum in Amsterdam in 1938. They shared their interest in the history and cultures of the Indonesian people. Charlotte Tillman, Georg's daughter-in-law, remembered the very lively discussions about the origins of motifs and patterns on the textiles which her father-in-law would have until deep into the night with Schrieke and others around the kitchen table in the house on the Prinsengracht.[213]
Concerning Tillmann's cultural-historical approach to motifs on textiles, Schrieke wrote: '[he] has opened up new perspectives on the unwritten past, revealing old and unsuspected relationships'[214]

Researchers such as Jager Gerlings, Lourens Langewis and others were inspired in their work by Tillmann's observations. Tillmann's research resulted in nine articles, seven of which are about Indonesian weaving. He viewed his collection as woven documents containing information about cultures from a distant past. In his research, Tillmann focused on the origins of and similarities between motifs on fabrics from different regions. His interest in historical and intercultural relations is also apparent from his purchase of two *ikat* cloths from Madagascar. He had detected striking similarities in the patterns on the cloths from Madagascar and those from Kalimantan and Sulawesi. In the article 'Het Ikatten op Madagascar' ('The *Ikats* of Madagascar') he writes about the centuries-old migrations from the Indonesian archipelago to Madagascar and the linguistic similarities between Malay and Malagasy (figs. 100, 101).[215] Georg Tillmann made plans to travel to Indonesia in 1939, but the threat of war thwarted these. When Tillmann decided to move to England he knew he would have to leave his collection behind, which as he had agreed with his friend Schrieke, was moved to the museum for safekeeping just before the outbreak of war. Wolf Tillman, Georg Tillmann's son, donated this invaluable collection to the Tropenmuseum in 1994.[216]

Between 1950 and 2014 the Tropenmuseum made several more important policy changes that affected both the collection and the exhibition policy. Jager Gerlings became director of the museum in 1965. He introduced a new acquisition policy and organised study and acquisition trips to Morocco, Libya and India to collect as many items as possible that together would create multi-faceted impressions of the everyday life of specific cultures in these countries.[217] The masterpieces in the collection, including the Indonesian textiles, were stored in the depot. A permanent exhibition on fabrics and weaving and decorative techniques was installed in one of the museum's towers to cater to the prevailing interest in textile technology.[218] International attention for Indonesian textiles grew throughout the 1970s and important collections were assembled in America and Australia. In the Netherlands, active collecting was at a low ebb, partly due to the country's frosty relations with Indonesia.

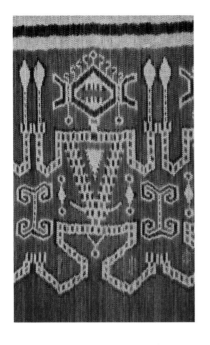

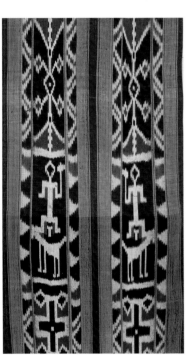

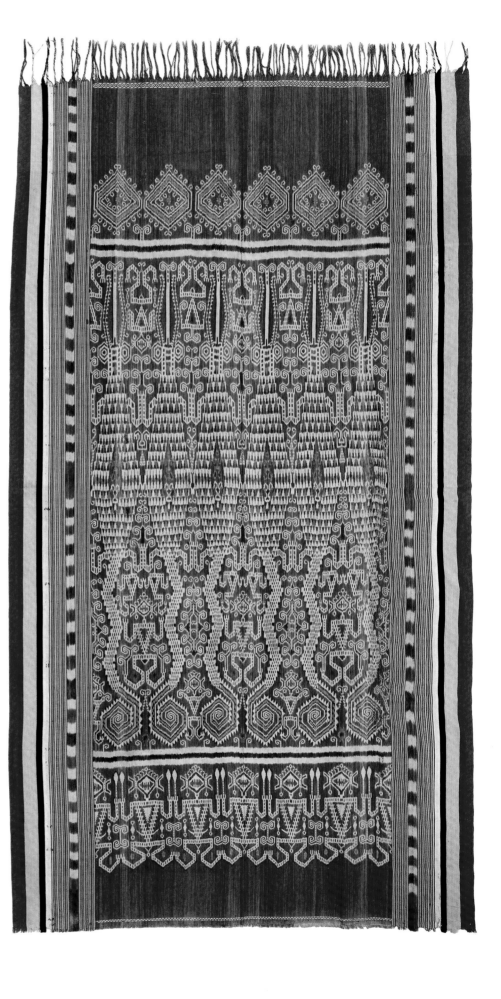

In the 1980s, the institute was affected by government cuts. Two years after Rita Bolland's retirement in 1984 the tradition of having a permanent staff member dedicated to the textile collection was continued.[219] This appointment meant that the focus shifted. In the years that followed, more emphasis was placed on exhibiting the museum's world famous collection. Masterpieces from both its own collection as well as loans from other museums and private collectors shone in thematic textile exhibitions. This choice had to do with the public's desire for 'aesthetic' exhibitions, both in terms of the exhibits and the design of the exhibition itself (see Chapter 'Presentation'). Lectures and publications at home and abroad also ensured the continuation of spreading knowledge about the collection.

Another change of direction awaited the museum at the end of the 1980s. Interest in their own colonial history grew in the worlds of academia and the ethnographic museums. In 1995 there was a debate in the Netherlands about the desirability of a 'colonial' museum. Although this museum was never realised, policy changes were implemented in the existing museums and consequently also in the Tropenmuseum. Under the leadership of the historian Susan Legêne, plans were made to redesign the semi-permanent exhibitions in the Tropenmuseum:

'Reflection on the colonial past – a theme of little interest in 1979 and thus almost non-existent in the "old" presentations – forms, where relevant, an integral part of the new scheme, as does the explicit involvement of the new ethnic target group in the museum design.'[220]

The new policy focused *inter alia* on the history of the collection and international collaboration. In 2003 the exhibition 'Eastward Bound! Art, Culture and Colonialism', about the colonial history of the Netherlands and the interaction between coloniser and colonised, opened in the museum. The exhibition 'Textiel uit Indonesië' ('Textiles from Indonesia') was mounted as part of the museum's refurbishment, the theme being the interaction between cultures and how it has influenced the development of weaving traditions in Indonesia (see Chapter 'Presentation').

The Indonesian textile collection has continued to grow over the years. Acquisitions have been made, among which an extensive collection of batiks from H.C. Veldhuisen (Series 5663) and a small collection of Indian tradecloths. The batik collection consists of textiles from different regions. Particularly well represented are the signed and unsigned batiks made in the Peranakan workshops in different cities on

102
Tubular skirt – *sarung*
Signed: 'E. van Zuylen'
Cotton, batik
198 x 104 cm
Java, Pekalongan
19th century.
TM-5663-811
Purchase: H. C. Veldhuisen, 1996

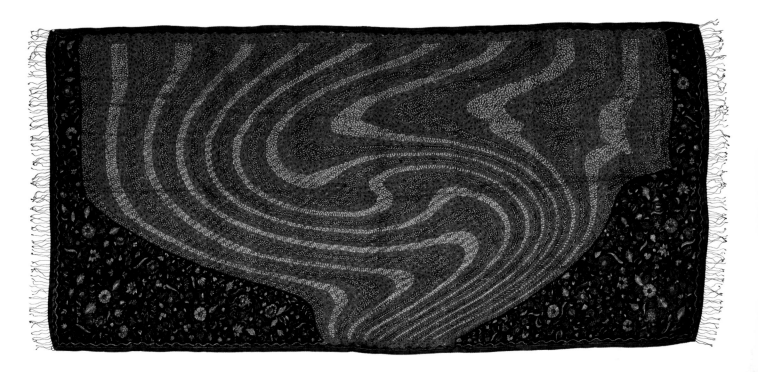

103
Shawl
Silk, batik
232 x 111 cm
Jakarta, Java
2010
TM-6457-10
Design and manufacture:
BIN house, Jakarta
Purchased with support from
the BankGiro Loterij, 2012

Java's north coast. Batiks with the signatures of well-known Indo-European batik entrepreneurs such as Lien Metzelaar and Eliza van Zuylen, and designs by various fashion designers from the 1970s and 1980s, are also included in this collection (fig. 102). To prevent the batik collection from becoming a purely historical collection, contemporary textiles were subsequently purchased from the design house BIN house in Jakarta (Series 6457). BIN house became known for their production process, which combines old and new techniques, materials and motifs in unique ways (fig. 103).

From the 1980s the museum also became active in the field of international cultural cooperation. Collaborations with various institutions in Indonesia led to exhibitions in, amongst others, Sintang in West Kalimantan, and in Berastagi on Sumatra, in which textiles from these regions played an important role. A small collection of textiles from an old 'orphaned' collection was returned to the Kapuas Raya Museum in Sintang, where they are now on display for the local population and can be studied by local weavers.

Following the trend established by other museums and private collectors, in the final year of the Tropenmuseum's independent existence it was decided to determine the age of a number of textiles from Indonesia using the radiocarbon dating method (C14). Probably the oldest textile in the entire collection is a cloth from Sulawesi in the Tillmann collection with *ikat* motifs on the warp threads. The C14 analysis gives a 95% confidence interval of 1433 to 1478 CE (see fig. 193).[221]

Objects and ethnographic collections are studied at different times employing different viewpoints and hypotheses. During the last few decades, in addition to the ethnographic collections and the images, the buildings in which they are stored are also considered 'a vitally informative window onto colonial society, for colonial culture was a profoundly material culture, based on the flow of materials'.[222] The building and the collection together constitute an archive for the study of the historical relations between the Netherlands and Indonesia. It began with Cornelis de Houtman's 'First Voyage', and hopefully, after several turbulent years, the Tropenmuseum has sailed into calmer waters and can once again focus on scientific and public-oriented tasks, but always with the collection as the port of departure.

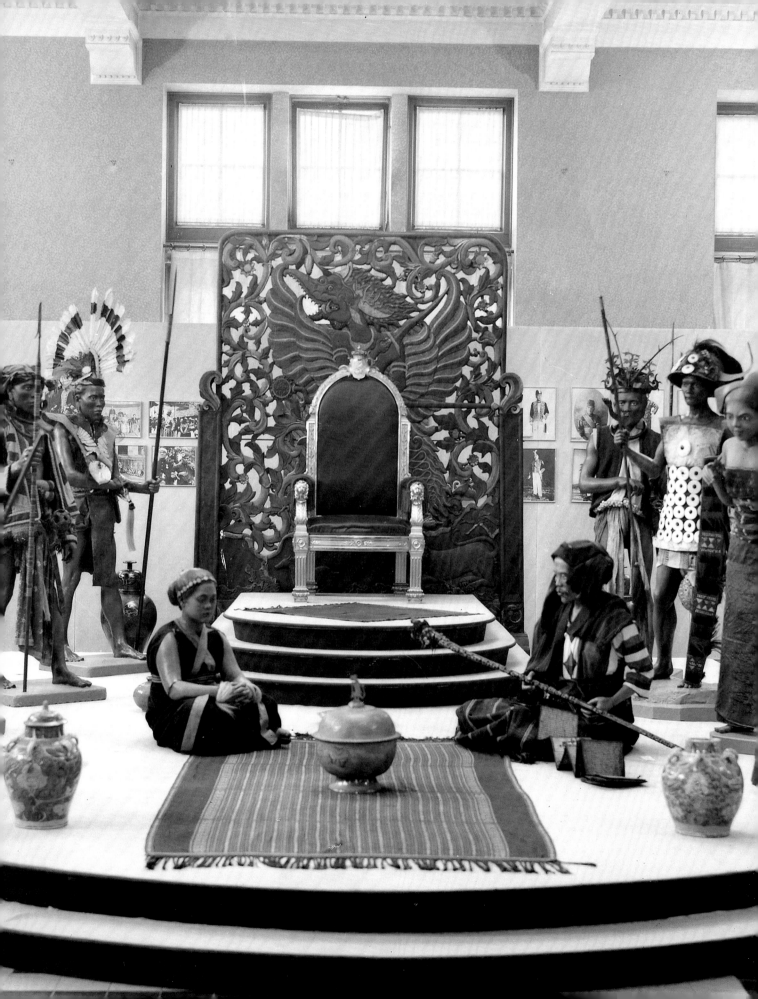

THE PRESENTATION OF TEXTILES: TRADE, ETHNOLOGY AND DESIGN

SONJA WIJS

<
Queen Wilhelmina's
symbolic throne
surrounded by peoples
of the Netherlands East
Indies at the exhibition
celebrating her 40-year
reign jubilee in 1938
See fig. 121

The Tropenmuseum developed a tradition of representing the indigenous peoples of the Netherlands East Indies by means of wax mannequins dressed in ethnic clothing. Dutch Queen Wilhelmina's 40th reign jubilee in 1938 was celebrated with the exhibition 'Nederlands-Indië – Een Koloniale Geschiedenis' ('The Netherlands East Indies – A Colonial History'). An empty throne was placed in the middle of the exhibition to symbolise the monarchy. The cluster of unnamed figures around it represented the various ethnic groups in the Netherlands East Indies. In the 1970s these wax mannequins were removed from the Tropenmuseum's displays. In 2002 they returned in the exhibition 'Eastward Bound! Art, Culture and Colonialism', no longer as anonymous 'ethnic types' but as historical figures who had played a role in colonial society.

In 1900, 36 years after the establishment of the Colonial Museum in Haarlem, a textile exhibition devoted exclusively to textiles from the Netherlands East Indies was held for the first time. Although interest in the arts and crafts was reflected in the textile exhibitions at the museum since it was founded in 1864, textiles had until then only been included in the semi-permanent installations. This chapter discusses the fluctuating interest in textiles and changing attitudes towards the function of clothing and textiles in the museum's exhibitions. This is done by focusing on the history of exhibiting based on a number of exhibitions that were held during the 150-year history of the Tropenmuseum and its predecessors. The focus is on exhibitions in which textiles from the former Netherlands East Indies played a key role.

Haarlem
The Colonial Museum, 1864–1923

'I do not really like exhibitions; I have seen far too many; and excess can be harmful.' [223]

This remarkable statement comes from F.W. van Eeden, the first director of the Colonial Museum. The museum mission was to familiarise the Netherlands with 'the wealth of our Overseas Territories […] to promote the general welfare both here and there', and all this 'for the benefit of trade and industry, and above all, to introduce and promote lesser-known yet important raw materials'. [224]

The world's first colonial museum opened in 1871. Its mission statement declared that as a typical trade museum it would provide information about natural resources, crops and products from the Dutch tropics. Besides plantation crops such as tobacco, sugar, indigo, tea and spices, examples of indigenous crafts and ethnographic objects were displayed. On arrival the collections were organised and classified by material, after which each category was assigned its own exhibition space.

The purpose of the ethnographic objects was first and foremost to showcase the technical proficiency of the various ethnic groups. The museum focused on carving, braiding and weaving, the processing of precious and non-precious metals, and the use of special materials such as horn, tortoiseshell and seashells. The Colonial Museum was unique in its technological approach to ethnographic objects and was therefore far removed from the methodology of classical ethnological museums such as the former National Ethnographic Museum in Leiden and the Museum voor Land- en Volkenkunde (Museum for Geography and Ethnography, now Wereldmuseum Rotterdam), which collected objects primarily to illustrate the lifeworlds of 'the Others', the non-European people.

Everything was arranged as systematically as possible in order to present visitors with a comprehensive overview of a particular product group. Every square centimetre of floor and wall space was used (fig. 104). Yet, even before the opening in 1871, the museum suffered from an acute lack of space, a complaint that was raised in almost every subsequent annual report. [225]

The role of textiles

Not many ethnographic objects were displayed in the first few years after the Colonial Museum opened, which is not surprising because this was not the museum's original purpose – in Van Eeden's words, 'the necessity to also represent the application of the raw materials in industry gradually became clear, to create an informative and appealing overview'. [226] A new Koloniale Volksvlijt (Colonial Handicrafts)

104
The Fibres department, Colonial Museum, Haarlem
Photographer: C. Zwollo
Silver gelatin developing-out paper
16.3 x 22 cm
1900–12
TM-60040437
Provenance: Colonial Museum, Haarlem

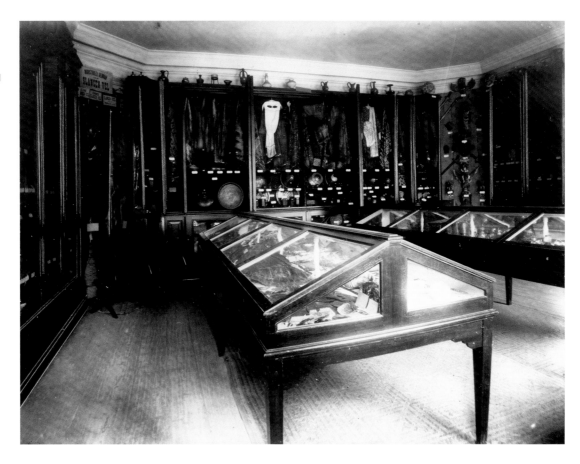

105
The East Indies Arts and Crafts department, Colonial Museum, Haarlem
The photograph was taken before 1912, the year when crafts products (including the tortoiseshells in the display case in the foreground) were removed to make room for ethnographic objects. It is difficult to identify the fabrics and clothing in the wall display cabinets; an exception is the white face veil (TM-H-242d) in the middle cabinet. This veil from Priangan (Indonesia) was part of a costume for a Muslim woman who had made the pilgrimage to Mecca.
Photographer unknown
Silver gelatin developing-out paper
16.6 x 21.9 cm
1900–12
TM-60040425
Provenance: Colonial Museum, Haarlem

department would fulfil this need. This became a place where people could admire Indonesian textiles. Categorising the textiles was problematic because they were not necessarily labelled as ethnographic objects. For example, batik *sarungs* were already part of the East Indies Arts and Crafts department in 1873, as proof that '[…] the innate sense of beauty of the natives places them higher in some respects than our nation […]'.[227] The batiks were displayed expressly for educational purposes and were presented together with a special collection of batik patterns drawn in wax. Both could '[…] be true learning experiences for many of our manufacturers'.[228]

The museum maintained a clear distinction between raw materials and finished products when organising the exhibits. Hence, fabrics and garments were placed in the East Indies Arts and Crafts department, but the raw materials for the same textiles were in the Vezelstoffen (Fibres), and Verf- en Looistoffen (Dyes and Tannins) departments. In the first department samples could be found of, amongst others, grass

linen, jute, bast, cotton, *kapok*, plant silk, etc.[229] Objects made from these materials demonstrated their use and therefore fabrics and looms were also to be found in this department.[230] The origin and production of dyes was similarly covered in the Dyes and Tannins department, which also focused on the most prevalent dying processes for Indonesian fabrics. The indigo tests conducted in the Colonial Museum's Laboratory, which opened in 1898 (see Chapter 'Colonial Collections'), were on the other hand presented in the East Indies Arts and Crafts department.

The late 19th and early 20th centuries saw a growing interest in the Netherlands for the various products of East Indies textile art, especially batik. Clothing and textiles were given more space and emphasis in the permanent exhibition. According to the 1902 guidebook, a visitor to the East Indies Arts and Crafts department would, in addition to Padang silverware, woodcarving, braiding and basket work, also see cotton garments from Java and 'woolly' fabrics from the Moluccas and other eastern islands.

'The Bugis, Timorese and Batak garments somewhat resemble the shawls worn in Europe in the past and are mostly dull in colour'.[231] In addition, even *baadjes* (small jackets) made of barkcloth from the most remote islands were exhibited. Cloths were hung, partially folded, in wall-mounted display cases (fig. 105), in contrast to the Fibres department where textiles were displayed full length so that visitors interested in their production and commercial potential could study the textures and materials. Information about the textiles was no longer just about the various weaving and decorative techniques, as was customary in the early years, but the meanings of the patterns and ornamentation were also considered. This shift in interest was typical of the time: the transition from an evolutionary mindset with a focus on technology to an anthropological approach to cultures.[232] Through displaying garments of residents from all parts of the Netherlands East Indies, the museum aspired to provide an overview of the daily and ceremonial attire of the local population. The first outlines of an ethnographic approach became visible. These would really take shape in the Colonial Institute, founded in Amsterdam in 1910. One display case in the East Indies Arts and Crafts department was entirely devoted to batik art. All objects relating to both East Indies and Dutch batik techniques were displayed inside it. *Ikat* was also included in the permanent display from 1903: in addition to the information, there were single strands of yarn decorated in the *ikat* technique in the display case. The part of the collection that belonged to the 'crafts' category was moved to a smaller room in the museum in 1912 to make way for the now extensive ethnographic collection. The establishment of the new Ethnology department finally affirmed ethnology as a separate discipline in Haarlem in anticipation of their move to Amsterdam: 'Now that our collections will be transferred to a spacious building within a few years, which will also house the Ethnology of the Archipelago, no reason remains to stem the natural growth of the ethnographic collection.'[233]

Temporary and external exhibitions

Regardless of how rigorous and systematic the museum layout was, by the end of the 19th century the chronic lack of space could no longer be ignored and many new acquisitions disappeared 'backstage'. A solution was found in temporary thematic exhibitions where as many new objects as possible were presented to the public. From 1894 these were held several times a year and lasted from one day to several weeks. These thematic exhibitions primarily targeted a specific, often pre-informed group of specialists. 'Over Indische Batik-kunst, vooral die op Java' ('About East Indies Batik Art, Especially on Java') was the Colonial Museum's first textile exhibition in this series. On 7 April 1900, G.P. Rouffaer gave an eponymous lecture that accompanied an exclusive one-day exhibition of precious batiks.[234] The entire West Indies hall was literally 'wallpapered' with batiks from the museum's collection, complemented by samples from several private collections (fig. 106).[235] Approximately 125 people attended. The two cloths decorated with gold leaf portrayed in the bulletin dedicated to this lecture and exhibition are unique (for a detailed description, see figs. 172, 173).[236]

A second temporary textile exhibition was held a year later: 'Proeven van Nederlandsche batik-techniek' ('Examples of Dutch Batik Technique'). Dutch batik made in the Colonial Museum's Laboratory was on show for one week. The exhibition was held on the occasion of the 124th general meeting of the Dutch Association for the Advancement of Industry, and included works by, amongst others, H.A.J. Baanders, M. Weerman, T. Slothouwer and M. Bekouw (see fig. 36). After this exhibition the results of these tests were included in the museum's permanent exhibition and were allocated their own display case in the East Indies Arts and Crafts department.

From 1878 the Colonial Museum participated in national exhibitions organised by the Maatschappij ter bevordering van Kunstnijverheid (Society for the Advancement of Applied Arts) and the museum of the same name. The branch of this society in Harlingen, a town in the north of the Netherlands, held an artisans' contest in May 1894, where the Colonial Museum was represented by its Batik-en Lak-industrie (Batik- and Lacquer Industry) departments.[237] Objects from the archipelago served as examples for Dutch artisans, '[…] because in the area of industrial and artistic sense, the "natives" are in some ways superior to the European workman. Individual creative expression is not yet supplanted by mechanisation'.[238]

106
Part of the exhibition
'About East Indies Batik
Art, Especially on Java',
7 April 1900
The two large cloths in the
lowermost row (see figs. 173-
174) were assimilated into the
collection of the Colonial
Institute museum in 1934.
When this photograph was
taken they were the private
property of Mr. M. Enschedé,
whom G.P. Rouffaer described
as a 'fortunate connoisseur
from The Hague'.
Photographer: unknown
From: *Bulletin van het
Koloniaal Museum* 23, 1908,
p. 16.

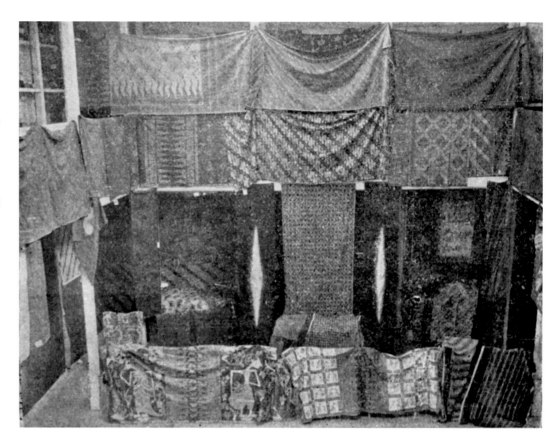

However, the Colonial Museum and its collection were not represented at the major international exhibitions and world fairs of the 19th century.[239] In Van Eeden's view, such exhibitions and world fairs were excellent sources to enrich museum collections but the reverse did not apply.

An exhibition is temporary and contains both ripe and green; a museum strives to seek out the ripe and preserve its enduring value. In this way, the museum rejuvenates itself and the exhibition has achieved its goal. If, however, the exhibitions have to feed on the museum's collections then that rejuvenation is not possible; then we learn nothing new. It's an absurd to-ing and froing, requiring the temporary dismantling of well-arranged installations. A museum should be like an inviting landscape that lies before us and as we walk through it, we should recognise a cohesive and understandable whole. It should also be like a picture book, in which the images are arranged in a deliberate order.[240]

Only shortly before his death in 1901 was this approach dismissed. The first international exhibition in which the Colonial Museum took part was the 1900 World Fair in Paris, after which the textile collection became an integral part of the contributions to other exhibitions. The textiles were not only displayed individually as distinct objects, but were also used to dress mannequins that represented the various ethnic groups in the Netherlands East Indies. Similar wax figures would later serve the same function in the permanent displays in the Colonial Institute (see figs. 111, 121). From 1901 the results of the batik experiments from the Colonial Museum's Laboratory were successfully incorporated in the exhibition (fig. 54). In 1902 the museum received a silver medal and diploma for the batiks it displayed at the First International Exhibition of Modern Decorative Arts in Turin.[241] Being present at these events brought international fame and recognition to the Haarlem batik research and products. After the Turin award the museum received significantly more enquiries about its experiments and soon became a national and international knowledge centre for research into the batik process. Batik was now an internationally

recognised phenomenon and the museum ensured that it was represented everywhere, such as in 1905 in the Kunstgewerbe Museum in Basel, where a special exhibition was organised to raise awareness of batik art,[242] and in 1906 with a room-filling contribution at the 'Nederlandsch-Indische Kunsttentoonstelling' ('Netherlands East Indies Art Exhibition') in the Kaiser Wilhelm Museum in Krefeld.[243] The Colonial Museum also arranged an exhibit at the 1910 Brussels World Fair.[244] At this exhibition the Dutch government and industry portrayed themselves as 'bringers of progress to the colonies', and the *Ethische Politiek* (Ethical Policy) was explained. The Colonial Museum exhibition included the various production stages and the tools used in the batik experiments, with which the museum hoped to 'provide information about

the goals and work methods of the Museum' abroad.[245] Photographs of the museum's interior and exterior completed the whole: effectively, the museum itself was on display.

The year 1910 turned out to be an important one for the future of the Colonial Museum and the presentation of its collections. The Colonial Institute Association was founded on 10 June 1910 in Amsterdam. This association built an extensive complex in Amsterdam to house the new institute. Part of this complex was allocated to the Colonial Museum. Here the Haarlem collection would have plenty of space and would also be expanded with a major Amsterdam collection, that of the Koninklijk Zoologisch Genootschap Natura Artis Magistra (N.A.M., The Royal Zoological Society Natura Artis Magistra, now Amsterdam Zoo).

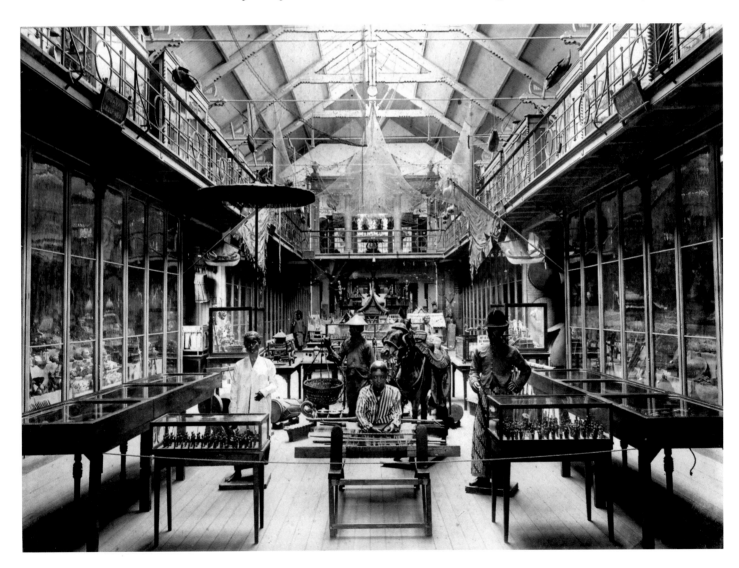

Amsterdam
Natura Artis Magistra (Artis), 1838–1920

In the year 1910 the directors of The Royal Zoological Society Natura Artis Magistra, better known as Artis, wrote a letter to the newly formed Colonial Institute Association expressing their intention to donate the Society's 'ethnographic collection' on the condition that the institute was built near Artis.[246] Founded in 1838, Artis was the first modern zoo in Europe and it strove to become an internationally recognised scientific institute. From its foundation until the early 20th century, Artis acted as a private society for the well-to-do and the middle classes of Amsterdam. Besides livestock, Artis managed extensive zoological, geological and ethnographic collections, which were exhibited at the Natural History Museum from 1851. In 1861 the ethnographic collection was moved to its own Ethnographic Museum where, because of the steady stream of donations, it soon outgrew this building too. Larger premises were found and the new Ethnographic Museum opened in May 1888 on the occasion of the society's 50th anniversary (fig. 107, also see Chapter 'Collecting').[247] The collection continued to expand in subsequent years. In the year in which the Society offered it for acquisition, the collection comprised over 15,000 objects from all over the world. The donation was gratefully accepted by the newly founded Colonial Institute Association, which, along with the collection from Haarlem, now had two entirely different but very valuable collections in its possession.

Artis Ethnographic Museum
Not much is known about the display in the Ethnographisch Museum van Artis (Artis Ethnographic Museum). An early source from 1869 implies that the objects were piled from floor to ceiling. In the field of textiles, the 'precious silk robes', decorated weapons and filigree silverware from Padang, Sumatra, that were on display conveyed an impression of 'Oriental opulence'.[248] Additionally, 'The art of batik...' was 'unravelled in a series of specimens and samples [...]'.[249] With this display, it was the first museum in the Netherlands – and in the world – to concentrate on the batik process, and where batik art was presented in a museum context. The Colonial Museum, where there would be a focus on the technical aspects of the batik process, only opened its doors in Haarlem ten years later.

More is known about the display in the museum building that opened in 1888 (fig. 107). The aim was to create an overall impression of a culture by exhibiting the collection on a regional basis in designated display cases.[250] Visitor's guides written by C.M. Pleyte Wzn., the curator at that time, contained additional information. Pleyte's opening paragraph in the introduction to the first guide is significant. He directly addresses the visitors who also frequented the Colonial Museum in Haarlem.

The first prerequisite for the success of negotiations with foreign nations is knowledge of their habits and customs and their language. It is especially for the entrepreneur that these two points are of the utmost importance. He should know which goods are most requested by this or that group, and familiarise himself with the products made by the natives that have sufficient value to appear on Western markets.[251]

It appears that both museums operated in a complementary fashion around the turn of the 20th century. Artis was a typical ethnographic museum, in both its organisation of the display and its underlying vision. It gave 'a picture of the life and efforts of man at different locations on the globe and knowledge about his creations'.[252] For the visitor who wanted more insight into the life of the 'natives' there was also a brief overview of their most characteristic 'mores'. Pleyte arranged the objects within the regions according to a system of twelve groups, with textiles falling under Group II, 'Clothing and Finery'. Textile manufacturing techniques were in Group VIII, 'Crafts'. Weaving techniques were represented by means of a life-size mannequin of a Javanese weaver at her loom. Weaving, according to Pleyte required no further explanation, as it was done in the same manner as in the Netherlands. On the other hand, the batik process, still unknown in the Netherlands at the time, was explained, from the application of the wax to the choice of dye.[253]

Unfortunately, detailed information is lacking and only summaries exist about the textile collection and how it was exhibited. Only the most widespread fabrics from Java were presented, divided between two display cabinets. One cabinet was reserved for

< 107
Exhibition in the Artis Ethnographic Museum
View of a section of the permanent Indonesian exhibit in 'de Volharding' building. Wax mannequins representing various trades and ethnic groups are in the foreground, in the middle an Indonesian weaver at her loom.
19 x 23 cm
c. 1890
0000181398
Provenance: Stichting RKD

the batiks, the second for woven fabrics predom-
inantly from the Priangan (the former Preanger
principalities). Mannequins were dressed in
clothing worn by the 'more affluent' people in the
principalities. There was also mention of a priest's
robe from Probolingo 'that is reminiscent of
a patchwork quilt'.[254] Unfortunately this very
special and rare robe cannot be traced in the
Tropenmuseum's old Artis collection (also see
fig. 95). In addition to Java, textiles from other
parts of the Netherlands East Indies were included.
As in the display at the Colonial Museum, there
were 'some very fine garments, *sarungs*, trousers
and headcloths, decorated with gold thread',[255] from
Palembang and Bengkulu, and mention is made of
looms and *koffo* fabrics from Sulawesi. The small
jacket (*baadje*) made of ornamented barkcloth from
Halmahera, and the royal tubular skirt (*kokerrok*)
from Sumba, were exhibited here (see figs. 16, 223).
Objects belonging to 'Foreigners in the East Indies'
were placed in a cabinet in the middle of the display.
In addition to Chinese and Arabian slippers and
a complete Chinese hawker's (*klontong*) suit,'[256]
there were also some garments made of white cotton,
kebaya, as worn at the time by European women in
the Netherlands East Indies.[257]

There is little information about the specific meaning
of the clothes themselves. The visitor's guide contains
general information about the garments from the
regions mentioned above, distinguishing between
the 'natives' who were still in their 'natural state'
and only wore a loincloth made of barkcloth, and
those 'who came into contact with civilisation' and
therefore wore cotton trousers or a *sarung* and a
jacket. A headcloth and shoes ensured that 'the naked
body' was 'hidden from view as much as possible'.
In short, it was thought that a person's level of
civilisation could be deduced from their clothing
and the extent to which it covered the body. This
ethnocentric vision, derived from evolutionism,
was characteristic of this period, the heyday of
imperialism and colonialism. The categorisation of
the world's population according to different stages
of civilisation, in which Western culture was at the
top, therefore legitimised European superiority and
thus colonial rule. In the Netherlands, this could
have resulted in the so-called Ethical Policy, which
was officially introduced in the colonies by the
Netherlands in 1901.

We can conclude that, in the Colonial Museum and
the Artis Ethnographic Museum, the same textiles
were considered important and presented to the
public. Only the context in which the textiles were
displayed and the underlying intentions differed.
Artis approached its collection from a typical
anthropological perspective, whereas Haarlem
was product- and trade oriented (also see Chapter
'Collecting').

Temporary textile exhibitions
Pleyte continued to struggle with the lack of space
for the textile collection after the move in 1888.
Several years later, he wrote specifically about the
problems associated with accommodating the
extensive textile collection:

*The space available in the museum is indeed completely
inadequate for exhibiting the textiles, of which there
are several hundred, in a somewhat effective manner,
for the simple but sufficient reason that because of their
dimensions they require so much space. Should one wish
to display these fabrics in their entirety, there would
be no more room left to display the other objects.*[258]

The society solved this pressing problem by
organising temporary exhibitions: the first textile
exhibition was in 1894. Nearly 200 Artis textiles were
displayed for 22 days at the 'Tentoonstelling van
Geweven Stoffen, uit den Oost-Indischen Archipel'
('Exhibition of Woven Fabrics from the East Indies
Archipelago') in the Koningszaal of the Groote
Museum (the 'Large Museum', or the 'Natural
History Museum' of Artis). The core consisted
of a large collection of Javanese textiles but there
were also textiles from almost every island in the
Netherlands East Indies. The emphasis was on Batak
fabrics from the 'extremely valuable collection'
compiled by Herman Neubronner van der Tuuk,
who passed away in August that year (see fig. 76).
Furthermore, fully functioning looms were
distributed throughout the exhibition along with
explanatory photographs. In addition to listing
the colours, materials, sizes and the local names
of each textile, the accompanying guide also included
detailed information about their functions and the
weaving techniques that were used. A cursory
assessment of the 'degree of perfection' of the fabrics
was also provided, with silks from Aceh being rated

the best. A newspaper described the exhibition in as being 'Interesting for anyone who wishes to form an opinion about the level of handiwork in the East Indies […]', and '[…] it is also instructive, as it contains the means to evaluate the level of civilisation of the different groups'.[259] The exhibition also aimed to fill the missing links in the collection. Pleyte expressed the hope that the museum would not be blamed for pointing out these shortcomings and that '[…] everyone will turn to their network to offer us a helping hand with filling them […]'.[260]

A few years later, in 1912, a so-called 'Na-tentoonstelling van Vezelstoffen' ('Post-Exhibition of Fibres') was organised in the Koningszaal in collaboration with the Colonial Museum. This product-oriented exhibition took place after the first successful Congress and Exhibition on the Cultivation and Production of Fibres', which was held in Surabaya in 1911. J. Dekker,[261] director of the Colonial Museum, was secretary of the Dutch Commission overseeing the entries for both exhibitions. After the exhibition all the samples of fibres, fabrics and wickerwork that had been displayed were donated to the Colonial Museum.[262] The importance of this exhibition should not be underestimated because in Europe a lot of capital and knowledge was invested in the fibre industry. The newspaper even discussed 'the national importance of expert theoretical and practical enlightenment having both earned their spurs, so that what is realistic can be (further) developed and what is less practical can be disregarded'.[263] Identifying and presenting fibres from the colonies that were valuable to Western markets was the core purpose of the congress and exhibition. The organisation hoped 'to advise the indigenous population on the role that they can play in the culture [sic. 'cultivation'] of fibre plants and the processing of the fibres'.[264] To this end, tools designed in the West that Indonesians could use to produce fibres with a good 'market value' at home were displayed in Surabaya.[265] Amsterdam and Surabaya shared the same main objective, but the Artis exhibition emphasised the textile techniques of the various ethnic groups in the Netherlands East Indies rather than the seemingly vital technical interventions in the 'cottage industry'. The exhibition included displays of strands of fibres from agave, hemp and sisal, Java jute, coconut mats and carpets, cotton from flowering bud to textile,

and samples of weaving materials such as bamboo, *lontar, mendong,* etc., in addition to goods produced from them. It was also an opportunity 'to admire the skill of native crafts' represented by the textiles from the private collection of J.E. Jasper, a *controleur* (district commissioner) and a member of the commission. It transpired that particularly the *ikats* from his collection drew much attention. A front porch of a 'native' house was constructed in a corner of the room, complete with a loom. The walls were lined with bamboo wickerwork from the Colonial Museum. This was the first time that employees of the Haarlem museum made a serious attempt at reconstruction. Unfortunately no photograph has survived of this display but the intention to give visitors a taste of the East Indies was apparent: '[…] so that the whole made an impression, as if one might see the weaver emerge from the doorway at any moment'.[266] Years later this method of exhibiting would become integral to the displays in the Colonial Museum in Amsterdam (and in its successor, the Tropenmuseum).

Colonial Institute Association, 1910–45

On 1 January 1913 the Colonial Museum's collection was conveyanced to the Colonial Institute Association.[267] At the same time the Ethnology, Tropische Hygiëne (Tropical Hygiene) and Handelsmuseum (Trade Museum) departments were founded. The Ethnology department managed around 30,000 objects. The entire collection could still be viewed in Haarlem until the Colonial Museum closed in 1923. The new institute's first textile exhibitions in Amsterdam were held in private homes.

The first textile exhibitions
In 1922 the first textile exhibition was organised with the title 'Eene verzameling voorwerpen van kunstnijverheid uit de hoofdstad Palembang en de landstreek Pasemah Lebar' ('A Collection of Arts and Crafts Objects from the Capital Palembang and the Pasemah Lebar Region').[268] On the initiative of, among others, J.C. van Eerde, director of the Ethnology department, ethnographic objects were displayed from C.J. Batenburg's collection, which he amassed while a *controleur* in Palembang. The emphasis of the exhibition was on textiles and fabrics

from Palembang. These objects were arranged by technique – lace, weaving, embroidery, *tambour-*, *prada-* and *ajour-work* – with other arts and crafts items supplementing the whole. The Palembang textile tradition was highly esteemed because of the artistry of the textiles. In her opening speech Mrs. Batenburg explained: 'In general […] products of native handicrafts, textiles for example, are only valued as a means to adorn bare walls or to conceal the ugliness of East Indies furniture, but soon people will begin to appreciate their true value.'[269] She then expressed a view typical of that time: through knowing the meanings and the ways of manufacturing the textiles, one 'learns more easily to understand the introspective soul of the natives'.[270]

The catalogue accompanying the exhibition contained an explanation of the various production techniques in addition to a list of the exhibits. The exhibition 'Soemba-weefsels' ('Sumba Textiles') followed in 1923 (fig. 108).[271] On show was the large collection of *ikat* cloths compiled by L. Maurenbrecher, a captain of infantry in the Oost-Indisch Leger (East Indies Army), the forerunner to the Royal Netherlands Indies Army (KNIL), while he was an administrator on Sumba. *Ikat* textiles and objects from the museum's collection were also on display. The museum's textiles covered an entire wall and also covered the tables on which objects were displayed. These textiles were 'among 'the very best examples ever to have been produced by Sumba in the area of *ikat* art'.[272] Photographs H. Witkamp made during his trip to Sumba in 1910 supplemented the presentation.[273] Strikingly, not a single piece from these two earliest textile exhibitions was purchased for the museum, contrary to what became customary in subsequent exhibitions. The likely reason was that the costs of the new building in Amsterdam had exhausted its financial reserves. In 1923 the building was sufficiently completed to organise a grand exhibition to mark the silver jubilee of Queen Wilhelmina.

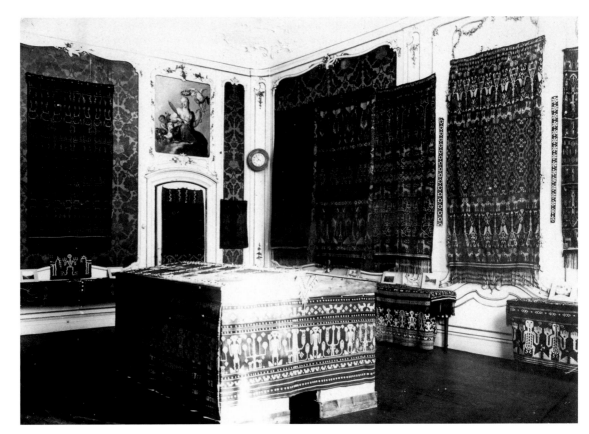

108

Part of the exhibition 'Sumba Textiles'

There are several *ikat* cloths on the wall from Mr. Maurenbrecher's collection, and photographs on the tables along the walls taken by H. Witkamp during his journey through Sumba in 1910. The cloth directly above the table at left shows a border of exceptionally beautiful beadwork that is sewn onto a woman's tubular skirt (see fig. 229).
Photographer unknown
Silver gelatin developing-out paper
7.9 x 11.1 cm
17 December 1923 – 16 January 1924
TM-60054511

109
Textiles from South Sumatra
from the Vattier Kraane
collection at the 1923
Jubilee Exhibition
Photographer unknown
Silver gelatin developing-out
paper
17.1 x 22.5 cm
1923
TM-60054504

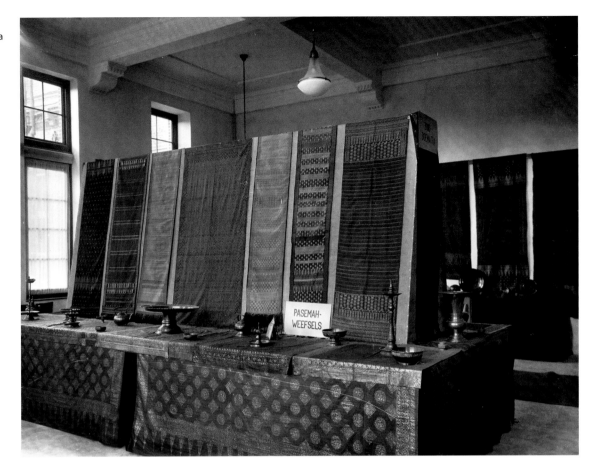

The 1923 Jubilee exhibition

The 'Jubileumtentoonstelling' ('Jubilee exhibition') can be seen as groundwork for the Colonial Museum, which would officially open its doors three years later. It allowed the museum staff to experiment freely with the categories and methods of presentation. The Ethnology department opted for a regional classification, in which textiles were exhibited hanging on panels and spread out on tables. In two sections – Sumba plus the surrounding islands, and South Sumatra – the emphasis was placed on the 'beauty of the fabrics from the East Indies'.[274] This choice appears to have been spurred by the degree of admiration these textiles evoked from the museum staff. The Sumbanese textiles with *ikat* on the warp threads and their complex decorations of human and animal figures in reserve on a coloured background were at the top of the 'hierarchy'. Next came textiles from Timor, Flores, Roti and Savu. So-called harmony-in-colour, interpreted according to Western standards, formed

a legitimate enough reason for whether or not to display certain textiles.

A large space in the building was dedicated to textiles from South Sumatra (fig. 109). The situation was now the reverse of that in Haarlem – textiles took centre stage as autonomous objects. Textiles were now specifically shown as ethnographic objects; copper- and lacquerwork was only exhibited to 'add lustre'.[275] The collection was owned by C.G. Vattier Kraane and originated almost entirely from Palembang. Vattier Kraane held a position on both the Jubilee and the Jubilee Exhibition committees and could exert considerable influence on the exhibition. According to the catalogue, the curators decided to display these textiles 'in an eye-catching location' to showcase the 'artistic beauty' as much as possible. People ran out of superlatives to describe the cloths: they were 'pleasing to the eye' and 'as a collection they showed an exuberant opulence and a certain aristocratic allure, qualities of the sophisticated Indonesians'.[276] The collection

Textiles, objects and
photographs of the Batak
(Sumatra) at the 1923
Jubilee Exhibition
All the textiles in this display are
from the former collection of
J.E. Jasper that was exhibited
at the 1910 Brussels World Fair.
A cotton shoulder cloth, *runjat
na bolak*, hangs on the left
(TM-48-193) and on the right
a *jung jung*, an early Batak
cloth that was already very rare
at the time of collection and
was no longer made or worn.
This cloth was exchanged with
Georg Tillmann and later came
into the possession of the
museum again when the rest
of his collection did (see fig.
143). Finally, a *ragidup*, a
cotton textile, is spread over
the table.
Photographer unknown
Gelatin glass negative
13 x 18 cm
1923
TM-10000391

of the Vattier Kraane-Daendels couple was donated
to the museum in 1946 (Series TM-1698, also see
Chapters 'Colonial Collections' and 'Collecting').
However, clothing and fabrics could also be seen
in other departments. For example, the Aceh section
was supplemented with F.W. Stammeshaus'
collection of 'the natives' everyday and […] festive
garb'. The museum would purchase a part of this
collection in 1931 (Series number TM-674). It already
had a collection of Batak cloths collected by Tassilo
Adam and J.E. Jasper (see Chapters 'Collecting' and
the Catalogue). The compilers of the catalogue were
unanimous in their belief that there was a direct
link between the appearance of the cloths and the
culture itself:

*The Batak cloths lack the polychrome and rich colour
of other textiles produced on Sumatra. They also lack
the radiance that comes with the use of gold and silver
thread. At first glance, they are somewhat monotonous,
sometimes even sombre. They are in harmony with the
Batak character that although not entirely sombre,
is on the whole serious. However, on closer examination
it has to be acknowledged that the arrangement of*

*colours is of great charm and distinction. In particular,
this applies to the fine ragihidoep. These cloths are
particularly admirable from a technical viewpoint,
and they include ikat yarn, which is yarn that is partly
undyed because the bundle of threads was bound with
vegetable fibre in certain places and then immersed
in the dye* [figs. 110, 144, 145].[277]

The Colonial Institute officially opened on 9 October
1926. The museum was divided over three storeys
totalling about 4000 m2; the space was equally
divided between the Ethnology and the Trade
Museum departments: Ethnology was in the left
wing, the Trade Museum in the right. Thus did the
distinction between the ethnographic collection
and the Trade Museum's product collection become
a fact. Van Eerde was more interested in the history
of the various cultures in the Netherlands East Indies
and less in the goods they produced. He therefore
freed his department from the constraints of
classification by product group that characterised
the Colonial Museum. However, the Trade Museum
department did maintain the traditional form of
classification. Later on, the Ethnology department

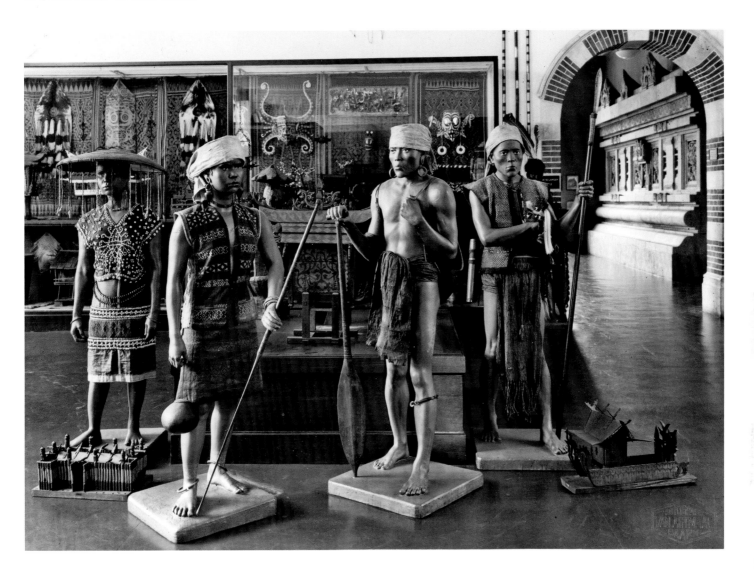

These wax mannequins are intended to represent Dayak people. As was emphasised to visitors, the items used to dress the figures did not form a cohesive whole. 'Because no collection is comprehensive enough to be able to find a complete set of clothing and accessories from each tribe, the assortment that the aforementioned figures are dressed in does not indeed form a matched entirety.'[1] For example, the figure of the woman on the far left of the photograph is wearing a small jacket (TM-H-156) from the Tebidah Dayak dating from 1900 and a bridal skirt (TM-A-4904) from Dayak groups in West Borneo. Both are decorated with *nassa* shell pieces and a band of beadwork is applied on the skirt. The long belt cord (TM-A-6605) is made of flat brass rings originated with the Kantu' Dayak. The other woman wears a small jacket (TM-A-2888) from a region somewhere in West Borneo and a skirt with silver thread, probably from southwestern Borneo. Her black wooden earrings (TM-A-3242a/b) are from the Biadjoes (Ngaju-Barito) culture. Note the use of the textiles arrayed along the wall as backdrops for the objects in the display cabinet.

111
Part of the Borneo section in the Colonial Institute's Ethnology department
Photographic Studio: Fotografie Van Agtmaal
Silver gelatin developing-out paper
24 x 30 cm
1929–35
TM-60054863

112

Portrait of Marianne Reyers wearing clothing and jewellery acquired by the museum from Savu

The lady is entirely dressed in textiles and jewellery from the then recently acquired series TM-789. At the time it was assumed that this was the correct way of wearing them. However inaccuracies crept in, for example, the cloth draped on Reyers' shoulders is a male cloth and she wears it in the way a stole is worn in Europe and not in the way a Savunese wears a shoulder cloth.
Photographer: unknown
Silver gelatin developing-out paper
16.6 x 10.3 cm
21-11-1932
TM-60054843

114

Cotton tubular skirt with warp *ikat* decoration

On either side of the red centre panel on the cloth, the letters 'R.P.M.P.' are applied four times: these are the initials of Raja Pono. The cloth was woven by female servants of the Raja's wife, who drew the patterns that had to be used when weaving the cloths. These patterns were not allowed to be imitated by others, which was also stipulated by naming the cloth '*kain raja*'.
Savu, Indonesia
c. 183 x 113 cm
Cotton
Before 1932
TM-789-27. Purchase: K. Heynen-Lans, 1932

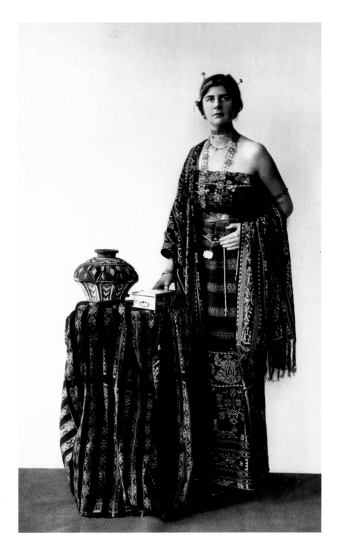

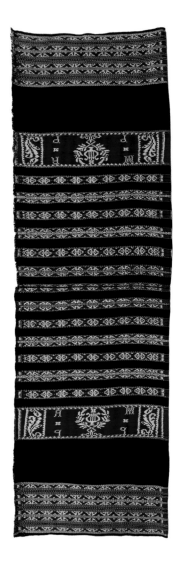

also had to abandon regional categorisation in some cases. In this way thematic sections arose such as 'Hinduism', 'the so-called *Schatkamer* (Treasure Chamber) and 'Looms and Textiles', within which everything was again categorised by region. Clothing and textiles were displayed in all regional presentations. Textiles had two functions in the Ethnology department. They were used as 'props', as bases or backgrounds for other objects, and 'special' textiles were showcased as autonomous objects, not only in the display cases, but also as clothing for dressing the numerous wax mannequins spread throughout the sections. Complete costumes were rarely collected and were therefore not to be found in the collection, which often led to creative but not always accurate combinations (see fig. 111). An exception was the acquisition

of textiles from Savu that were used to 'correctly' dress a mannequin in the permanent exhibition – or so it was thought at the time – after an Ethnology department assistant had demonstrated how it should be done. Clothing and gold jewellery, as worn by an aristocratic woman from Savu, can be seen in a photograph from 1932 (see fig. 112). The museum had recently acquired the collection from a Raja family from Savu (Series TM-789). According to the documentation, the regalia are 'unique and original, antique and centuries-old' and can be considered as 'crown jewels'. This photograph probably served as an example when dressing the 'Savunese bride', a wax figure that was placed in the *Schatkamer* in early 1933.[278] Because of the valuable jewellery it was placed inside a display case for safekeeping (see fig. 113).

Semi-permanent exhibitions: Looms and textiles

A department devoted entirely to the textile collection was developed only a few years after the museum opened. The department stemmed from a temporary exhibition of fabrics and looms collected during a study trip by Van Eerde in 1929 (see Chapter 'Collecting').[279] The exhibition 'Weefsels en weefgetouwen uit Nederlandsch-Indië' ('Fabrics and Looms from the Netherlands East Indies') was presented in the Ethnology department's main hall (fig. 115). Fabrics and looms were arranged by region and technology. A special feature was that photographs were used to illustrate the correct operation of some of the looms.

Afterwards, a semi-permanent display, 'Weefgetouwen en weefsels' ('Looms and Textiles'), was set up in the same location and with more or less the same collection. With it, the Ethnology department could emphasise the importance of weaving as a field of interest. This continued focus on textiles was probably also due to the presence of B.M. Goslings who had been affiliated with the institute since 1918 (also see Chapter 'Colonial Collections').

Different types of looms from Sumba, Borneo, Sangihe, Tanimbar, Aceh, Gayo and South Sumatra provided visitors with an overview of the various weaving techniques in the Netherlands East Indies. The accompanying captions explained the weaving and decorative techniques step-by-step. In short,

113
Mannequin dressed in clothing from the island Savu
This figure is described in the museum guide as a 'Savunese bride'. The photograph of Mrs. Reyers probably served as a model when dressing this figure. The 'bride' has therefore stood in the *Schatkamer* (Treasure Chamber) for decades incorrectly dressed in a male cloth.
Photographic Studio: Fotografie Van Agtmaal
Silver gelatin developing-out paper
22.5 x 16.6 cm
1933–39
TM-60042060

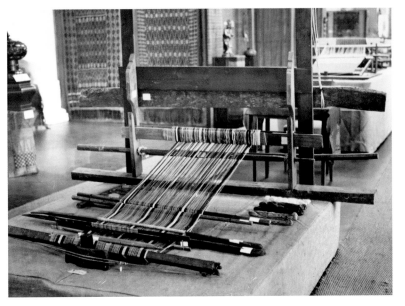

115
A loom from Aceh at the exhibition 'Fabrics and Looms from the Netherlands East Indies'
The loom in the foreground is from Aceh. *Ikat* cloths from the Kodi district in West Sumba hang in the background (See fig. 216).
Photographic Studio: Polygoon
Silver gelatin developing-out paper
December 1929 – July 1930
TM-60054951

after studying all the information provided here, a visitor should have been able to recognise the techniques used to make the textiles that were displayed in the other departments. A comprehensive guide to the Ethnology department, written by Goslings, was published in 1932. Unfortunately photographs relating to this display have not been preserved, but the guide does provide some clues regarding the presentation and perspective. A wax figure representing a weaver from Aceh at her loom was the most eye-catching exhibit in this department (figs. 116, 117).

Despite the overall colonial paternalism in the museum at that time, this display seemed to testify to a deep respect for the art of weaving from the Netherlands East Indies: 'rare', 'beautiful colours and patterns', 'a peerless reputation', 'the most artistic textiles', 'harmonious colours' – such superlatives abound in the department's guide.[280] In addition to specifying how the looms functioned,

116
Mannequin of an Aceh weaver at her loom
Photographer unknown
Silver gelatin developing-out paper
10.5 x 16.5 cm
1930–50
TM-60054832
As in figure 113, a male cloth has erroneously been draped around this female mannequin's shoulders.

117
Shoulder cloth
– idja seulimot
The cloth is worn by a man over one or both shoulders and is part of a complete outfit.
Aceh, Sumatra, Indonesia
Cotton
98.5 x 200 cm
Before 1916
TM-45-341f
Purchase: J. Kreemer, 1916

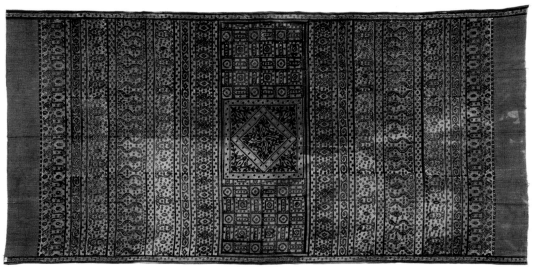

the final uses of the textiles were explained in brief: how they were worn, by whom, and whether they were for daily or ceremonial use. The spiritual and social aspects of the weaving process were highlighted by explaining that the rhythmic sound made while weaving would either scare away evil spirits or attract handsome young men.[281] The exhibit also expressed concern about the imminent disappearance of the weaving traditions. Thus, about the Aceh loom, Goslings wrote: 'nowadays this peerless form of woven art has actually almost disappeared and it is only practised in a few *kampungs* in a scattering of regions of Great Aceh'.[282] Interventions in traditional techniques were not really valued; cloths made using imported (industrially manufactured) fibres or dyes were displayed here and in the other exhibits, but mainly to demonstrate their inferiority compared with the 'real work'. The museum had put its collection on display whilst assuming that the original context within which these objects had once functioned had remained the same, while simultaneously presenting these people and their cultures in a timeless present. The emphasis in the displays was not on the changes taking place in the lives of the Netherlands East Indies population but on a traditional society that was presumed to be static. The major historical changes and the impact of becoming subjects of the Dutch colonial empire were barely mentioned.[283] Meanwhile supporters of Indonesian nationalism in the Netherlands challenged the Colonial Museum, for example, in a poem called 'Colonial Institute': 'They organised Beauty and Crafts / Coolly on view, with label, behind glass / They stole the dreams of a people / To put them on display for only a dime [...]'.[284]

The department was located here until the late 1940s, with a short break for the Jubilee Exhibition in 1938 for which the entire museum building was temporarily cleared. In 1949 it was moved to the front gallery on the same floor. The department was then simply called the 'Textile Room'.

Ethnology or trade
The differing views on the Indonesian textile tradition within the Ethnology and the Trade Museum departments can best be illustrated by two photographs of exhibits (see figs. 118 and 119), which presented the batik technique to the public in two different ways.

The first photograph is of a display case in the permanent Java exhibit that was installed by the Ethnology department. Here a wax figure of a Javanese woman making a batik illustrates the traditional technique. She sits in front of a richly decorated batik rack, a *gawangan*, over which hangs an unfinished batik cloth. She is holding a *canting*, the pen-like tool used to apply the patterns in wax to the cloth. Some Javanese batik cloths – each and every one of them a masterpiece – were exhibited behind the figure.

The following information was provided in a guide from 1943: 'Batik, the Javanese women's handicraft *par excellence*, with its calming, distinctive blue and brown colours, immerses us in the ambiance of the unpretentious, peaceful Javanese people.'[285] This display, in which there was a complete return to traditional examples and resources, was designed to give visitors insights into the authentic batik process. The tendency to modernise traditional production and decorative techniques for commercial ends was not really appreciated by the Ethnology department. Its publications repeatedly pointed out that factory-made products could cause 'taste decay' and endanger traditional techniques which could eventually become extinct: views that both Frederik van Eeden of the Colonial Museum, and the batik expert G.P. Rouffaer, had expressed earlier (see Chapter 'Collecting').

On the other hand, the Trade Museum department was also building on the Colonial Museum's tradition and ideology, focusing on the presentation of so-called enhanced methods and processes. This was in line with the so-called Ethical Policy according to which, 'the Netherlands as an enlightened coloniser was duty-bound to develop colonial society overseas not only for its own benefit, but also for the benefit of its colonial subjects'.[286] By displaying the latest innovations in its department, Dutch people who wanted to invest in the Netherlands East Indies or who were trying to establish a business, could take note of these developments.

The batik technique was explained in the Indische nijverheid en mijnbouw (East Indies Crafts and Mining department, see fig. 119). This display was refurbished in 1939 and presented a rich collection of products that 'offer a beautiful and clear picture of vigorously developing industries, especially on Java [...]'.[287] The simplicity of the display is striking

118
Display cabinet in the permanent Java department with a mannequin of a woman making a batik
A batik hipcloth decorated with the *banji* motif hangs on the wall behind the figure (TM-A-5014). The Java department was redesigned in 1948 by adjunct curator J. Pape van Steenacker and curator J.H. Jager Gerlings.
Silver gelatin developing-out paper
12.9 x 18.2 cm
1948–52
TM-60059425
Gift: W.H. Kal

119
Mannequin of a Javanese woman making a batik, in the background a mannequin of a weaver at a modern loom
This exhibit, dating from 1939, was redesigned in 1948 by the Tropische Producten (Tropical Products) department (formerly the Trade Museum department). The focus on batik and weaving remained unchanged, as illustrated by the mannequins that depict the methods of production. Note the batik samples (TM-H-3301-a/c) in the foreground that illustrate three consecutive stages of the batik process.
Silver gelatin developing-out paper
11 x 16.9 cm
1948–56
TM-60059452
Gift: W.H. Kal

when compared to those of the Ethnology department. The woman making a batik sits behind a simple, unadorned batik rack and works on a cloth with what is still an uncomplicated pattern – a first stage that can become even more complex – in comparison to the one displayed in the Ethnology department. The focus here is more on the technique and the material. Along the bottom of the display case the batik process is clarified for visitors with a few samples showing stages in the batik technique that I.G. Farben Industries on Java had provided to the Colonial Museum.[288] This implied that using synthetic dyes in the traditional batik process would mean progress for the people, and indeed such dyes did speed up the work. The Trade Museum made this message clear with the looms in this department. According to the 1943 museum guide '[…] an impression […] was given of the native and European industries in the Netherlands East Indies: the extremely primitive and modernised looms of the population with their products, photographs of the most modern large European textile firms there, with their broad spectrum of products […]'.[289] One such

modern loom is visible in the background in figure 119. Here a wax figure 'works' a loom introduced to the Netherlands East Indies by Western manufacturers to accelerate the weaving process. But its introduction had an unexpected outcome: operators were unimpressed and worked much more efficiently with their old familiar looms.[290] In short, textile production was regarded by the Trade Museum department as an 'industry' that had to be developed.

The Ethnology department's display was intended to give civil servants or entrepreneurs travelling to the colony a clear overview of the various ethnic groups and the cultural diversity and wealth of the Netherlands East Indies. In the field of textiles the installation expressed unequivocal admiration for traditional weaving and there was no need for improvements or change. The traditional techniques and the operation of the looms were explained in detail. The intention was to present disappearing cultures, knowledge and skills, and preserve them from modernisation. This was a real paradox reflected in the museum's policy: development simply

120
Women making batiks at the exhibition about the Netherlands East Indies at the 1900 Paris World Fair
The cloth undergoing the batik process is hanging over a batik rack (TM-964-1) that is ornamented with gilded *nagas* and a figure of a bird that was made available especially for this exhibition by the Colonial Institute's Ethnology department (see also fig. 118).
As far as is known, the cloths on the wall were not part of the Colonial Institute collection.
Photographic Studio: La Burthe & Warolin
Silver gelatin developing-out paper
16.2 x 22.3 cm
May 1937
TM-60047393
Provenance: unknown

wasn't possible without change. Dutch colonial rule and the Ethical Policy led to some fundamental and irreversible changes in the traditional and material culture of the native population. Consequently, disparate opinions arose on the objectives of presentations within a single institution. Despite this, the two departments often collaborated both inside and outside the museum. Representing the museum at major trade and world fairs was a permanent task of the Trade Museum department. A good example of this is the batik presentation in the Dutch pavilion at the 1937 World Fair in Paris (fig. 120).

Women gave live demonstrations of the batik technique on a small stage surrounded by batik textiles. In the catalogue the setup is described as follows: 'a collection of particularly attractive batiks, in the middle of which an authentic worker practises her happy trade'.[291] What is striking is that the Trade Museum department addresses neither the batiks themselves nor the underlying technology. The text only goes on to say that the type of wood used for the stage, *bangkirai*, is especially suitable for making parquet. The commercial value of each item in the exhibition seems to be more important than its function and meaning, and this included the batik fabrics. Thanks to the effective collaboration between the Ethnology and Trade Museum departments during these exhibitions, 'batik' gained international acclaim. On the level of the objects, this cooperation is strongly reflected in the photograph: the batik rack comes from the Ethnology department's collection, and the wood the stage is made of is being commended by experts from the Trade Museum department.

The 1938 Jubilee exhibition

A second major jubilee exhibition honouring Queen Wilhelmina followed in 1938 with the theme: '40 years of development in the Netherlands and its overseas territories during the reign of H.M. the Queen' (fig. 121). The entire museum building was emptied and temporarily refurbished with presentations from all three departments, and by third parties.[292] As is evident from the theme, the Trade Museum department had the largest say in the organisation. This department presented textiles under the rubric 'national unity through craftsmanship'. The display consisting of four

figures – a Javanese woman making a batik (the same figure as in fig. 119), a Dutch cheese maker, a Surinamese cotton spinner and a hat weaver from Curaçao – was placed on a rotating stage and described as a 'revolving symbolic representation of national unity'.[293] For its exhibits, the Ethnology department focused on the latest developments in the fields of culture and science. The recently discovered 'ship cloths' from South Sumatra, largely from Georg Tillmann's private collection (see the Catalogue) were presented to the public for the first time. Barely a year later, World War II broke out and a turbulent and uncertain period began for the Colonial Institute. Normal museum business came to a virtual standstill and it survived through the war years with a greatly reduced display, minimal resources and a skeleton crew. Only after the war, when most of the objects had been hidden or stored, did they gradually return to the museum and the exhibitions/display cases.[294]

The Indies Institute, 1945–50

In November 1945 the Colonial Institute was renamed the Indisch Instituut (Indies institute), primarily because of political developments in the post-war world. A refurbishment of the museum was begun as a consequence of the change of name and policy. Exhibitions had to focus exclusively on the former East and West Indies colonies, now called the 'Overseas Territories'. The refurbishment progressed slowly, mainly due to the shortage of financial and material resources in post-war Netherlands. In general, the display was simplified, 'which was beneficial for the examination of each object individually'.[295] Display cases were mostly used for new acquisitions, something that had not been done for years.

At the end of 1949, the semi-permanent Textile exhibition could be enriched with a true novelty in the area of presentation, 'the textile cabinet' (fig. 122). Museum staff had been inspired by the 'modern museums in Copenhagen and Paris', where they had seen cabinets with pullout frames in which the textiles were exhibited behind glass. The way that the textiles had hitherto been displayed in the museum was far from ideal. They were hardly, if at all, protected from sunlight, moisture and pests. The hundreds of precious and fragile textiles that the museum had acquired in recent years were the

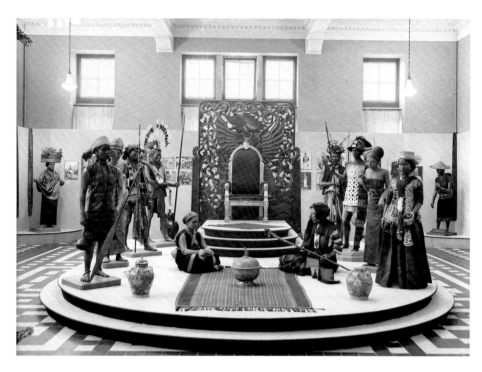

decisive factor: it was an 'irreplaceable art collection' that brought with it a great responsibility and obligations towards the donors, interested parties and 'The Nation'. Included in this recently acquired 'irreplaceable art collection' was the Vattier Kraane-Daendels collection (1946) of 200 Sumatran textiles, and the Tillmann collection (1947),[296] comprising 670 extremely precious cloths from the archipelago. The textile cabinet could house 150 'superior' cloths and had a dual function: it was a safe way to store as well as exhibit. It also proved ideal for the comparative study of textiles, and experts from the Netherlands and abroad took advantage of this opportunity. When the department was 'modernised' in the 1960s the cabinet disappeared from the display.[297] In the 1987 exhibition 'Budaya Indonesia' ('Culture of Indonesia'), the idea of the cabinet was reintroduced, allowing visitors to browse through part of the textile collection by means of an ingenious, electric rail system. This textile cabinet also returned with a modern twist during the semi-permanent exhibition 'Textiel uit Indonesië' ('Textiles from Indonesia', 2002–9).

Even before the textiles from the above two collections could be incorporated into the textile cabinet, they formed the core of the large exhibition in the Atrium, 'Wonderen van Sumatraanse Weefkunst' ('Marvels of Sumatran Weaving', 1948–49).[298] With this exhibition the museum wanted to demonstrate both the historical significance of these carefully compiled ethnographical collections as well as the importance of preserving these examples of Sumatran art for future generations. The diversity of Sumatran textiles that were either no longer being produced or were about to disappear were highlighted. Visitors saw 'an exclusive collection of Sumatran gold and *ikat* textiles, *Kroë* cloths, embroidery and lace'.[299] At the time the textiles were estimated to be between 40 and 75 years old, with the 100 to 150 year-old ship cloths from the Lampung area (*Kroë* cloths) being the exception. Since then the radiocarbon dating method has showed that a ship-cloth from the Tillman collection may well have been produced between the 15th and 17th centuries (radiocarbon dated with a calibrated date with 95% confidence to between 1499 and 1645, see the Catalogue).

The exhibition was arranged by region with further thematic classifications by technique, iconography and function. The wax figure representing a weaver from Aceh (fig. 116) stood at the entrance to the exhibition and illustrated how fabrics were woven from yarns of different colours. *Ikat*, batik, *plangi* and *tritik*, embroidery and *prada* (the application

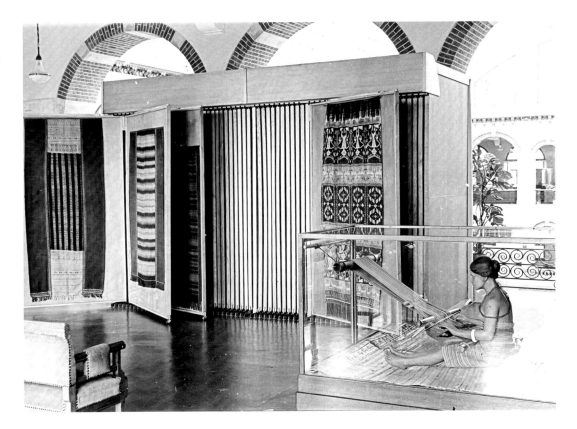

122
The textile cabinet and
a mannequin representing
a Moluccan weaver
(Tropenmuseum)
Two rare and beautiful *Toba
Batak* cloths hang on the far
left (see fig. 146).
Photographer: R.L. Mellema
Silver gelatin developing-out
paper
12.9 x 18.2 cm
1949–59
TM-60059490
Gift: W.H. Kal

of gold leaf) were also subjects of focus. The second
theme consisted of an explanation of the iconographic
aspects of the textiles, and the names and meanings
of the patterns. Lastly, the function of the textiles was
addressed. A glowing review in the press stated that
it was a 'must see' exhibition because of the beauty
and richness of the textiles, but what let it down was
the space in which it was exhibited:

*What a shame that the management of the Indies
Museum in Amsterdam is forced to organise exhibitions
in a completely unsuitable space. 'Space' is not correct,
because there is no space – but it is not a hall either. It
consists of some stairs and holes in the walls with arches
and columns filled with all sorts of huge ethnographic
objects, with the floor a miserable colour and what
remained of the walls 'decorated' in a pseudo-East
Indies artistic fashion […].*[300]

It was the first time that an exhibition in the Indies
Museum had to be extended due to overwhelming
interest.

The Tropenmuseum, The Royal Tropical Institute, 1950–2014

The institute and museum underwent a process of
decolonisation after Indonesia gained independence.
The independence movement in the Netherlands
East Indies was unstoppable by the late 1940s. The
political situation in the post-colonial world forced
the Indies Institute to reinvent itself within a period
of five years. In December 1950, it became the Royal
Tropical Institute (KIT). The Indies Museum would
henceforth be called the Tropenmuseum, and the
Ethnology department changed its name to the
Culturele en Physische Anthropologie (Cultural
and Physical Anthropology) department. The focus
and scope of activities of both the institute and the
museum shifted from the former Dutch colonies
to encompass the entire tropical world. Not only did
this mean a huge expansion in the areas to be studied
and where objects were to be collected, but also
changes in approaches to exhibiting. Indonesia
disappeared from the agenda until 1987 as a suitable
subject for temporary exhibitions. The permanent
exhibition still acknowledged the former colony, but

there was a cautious approach to aesthetic design and more and more emphasis was placed on the theme of development issues.

Joop Jager Gerlings became a curator at the end of the 1940s, and played a major role in the museum's development. As chief curator and later director he introduced a more aesthetic design for the exhibitions as well as innovative policies, and guided the Tropenmuseum to its role as an independent department of the institute. His special interest in Indonesian textiles resonated strongly both in the research and in the exhibitions. Together with the museum staff he arranged two important external exhibitions of Indonesian art, compiled from the museum's collection, which greatly increased the international reputation of the Tropenmuseum Collection. These exhibitions were in the Asia Institute in 1948 in New York, and in 1952/53 at the Palais des Beaux-Arts in Brussels.[301] Jager Gerlings had a like-minded colleague in Rita Bolland, who had also been working for the museum since 1947 (see Chapter 'Collecting'). Through exhibitions and publications, they would together elevate textiles on many levels to become the museum's core focus. The 1953 exhibition 'Beads, Seeds and Shells' was probably the first time they combined forces.

Partnerships

'Beads, Seeds and Shells' was the first exhibition in the history of the Tropenmuseum in which the bead took centre stage The second exhibition realised around this ornament, entitled 'Pracht en Kraal – Van Madonna tot de Masaï' ('Beauty and the Bead – From Madonna to the Maasai'), was in 2006 (see fig. 126). For the 1953 exhibition the focus was on beaded objects from the 'tropical regions', occasionally supplemented with relevant examples from the rest of the world. This exhibition was realised in close collaboration with M.L.J. Lemaire, owner of the eponymous Amsterdam antique shop.

Jager Gerlings employed a broad definition of what exactly a bead was, namely: 'everything that can be strung',[302] which provided scope for a presentation with the most diverse materials. Objects were arranged by region and their functions were highlighted: the bead as a trade item, as means of contact between different peoples, as an amulet and as a status symbol. The different techniques were also explained: from their method of production from various materials to the use of beads in various threading, embroidery and stitching techniques. Bolland undoubtedly contributed to the research into these methods for both the exhibition and the catalogue in which illustrations of the various threading techniques are included, but her name is never mentioned.

The press rated 'Beads, Seeds and Shells' as the 'the finest collection ever assembled in our country',[303] and as 'a compelling and comprehensive exhibition'.[304] The high quality of the displayed objects was also praised and some, it was thought, would even create a good impression 'in the Dior boutique'.[305] This happened later, in 2006, when ethnographic objects were included in a fashion show featuring several world-renowned brands such as Maison Christiaan Dior (see fig. 126[306]). The museum deliberately targeted women with 'Beads, Seeds and Shells', which was so successful that some of the exhibits were shown for ten days at the Damesbeurs (Ladies' Fair) in The Hague by special request.

The collaboration between Jager Gerlings and Bolland that we can only surmise existed for 'Beads' is clearly evident in 'Kleur op doek' ('Colour on Cloth', 1954–55). Jager Gerlings took care of the organisation and Bolland focused on the catalogue, detailing the various techniques through descriptions of the work and photographs of the exhibited textiles. At the same time a new way of working was introduced during this exhibition – it was a loan exhibition, both in terms of the information provided and the collection, and was based on the technical textile research conducted by Alfred Bühler, director of the Museum für Völkerkunde in Basel, and the museum's collection. In Amsterdam, the exhibition was supplemented with objects from the museum's own and private collections. It provided an impression of the different textile dyeing techniques in the tropics. It also explained the significance of weaving and textiles for the people and the society. The exhibition fitted entirely within the guidelines for research into textile weaving and decorative techniques that the Tropenmuseum had deployed not only historically but also with particular intensity in recent years. It was also the first exhibition in which all tropical regions were represented, making

it a perfect opportunity to demonstrate the broadening of the workfield that the institute as a whole undertook in 1950. The exhibition had a strong educational element that focused on 'all those who have a role in educating young people'. And once again, there was an emphatic focus on 'women': handicrafts were seen as a typically female activity. The curators also deliberately played upon the prevailing *zeitgeist* of the 1950s in which creative work was strongly emphasised; as the flyer said: 'In this increasingly mechanised world the confrontation with handiwork, which in its result demonstrates technical perfection and aesthetically pleasing design, is a real eye opener'.[307] A connection with modern times was formulated as a specific objective of this exhibition. The technical aspects had to be highlighted such that interest was generated among art lovers as well as Dutch entrepreneurs, thus building on the principles established by the Colonial Museum in Haarlem. Just as at the beginning of the 20th century, newspaper reviewers expressed their admiration for the supposedly simple and 'primitive' techniques used in the tropics and these were not only compared with, but also viewed as being superior to the modern, machine-printed fabrics from Western factories.

A dormant period

'Colour on Cloth' was followed by a 20-year hiatus in mounting textile exhibitions. In 1964, the KIT's new long-term work plan was formulated, which encouraged a change in its mission and a refurbishment of the museum. The colonial culture disappeared from the museum floor along with the majority of the collection from Indonesia, which was stored in depots. Henceforth, the institute had to focus on information relating to development issues, also through a permanent exhibition of the 'cultural, social and economic changes in the developing world'.[308] In 1970, Development Minister B.J. Udink[309] underlined the museum's importance and 'suggested' converting it into a presentation centre where the background, meaning and objectives of the government's development strategy could be clarified for the general public.[310] The museum worked towards a thorough renovation but without its inspirer and champion: Jager Gerlings retired from the museum in April 1971 to become director of the Openlucht Museum (Open Air Museum) in Arnhem.

The remodelling plans were a blessing for the visibility of the textile collection. Although all eyes remained focused on the then so-called Third World (and its relation to our own society), there was room once more for the 'highlights' from the collection. The general opinion was that cultural manifestations of other societies had to be researched. However, it was difficult for exhibitions focused exclusively on textiles to conform to musealised Third World development issues.[311] Indonesian textiles, with the exception of those incorporated into the permanent regional displays, vanished almost entirely from the frame until 1974, when space was cautiously made for textile-specific exhibitions.

Semi-permanent exhibition:
Textiles, technology and function

The Tropenmuseum had to transform from being an 'institution that was focused on preserving the past' into one 'that transports the audience into and answers topical questions about the present and future'.[312] A brand new museum had to be created in record time. From 1972 to 1976, museum staff and civil servants developed and implemented a broad-ranging refurbishment plan, based on a worldview extrapolated from the Ministry's development model. The sections were divided by region and complemented with some smaller thematic displays, including 'Textiles, technology and function'. Led by Rita Bolland, a section devoted to 'Textiles and everything connected to them', which would be 'of interest to everybody' was established in one of the building's corner towers. The limited space allotted to textiles necessitated a careful choice of themes. From the outset it was stipulated that the new Textile department should focus more on materials and techniques, which were after all Bolland's areas of expertise. Knitting, crochet, embroidery, *plangi*, dyeing, batik, *ikat*, block printing, spinning and weaving were among the techniques presented.[313] Dress codes, 'how clothes reflected the status and function of the wearer',[314] constituted the department's second main theme. Central to the display were eight mannequins representing men and women from Peru, Guatemala, Upper Volta (now Burkina Faso), Yemen, the Sahara, Java, Japan and India, dressed in costumes typical of these countries.[315] Bolland considered it important that the mannequins stood in an open space so that

visitors could walk around them to see the back of the clothes. Additionally, the outfits would not be complete without jewellery, accessories and footwear, which along with the mannequins' hairstyles and headgear would form a unity with the clothing.[316] Taking such painstaking care to create an accurate overall impression was a vast improvement compared to the situation in the first decades of the Colonial Museum existence, where the mannequins were dressed in a concoction of garments from several cultures and regions (fig. III). A mannequin of a Javanese woman, dressed in a batik *sarung*, blouse (*kebaya*), shoulder cloth (*slendang*), and jewellery, showcased the Indonesian textiles. This mannequin

demonstrated how a hipcloth was wrapped around the body and batik as a technique. The various stages of the batik process on Java, including the tools used, were in an adjacent batik display cabinet. It was not the past, but rather contemporary practices that the department was concerned with, and it exhibited many objects and techniques that were still being made and used at the time.

The first theme was a continuation of the Trade Museum department's *modus operandi*: research and the presentation of materials and techniques in which the various production stages were also shown, from the raw material to the finished product. The second theme was approached from an anthropological angle. At any rate, the new semi-permanent Textile exhibition placed textiles and the Tropenmuseum's collection back on the map.

New connections

The first years after the refurbishment were difficult, both financially and in terms of human resources. All available funds and time were used to complete the semi-permanent exhibits. The curators had no time to assemble temporary exhibitions, hence in those years the museum was more open than before to offers to stage exhibitions from outside groups and parties.

An example of an exhibition initiated by textile experts from outside the museum, '*Ikat* in katoen, oude gebruiken, nieuwe ontwerpen' ('*Ikat* on Cotton, Old Customs, New Designs'), was held in 1982.[317] It was an initiative of Loan Oei, an independent textile researcher, and was developed in cooperation with the International Cotton Institute and the enterprise Capsicum Natuurstoffen.[318] The exhibition would give visitors an idea of the origin and global distribution of the *ikat* technique, the traditional use of the textiles, and the socio-economic conditions in which they were made, both past and present. In addition, a large section was dedicated to contemporary applications in the West and to the countries where cotton *ikats* were produced for export. Old *ikat* cloths from Asia, Latin America and Africa were shown in conjunction with examples of 'modern' *ikat* fabrics, as used and processed by Western fashion designers, interior designers and hobbyists. Supported by the Centrum tot Bevordering van de Import uit Ontwikkelingslanden (Centre for the Promotion of Imports from

123
View of the indigo blue canopy at the exhibition 'Indigo, Natural Blue'
Photograph: Architectenbureau Jowa
18 December 1985 – 7 April 1986

Developing Countries) and under the supervision of the Ministry of Development Cooperation, the organisers of this exhibition hoped to stimulate interest in *ikat* and generate employment and raise the standard of living in the Third World. This was the first textile exhibition assembled from the perspective of development cooperation. It was also the last textile exhibition that curator Rita Bolland supervised in her official capacity. She retired in 1984, but remained affiliated with the museum as an honorary employee. In the 1980s the museum had to contend with cuts by the Ministry of Development Aid. The management responded vigorously with a combination of exemplary exhibitions, events focused on the public, and intensive publicity campaigns. One such event was the exhibition 'Indigo, natuurlijk blauw' ('Indigo, Natural Blue'), which opened in the Atrium in 1985, which, along with the accompanying publication was dedicated to Bolland. Nearly 100,000 people visited the Tropenmuseum especially to attend this exhibition. 'Indigo, Natural Blue' was the second major textile exhibition organised by the museum in collaboration with an external party, in this case Stichting Indigo (the Indigo Foundation), which shared the responsibility for fundraising. Once again, Loan Oei came up with the idea, developed the concept and oversaw all preparations during the three years preceding the opening. The exhibition relied on a large quantity of loans and made minimal use of the museum's collection. It provided information about indigo's botany, other vegetal and synthetic dyestuffs, and included a geographical overview of the wide variety of traditional and current uses of indigo as a textile dye: from India to Europe and from the time of the Vereenigde Oostindische Compagnie (VOC, Dutch East India Company, 1602–1799) to the present. Original textile fragments from ancient cultures, ceremonial clothing, uniforms, jeans, modern fashion design, and textile objects by contemporary artists were displayed side by side. The exhibition, designed by Architectenbureau Jowa, could in itself be regarded as a work of art. An indigo blue canopy protected the light-sensitive textiles against unwanted UV radiation that entered the Atrium from the top (fig. 123). The batiks produced in the Colonial Museum's Laboratory in the early 20th century were also shown, now categorised as 'Free artistic expression'. Besides the work of Chris

Lebeau and J. de Wilde, representatives of the Art Nouveau movement in the Netherlands and works by contemporary artists from Japan and elsewhere were also displayed (see Chapter 'Colonial Collections', figs. 54, 56).

Because of the funding cuts, the Tropenmuseum was unable to fill the position of textile curator for a while. This changed soon after Henk Jan Gortzak was appointed director. His efforts ensured that a successor to Bolland was appointed in 1986. Bolland's departure resulted in less research into manufacturing techniques and more focus on the function of textiles from a cultural anthropological perspective.

The first exhibition that the new curator, Itie van Hout, worked on was 'Culture of Indonesia'. It was a special exhibition because, for the first time in years, Indonesia and the showpieces were back in the limelight. A selection of textiles that would represent the richness and variety of the Indonesian weaving tradition was presented in a mechanically operated textile display that was specially designed for the museum. With the press of a button, visitors could activate the system whereby the cloths emerged one after another from a dark cabinet. Precious textiles could thus be displayed safely, as they were only briefly exposed to daylight. A slide show alongside the textiles informed visitors about the makers and wearers of the textiles in their cultures of origin. This display fulfilled a long-cherished wish, if only temporarily: the return of the textile cabinet. The design was a prelude to the version that would later be realised in the new Textile department.

The 1990s
From the 1990s onward, globalisation and the rise of cultural diversity within Dutch society were incorporated in the Tropenmuseum's exhibitions. Shared heritage and cultural exchange became increasingly important themes. The richness and beauty of weaving traditions, linked to the importance of textiles in the different cultures, was the focus of exhibitions that would be realised in the Tropenmuseum in the 1990s. The anthropological approach was evident in the exhibition 'Woven Documents: The Georg Tillmann Collection' (1996–97). The exhibition marked and celebrated the exceptional gift it received in December 1994. That year Wolf Tillman donated his father's collection of

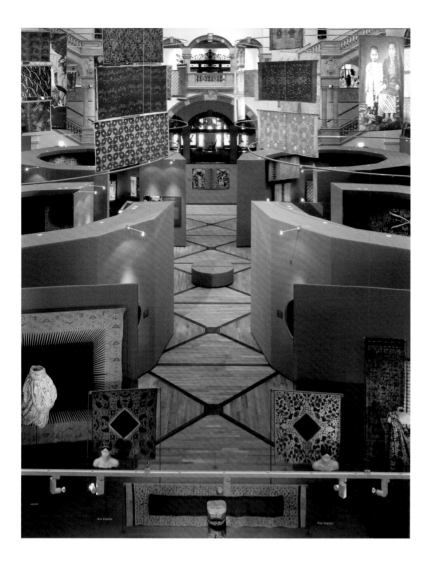

124
'Batik – Drawn in Wax. 200
Years of Batik Art from
Indonesia'
View of the textiles that were
hung high up in the Atrium
so it was possible to see them
from all angles and all floors
of the museum.
Photograph: Judith Jockel
2001–02

especial interest. After six months, the exhibition had already attracted 85,000 visitors and was extended by another three months due to its success.

In order to make a contribution to the study of the symbolism of birds in Southeast Asia by P. Le Roux and B. Sellato, research was conducted at the Tropenmuseum into the religious connotations of bird motifs on Indonesian textiles.[319] In 1999 this research resulted in the exhibition 'Over Vogels, Goden en Geesten' ('About Birds, Gods and Spirits'), which presented a collection of Indonesian textiles in which birds play a prominent role in the iconography. The symbolism of the bird in various Indonesian cultures was elaborated upon using textiles from the museum's collection, complemented by a number of loans.

Batik – Drawn in Wax. 200 Years of Batik Art from Indonesia, 2001–2002

An exhibition of batik art from Indonesia was held in 2001 to celebrate the acquisition of an important collection of batik cloths from H.C. Veldhuisen. Exceptional batiks from existing and newly acquired collections were brought together in the Atrium and for the first time in the museum's history, masterpieces from this unique collection could be admired in their full glory. The exhibition told the stories of the creators and wearers of batik. Besides filling the exhibition floor, textiles hung high up in the Atrium made it possible to see them from all angles and all floors of the museum. Because of the batiks' fragility and sensitivity to light, the Atrium was darkened completely (fig. 124).[320]

A documentary was made for this exhibition about the batik technique that is used in Jambi on Sumatra.[321] The trepidation among the former Ethnology department staff that knowledge and tradition in this area would soon disappear proved as yet to be unfounded. Even though the emphasis was on batiks from the colonial era, the link to the present was an important facet of the exhibition: batik still is part of everyday fashion. Hence, contact was sought with contemporary Indonesian fashion designers like Iwan Tirta and Josephine (Obin) Komara from BIN house, the Indonesian design and fashion house. Their designs and batik art by students of the Gerrit Rietveld Academie (Rietveld School of Art & Design) formed the finale entitled 'Batik Now'. A highlight was the batik K.R.H.T. Hardjonagoro designed especially for the then Vice President Megawati Soekarno

2000 objects, mostly Indonesian art, to the museum. The collection included many exceptional textiles and ritual objects and jewellery. For the first time ever, 85 precious textiles from this famous collection of 670 textiles were presented together.

The function, meaning and technique were explained per cloth, and attention was given to Tillmann's research into several Indonesian textile traditions. Tillmann saw the textiles as 'woven documents' from a distant past, documents that he tried to 'read'. He believed that through examining the meanings of the representations on the textiles it was possible to 'gain an understanding of the spiritual life of Eastern peoples'. The exhibition achieved its goal: textile experts from around the world came to the Tropenmuseum to view this unique collection. But the regular Dutch museum visitors also showed

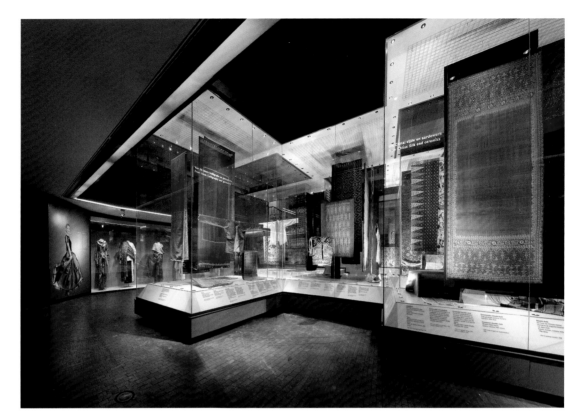

Semi-permanent[7] exhibit
'Textiles from Indonesia'
View of part of the exhibition
where the traditional and
the current Indonesian textile
designs were both presented.
At the left the creations by
BIN house.
Photograph: Versnel
Fotografen
2002–09

Putri (fig. 189). The attendance figures were so high that once again it was decided to extend a textile exhibition.[322]

Eastward Bound! Art, Culture and Colonialism 2002 – present

A complete refurbishment of the museum began in 1994, and accelerated towards the turn of the millennium. In 'Eastward Bound! Art, Culture and Colonialism', the entire first floor was used to confront the Dutch with their history as a coloniser as well as the institute's history, the period during which the greater part of the collection was brought together. Masterpieces from the museum's collection cast a new light on the Netherlands' colonial past. This theme was placed in a contemporary context of globalisation and the intensifying debate on national identity. The Tropenmuseum thus became the first ethnographic museum in Europe to revisit its colonial roots and lay them bare for the public.[323] One of the exhibitions that was part of 'Eastward Bound!' was a new semi-permanent textile exhibition 'Textiel uit Indonesië' ('Textiles from Indonesia', 2002–2009) (fig. 125). This exhibition enabled the

museum to display the highlights of its textile collection. As in 'Eastward Bound!' both the original context of the textiles and the stories behind the objects were the primary focus, and Collectors and their, i.e., 'our' relationship with the former Netherlands East Indies and Indonesia today were cast in the limelight. An innovative approach was that every department presented cultures and the differences between them from a historical perspective. The history of the Indonesian archipelago is in fact also reflected in the textiles.

The connection to contemporary batik and weaving was extrapolated through a presentation of six creations by BIN house. The museum thus demonstrated how a modern enterprise was able to maintain a textile tradition and preserve an important part of the cultural heritage of Indonesia for future generations.

The various textile techniques were presented on the first floor in a special 'depot display'. It drew on the extensive collection of looms and other tools such as spinning devices of various types and origins. Films and photographs illustrated techniques from both the past and the present.[324]

The temporary exhibition 'Wereld van Weefsels' ('Woven Worlds', 2006) was organised in collaboration with guest curator Sandra Niessen. In addition to Batak textiles from North Sumatra, in this exhibition a central place was also reserved for (biographies of) the textile collectors. This layered exhibition offered, through the objects, insights into developments within the Batak culture as well as the motivation, perception and priorities of the collectors. The ever-changing tradition of collecting thus had a prominent place in the narrative of the exhibition.[325] The third major textile exhibition realised in collaboration with guest curator Loan Oei and Architectenbureau Jowa opened in 2006: 'Beauty and the Bead – From Madonna to the Maasai' (fig. 126). As with 'Beads, Seeds and Shells' in 1953, the bead also took centre stage here. However, all was now on a grander scale and encompassed the whole world, not just the tropical regions. The bead was presented in all its diversity as a global and centuries-long beloved ornament and symbol. It was clear from the exhibition that the evolution of the bead is inseparably connected to that of mankind: as a symbol of identity, status or origin, a testimony to self-expression and creativity, vanity and greed, power and seduction, but also to spirituality. Western and non-Western designs were juxtaposed, completely in line with the museum's aim to make people aware of how cultures interact. This was the first exhibition ever to focus on the bead as a worldwide phenomenon, revealing how it has brought people from different continents into contact and how they influenced each other: the bead as a visual language.

The appreciation of the visitors for this exhibition is reflected in their number: 'Beauty and the Bead' attracted more than 119,000 visitors in six months.[326] At the time of writing, it was the last major exhibition to be held on the theme of textiles,[327] and an excellent example of the fact that textile-related exhibitions have been among the most successful in the long history of the Tropenmuseum and its predecessors: a rich history of collecting and exhibiting spanning 150 years (1864–2014), a history which since 1 April 2014 continues to unfold at the Nationaal Museum van Wereldculturen in the Netherlands.

126
'Beauty and the Bead'
View of the catwalk with a modern variation on a Dayak dress.
Photograph: Alexander van Berge
15 December 2006 – 13 May 2007

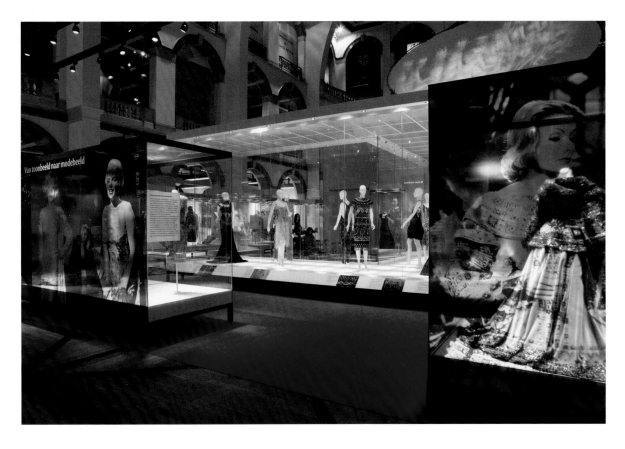

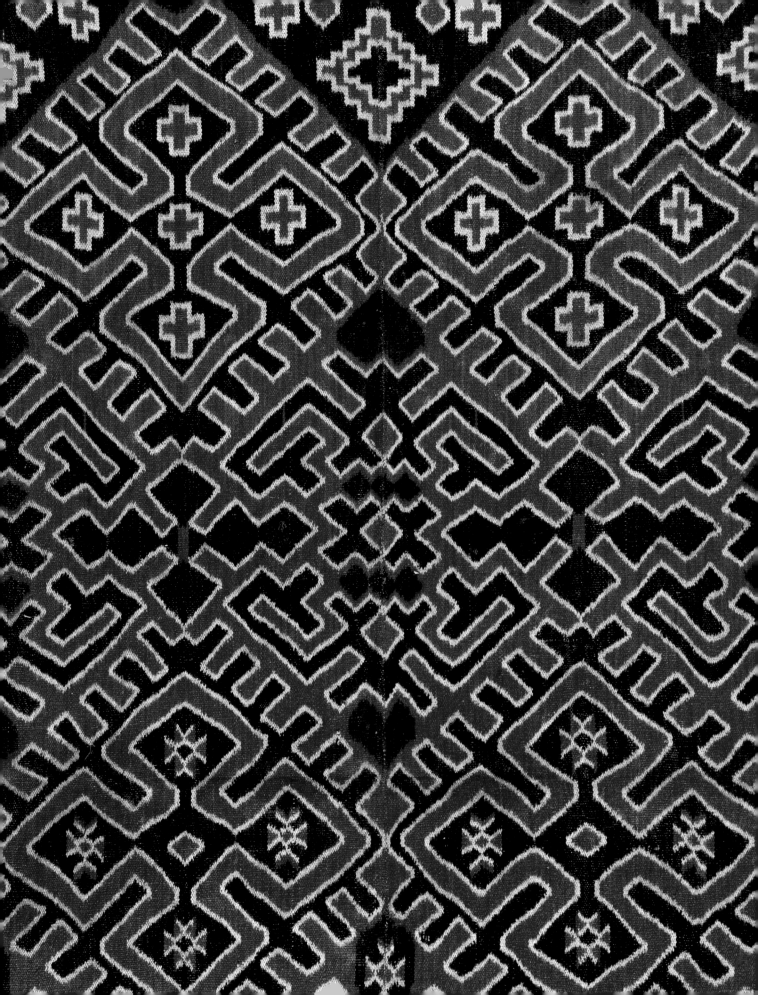

CATALOGUE

<
Ceremonial hanging,
shroud – *papori to noling*
See fig. 205

This cloth from Sulawesi was made by an experienced weaver who had mastered all of the techniques required to make such a cloth to perfection. In her community, life without such ceremonial textiles was unthinkable. This type of cloth is called '*papori to noling*', from '*papori*', 'to bind, wrap', a reference to the *ikat* technique; and '*Noling*', which denotes the weaver's group. Among others, these textiles were used as shrouds at funeral rites for high-ranking members of the community.

Elements of the textile production process form the subject of numerous Indonesian myths that recount the creation of humankind and all its surroundings. The essence of this process is that weavers create a coherent whole out of separate components. Techniques such as spinning, tying the threads, dyeing and weaving, result in a thread, a pattern, a cloth. In Indonesia the creation of a textile is associated with fertility and is a metaphor for the human lifecycle.

Examples from the weaving traditions on Sumatra, Java, Sumba and Sulawesi have been selected for this catalogue section since they are the most prevalent in the Tropenmuseum collection.

Sumatra

The Tropenmuseum has collections of objects from different regions of Sumatra. Textiles from the Batak in the northern highlands and from the Lampung region in South Sumatra are discussed here. Over thousands of years a diversity of textile traditions developed on the island of Sumatra, which are characterised by a broad variety of materials and weaving and decorative techniques. This has everything to do with the location of Sumatra on ancient trade routes and the emergence and flourishing of Hindu–Buddhist kingdoms in the coastal regions in the south of the island, resulting in them being introduced to new materials and decorative techniques. The peoples living in the interior, such as the Batak, only interacted with the outside world indirectly, but nonetheless incorporated elements into their weaving that display influences from these kingdoms. Dutch colonial expansionism in the 19th century brought to an end the isolation of these communities in the hinterland.

Batak

Si Boru Deak Parujar, the daughter of Batara Guru, the god of the upperworld, spun a thread down which she lowered herself into the sea. She wanted to avoid marrying the fearsome son of the god of the underworld. On seeing his granddaughter in the sea, Mula Jadi Na Bolon took pity on her and gave her a handful of earth. From this, standing on her spindle, she created the earth. For the Toba Batak, Si Boru Deak Parujar is the first spinner, the goddess of weaving and the primeval mother of the Batak.[328]

Several ethnic groups living in the mountainous regions around Lake Toba in North Sumatra are often referred to by the generic term 'Batak'. Despite the differences between these groups, also in their weaving, the similarities in their social and religious spheres denote an ancient shared tradition. Even though the Batak lived in a remote region, between the 2nd and 15th centuries influences from India penetrated here, including the use of cotton and of tools such as the spinning wheel.[329]

Batak society was organised into patrilineal descent groups that trace back to a male ancestor, Si Raja Batak, the son of Si Boru Deak Parujar. The Batak practised an asymmetrical marriage system: group A received brides from group B, which took wives

from a third group C, which received wives from group A. This resulted in a network of relationships regulated by specific rights and obligations. The bride-giver's family enjoyed a higher status than the bride-takers, as the former was the source of fertility, ensuring the continuity of the latter family. At every marriage a ritual exchange of gifts took place between the two families. Based on this symbiotic arrangement the gifts were divided into two categories. Textiles, *ulos*, the main ceremonial component of the 'female' gift, were transferred from the bride-giver's group to the bride-takers, and the 'male' gift, knives or other metal objects, *piso*, were received in exchange. Besides these two significant categories other valuable possessions such as land (female) and money and cattle (male) also formed part of this exchange. These categories also played a role in textile production. Weaving was the domain of women, but men made the tools necessary for the weaving process. Bamboo shuttles were among the objects they made to present to their wives or prospective brides (fig. 127).[330]

The notion of totality played an important role in the socio-religious ideas of the Batak. The universe as a whole consisted of three worlds: the upperworld, the middle world and the underworld.[331] This tripartite division, also referring to the three family groups in the asymmetrical marriage system, is reflected in the arrangement of patterns on textiles and in the use of the colours red, white and blue/ black. Tripartitioning as a religious concept indicates an influence from India, it could however be a far older concept: 'It may be that in the expressions of

tripartitioning in Batak cloth we have an example of an Indian concept coinciding with an indigenous concept.'[332]
Sandra Niessen described more than a hundred types of textiles in *Legacy in Cloth*, her definitive work on Batak textile art. She stressed in her research the importance of studying materials and techniques: '[…] the material, the textile production techniques and the resulting textiles, are all invested with meaning […]'.[333] The names and functions of some types of textiles thus refer to the techniques used to produce them.
(fig. 128) In the Batak region weaving was done on the aforementioned backstrap loom with circular warp. Characteristic of textiles woven on this loom is that when the cloth is almost completed its beginning and end are very close to each other, separated only by a small section of warp threads where the weft threads have not been woven in. After the weaving is completed, the textile is taken from

128
**Ceremonial cloth
– *handanghandang***
Cotton
Coloured warp stripes,
supplementary warp
170 x 67 cm
Toba Batak, Sumatra
19th century
TM-0-379
Provenance unknown

129
Ceremonial textile – *julu*
Cotton
171 x 106 cm
Karo Batak, Sumatra
Late 19th/early 20th century
TM-3963-10
Gift: E.E. Creutzberg, 1971

130
A *julu* used as a pall
Photographer unknown
Karo Batak, Sumatra
18 x 12.5 cm
1915–18
TM-60044447
Provenance unknown

131
Pa Mbelgah from Kabanjahe
Photographer: Tassilo Adam
Silver gelatin developing-out
paper
50.5 x 35.5 cm
1918
TM-60032070
Purchase: Tassilo Adam

the loom, and then the circular warp threads in the non-woven part are usually cut to form a rectangular cloth. However, in certain types of ritual textiles the warp threads are not cut. In his dictionary, the *Bataksch-Nederduitsch Woordenboek* (1861), Van der Tuuk describes a textile, the *handanghandang*, in which the warp threads were left uncut because the cloth was dedicated to a person's soul. The circular threads represented ongoing life and gave the textile special powers. These textiles were also used to welcome newborn children into the community, and sick children were carried in them so that the healing powers could do their work.[334] A *handanghandang* has the function of '*pagar*' or protection. The border motifs on this kind of textile formed a protective 'barrier' to ward off malevolent forces.[335]

Indigo dark blue cloths are among the oldest type of Batak textiles. In a variation on the Si Boru Deak Parujar myth above, Niessen states that the thread down which the princess lowered herself was dyed blue with indigo. This thread connected the upperworld and underworld. Connecting and

mediating are functions of several types of Batak textiles: 'The shoulder cloth [...] is the medium through which the prayers of the wearer are transported to the spiritual world.'[336]

The sober, blue *julu* has two equally dark blue side panels, separated from the two-tone central section by two white borders. These borders represent elephant tusks – in Karo mythology the elephant protects humans. Men and women wore the *julu*. At a birth the mother's parents wrapped their daughter and her newborn child in a *julu* to protect them.[337] At funeral rites, the deceased is covered with a *julu*. The photograph taken by Tassilo Adam is of Pa Mbelgah wearing a *julu*; Pa Mbelgah was an influential local leader from the Karo Batak village of Kabanjahe (figs. 129–131).

The *surisuri* also belongs to the category of *adat* textiles. The name '*surisuri*', which means 'comb', probably refers to the longitudinal stripes on the cloth. These continuous lines symbolise the progress of time and the sequence of generations.

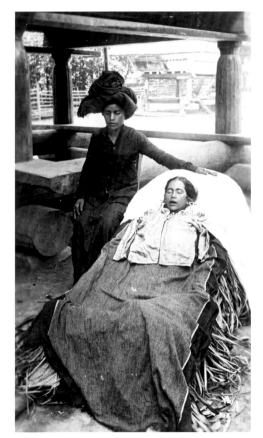
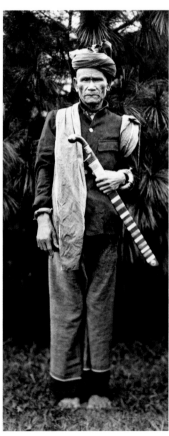

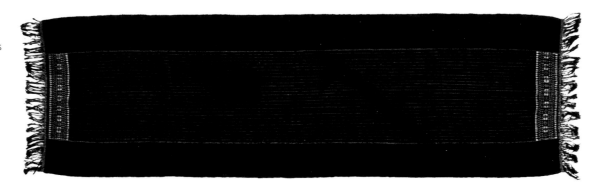

132
Shoulder cloth – *surisuri*
Exhibited at the 1910 Brussels
World Fair.
Cotton
Supplementary weft
patterning
173 x 52 cm
Simalungun Batak, Sumatra
Late 19th/early 20th century
TM-48-205
Purchase: J.E. Jasper, 1912

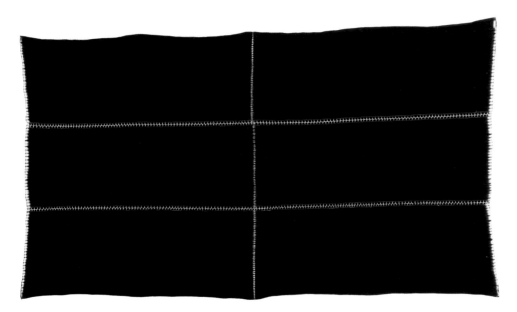

133
Hip- and breastcloth
– *sambat*
Cotton
Tritik, embroidery
165 x 98 cm
Karo Batak, Sumatra
Early 20th century
TM-903-8
Bequest: Maurits Enschedé,
1934

134
Karo Batak woman
Photographer: Tassilo Adam
Silver gelatin developing-out
paper
Sumatra
58.5 x 43 cm
1918
TM-60052522
Purchase: Tassilo Adam

These textiles were used in various rituals; at a funeral the light stripes symbolised the continuation of the deceased's life force in his or her offspring (fig. 132).[338] A completely different type of Karo textile is the *sambat*, made of imported, undyed cotton. In colonial times Karo men worked on the plantations on Sumatra's eastern coast where they had access to items that were traded there. White cotton fabric was dyed blue in the Karo region and sometimes decorated with small white *tritik* motifs and decorative stitching. Several variants were used as a hip-, shoulder- or headcloth (figs. 133, 134). Red, white and blue/black are the basic colours for a variety of ritual textiles and ceremonial garments. In the Batak region patchwork ritual garments were created from red, white and black cotton fabrics (also see fig. 95). The museum documentation mentions that the donor of this priest's robe stated that 'it was worn when calling "great spirits" because this garment facilitates the communication between the wearer and the spirit world'. As in other places around the world, the clothing, accessories and attributes of priests and shamans were often embellished with bronze bells, shells and coins. In ritual dances the rhythmic sounds of these objects facilitated the process of entering a trance state so that contact could be established with the supernatural world. The *simata godang* is a necklace that was worn by dancing women during rituals. To repel malevolent forces, shells and beads were also attached to clothing worn by people who were undergoing a potentially dangerous transition, like a bride who, when leaving her family home, was relinquishing the protection of her descent group while she was not yet fully protected by her future family group (figs. 135–139).[339]

135
Priest's robe
Cotton
Patchwork
117 x 86 cm
Toba Batak, Sumatra
19th/20th century
TM-60-6
Gift: A. Bierens de Haan,
1918

136
Priest's robe
Cotton, metal coins
and bells, glass beads
82 x 44 cm
Batak, Sumatra
19th/20th century
TM-137-151A,B,C
Purchase: Tassilo Adam,
1921

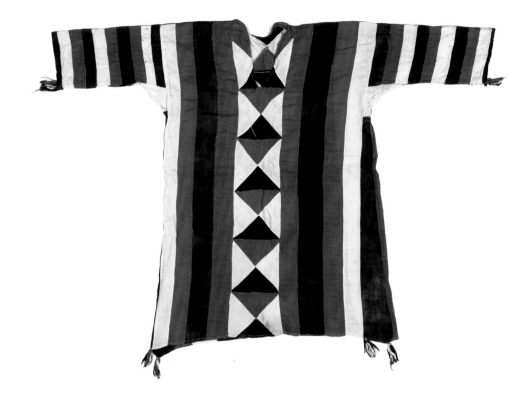

137

Shoulder and neck ornament – *simata godang*
Wood, cotton, glass beads, shell, copper bells, coins
198 x 75 x 11 cm
Toba Batak, Sumatra
19th/20th century
TM-153-64
Purchase: D. van der Meulen, 1922

138

Aristocratic women in ceremonial dress
During the annual agricultural ritual, *mangase*, wives of clan leaders wore their most precious clothes, of which beaded objects were an integral part. The ritual was led by the priest; the women were possessed by spirits during their dance.
Photographer unknown
Gelatin print on acetate
Toba Batak, Sumatra
c. 1920
TM-60033209
Gift: J. A. Honing

139

Bridal jacket – *baju omon*
Cotton, glass beads, bronze bells
Supplementary weft patterning, beadwork
105 x 46 x 3 cm
Angkola Batak, Sumatra
19th/20th century
TM-1772-16
Gift: W.G. Tillman, 1994

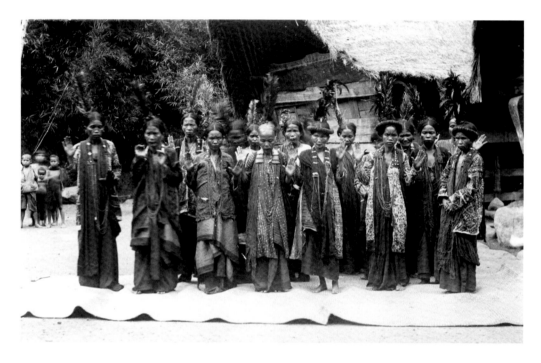

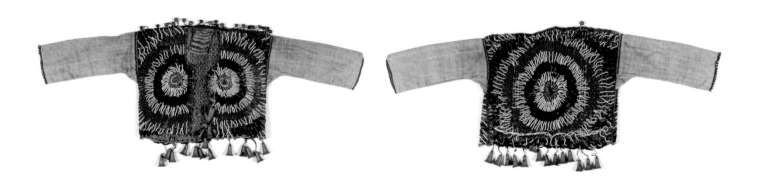

140
**Ceremonial cloth
– *harungguan***
Exhibited at the 1910 Brussels
World Fair. Submitted by Raja
Renatus.
Cotton
Various techniques
190 x 88 cm
Huta Barat, Toba Batak,
Sumatra
19th/20th century
TM-48-200
Purchase: J.E. Jasper, 1912

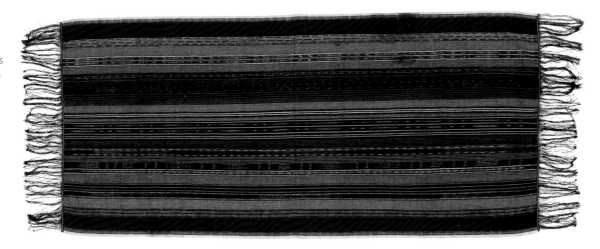

141
**Ceremonial textile
– *ragi hotang***
Cotton
Supplementary-weft
patterning
225 x 75 cm
Toba Batak, Sumatra
19th/20th century
TM-137-109
Purchase: Tassilo Adam, 1921

142
Ceremonial textile – *runjat*
Exhibited at the 1910 Brussels
World Fair.
Cotton
Warp *ikat*, supplementary
warp patterning
182 x 132 cm
Toba Batak, Sumatra
19th/20th century
TM-48-193
Purchase: J.E. Jasper, 1912

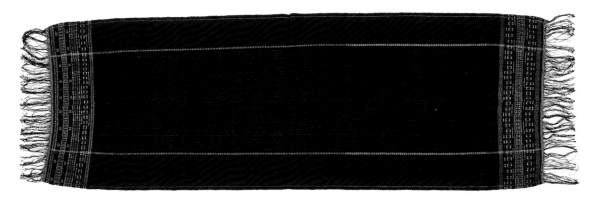

> 143
Shoulder cloth – *barunjat*
Cotton
Warp *ikat*
182 x 74 cm
Hutabarat, Toba Batak,
Sumatra
19th/20th century
TM-1772-1340
Gift: W.G. Tillman, 1994

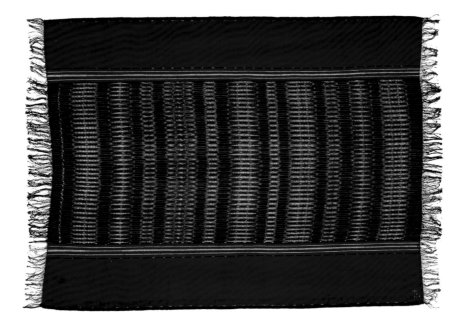

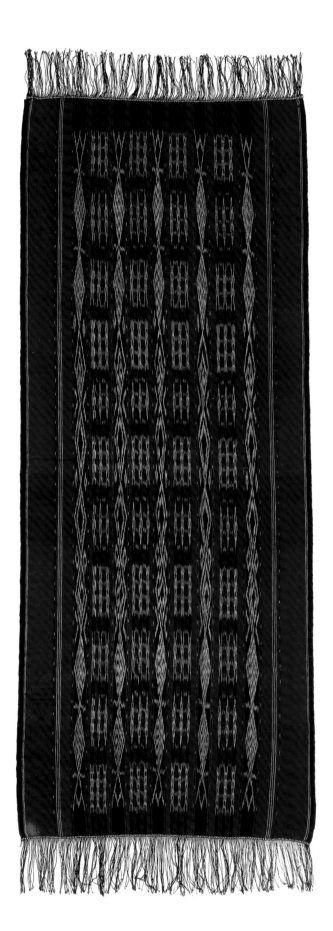

The notion of unity and totality is also reflected in a textile called 'harungguan', derived from 'runggu', which means 'meeting' or 'gathering'. The cloth can be seen as a meeting of motifs. Such cloths were made on the advice of a local healer, the idea being that at least one of the motifs would please, strengthen and protect its owner's soul. Usually these cloths were created for a child whose soul was not yet strong enough and needed protection (fig. 140).[340]

When a child was born the paternal grandmother wore a *ragi* (motif) *hotang* (rattan), a cloth with *ikat* motifs that resemble the flecks on rattan bark if the child was a boy, or a *runjat* if a girl.[341] The *barunjat* is a cloth that has not been found so far in any other museum collection besides the Tropenmuseum's. In 1909, Raja Renatus, the head of the village Hutabarat, submitted the cloth to the fourth annual fair in Surabaya. J.E. Jasper, the organiser of the fair, bought it from Raja Renatus when the fair ended,[342] so that it could be exhibited at the 1910 World Fair in Brussels. After this it was acquired by the Colonial Institute in Amsterdam, and was then exchanged with the private collector Georg Tillmann, whose son returned it to the Tropenmuseum as a gift in 1994 (figs. 141–143).

The *ragidup* was one of the most important textiles in Batak society.[343] Typical of the *ragidup*, the 'pattern of life', is how the white end panels are made (fig. 144). For the Batak this is a cloth of great spiritual importance both because of the technique that is used and for the meanings of the motifs. In a technically complex process, the coloured warp threads of the central panel are replaced by a new set of white warp threads. Then, by means of supplementary weft weaving, black motifs are created on the white warp threads.[344] These motifs include 'male' components on one side of the cloth, and 'female' components on the other side, which together represent the earth, mankind, flora and fauna. Niessen cites the Batak Philip Tobing who considered the *ragidup* as a representation of the High God of the Batak and thus an embodiment of totality and unity.[345] This cloth was a wedding gift from the bride's father to the groom's mother and was a pre-eminent example of a cloth endowed with 'life force', hence a symbol of fertility. Parents gave their daughter a *ragidup* in the seventh month of her pregnancy, which at such a time was regarded as an *ulos ni tondi*, a 'cloth for

144
Ceremonial textile
– ragidup
Cotton
Coloured warp stripes,
supplementary weft patterning
219 x 126 cm
Toba Batak, Sumatra
19th/20th century
TM-1772-1316
Gift: W.G. Tillman, 1994

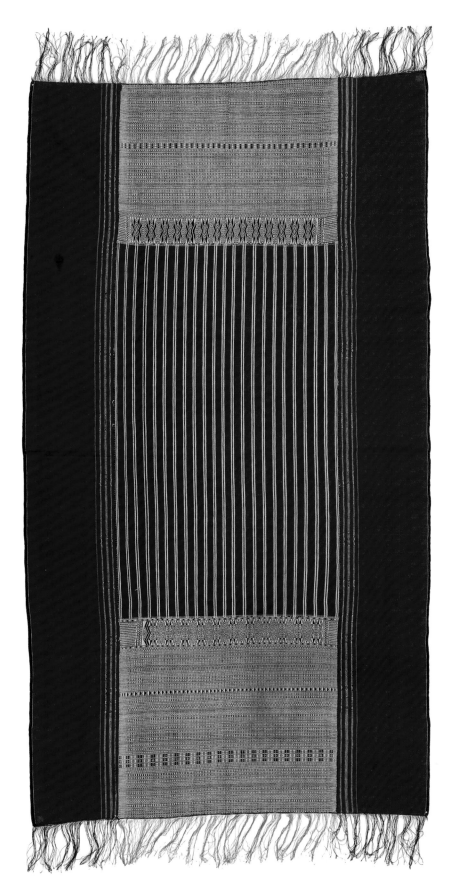

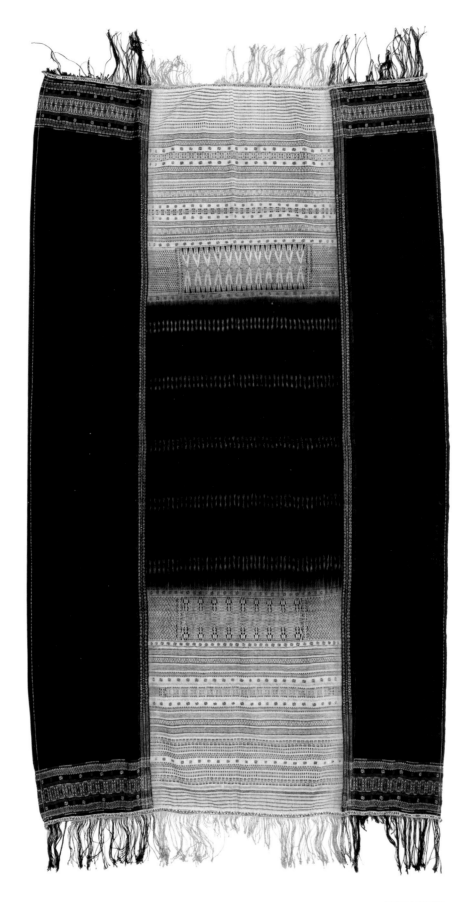

145
**Ceremonial textile
– *ragidup***
Cotton
Warp *ikat*, supplementary
weft patterning
215 x 128 cm
Toba Batak, Sumatra
19th/20th century
TM-1772-1317
Gift: W.G. Tillman, 1994

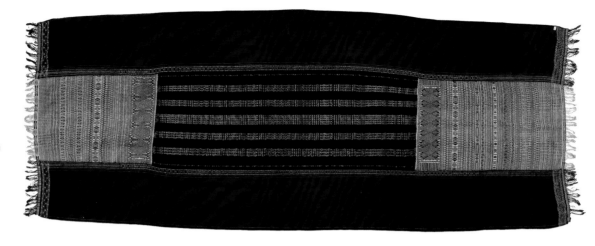

146
Ceremonial textile
– pinunsaan jugia so pipot?[1]
Cotton
Supplementary warp patterning, supplementary weft patterning
270 x 104 cm
Sibolga, Toba Batak, Sumatra
19th/20th century
TM-A-5140
Gift: Artis
Collected by A.L. van Hasselt

147
Toba Batak woman
Photographer unknown
Daylight collodion silver print
Sumatra
20 x 14 cm
1890-1915
TM-60046360
Gift: H.P. Premsela-van Teutem

the soul', and would bestow health and prosperity on the child, the mother and the family. Only after all her children were married and all of them had borne sons and daughters, could a woman, now a grandmother with a certain status, wear this cloth. When someone passed away, this cloth also served as a death shroud. Another textile in the collection resembles a *ragidup*; however, a divergent and rare technique was employed when making the central panel. The dark blue warp threads were not replaced by white threads but were left undyed (white), which was done by binding off this section of the threads prior to dyeing (fig. 145). The next cloth is special for several reasons. Supplementary warp threads were used to apply highly detailed motifs on the red middle panel. Like the *ragidup*, this example has an extended warp in the middle panel (fig. 146).[346] An image in the Tropenmuseum Photographic Collection shows an aristocratic Toba Batak woman wearing a ceremonial cloth with white end panels, with motifs applied with supplementary weft threads (fig. 147). Headcloths, *bulang*, were made with a technique that is similar to that used for the *ragidup*. *Bulang* were a wedding gift from the bride's parents to their daughter and were consequently only worn by married women. Typically, both side panels and the central panel of this type of headcloth are woven from red thread. Cloths with a black/blue middle section are rare (figs. 148, 149).

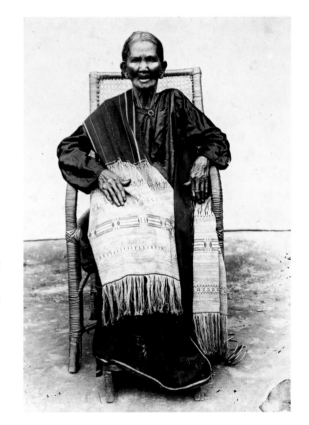

148

Headcloth – *bulang*

Exhibited at the 1910
Brussels World Fair.
Cotton
Supplementary warp
patterning, supplementary
weft patterning
192 x 44 cm
Simalungun Batak, Sumatra
19th/20th century
TM-48-212
Purchase: J.E. Jasper, 1912

149

Headcloth – *bulang*

Cotton
Supplementary warp
patterning, supplementary
weft patterning
185 x 36 cm
Simalungun Batak, Sumatra
19th/20th century
TM-932-12
Gift: Dutch Society for Industry
and Commerce, 1935

Lampung

[T]he woman was regarded as a boat, lying on the beach, waiting for a man who wanted to go sailing. Only when the man – the helmsman or captain – boarded the boat could it set sail, that is, could society come into being.[347]

Representations of boats and ships, varying in size and kind, are the central motif on textiles from the Lampung region in South Sumatra. Hence, the cloths are referred to as 'ship cloths' in the West.
Over the centuries one of the richest textile traditions in Indonesia evolved in Lampung. The complex weaving and decorative techniques, layered iconography as well as the ritual functions that the textiles fulfilled within the society make this textile art a unique artistic tradition. Three Lampung groups, the Abung in the north of this region, the Pubian in the east, and the Paminggir in the southern coastal region, are the best known for their textile traditions.
From the introduction of weaving, about 4000 years ago, external cultures and religions have, over the centuries, influenced the lifestyle and worldview of the archipelago's inhabitants. But these influences did not exert themselves equally everywhere. The southern Lampung region is probably one of the few regions in the archipelago where all the great civilisations and religions that interacted with the archipelago left their mark. Newly introduced cultural elements were adopted by or adapted to the local culture, with the result that it was in constant flux. These cultural innovations were visible in the material culture and especially in the weaving tradition, which reflects the long history of this region.
Like most peoples in the archipelago, cultures in this region are rooted in the Neolithic Period, when groups of migrants, the Austronesians (those who spoke the Austronesian languages), spread throughout the archipelago. Religious concepts such as ancestor worship, headhunting and ideas about cosmology can be traced to this culture. Then, over a period of thousands of years, particularly the coastal regions were exposed to influences from India and China, then the Middle East and, finally, Europe.[348] These influences did not fully penetrate the interior, with the result that the old cultures present there were much less subject to change. Consequently, weaving styles that developed in the inland differ from those in the coastal regions.

The Lampung region maintained close economic and cultural ties with Java, directly across the Sunda Strait. Its strategic location meant that the South Sumatran coast was part of the ancient maritime trading route between India and China. Indian traders were already active in this region around the beginning of the Common Era. In the 7th century, South Sumatra was part of the Buddhist kingdom of Srivijaya (7th–14th centuries). With the decline of the kingdom, Hindu–Buddhist influences reached the Lampung region via Bantam (now Banten) in West Java, a major port for the trade in Sumatran pepper. In the mid-16th century, the influential ruler of Bantam converted to Islam and from then on Islam spread throughout the southern Lampung region. The pepper trade brought great wealth, and vying for status, an important social aspect in this region, grew accordingly. With the collapse of the global pepper trade around 1870, the population sank into poverty. The eruption of the volcano Krakatoa in 1883 and the tsunami that followed destroyed sections of the coast, including Kalianda, an important weaving centre. These events eventually led to the disappearance of the Lampung weaving tradition. The skills required to produce these complex textiles were lost around the turn of the 20th century. The many textiles that were stored locally and only came to the West in the 20th century testify to the former wealth of the Lampung region.
For centuries a variety of ceremonial textiles were produced in the Lampung region. *Tampan* are square cloths woven both on the coast and inland; *tampan maju* are ceremonial mats with representations executed in beads. Large, oblong cloths, *palepai*, were only produced and used on the coast. These items had different functions, but like the *tampan*, were never used as clothing. Ceremonial textiles that were worn as clothing are the richly decorated tubular skirts, *tapis*. In this society, textiles were an indispensable attribute of rites of passage like birth, marriage and death. *Tampan* had multiple functions: they circulated throughout society as ritual gifts; they served as a seat for the bride; newborn children were presented to the grandparents covered with a *tampan*; and when someone died a *tampan* was placed under his or her head.[349] Owning large oblong *palepai* was an exclusive prerogative of the aristocratic families. These cloths were part of the family heirlooms and stayed in the

family for generations. *Palepai* adorned the walls of the house where a ritual was held.

An important goal in this stratified society was climbing the social ladder. Each subsequent stage could be achieved by hosting large feasts of merit in which the candidate shared his wealth with the community by providing copious amounts of food and textiles. The attainment of the highest rank was celebrated extravagantly by ascending the throne, or *papadon* (seat of honour). During celebrations many rituals were performed, including the setting up of a tree-like structure draped with gifts consisting of textiles, mats and baskets. After the festivities ended children took the gifts. If the occasion was a wedding the gifts were presented to the maternal grandparents. This custom is associated with the notion of fertility; as Toos van Dijk writes: '[T]he younger generation grasps the "fruits" from the "tree of life", as it is sometimes called. By doing this the continuity of life is ritually expressed.'[350] The motifs on the textiles have been analysed and interpreted over time by numerous researchers.[351] The ships were seen as 'ships of the dead' that transported the souls of the deceased to the land of the ancestors, or as 'lifeboats' at ceremonies involving potentially dangerous transition rites.[352] Over time, however, opinions changed, and Holmgren and Spertus wrote:

'All these speculations, however, probably are subordinate to the essential symbolism of boats as organized communities'.[353] This idea is also reflected in the literal meaning of the name of the region, 'Lampung', which means 'floating on the water'. The inhabitants, who called themselves 'the people of the sea', saw themselves as the 'crew' of a ship – the Earth – that drifted between heaven (the upperworld) and the sea (the underworld).[354]

As the quotation at the beginning of this chapter implies, Nico de Jonge suggests that besides the image of the boat as a metaphor for society, it was also associated with the origin of the Lampung community as: '[A] more "hidden" form of nautical symbolism […] focussing on the creation of society; this symbolism represented the marriage of the first ancestors.'[355] As a metaphor for 'fertility' the boat denotes the woman who is waiting for the helmsman to create life. This idea was already known in the Austronesian tradition and is frequently found in the cultures of the islands in the east of the archipelago. De Jonge concludes that in the distant past this interpretation of the boat motif as a symbol of fertility in all likelihood prevailed throughout the archipelago.[356] The boat motif is frequently represented in the material culture of the Lampung region, in the houses, in the carriage that transports the bride and groom, and in depictions of boats and ships on the textiles that have been preserved.

Tampan

A mixture of influences is reflected in the *tampan*, particularly in the cloths that were produced in the coastal regions. Prehistoric elements, traces of the Dong Son culture, Hindu–Buddhist ideas and Chinese influences have been detected in the iconography and also in the techniques used. Representations on *tampan* produced inland consist of geometric shapes or a single large representation of a tree, a mythical animal or a house, sandwiched between two small boats. Portraying mythical beings that possess protective powers is well known in the material culture of South Sumatra. On the textiles, the animal's face is proportionally larger and is reminiscent of a voracious monster, the *t'ao t'ieh*, which is seen on Chinese bronzes and ceramics. Inside the creature are human figures who could represent ancestors or influential members of the local elite (fig. 150).[357]

150
Ceremonial cloth
– *tampan darat*
Cotton
Supplementary weft
79 x 63 cm
Lampung, Sumatra
19th century
TM-2125-29
Purchase: C.M.A. Groenevelt, 1951

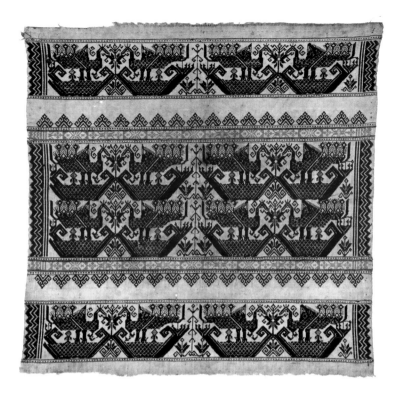

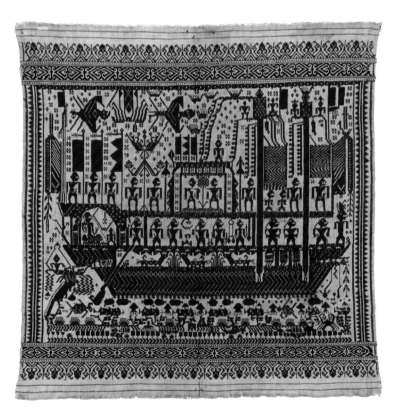

An old *tampan* from the coastal region (radiocarbon dated to between 1499 and 1645) combines the prehistoric boat motif and Indian influences in a refined way. The image consists of a repetition in three layers of the same motif: a boat with a peacock. The peacock, a motif originally from the Asian mainland, was included in the local tradition in the Lampung region as a symbolic animal. This representation refers to the traditional Lampung wedding, with the boat as the bride and the groom as the peacock, and is thus a symbol of fertility (fig. 151).[358]

A large number of textiles have been preserved with depictions of ships of various shapes and sizes. Some show seaworthy vessels with multiple decks, sails of joined mats and equipped with an external rudder. It was with such ships that Asian traders already dominated the seas in this region before 1600.[359] Other textiles have vessels shaped as a dragon boat or a simple stylised boat. These representations radiate wealth and prestige. It appears as if some ritual activities are taking place on the upper deck. It could be a marriage or a status-enhancing ritual (feast of merit) of the aristocracy, who are depicted in and around temple-like structures or beneath a canopy on the deck that is lavishly decorated with banners (figs. 152–156). On some textiles a gamelan orchestra performs on the lower deck, and a pilot with a feathered headdress stands at the front of the boat. Holmgren and Spertus relate this figure to the priests of the Ot Ngaju in South Borneo whose feathered headdress, which was worn during life cycle rituals, represents a ceremonial tree. As an incarnation of the deity, this priest welcomed the guests to the ceremony, including the divine ancestors: '[T]he deities, like the actual human participants, are imagined as arriving at the sacred service in boats laden with valuable gifts for the feast (food, jars, gongs), sacrificial animals, and slaves'.[360] The value attached to the concept of the boat is also reflected in the language spoken in the Lampung region in which nautical terms are used symbolically, as in a children's song that contains the words 'my ancestor was a seaman', or in the naming of priests and local leaders as 'helmsman' or 'captain'.[361] Representations that refer to a prehistoric origin are the boat itself, and also the birds and human figures representing the upperworld in the sky above the ship, with the aquatic animals in the sea around

< 151
Ceremonial cloth
– tampan pasisir
Cotton
Supplementary weft
62 x 61 cm
Lampung, Sumatra
Date 14C: 1499–1645,
95%-confidence interval
TM-1772-1529
Gift: W.G. Tillman, 1994

< 152
Ceremonial cloth
– tampan pasisir
Cotton
Supplementary weft
71 x 69 cm
Lampung Bay, Sumatra
Date unknown
TM-1772-1547
Gift: W.G. Tillman, 1994

153
Ceremonial cloth
– tampan pasisir
Cotton
Supplementary weft
71 x 73 cm
Semangka Bay, Lampung,
Sumatra
Date 14C: 1528–52, 1634–65,
or 1787–93, 95%-confidence
interval
TM-2125-24
Purchase: C.M.A. Groenevelt,
1951

154
Ceremonial cloth
– tampan pasisir
Cotton
Supplementary weft
79 x 72 cm
Lampung, Sumatra
Date unknown
TM-2125-11
Purchase: C.M.A.
Groenevelt, 1951

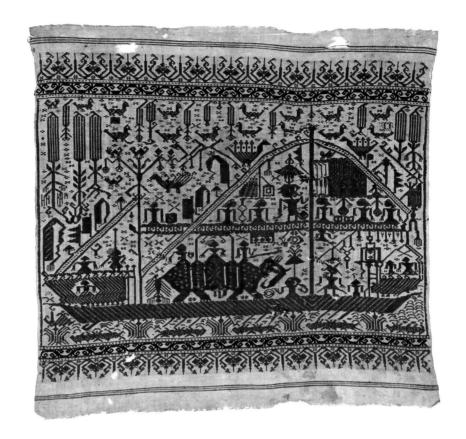

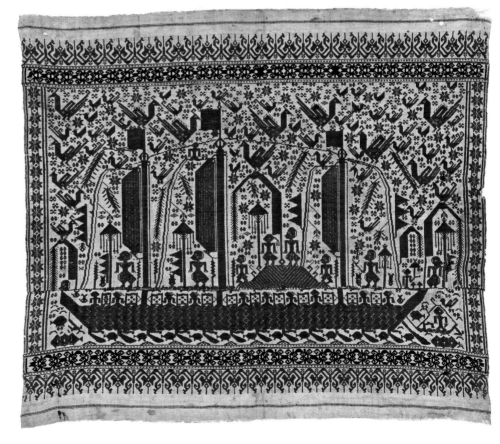

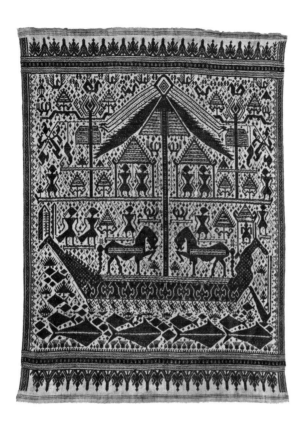

the boat representing the underworld. In addition to the 'female' and 'male' aspects of the boat and the helmsman, the 'male' upperworld and the 'female' underworld also expressed the union of a man and a woman and the ongoing sequence of the generations. Besides the various human figures, several animals such as the elephant, the hornbill and the water buffalo are also depicted on the textiles. In the Lampung region these were associated with power, victory and prestige. These native species are accompanied on the cloths by mythic animals introduced from India and China, like the *garuda* bird, the mount of the Hindu god Vishnu, and the dragon, *naga*, which is associated in China with imperial power and fertility.[362] The presence of these prestige animals acknowledges the importance and high status of the people on the upper deck. The Lampung region maintained close economic and cultural ties with nearby Java. This relationship is reflected in the representations on the textiles that are reminiscent of Javanese *wayang* theatre, both in the form of *wayang kulit* in which dark

155
Ceremonial cloth
– *tampan pasisir*
Cotton, gold thread
Supplementary weft
92 x 68 cm
Semangka Bay, Lampung,
Sumatra
Date unknown
TM-1772-1278
Gift: W.G. Tillman, 1994

156
Ceremonial cloth – *tampan*
Cotton
Supplementary weft
75 x 70 cm
Kalianda, Lampung, Sumatra
Date 14C: 1650–80 or
1764–1801, 95%-confidence
interval
TM-1969-1
Purchase: B. Zorab, 1950

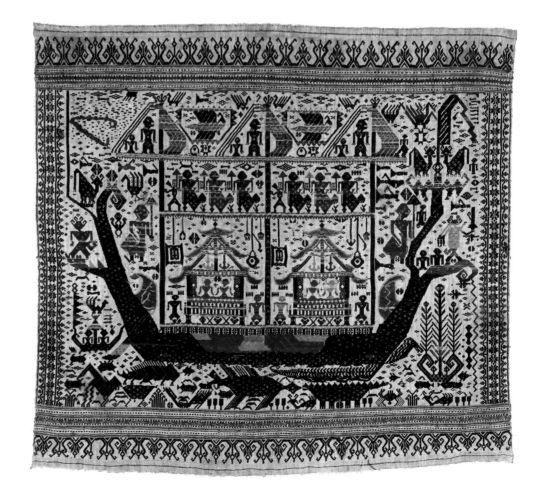

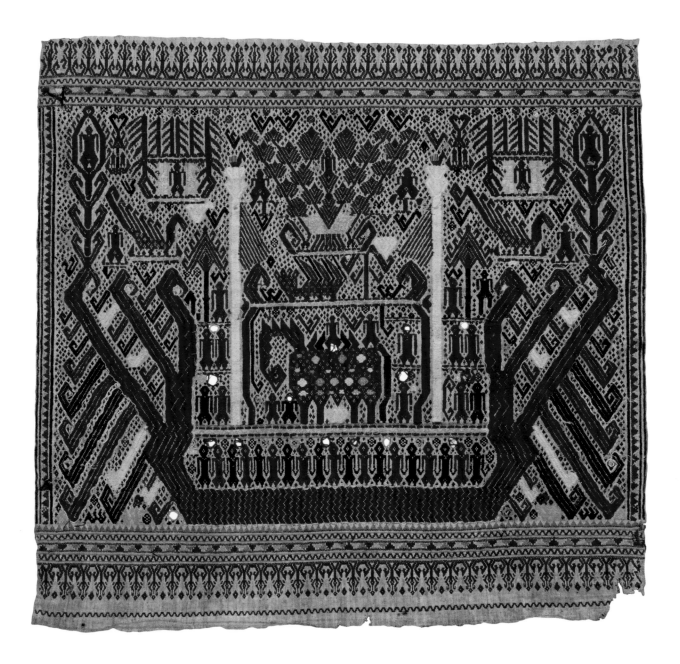

157
Ceremonial cloth – *tampan*
Cotton, mica
Supplementary weft
75 x 70 cm
Kalianda, Lampung, Sumatra
19th century
TM-1772-1553
Gift: W.G. Tillman, 1994

shadow figures act against a light background, as well as *wayang beber purwa*, where a painted scroll depicting the events in the story is unrolled during the narration.[363] Those on board the ship wear court dress similar to that worn at the Javanese royal courts. They are dressed in a ceremonial garments, '*dodot*', wear ritual daggers, *krisses*, and are accompanied by attendants with parasols. *Tampan* made in Kalianda show similarities to the representations on *palepai* with respect to imagery and use of colour (fig. 157).

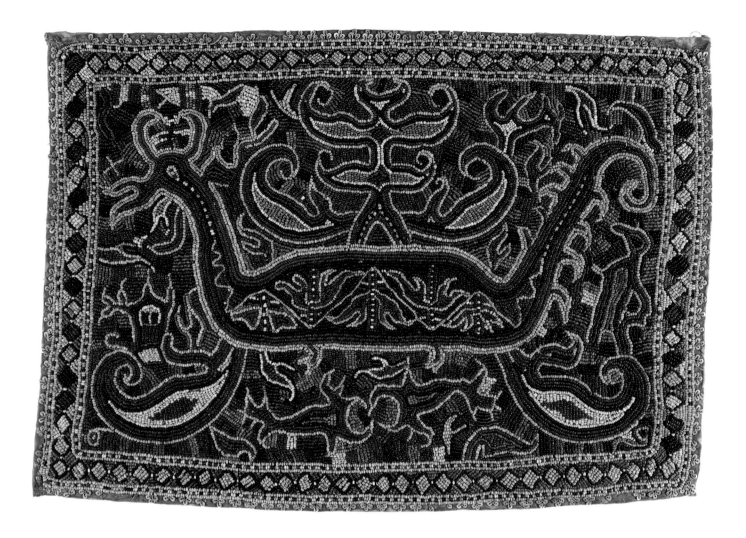

158
Beaded mat – *tampan maju*
Vegetable fibre, cotton, *muti
salah* beads, glass beads,
nassa shells
87 x 61 cm
Lampung, Sumatra
Date 14C: 1696–1727,
1814–39, 1842–54, or
1868–1918, 95%-confidence
interval
TM-1772-497
Gift: W.G. Tillman, 1994

Tampan maju

A few years ago, the Tropenmuseum received
a special gift, a *tampan maju*. The museum already
considered itself fortunate to have a *tampan maju* in
the Tillmann collection. It is thought that these mats,
on which representations are depicted with beads
and shells, including the ancient *mutisalah* bead,
were among the gifts the groom gave to the bride.
The term '*maju*' refers to the status of 'married
woman', which the bride attains at her wedding.[364]
The two beaded mats differ broadly. One shows
a boat in the form of a *naga*, a dragon. In the middle
of the deck is a tree with a large bird on one of the
branches. An anthropomorphic creature stands at
the stern, and mythical aquatic creatures and birds
complete the scene. The second *tampan maju* has

a completely different, more abstract representa-
tion. What could be human heads adorned with
the *siger*, the ceremonial head ornament shaped
as a boat, are placed above and below the central
motif (figs. 158, 159).
Tampan and *tampan maju* seem to be strongly
associated with marriage and the notion of fertility.
Palepai, the large impressive hangings owned
by the aristocracy, were essential attributes at
ceremonies celebrating the achievement of
a high status.[365]

159
Beaded mat – *tampan maju*
Cotton, *muti salah* beads,
glass beads
80 x 73 cm
Date 14C: 1695–1727,
1813–54, or 1868–1919,
95%-confidence interval
Lampung, Sumatra
TM-5996-1
Loan: Th. B. de Clerq-Zubli
(bequest)

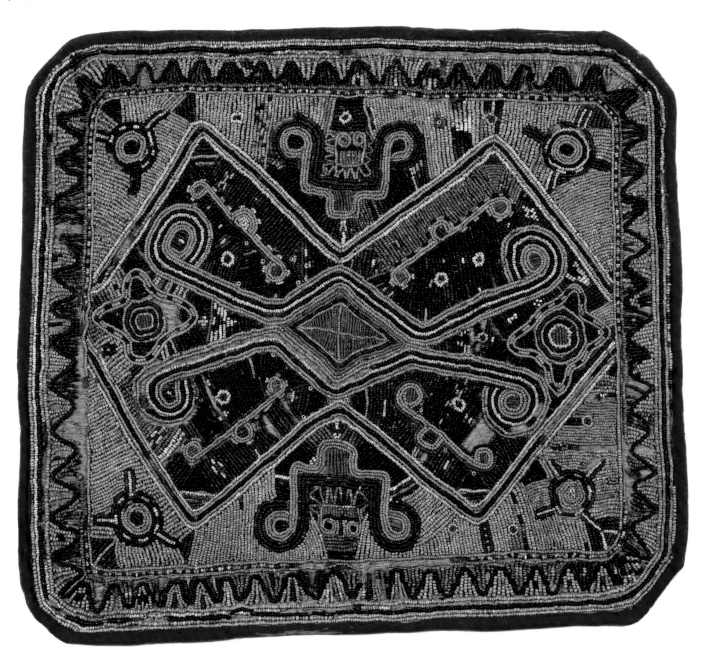

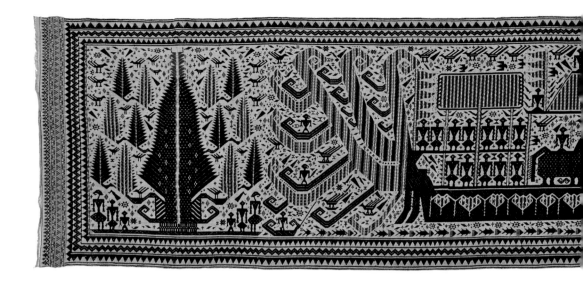

160
Ceremonial textile – *palepai*
Cotton, silk, gold thread
Supplementary weft
285 x 61 cm
Kalianda, Lampung, Sumatra
Date unknown
TM-1969-4
Purchase: B. Zorab, 1950

161
Ceremonial textile – *palepai*
Cotton, mica
Supplementary weft
248 x 62 cm
Lampung, Sumatra
Date unknown
TM-1772-1326
Gift: W.G. Tillman, 1994

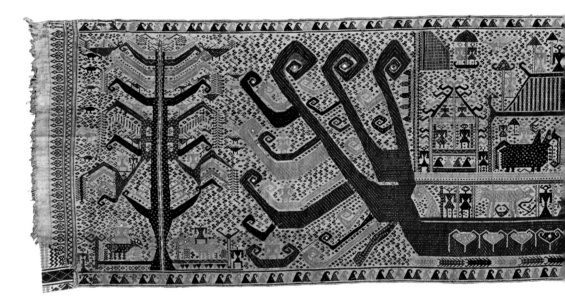

Palepai

On *palepai* one or two vessels are depicted either in red or blue. De Jonge hypothesises that, in contrast to the portrayal of ships on *tampan*, *palepai* show boats with a forked stern from the front. On the deck two large animals (elephants or water buffaloes), each with one or more persons on their back, are depicted below a canopy. These animals, the elephant as the mount of the brave warrior and the water buffalo as a symbol of wealth and prosperity, represent the high status of the owner of the cloth and his family. Although there were elephants in South Sumatra, it has been assumed that the depictions of these animals were influenced by the *patola* from India with representations of elephants.[366]

The use of these cloths is connected to the ceremony that was held when ascending the *papadon*, the throne. Supposedly, *palepai* were wrapped around the base of the throne, which was decorated with woodcarvings. When used thereafter as wall

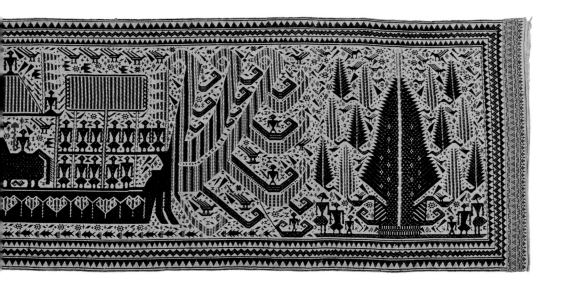

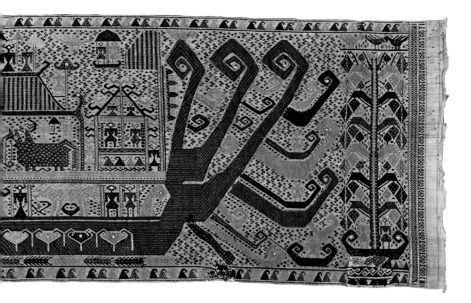

hangings in other rituals, these cloths were seen as
the representation or manifestation of the accession
to the throne. The order in which the textiles were
hung in the ceremonial space where the aristocratic
families were assembled correlated with the order
of the *papadon* seats and the corresponding status
of each family group (figs. 160–164).[367]

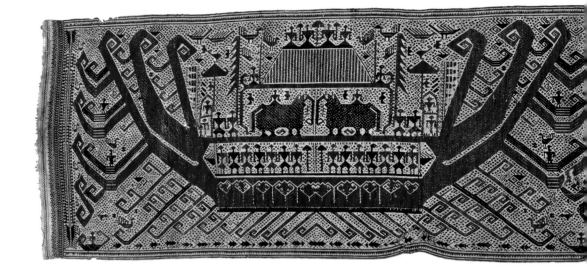

162
Ceremonial textile – *palepai*
(idem)
Cotton
Supplementary weft
288 x 62 cm
Lampung, Sumatra
Date 14C: 1662–83 or
1736–1805, 95%-confidence
interval
TM-1772-1276
Gift: W.G. Tillman, 1994

163
Ceremonial textile – *palepai*
(idem)
Cotton
Supplementary weft
292 x 65 cm
Lampung, Sumatra
Date unknown
Purchase: C.M.A. Groenevelt,
1951

164
Ceremonial textile – *palepai*
(idem)
Cotton, silk, gold thread, mica
Supplementary weft
276 x 62 cm
Lampung, Sumatra
Date unknown
TM-1772-1536
Gift: W.G. Tillman, 1994
Collected by C.M.A.
Groenevelt in Batavia (Jakarta)
in 1937

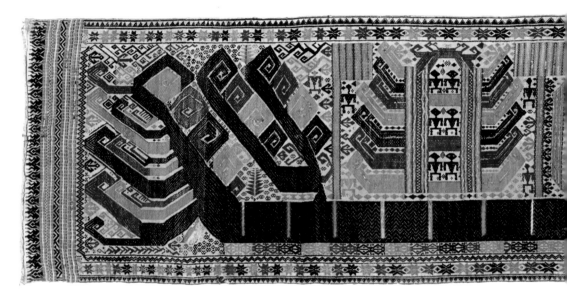

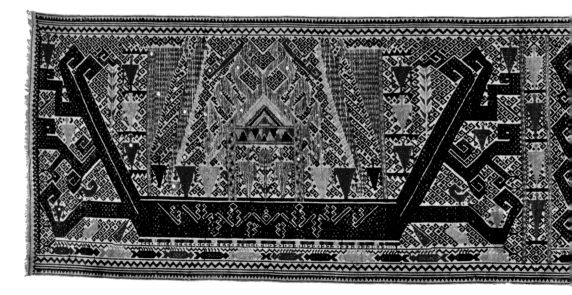

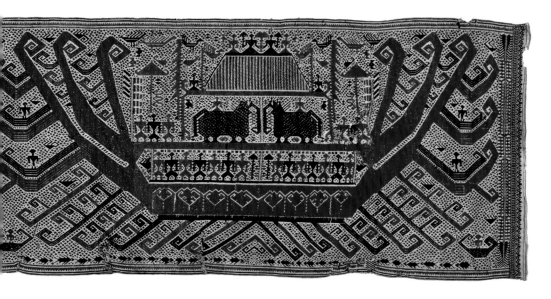

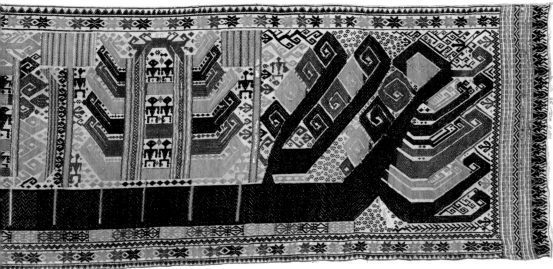

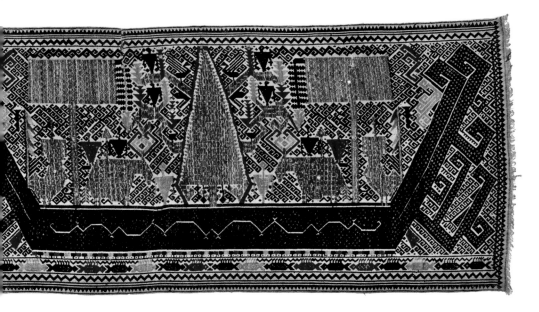

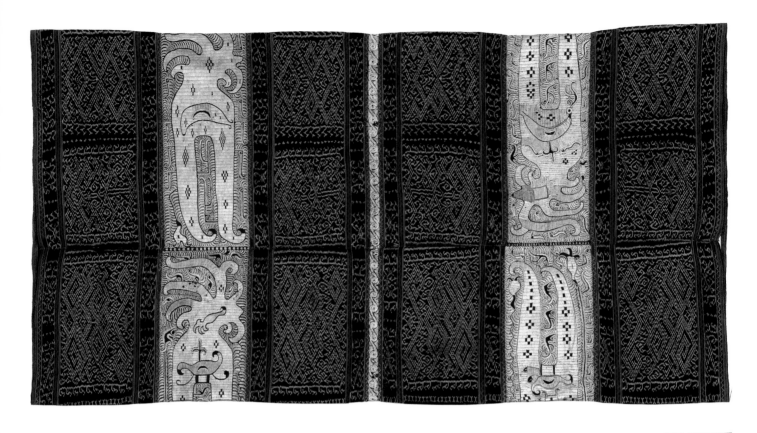

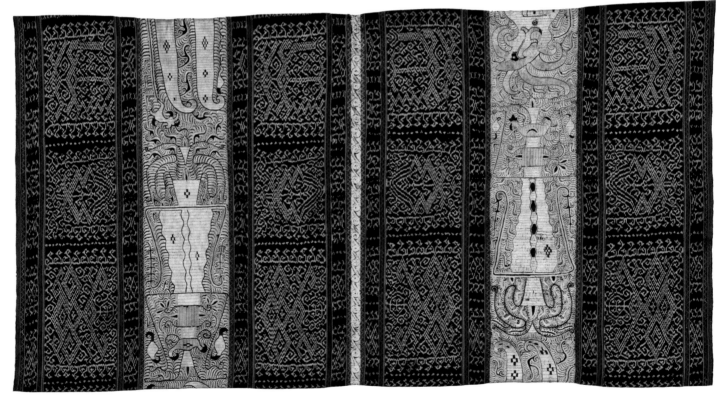

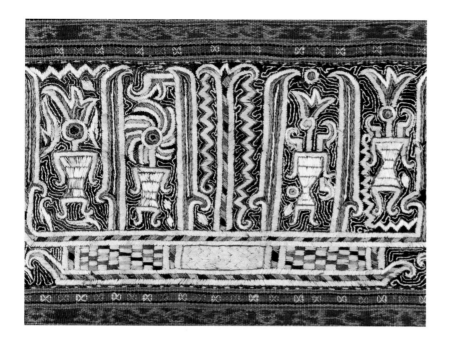

Tapis

In the Lampung region tubular skirts for women, *tapis*, were provided with representations that preserve the old original culture. These ceremonial garments also belonged to the ritual attributes that were used in various rites of passage.

Different types of *tapis* were made inland and on the coast. The tubular skirts were richly decorated with *ikat* on the warp threads, silk embroidery, figures applied in gold thread, or adorned with countless pieces of mica.

The representations consist of ships with crews of feathered human figures, with animals, dwellings and trees and plants, but also abstract motifs or figures, the meanings of which are unknown. Ancient motifs consisting of hooks and crosses in *ikat* on the warp threads are combined with silk embroidered 'anthropomorphic (aquatic) creatures'. These and

< 165
Ceremonial skirt – *kain inu*
Cotton, silk
Warp *ikat*, embroidery
124 x 67 cm
Lampung, Sumatra
Date 14C: 1649–76 or
1778–1800, 95%-confidence
interval
TM-1772-1332
(both sides)
Gift: W.G. Tillman, 1994

166
Ceremonial skirt – *tapis*
(+ detail)
Cotton, silk
Warp *ikat*, embroidery
125 x 116 cm
Lampung, Sumatra
Date unknown
TM-1772-1514
Gift: W.G. Tillman, 1994

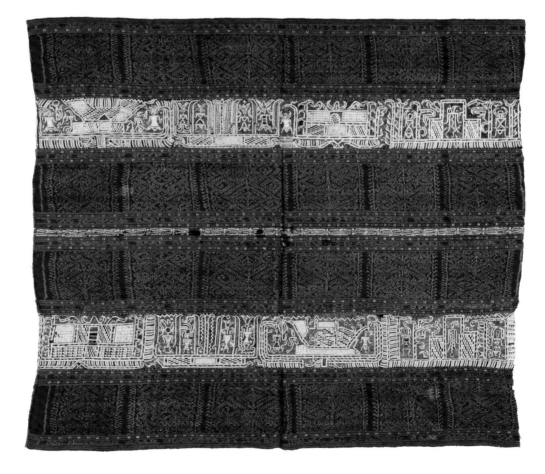

167
Ceremonial skirt – *tapis*
Cotton, silk
Warp *ikat*, embroidery
120 x 120 cm
Lampung, Sumatra
Date unknown
TM-1772-1513
Gift: W.G. Tillman, 1994

168
Ceremonial skirt – *tapis*
Cotton, silk
Laid-in supplementary weft
108 x 105 cm
Lampung, Sumatra
Date unknown
TM-1772-1593
Gift: W.G. Tillman, 1994

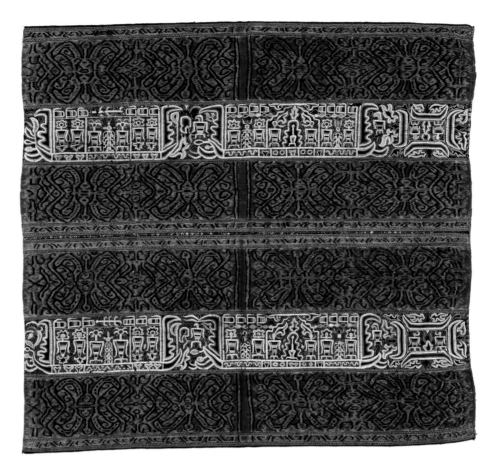

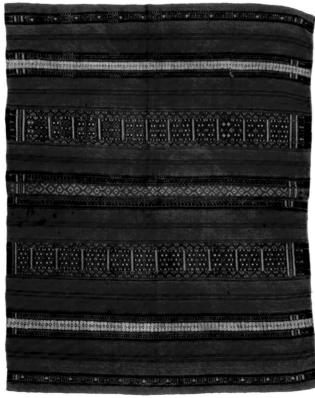

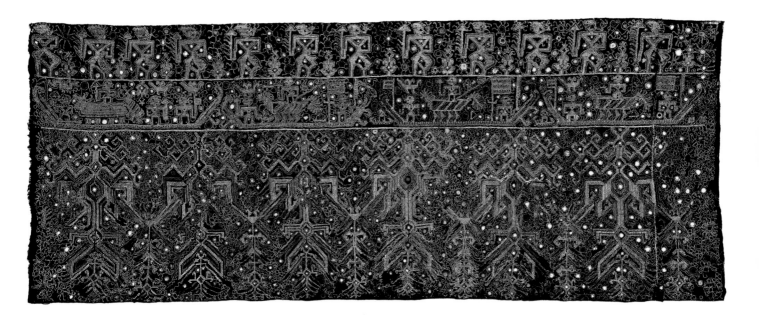

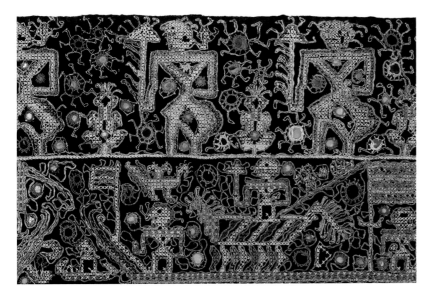

169
Fragment of ceremonial textile (+ detail)
Cotton, silk, mica
Embroidery, couching
124 x 49 cm
Lampung, Sumatra
19th century
TM-1319-4
Exchange: G. Tillmann, 1939

other motifs and scenes bear similarities to motifs on bronze drums of the Dong Son culture, thus alluding to the possibly great antiquity of this weaving tradition (figs. 165–168).[368]

A textile fragment, perhaps a panel to embellish a tubular skirt, is decorated with embroidery and sequins. The representation consists of people with parasols, boats with human figures seated on a riding animal, and intricate tree-like or anthropomorphic figures. Some motifs are reminiscent of figures on *sungkit* textiles made by the Iban in Sarawak (fig. 169).[369]

Due to the variety of materials and colours and the richness of the representations, the iconography on these textiles reflects the cosmopolitan character of the coastal region, which because of its strategic position was exposed to numerous foreign cultural and religious influences through the ages. Unfortunately, no anthropological field research could be conducted into the meaning of the production techniques in relation to the importance of the textiles in Lampung, as the weaving tradition was lost around the turn of the 20th century.

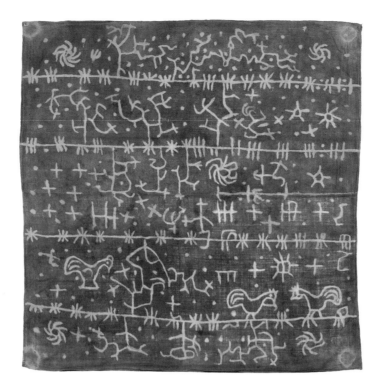

170
Sacred cloth – *kain simbut*
Mr. Suyk was the owner
of the Gunung Rosa tea
plantation in Lampegan,
West Java.
Cotton
Rice paste batik
168 x 156 cm
West Java
19th century
TM-591-1
Gift: H.L. Suyk, 1930

Java

Nyi Pohaci (Dewi Sri), goddess of rice, meditated in the upperworld on how she could best serve humanity and protect it from both physical and supernatural harm. To achieve this she made the plant world subservient to humans. She knew a mountain where a diamond fruit grew on a golden tree with silver leaves. She asked a human being to pick it for her. When Nyi Pohaci opened the fruit, white flakes sprang out. From these she spun the first thread. In order to weave this thread Nyi Pohaci offered up parts of her own body to build the first loom.[370]

Java has had a rich and diverse textile tradition in which textiles were created using a variety of weaving and decorative techniques. As on other islands, a number of them have also disappeared on Java. The batik technique has managed to survive despite all the changes and threats posed by technological advances. This technique became well known in the West and large collections of batik cloths were assembled, also in the Tropenmuseum. Batik became the most intensively studied textile technique in the Netherlands. Various batik styles have developed on Java, the most famous being those from Central Java and the North Coast (*pasisir*). In addition to Java, batiks were also produced in Jambi on Sumatra, on the island of Madura and on Sulawesi. With a few exceptions, batik cloths are generally used as clothing. The rectangular or square cloths, in some cases sewn into a tube, are wrapped around the body or used as shoulder cloths. Wearers identified their origin by region, ethnic group and social class through their choice of batik style. Each period in Java's history was accompanied by changes that also affected the appearance and use of batik dress.

Origin of batik
Batik is a widely studied textile decorative technique.[371] Although little is known of its origins, in the course of time scholars have developed several hypotheses. Certain handspun and handwoven batiks are possibly redolent of an early form of motif application in which the resist was applied with a cruder implement than the wax pen. Examples include the *kain simbut* from West Java, blue and white batiks from Ceribon on Java's north coast (figs. 170, 171, 174), and from Sulawesi (see fig. 203).
The patterns on the *kain simbut* were created by drawing with the resist (rice paste) on the fabric with a finger or a bamboo stick. Then the cloth was dyed

171

Tubular skirt – *sarung*
Two large *wayang* figures, Prince Panji and Princess Candra Kirana, are portrayed on this cloth embellished with gold leaf. The text below the figures reads: 'Radhen Pandji Iennnoe Karto pati, Anaknja Radja Djengolo en Radhen Galoo Tjondro Kirono, Anaknja Radja Kedirie'. Prince Panji's hipcloth shows the *kembang tarate* motif, representing the lotus flower. Princess Candra Kirana wears a breastcloth, a *kain kembangan*, and a batik hipcloth, with a *Kala* (demon) head and *semèn*-motif. According to the museum's records, both of these tubular skirts were presented to the wife of a prominent Dutch government official between 1850 and 1860.
Cotton, gold leaf, batik, painted
208 x 114 cm
Semarang, Java
19th century
TM-903-16
Bequest: Maurits Enschedé, 1934

red and the resist removed. This batik technique was practised in West Java until circa 1900. Magical and protective powers were attributed to *kain simbut*. They served as blankets or as cloth partitions at ceremonies centred on life cycle rituals.[372] The first mention of patterned textiles that might allude to the batik technique is in 12th-century Javanese charters. There is a reference to *tulis* (*tulis warna*, *tulis* = writing, drawing, outlining, *warna* = colour), a term that was later used in combination as *batik tulis*: applying the resist, the wax, using the wax pen. *Tulis mas* (drawn with gold) is also mentioned and may refer to what is now called *prada*: the decoration of textiles with motifs in gold leaf.[373] An interesting relationship exists between the proto-Austronesian word '*beCik*' and '*batik*'. The former means 'tattooing, the application of motifs on the skin', and '*batik*', 'creating patterns on fabrics used as clothing'.[374] Moreover, Anthony Reid states that healing and protective powers were attributed to specific tattoo and batik motifs.[375] Thus, in the legend of Prince Panji, a hero from a Javanese epic *wayang* story, it is said that the *parang rusak* motif protected him during his perilous travels.[376] A Javanese myth recounts the introduction of batik from India to Java's north coast. Supposedly, a princess from the

Coromandel Coast brought the arts of weaving, batik and dyeing with her around 700 CE when she married a legendary prince of Janggala (a kingdom near Surabaya on Java's north coast) (figs. 172–175).[377] Following studies by Dutch researchers such as G.P. Rouffaer and J.E. Jasper around the turn of the 20th century, the batik style of the Central Javanese courts was for a long time considered as the most original form of batik on Java. At that time there was widespread interest in the old civilisations of the Hindu kingdoms in Asia (see Chapter 'Textiles in Indonesia'). Batik was compared to a centuries-old resist dye technique used in India, which, influenced as they were by Hinduism, would have been introduced to the Central Javanese royal courts. The use of the wax pen (*canting*), a tool used only in Indonesia to apply the hot wax to the fabric, was probably a Javanese invention. Hence, the Dutch researchers focused their studies on the batik clothing of the Central Javanese courts. G.P. Rouffaer wrote about this in 1900: 'My firm conviction is: the seed of the Javanese batik came from abroad; primarily introduced by Klingalese and Coromandelese Hindus who since 400 CE have exerted their influence over Java, first as seafaring merchants, then as immigrant colonisers'.[378]

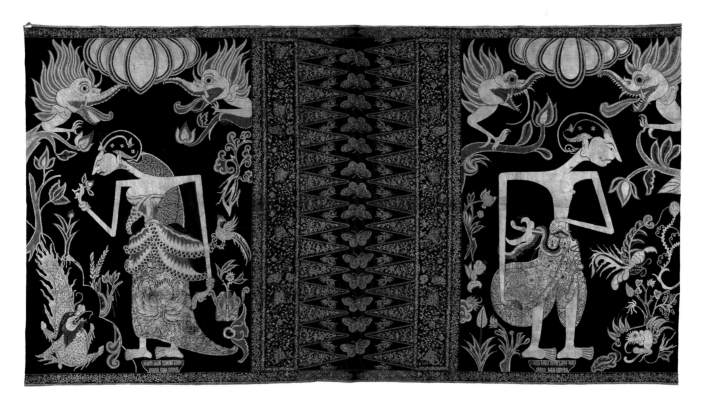

THE STORY OF PRANJI AND CANDRA KIRANA

The cloth is made of the finest quality cotton from the Netherlands called 'primissima'.

The centre panel, *kepala*, is decorated with motifs in the batik technique; the representations in the squares were painted directly on the cloth and embellished with gold leaf. This *sarung* was possibly made around 1850 in Carolina Josephina von Franquemont's workshop in Semarang. Von Franquemont was one of the first Indo-European batik entrepreneurs who became known for the quality of the batiks she produced. The cloth shows the love story of the Javanese prince Panji and his bride Candra Kirana.

The names of the different characters in this *wayang* story are in Javanese script beneath the image. The squares are positioned in such a way that when the textile is sewn into a tube, and is worn in the correct way, the story can be 'read' in the correct sequence.

172
Tubular skirt – *sarung*
Cotton
Batik, painted
208 x 114 cm
Semarang, Java
c. 1850
TM-903-15
Bequest: Maurits Enschedé, 1934

173
Hipcloth – *dodot*
Cotton
Batik
290 x 150 cm
Cirebon, Java
19th century
TM-807-1
Purchase: Boeatan, 1933

174
Hipcloth – *kain panjang*
Cotton
Batik
226 x 108 cm
Cirebon, Java
19th century
TM-A-4948
Gift: Artis

175
Fragment of an Indian tradecloth
Cotton, block-printed, mordant-dyed, resist-dyed
130 x 41 cm
Coromandel Coast, collected in Indonesia
18th century
TM-6361-5 (See fig. 10)
Purchase: T. Murray, 2009
With support from the Mondriaan Fonds/Bank Giro Loterij

Rouffaer and others theorised that batik had spread from the principalities (*de Vorstenlanden*) to other regions on the island. The brightly coloured batiks produced on the north coast of Java were seen as a later development, a response to the disappearance around the turn of the 19th century of imported multicoloured tradecloths from India. The renowned batik expert Rens Heringa developed a new theory in the 1980s.[379] Heringa propounded the idea that the influence is likely to have spread in the opposite direction. Between the 12th and 17th centuries, prosperous ports were established on the north coast as a result of the blending of local Javanese–Chinese traditions with those of Muslim migrants from Southern China. Heringa: '[…], recent studies have amply demonstrated that Central Javanese court culture only developed in the early seventeenth century and benefited considerably from the downfall of the rich trade ports of the north coast'.[380] Over the centuries, the *pasisir* style developed along this multi-ethnic northern coastline, which, according to Heringa, '[…] has retained aspects from an earlier phase in batik development, while Central Javanese designs are the result of a later evolution in which an increasing abstraction took place'.[381]

The fact that batiks made on Java's north coast resemble cloths from the Coromandel Coast probably means that the latter were *Indiennes de commande*, cloths produced in India to suit the tastes and needs of customers on Java.[382]

The North Coast

In the 11th century, the port of Tuban on the East Javanese coast was a vital hub in the spice trade. Chinese, Persian and Indian traders, and from the 16th century, the Portuguese and the Dutch, exchanged their goods here, including Indian textiles, for spices from the Moluccas. The local weaving tradition was already noted in the travel report that appeared at the time of the second Dutch voyage to the archipelago in 1599 (also see Chapter 'Collecting').[383] Rens Heringa made an in-depth study of the textile tradition in the Kerek district, situated between the port cities Lasem and Tuban. She suggests that the textiles in this region may be directly linked to the earliest batik styles of Java's north coast. In the Indonesian archipelago the materiality of objects, their physical form, and cosmological concepts are thought to be closely related. Heringa studied the meaning of materials and techniques, which she calls the 'inward form' of the textiles.[384] Various types of textiles were produced in Kerek, each with its own decorative technique. The most richly decorated cloths, the batiks, were reserved for the elite, who were considered to be descendants of the first inhabitants of this region.

Kerek is comprised of a cluster of hamlets that are grouped according to the principle of the compass around the 'oldest' cluster in the centre, the seat of power. Each of the other clusters is linked to a cardinal direction. According to Heringa each of these directions is metaphorically linked to a stage in a woman's life cycle: the birth of a girl is situated in the East where the sun rises, the physical maturity of the woman in the South, motherhood in the West, and finally being a grandmother and the end of life in the North. The various activities associated with the production of textiles were divided between the clusters in accordance with customary law (*adat*). The 'youngest', in the East, were responsible for cultivating the cotton, the 'mothers' provided the textiles with woven patterns and the 'grandmothers' in the North were the experienced spinners and weavers of the cloth to be used for batik. Although women in all the hamlets knew how to produce batiks, the most experienced batik workers lived in the centre. Each cardinal direction has its own colour combination. The gradations of the entire compass, starting in the East and ending in the North, progressed from light to dark. These colour gradations characterised the cloths that were worn in the different regions. Traditionally, a family of dyers living in the central cluster would dye the batik cloths for ceremonial use. Women from other clusters would bring their waxed cloths to the centre for dyeing.[385] Each life phase had its own colour combinations of batik cloths, which ideally would be produced in the corresponding residential area. Seven different types of cloths can be distinguished on the basis of colour. Three shoulder cloths, *sayut*, that together form an important subgroup, are discussed here. They were worn respectively by daughters, mothers and grandmothers. The red-white cloth, the *bangrod*, was worn by marriageable young women and is associated with the East; cloths with both blue and red colours, *pipitan*, belong to the South and were worn by women with young children.

176, 177, 178
Shoulder cloths – *sayut*
Cotton, batik
282 x 57 cm, 306 x 57 cm,
302 x 56 cm
Tuban, Java
20th century
TM-5663-221, TM-5663-220,
TM-5663-218
Purchase: H.C. Veldhuisen,
1996

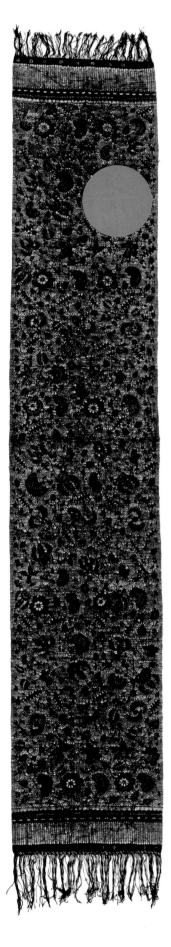

179

Tubular skirt – *sarung*

A Chinese wedding is
portrayed on this cloth:
the bride and groom are
sitting in front of a house altar
in a grand pavilion. Family
members and other guests
are gathered in two smaller
pavilions. Below and above
these buildings is a parade
of men with lanterns and
banners, carriages with horses,
a gamelan orchestra and
a Chinese orchestra.
Cotton, gold leaf, batik
224 x 106 cm
North coast of Java,
Peranakan Chinese
19th century
TM-1996-1
Purchase: W. Vermolen,
1950180

> 180

Tubular skirt – *sarung*

Cotton, batik
106 x 199 cm
North coast of Java,
Peranakan Chinese
19th century
TM-1772-1239
Gift: W. G. Tillman, 1994

The darkest cloth, *irengan*, was for older women and grandmothers from the cluster in the North (figs. 176–178).

In addition to this spatial specialisation of work between clusters, there was also a division of labour within the family, where three generations of women usually lived together. The grandmother, the most experienced, took care of spinning, preparing the warp threads (warping) and wove fine textiles that would be decorated with the batik technique. The tasks of the second generation consisted of applying the hot wax to the cloth and weaving cloths that would not receive batik ornamentation. The youngest generation began learning about the various activities by cleaning cotton and taking care of other preparatory processes. When they reached marriageable age they were considered capable of weaving a cloth.

Just as on other islands, in Kerek the dyeing process was imbued with mystery and ritual, especially when it came to the sacred blue dyeing with locally grown indigo. Heringa states that the indigo vat is seen as a metaphor for the womb.[386] In Kerek this stage in the textile manufacturing process was related to fertility and the reproductive role of women.

Until the beginning of the 19th century, the production of batik cloths on Java was a cottage industry in which the batiks produced were solely for family use. During the 19th century production was commercialised due to the mercantile activities of the Peranakan Chinese and the import of machine-woven cotton from India, England and the Netherlands.[387] Besides the Peranakan Chinese, Indo-Arab and Javanese traders, after 1840 Indo-European women also started running batik workshops. The various batik styles produced on the North Coast were collectively known as *batik pasisir* (*pasisir* = coast). The different ethnic groups who lived here each developed their own batik style with different colour combinations and choice of patterns. Batiks made by the Peranakan Chinese are characterised by the use of soft pastel hues for young women and darker colours for older women. Besides various seasonal flowers, birds and mythical animals are also preferred subjects to depict on batiks. Colours and motifs often refer to happiness, prosperity and longevity (figs. 179–182). Indo-Arab women opted for deeper colours and geometric patterns.[388] Inspired by modernity, Indo-European entrepreneurs introduced a number of innovations both in the arrangement of the patterns on the cloth as well as in the choice of motifs and patterns. Representations included floral bouquets, themes such as love and marriage, transportation, fairy tales, opera scenes, etc. They started signing their work in the batik technique from circa 1860, not only to indicate that the design was theirs but also to underscore the excellence of the work.[389] Cloths made on the North Coast were traded and worn throughout Indonesia (fig. 183, 184).

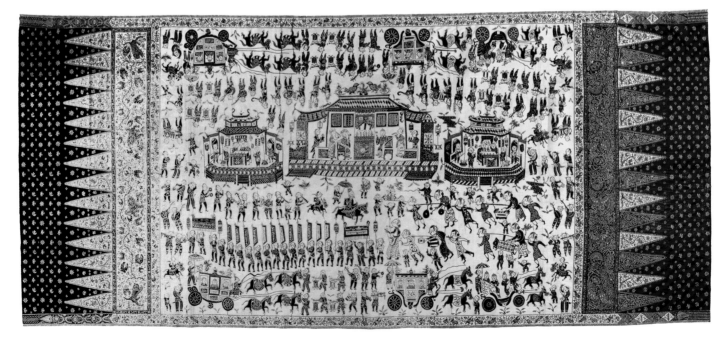

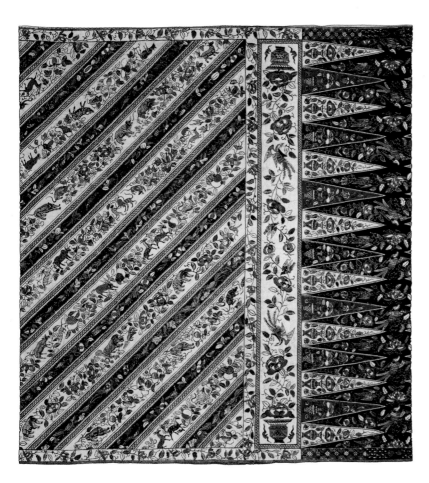

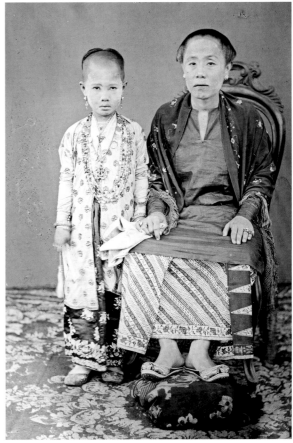

181
**Portrait of a Chinese
mother and child**
Photographer unknown
9 x 12 cm
Java
1918
TM-10005174
Provenance unknown

182
Hipcloth – *kain panjang
pagi sore*
The skirt was produced
in the workshop of Oey
Soe Tjoen, a Chinese batik
entrepreneur known for
his high-quality batiks.
Cotton, batik
240 x 108 cm
Kedungwuni, Java,
Peranakan Chinese
20th century
TM-3640-1
Purchase: R. Abdoerachman,
1967

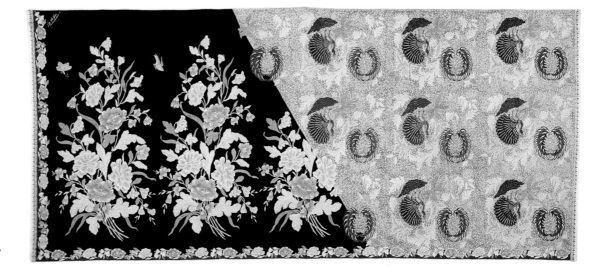

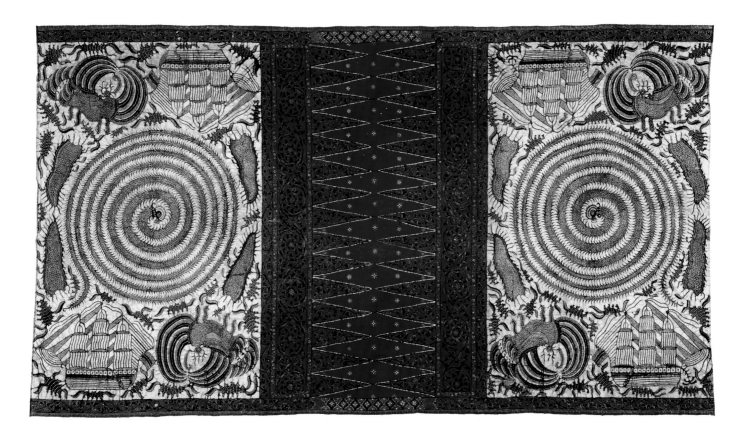

183
Tubular skirt – *sarung*
Possibly made for export
to Jambi, Sumatra.
Cotton, batik
194 x 108
Lasem, Java
19th century
TM-A-4961

184
Tubular skirt – *sarung*
An Indo-European tubular
skirt, decorated with floral
bouquets, birds, butterflies
and insects and an ornamental
border in Art Nouveau style.
The tubular skirt was made
in E. Coenraad's workshop
in Pacitan.
Cotton, batik
218 x 107 cm
Pacitan, Java
c. 1910
TM-5663-575
Purchase: H. Veldhuisen,
1996

Central Java

Halfway through the 18th century, wars and political intriguing resulted in the partition of the sultanate of Mataram (founded in the 16th century) into two realms: Surakarta and Yogyakarta. In accordance with Hindu–Buddhist tradition the rulers of both kingdoms were seen as the 'centre of the universe'. Their power and status was, among other privileges, apparent from their clothing, especially when it came to the size of the hipcloths and the special batik patterns that could only be worn by the rulers and their inner circles.

The most important batik cloths that were traditionally worn at these courts were the *dodot*, large ceremonial hipcloths; the *kain panjang*, a hipcloth; the *kemben*, worn by women as a breastcloth; and the rectangular headcloth for men, the *iket*. Tubular skirts, *sarung*, were not among the traditional clothing worn at the courts. This changed over time, as did the restrictions on the 'forbidden patterns', which beyond the influence of the court, were also worn by ordinary citizens.

A unique Central Javanese batik style developed at the royal courts of Surakarta and Yogyakarta that was intrinsic to the refined artistic life at court. This applied to both the choice of patterns and the beige, brown and blue tones that were sombre in comparison to batiks from the North Coast. The batik styles of the two principalities differ. Colours and designs on batik produced in Surakarta are considered more sophisticated, batiks from Yogyakarta more powerful. The background

185
Hipcloth – *kain panjang*
A batik hipcloth with the *tambal* motif (*tambal* = patchwork).[2] This pattern comprises a multitude of small shapes, each with a different motif. The *tambal* motif is associated with patchwork garments such as the ceremonial jacket *Kyai Antakusuma* (see fig. 95).
Cotton, batik
269 x 109 cm
Yogyakarta, Java
19th century
TM-A-5200
Gift: Artis

186
Hipcloth – *kain panjang*
Cotton, batik
252 x 106 cm
Surakarta, Java
19th/20th century
TM-2160-46
Bequest: W.T.C.C. Pijnacker Hordijk (1867–1938), 1952

187
Hipcloth – *dodot*
Cotton, batik
352 x 213 cm
Yogyakarta, Java
19th/20th century
TM-1772-1226
Gift: W.G. Tillman. 1994

of the Surakarta batik is cream coloured, the browns are warm and gold-like and the indigo blue is deep and dark. In Yogyakarta the backgrounds are lighter, almost white, and the browns and blues are bright (figs. 185–187, also see figs. 34, 42).[390]

During their occupation of Java (1942–45) the Japanese introduced a new batik style, 'Hokokai', named after the Japanese organisation that was founded to indoctrinate the youth of Indonesia with Japanese dogma.[391] These cloths are characterised by a combination of motifs from Central Java and the North Coast executed in *pasisir* colours (fig. 188). After Indonesia declared independence in 1945, K.R.T. Hardjonogoro was asked by the first president of the republic and his friend Sukarno to produce a 'batik Indonesia' that would unite the styles of Central Java and the North Coast. K.R.T. Hardjonogoro was born as Go Tik Swan to a Chinese family in Surakarta in 1931, and was raised by his grandfather, a batik entrepreneur. Hardjonogoro became an expert on Javanese culture and the associated art forms such as Javanese literature, dance and batik art. He designed batik patterns that were executed in a small workshop next to his house. Hardjonogoro felt that batik

– applying hot wax to a cloth in a constant repetition of motifs – was a form of meditation. He created a design dedicated to Ibu Megawati Sukarno Putri, Indonesia's president from 2001 to 2004. His pattern expressed Ibu Megawati's development from being a little girl to becoming an important political leader in Indonesia.[392] In the past batiks were commissioned for special events, such as congresses (see figs. 46, 79). In 1999, the Tropenmuseum commissioned a batik for the exhibition *Drawn in Wax – 200 Years of Batik Art from Indonesia*. It was made by Linas Batik Cirebonan in Cirebon. With this textile the Tropenmuseum hoped to perpetuate a tradition of commissioning textiles for exhibitions and conferences (fig. 189, 190).

In 2009 batik was recognised internationally as one of the most important forms of Javanese handicrafts and was placed on the UNESCO World Heritage list.

188
Hipcloth – *kain panjang pagi sore*
Cotton, batik
248 x 107 cm
Pekalongan, Java
1942–45
TM-5663-965
Purchase: H. Veldhuisen, 1996

189
Hipcloth – *kain panjang*
Cotton, batik
266 x 103 cm
Surakarta, Java
Late 20th century
TM-5926-4
Purchase: Itie van Hout, 2001
With support from the Mondriaan Fonds

190
Tubular skirt – *sarung*
Silk, batik
244 x 107 cm
Cirebon, Java
2000
TM-5942-1
Purchase: Itie van Hout, 2000

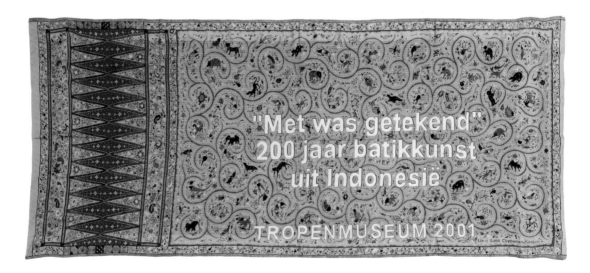

191
Dress
Bamboo, cotton
Embroidery, tablet weaving
120 x 118 cm
Minahasa, Sulawesi
Before 1887
TM-A-6460
Gift: Artis

192
Tubular skirt – *kain bentenan*
Cotton
Warp *ikat*
162 x 72 cm
Minahasa, Sulawesi
Date 14C: 1665–89 or 1730–1810, 95%-confidence interval
TM-48-13
Purchase: J.E. Jasper, 1912

Sulawesi

Sulawesi, in the east of the archipelago, is an irregularly shaped island that is often compared to a spider, where various weaving traditions have developed along the southern and northern coasts and in the mountainous interior. The Tropenmuseum collection has fabrics and garments from each of these regions. Most objects were collected in the Toraja region and other surrounding communities in the interior, which was hard to access until the end of the 19th century.

The north, called Minahasa, and the south, where the Bugis and Makassar peoples live, had already been major regional and inter-regional trading hubs for centuries. From the 16th century onwards, ethnic groups in the northern part of Minahasa largely succumbed to European influence. After the Spanish and Portuguese, the VOC followed in the mid-17th century. In 1679, the leaders of the region collectively signed a trade agreement with the Dutch. Close relationships developed between the Netherlands and this region after the Dutch helped the local rulers defeat a hostile group south of Minahasa in 1693. The population embraced European culture in the ensuing centuries and most of them converted to Protestantism around 1860, leading to the demise of local weaving traditions in this region.

In Minahasa, textiles were made of various materials, such as banana and pineapple fibre, bamboo and cotton. Young bamboo fibres were made pliable by chewing them, and were then processed into yarn. Among other items, this material was used for garments that covered the upper body (fig. 191). *Kain bentenan*, tubular skirts with motifs in warp *ikat* were also made in this region. These tubular

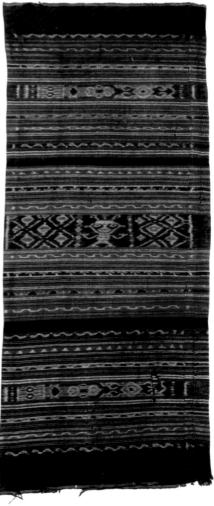

193
Tubular skirt
Cotton
Warp *ikat*
250 x 207 cm
Poso, Sulawesi
Date 14C: 1433–78,
95%-confidence interval [3]
TM-1772-1141
Gift: W.G. Tillman, 1994

skirts were woven on a backstrap loom with circular warp. A special feature of these tubular skirts is that they were entirely woven on the loom: even the last warp threads were provided with a weft, and not cut, as was customary. According to Jasper they were usually executed in two colours, the use of three colours is rare (fig. 192).[393]

Georg Tillmann added a cloth to his collection, the origin of which is specified in the museum records as Flores. The *ikat* motifs on it are strongly reminiscent of those on fabrics from eastern Indonesia, including Flores. However, this tubular skirt is an example of a type of cloth that was made in the Poso region centuries ago (fig. 193). Poso is situated in the northeastern coastal region of Central Sulawesi. Like the *kain bentenan* from North Sulawesi, this cloth was made entirely on a loom

by applying the last weft threads manually.[394] It was then cut to create a rectangular cloth, probably outside its region of origin. The textile was radio-carbon dated to between 1433 and 1478.

The seafaring Bugis and Makassar peoples in the south are known for their chequered cotton hip-cloths that were made on a loom with a reed and discontinuous warp (see fig. 11). These cloths were calendered to make them shiny for high-ranking people.

The Tropenmuseum's collection from Sulawesi consists mainly of textiles, garments made of barkcloth, and beaded objects from the northern mountainous region of South Sulawesi where the Toraja live.

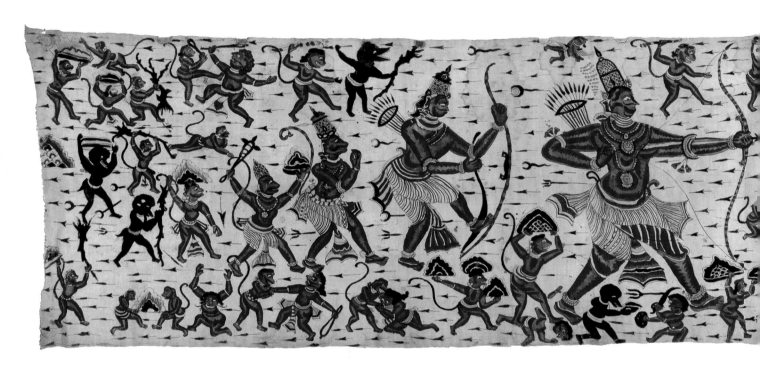

194

Sacred textile – *maa'*
Several examples of this
type of cloth made for export
to Indonesia are known.
A number of them bear
the VOC stamp and were
transported to the Indonesian
archipelago before 1799.

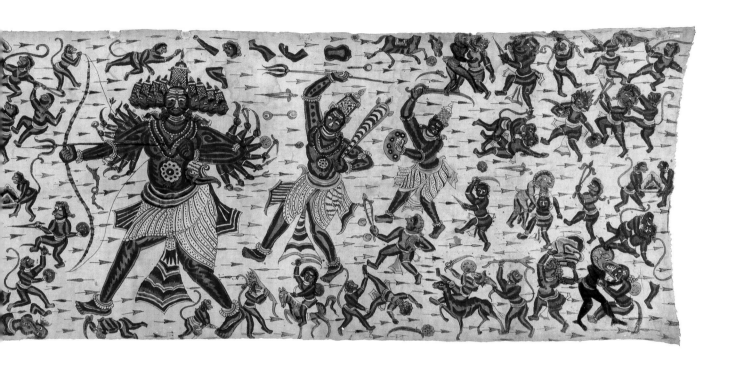

Cotton
Mordant painting, batik
480 x 97 cm
Sa'dan Toraja, Sulawesi
Made on the Coromandel
Coast, India
18th century
TM-H-69
Purchase: H.R.F. Kijftenbelt,
1931

195
Sacred textile – *maa'*
Cotton
Painted
320 x 89 cm
Sa'dan Toraja, Rantepao,
Sulawesi
19th century
TM-1752-7
Exchange: J. Langewis, 1947

196
Sacred textile – *maa'*
(+ detail)
Geese, *hamsa*, surround the
medallions on this cloth.
An Indian court poet described
bridal wear with portrayals
of the sacred goose as early
as the 5th century. From the
14th century fabrics with this
motif were traded to the
Middle East, fragments of
which were found during
excavations in Fostat in Egypt.
Complete cloths have only
been collected in Indonesia.[4]
Cotton
Block-printed, mordant-dyed
280 x 95 cm
Toraja, Sulawesi
Made in Gujarat, India
Date 14C: 1450–1650,
95%-confidence interval
TM-6005-1
Purchase: T. Murray, 2002

Toraja

*Laungku married the earth and fathered 'fruit' as 'white
clouds', from which a thread was spun and thereafter
used to weave the sacred maa' and sarita.*[395]

and

God who dwells in his abode high,
Lord who is seated behind his curtain,
God who is enfolded within a wall of the short
wide cloth,
Lord who is enclosed inside a curtain
of an old short wide fabric with a cross motif on it.[396]

In the stories of the Sa'dan Toraja, their divine
ancestors lived in a heavenly space that was protected
by sacred cloths. When they descended to Earth,
they brought with them the sacred *maa'* and *sarita*
cloths.[397] Alfred Gell wrote: 'Many objects which
are in fact objects manufactured by (human) artists,
are not believed to have originated in that way;
they are thought to be of divine origin or to have

mysteriously made themselves.'[398] Some of these
sacred textiles were made locally, and many came
to the isolated mountainous region from India and
Java through ancient trade routes. In the 19th century,
cloths made in the Netherlands were also added
to this category.

The ritual life of the Sa'dan Toraja centred on the
richly decorated family home. The Sa'dan Toraja are
organised into family groups that trace their origins
to a common ancestor. Religious life, 'the ways of the
ancestors', was organised around rituals of the East,
where the sun rises; and rituals of the West, where
it sets. The rituals of the East, which were associated
with fertility and life, were dedicated to the
ancestors. The rituals of the West were death rituals
that facilitated the journey of the soul to the land
of the dead. A member of an aristocratic family
who was honoured with elaborate and extensive
rituals upon his death could become a deity, a *deata*,
who travelled to the upperworld of the gods.
Each family group possessed a number of sacred
heirloom textiles and beaded objects that played

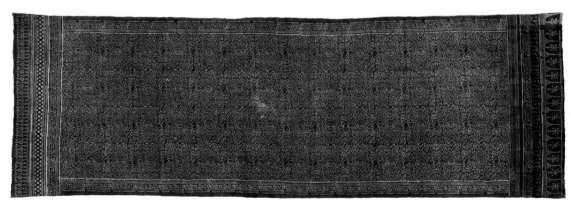

essential roles during ritual activities. The *maa'* and the *sarita* were used in the rituals of both the East and the West. The main festival of the East was a ritual in which two or more neighbouring villages would participate. The centrepiece of this celebration was a bamboo structure, the 'virgin', held together by sacred cloths and guarded by women wearing sacred textiles. Rituals of the East were held when an ancestral home was being renovated and at thanksgiving feasts when the ancestors' blessings were requested for the family home and kin (figs. 194–199). On these occasions the façade of the family home was decorated with sacred cloths, ritual objects made from beads, *kandaures*, and weapons. *Kandaures* were also used in the rituals of the West, when a *kandaure* was placed on the bier or hung as a parasol over the deceased. When greeting the funeral guests the female members of the deceased's family wore the *kandaure* on their backs with the fringes interlaced at the front of their bodies. Old *kandaures* made of precious beads had protective properties and were, in some instances, given a title,

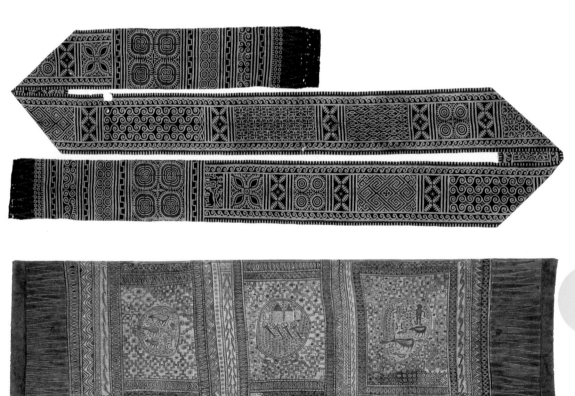

200
**Beaded ornament
– kandaure**
Vegetable fibre, glass beads
55 x 35 x 35 cm
Sa'dan Toraja, Sulawesi
19th century
TM-2198-1
Gift: A.W.A. Miechielsen,
1952

> 201
Mourning hood – pote
Cotton, glass beads
77 x 40 cm
Sa'dan Toraja, Sulawesi,
19th century
TM-1641-1
Gift: L.J.J. Caron, 1944

> 202
Mourning Toraja women
Photographer unknown
Silver gelatin developing-out
paper
1910–40
TM-60028787
Provenance unknown

> 203
Ceremonial headcloth
L.J.J. Caron was governor of
Celebes and its Dependencies
at the time of this acquisition
(1929–33). He worked at the
Colonial Museum during
World War II.
Cotton
Batik, ikat (fringe)
193 x 77 cm
Galumpang Toraja, Sulawesi
19th century
TM-835-1
Gift: L.J.J. Caron, 1933

> 204
**Ceremonial headcloth
– tali to batu**
Cotton
Slit tapestry weave, tie-dye
290 x 34 cm
Rongkong, Limbong village,
South Sulawesi,
19th century
TM-1752-8
Exchange: J. Langewis, 1947

like other sacred objects (fig. 200). At the funeral rites, including the vigil for the deceased, the closest female relatives wore a black, woven head covering – sometimes decorated with beads – which were only removed after the rites had ended (figs. 201, 202).[399] There are two more ceremonial headcloths in the collection, both produced using a special technique. One has two batik panels. This type of batik is associated with a prehistoric resist dye technique that was also used in Southern China. Wearing such a headcloth was the privilege of a *Tobara*; in Galumpang, this was a title for high-ranking elderly men, of whom there were two in each village. This example was worn by the *Tobara* of Bulu (Boelloe). In Galumpang this resist dye technique is called *matobo* (fig. 203).[400]

The other headcloth was woven in a slit-tapestry technique after which bundles of thread were tied and dyed as in the *ikat* technique. This is unique because usually with *ikat*, tying-off and dyeing is done prior to the weaving. The collector J. Langewis remarked on this headcloth: '[the cloth] such as the deceased either made and/or possessed, is tied round the head by a very close relative and worn thusly during the funeral' (fig. 204).[401]

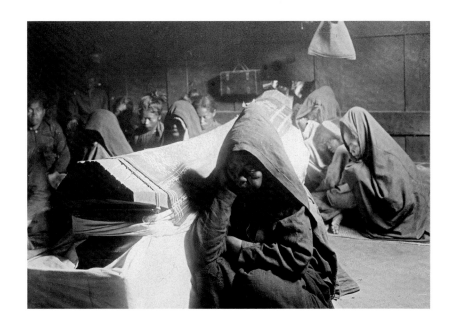

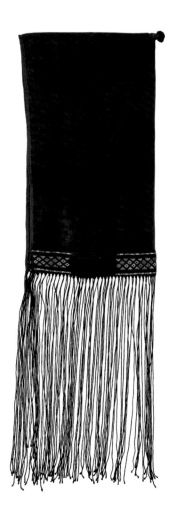

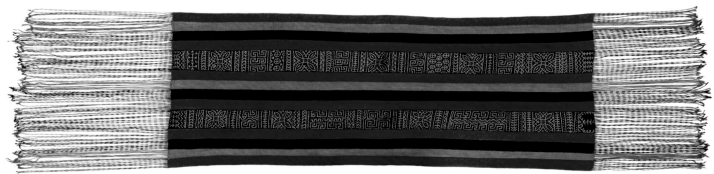

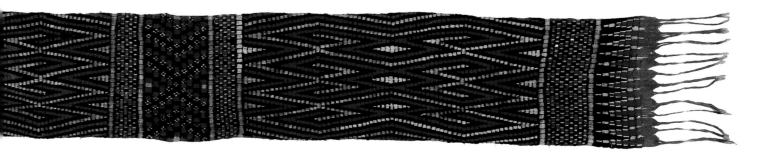

205
Ceremonial hanging,
shroud – *papori to noling*
Cotton
Warp *ikat*
196 x 96 cm
Toraja, Galumpang, Sulawesi
19th century
TM-1982-4 (see fig. 3)
Gift: W.G. Tillman, 1994

206
Ceremonial cloth – *pori tutu*
Cotton
Warp *ikat*
270 x 185 cm
Sa'dan Toraja, Sulawesi
Made in Rongkong
19th–20th century
TM-6207-2
Loan: Ethnological Museum
Gerardus van der Leeuw

207
Sa'dan Toraja couple
Sulawesi
Photographer unknown
Gelatin developing-out paper
c. 1929
TM-60018534
Provenance unknown

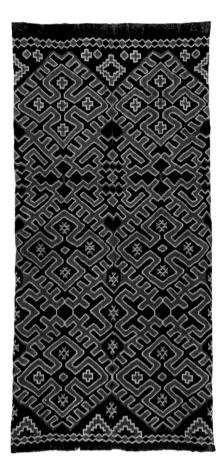

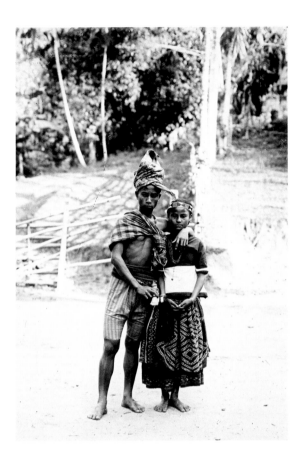

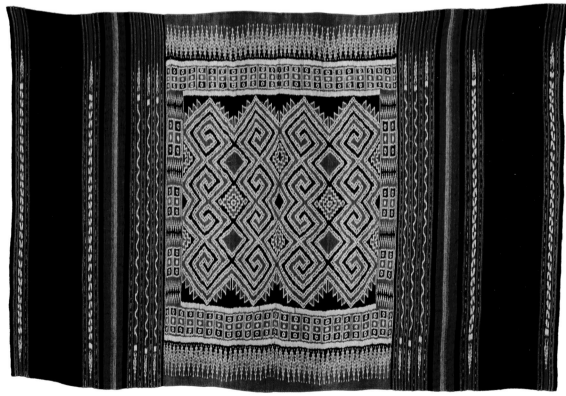

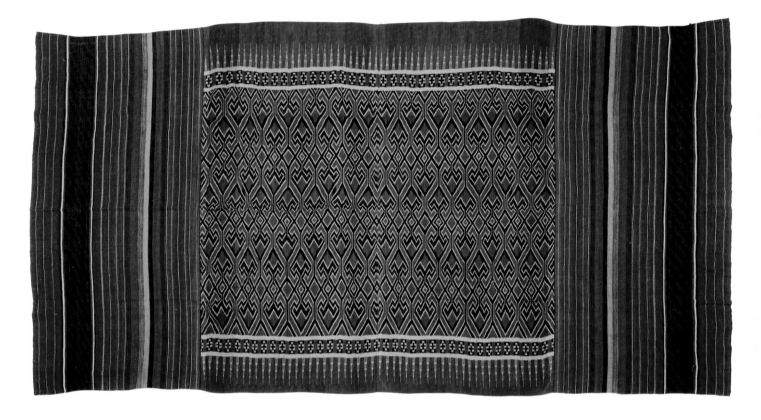

208
Death shroud – *sekomandi*
Cotton
Warp *ikat*
300 x 181 cm
Galumpang Toraja, Sulawesi
19th–20th century
TM-1132-2
Purchase: W.A.C. Galestien,
controleur in the Netherlands
East Indies Administration,
1938

In Galumpang and Rongkong in the highlands of South Sulawesi, ceremonial textiles were made with *ikat* decorations. Scant research has been conducted into this region, but the beautifully crafted, impressive cloths such as the *papori to noling* would have played a crucial role in the elaborate funeral rites. The cloths display motifs that often consist of interlaced spirals and hooked lozenges. Carl Schuster and Jager Gerlings interpreted these motifs as rows of interlocking ancestral figures (fig. 205).[402] The Rongkong Toraja created very large *ikat* textiles that were exclusively used as shrouds. They also traded them with neighbouring communities such as the Sa'dan Toraja who used them as ceremonial attire during rituals (figs. 206–208, also see fig. 3).[403] The patterns on these textiles probably date from the distant past: similar figures, also in the colours reddish-brown, black and beige, are found on pottery from the Niah caves on Borneo (1600–400 BCE).[404]

Sumba

A princess in the upperworld unrolls the thread of her spindle and asks her suitor to climb up. The child born of this union falls to the earth as a blood clot where a wise old woman finds it. She preserves the blood clot between her precious textiles until it grows into a beautiful young man.[405]

Located in the east of the Indonesian archipelago, Sumba was once an important island for regional and interregional trade. Not only residents of neighbouring islands but also Arabs, Chinese, Indians and later the Europeans visited Sumba. For centuries they traded their products for Sumbanese sandalwood, horses, slaves, and textiles, which were specially made for this purpose.[406] In the 19th and early 20th centuries, the trade in horses made the aristocracy on the island very wealthy. This wealth, in the form of gold and silver, beads and precious textiles was a major component of the grand ritual feasts at weddings and funerals. For Dutch civil servants or entrepreneurs, the East Sumbanese multicoloured 'male' cloths were popular mementos of the time they had spent in the Netherlands East Indies. These textiles were used to decorate walls and couches in Dutch households, and together with the batik cloths from Java, became the most well known examples of Indonesian weaving in the West (figs. 209, 210).

On Sumba, however, distinctive weaving traditions also developed in other, less well-known regions. The variation in techniques and the appearance of the cloths vary by region, but together they form a cohesive cultural whole.[407]

Marie Jeanne Adams, Daniëlle Geirnaert-Martin and Janet Hoskins have carried out in-depth studies into Sumbanese textile traditions. They demonstrated that documenting and interpreting production techniques was an important part of the research into the meaning of weaving on Sumba. Adams wrote in 1971:

The painstaking efforts and disciplined talent that are devoted to the decoration of textiles are concomitants of their importance and value – and perhaps we should not be surprised to find that the work itself provides a structure for symbolic meanings. In myth, ritual and social rules on Sumba, the stages of textile work are consistently linked to the progressive development of individual human life. These stages provide an overarching metaphor for the phases of the Sumbanese life cycle.[408]

The regulations governing all that was prohibited or allowed around the various stages of processing, from planting the cotton to the finished fabric, emphasise the sacred nature of the art of weaving and the textiles as its product.[409]

The above myth from Kodi in West Sumba is one of many that enrich Sumbanese culture. The myths discuss the relationship between humans and the supernatural world and the resulting code of conduct for mankind. Weaving and production techniques play an important role in many of these narratives. Techniques whereby individual components are combined into a coherent whole, such as spinning, weaving and plaiting, were associated with fertility. They therefore metaphorically contributed to maintaining and promoting the greatly desired continuity of society. In light of this, women, the weavers, made a significant contribution to communities' religious, social and political life.[410] A mythical bundle of warp threads plays a role in one of the stories. The island Sumba is held in place by means of this bundle of threads. This mythical

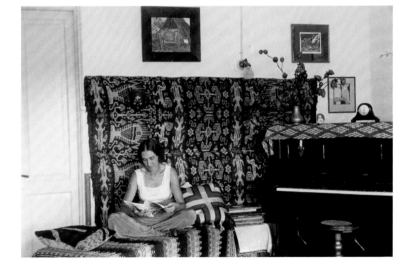

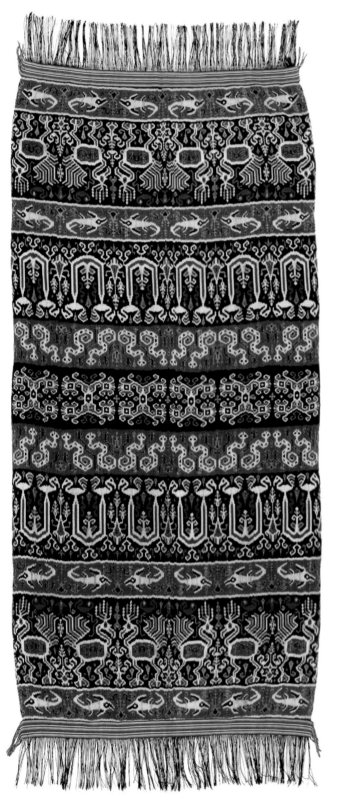
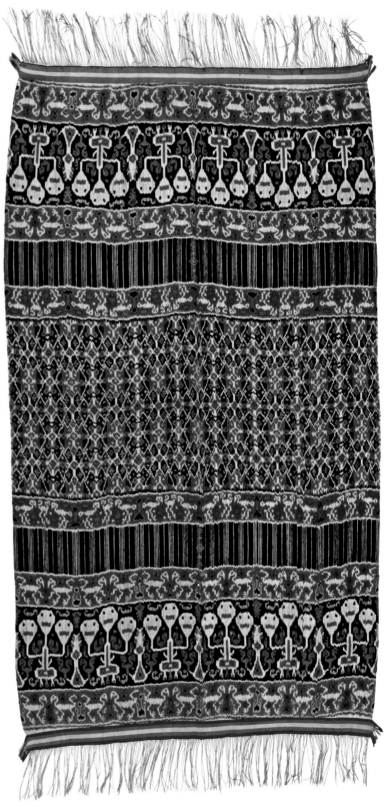

212
Shoulder / hipcloth
– *hanggi nggoko*
Cotton
Warp *ikat*
244 x 112 cm
Kodi, West Sumba
19th/20th century
TM-1772-1118
Gift: W.G. Tillman, 1994
Collected on Sumba by
B.A.G. Vroklage

warp, like an umbilical cord, connects the island to the heavens, the upperworld of the gods, and to the bottom of the sea, the underworld. Only the ancestors can perceive this bundle of threads, which runs through the middle of the island. During the weaving process the warp threads on the 'cosmic' loom wear out, as they do on an 'earthly' loom. If they break, the island will sink into the sea. To prevent this, the people who live in the middle of the island are forbidden to weave; the mythical warp would be in danger of breaking. These threads are part of the mythical concept that connects the different weaving traditions on the island with each other.

The use of the *ikat* decorative technique on the island is explained in a West Sumbanese myth. The island, we are told, is enveloped by a fabric that, like a 'skin', allows rain to permeate it and also protects the groundwater. To prevent the fertile 'male' rainwater from flowing away in the East and the West, both ends of the island of the 'female' earth must be 'tied off'. This idea is translated into the mandatory use of the *ikat* tying technique in the East and the West (figs. 211–213). In order to allow the 'vital juices' to freely circulate across the island, in the other regions on the island where weaving is done, the *ikat* technique must not be used. In these regions, the weavers apply motifs of coloured stripes and fringes or twisted borders to the cloth (fig. 213).[411]

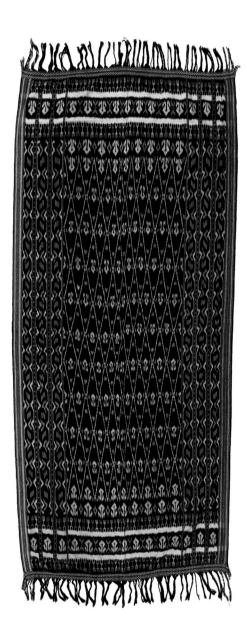

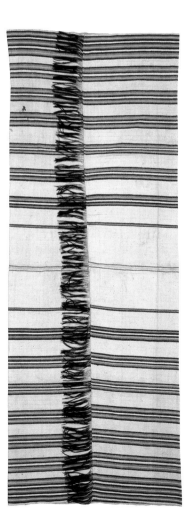

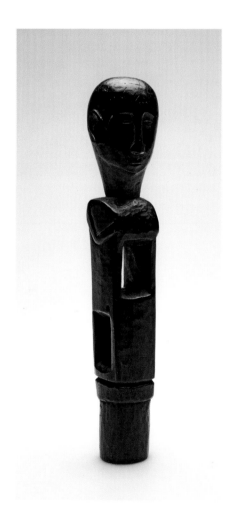

< 213
Tubular skirt – *ye pawora*
Cotton
Coloured warp stripes, fringes
177 x 74 cm
Laboya, Sumba
20th century
TM-5129-1
Purchase: D.C. Geirnaert-
Martin, 1987

< 214
Reel – *kijora*
Wood
24 x 5 x 5 cm
West Sumba
19th century
TM-5281-1
Gift: J.P. Barbier, 1989

215
Shoulder / hipcloth
– *hinggi kombu*
246 x 126 cm
Cotton
Warp *ikat*
East Sumba
Late 19th/early 20th century
TM-3937-14
Gift: J. van der Grift, 1970

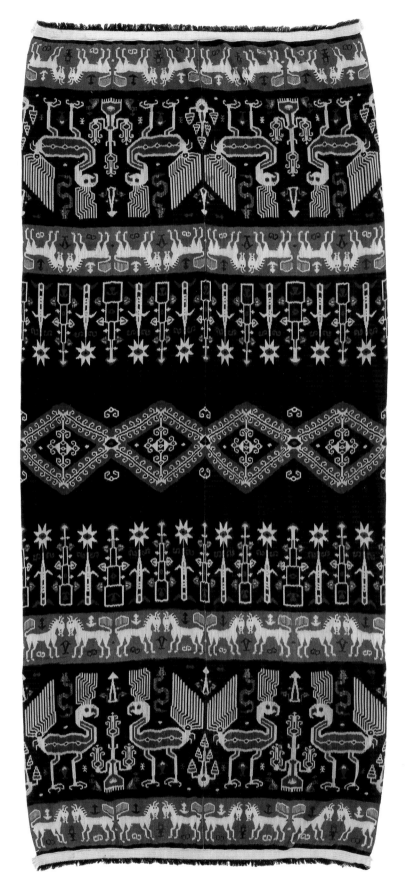

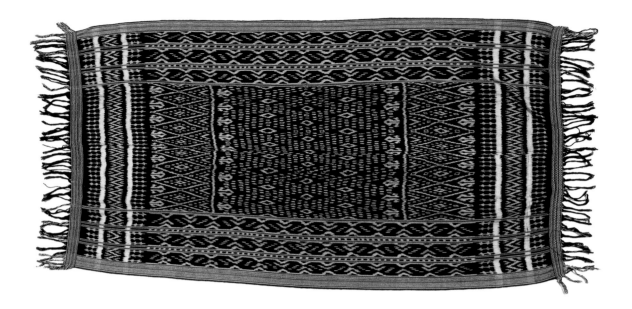

216
Shoulder / hipcloth
– hanggi nggoko
265 x 128 cm
Cotton
Warp *ikat*
Kodi, West Sumba
Late 19th/early 20th century
TM-556-95
Purchase: J. C. van Eerde,
1929

Adams was the first to mention the relationship between the various stages of textile production and the stages of the human life cycle. Sowing cottonseeds during the rainy season was one of the first actions that shaped the symbolic relationship between the production of textiles and fertility. The fertile mud in which the cotton was sowed was the result of the union of the 'male' rain and the 'female' earth as stated in the above myth.[412] Daniëlle Geirnaert-Martin described how in Laboya in West Sumba, spinning, the production of yarn, was a metaphor for human conception. During the spinning process, the women symbolically glued the necessary ingredients for a human being together.[413] After the threads were put on a reel, they were wound into a white ball. The growth of this ball of cotton was compared with the growth of a foetus and a newborn child. In the past, each family would ideally own two ceremonial reels, *kijora biha*, one in the form of a man, and one in the form of a woman (fig. 214). These represented the male and female ancestors to whom food offerings were regularly made. Sticks, which formed the arms and legs, were inserted into the openings around which the thread was wound.[414] After spinning and warping, the warp threads were stretched on a wooden frame where the motifs were secured by tying-off small bundles of threads with a resist material. Multicoloured and two-tone *ikat* cloths were made in East Sumba. The dyeing processes to obtain the colours red-brown (*mengkudu*)

and indigo blue were accompanied by all kinds of ritual regulations (fig. 215). In the west of the island, the prevalent colour used for the cloths was blue. Janet Hoskins studied the art of traditional indigo dyeing in Kodi, in western Sumba.[415] Hoskins: 'In its magical aspects, as a series of mysteries that only cult initiates may penetrate, this "blue art" is a ritual as well as a technical process' (fig. 216).[416] Indigo dyeing was subject to regulations and taboos. Only older, experienced women with knowledge in the fields of herbalism, midwifery and sorcery mastered this 'occult art'. By performing the same rituals prior to the blue dyeing process and childbirth, the dyer/midwife gave expression to the symbolic relationship between the dyeing process and the notion of fertility. In Kodi, as in other places in Indonesia and around the world, the chemical reaction that occurred during this dyeing process was experienced as a magical moment.[417] On Sumba, weaving was done on the backstrap loom with circular warp. After the textile was completed, the warp threads had to be cut, and male shoulder- and hipcloths and tubular skirts for women were made from the resulting rectangular cloths. Similar to other islands, on Sumba, cutting the last length of the unwoven warp threads was perceived as being dangerous and was associated with death.[418] As in the myth, where the warp threads on the 'cosmic' loom formed the connection between people and their ancestors, the cutting of the warp threads not

only signified the end of the weaving process but also implied the severing of the link with the ancestors. To avoid disaster, rituals were performed and offerings were made to the ancestors. After cutting the warp threads, a woven or twined border, *kabakil*, was applied to prevent the weft threads from unravelling from the fabric. This border also had a symbolic meaning. A fabric with weft threads that could unravel was associated with death; it is compared to a skin that loses its contents. The border marked the boundary between life and death.[419] Many operations that were performed when making a textile, from the sowing and harvesting of the cotton, the tying of the threads, the dyeing and weaving, to applying the border, are on Sumba a metaphor for the human life cycle from conception to death.[420]

The textiles were an important attribute in the ritual activities that were organised around, among other events, weddings and funerals. The largest and most important festivals accompanied the death, burial and erection of a tombstone of a high-ranking individual. The deceased was wrapped in numerous cloths that were donated to his or her family by the group of bride-giving families with whom relationships had been built up over the years. For a member of an aristocratic family it could take years before there were sufficient cloths available to allow for the staging of the official funeral, which itself often lasted for months. Shortly before the final burial a huge stone monument on a wooden structure that represented a boat was transported to the village by hundreds of men. White and multicoloured textiles symbolised the sails of the 'boat' that would transport the deceased to the land of the dead (fig. 217). Daniëlle Geirnaert writes: 'In the western part of the island people believe that in a blessed mythical past, ancestors helped the living to pull these megaliths. However, they did so by using only one or more hand-spun cotton threads instead of lianas and this is interpreted as a sign of their superiority over the living.'[421] On arriving in the ancestral realm the deceased presented the cloths as gifts to relatives and friends.

In East Sumba, only weavers from aristocratic circles were allowed to make the multicoloured ritual cloths. The ceremonial attire for men consisted of two identical cloths with *ikat* motifs (*hinggi*), one worn

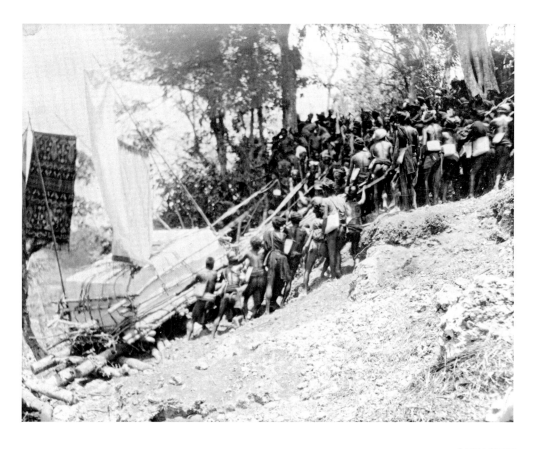

218
Shoulder / hipcloth
– hinggi kombu
Cotton
Warp *ikat*
217 x 140 cm
East Sumba
19th century
TM-1772-1107/1108
Gift: W.G. Tillman, 1994

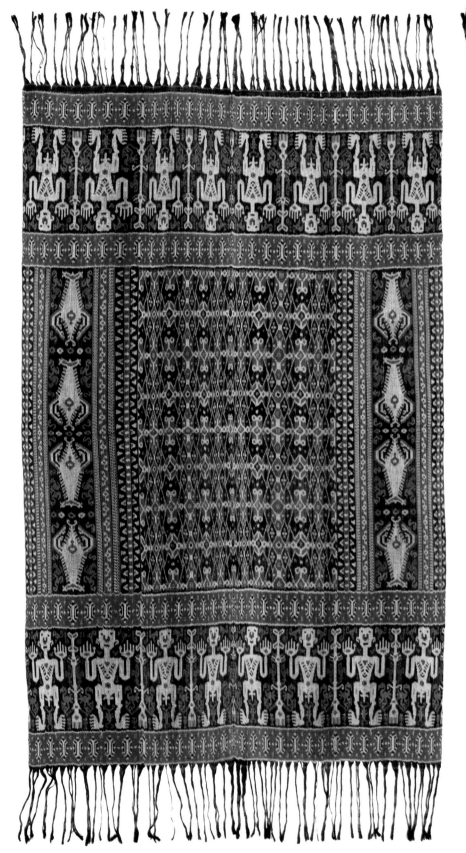
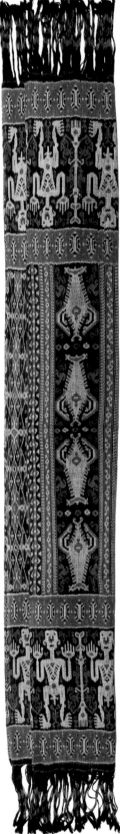

219
Shoulder / hipcloth
– *hinggi kombu*
Cotton
Warp *ikat*
214 x 112 cm
East Sumba
19th century
TM-1772-1095
Gift: W.G. Tillman, 1994

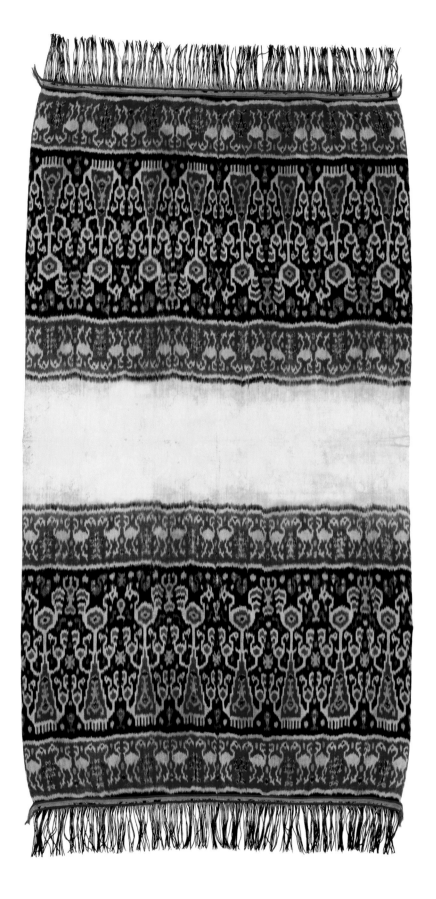

220
Shoulder / hipcloth
– hinggi kombu
Cotton
Warp *ikat*
280 x 128 cm
East Sumba
20th century
TM-4985-3
Purchase: Christie's
Amsterdam, 1986

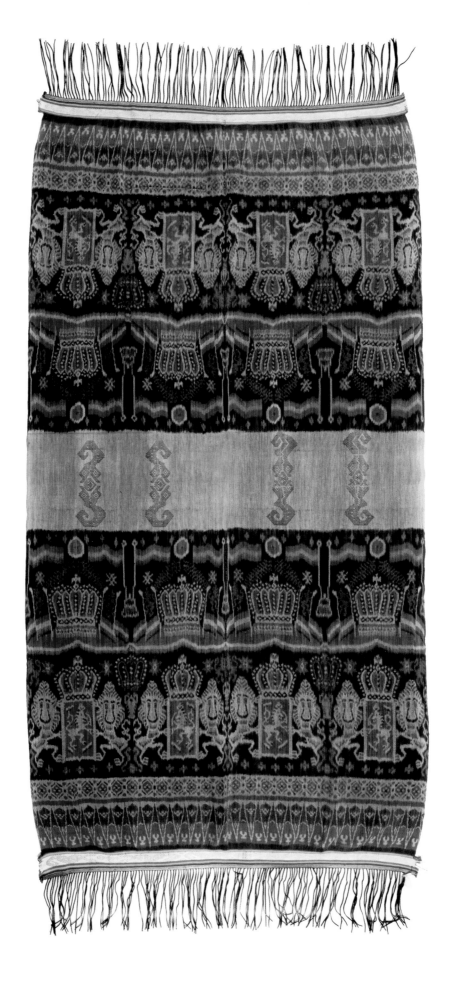

221
**Shoulder / hipcloth
– *hinggi***
Cotton
Warp *ikat*
228 x 110 cm
East Sumba
20th century
TM-1772-1102
Gift: W.G. Tillman, 1994

222
Pattern sample – *pahudu*
Wood, palm-leaf veins, cotton
47 x 25 cm
Sumba
19th century
TM-5220-1
Purchase: Far East Primitive
Art, 1989

as a shoulder cloth and the other as a hipcloth (fig. 218). The Tropenmuseum has a pair of identical cloths that both in terms of size and the applied designs could only have been made for a royal person. The distribution of patterns on these two textiles differs from that on the majority of male cloths from East Sumba, which usually show patterns arranged in an uneven number of horizontal bands. The identical textiles, with a centre panel surrounded by wide bands, are redolent of the *patola* (double *ikat* cloths) from India. The motif on the centre panel also resembles *patola* motifs. Wearing multicoloured, white/

brownish-red/blue cloths, *hinggi kombu*, was the preserve of the East Sumbanese aristocracy; cloths with a white centre panel were reserved for the royal family (figs. 219, 220). The middle class wore blue and white cloths that had only been immersed in the indigo vat once (fig. 221). The weavers applied a broad palette of motifs in numerous variations: representations of ancestral figures, skull trees, horses, deer, snakes, countless birds and aquatic animals, and ear and head jewellery. Motifs from other cultures were adopted, such as dragons from Chinese pottery and lions from the Dutch coat of arms and flag.

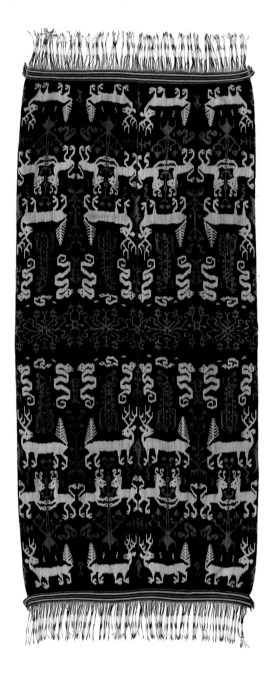

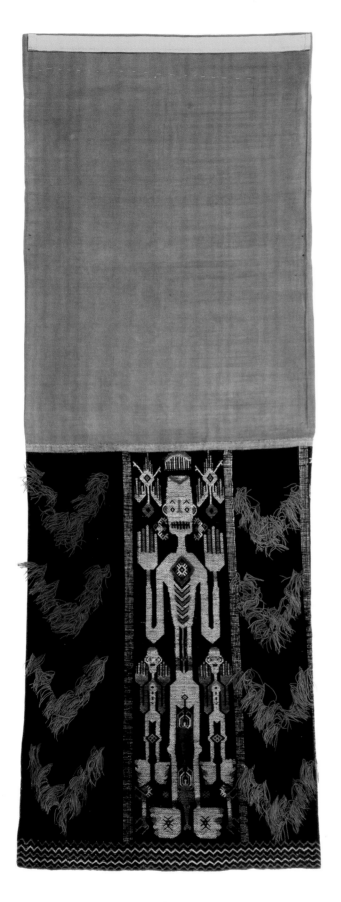
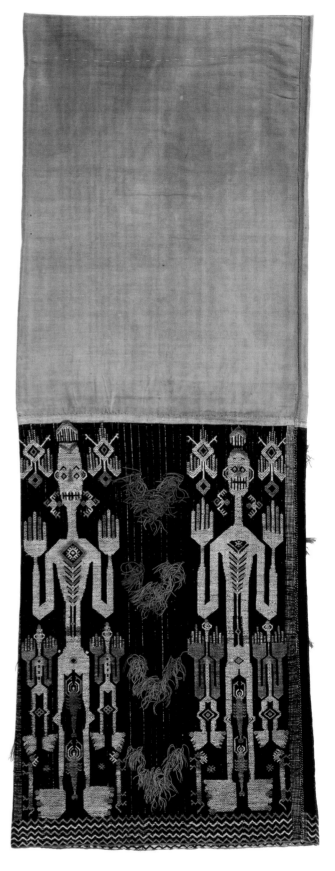

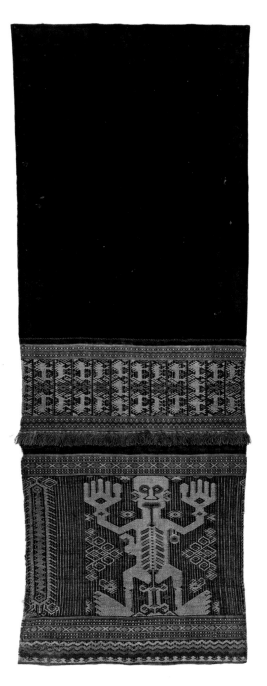

< 223
Tubular skirt – *lau pahudu*
(+ reverse)
Cotton
Supplementary warp, fringes
160 x 60 cm
Sumba
Date 14C: 1690–1730
or 1820–1926,
95%-confidence interval
TM-A-5244
Gift: H.C. Humme

224
Information card
'A beautiful cloth embroidered
by a Sumbanese princess'

225
Tubular skirt – *lau pahudu*
Cotton
Supplementary warp, fringes
155 x 54 cm
Sumba
19th century
TM-2118-16
Gift: Koninklijk Militair
Invalidentehuis, Bronbeek,
1951

On ceremonial occasions, aristocratic women wore richly decorated tubular skirts, *lau*. The motifs on these skirts were applied using various techniques, such as the supplementary warp technique and warp *ikat*, but also had decorations made of beads and shells and motifs executed by means of plied fringes. The supplementary warp technique is a complex and rare technique. When using this technique, the weavers used often generations-old pattern guides, *pahudu*, and whenever these wore out, new ones were made with the same representations (fig. 222). This way of working meant that the motifs were passed down to future generations over long periods of time and thus were less subject to change than was the case with other decorative techniques. Holmgren and Spertus suggest that these tubular skirts 'may be an unrecognized source of information about the visual appearance of textiles during the pre-colonial period, precisely because they follow old pattern guides and therefore discouraged iconographic innovation.'[422] The weavers often had a collection of these examples and regarded the motifs as their personal property. The weavers of the many tubular skirts in Western collections are unknown and nameless.[423] However, there is a spectacular tubular skirt in the Tropen-

226
Tubular skirt – *lau pahudu*
padua
Cotton
Warp *ikat*, supplementary
warp
165 x 95 cm
Sumba
19th century
TM-48-48
Purchase: J.E. Jasper, 1912

227
Tubular skirt – *lau pahudu*
padua
Cotton
Warp *ikat*, supplementary
warp
149 x 65 cm
Sumba
19th century
TM-6207-182
Loan: Museum Gerardus van
der Leeuw

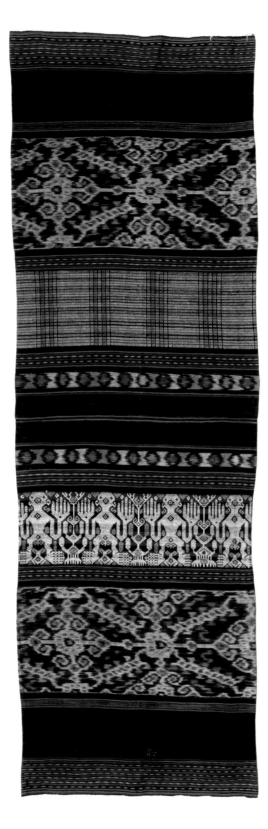
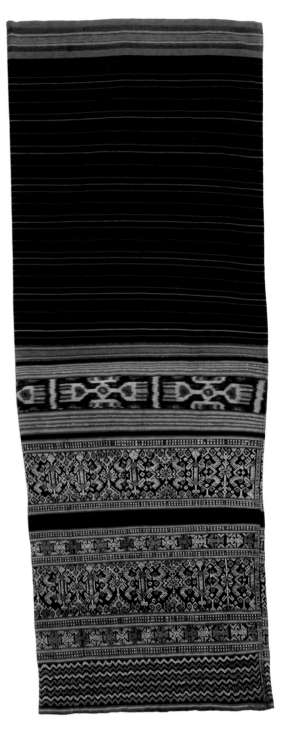

228

Tubular skirt – *lau hada*

Van Nouhuys referred to these skirts as *'pakiri mbola'*, which means 'at the bottom of the basket'. Skirts such as these were placed in the bottom of the basket along with the textiles that were given to the groom's family at a wedding.

Cotton, glass beads, *nassa* shells

144 x 56 cm

Sumba

19th century

TM-2118-14

Gift: Koninklijk Militair Invalidentehuis Bronbeek, 1951

229

Beaded panel for tubular skirt – *lau katipa*

Cotton, glass beads

63 x 38 cm

Sumba

19th century

TM-140-3/1

Gift: D.H. Hardenberg-Meiners, 1922

museum collection that was brought to the Netherlands in the mid-19th century by a Dutch government official. H.C. Humme (1826–92), resident of Timor and its Dependencies, accurately described the provenance of this tubular skirt on a piece of paper that was attached to the documentation: 'The weaver is Princess Amaloekoe, daughter of the Raja of Kapedoe on the island of Sumba. Extremely rare specimen. Only a Raja may wear such a garment.'[424]

Three large female figures are depicted frontally with raised arms in *orant* pose on the skirt, each flanked by two smaller human figures. The faces are realistic, and important parts of the body such as the heart, rib cage, the navel and genitals are visualised. They wear a comb in their hair and are surrounded by birds, reptiles and aquatic animals, representatives of the upper- and underworld. Also pictured are the horses that brought the ruling families so much wealth and promoted the production of these textiles that displayed that wealth (figs. 223–225).

Textiles for the aristocracy, for example, women's skirts, *'lau pahudu padua'*, combine the supplementary warp technique and the *ikat* technique (figs. 226, 227).[425] The presence of motifs borrowed from the prestigious Indian *patola* implemented in warp *ikat* referred to the social and financial status of the weaver of the skirt (figs. 226, 227). Beads were the main decoration on another type of skirt, *lau hada* (fig. 228). Loose panels, often made of red imported cotton, were decorated with beaded representations and attached to the bottom of the tubular skirt.[426]

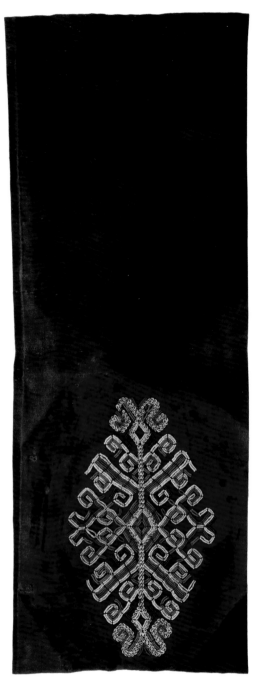

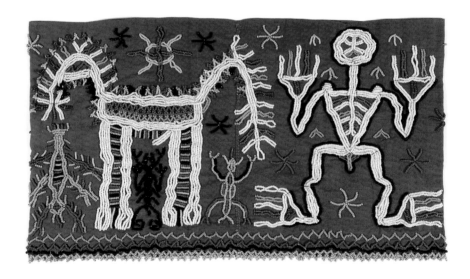

CONCLUDING REMARKS

Alfred Gell, whose anthropology of art, in which he analyses the agency or efficacy of art objects, is discussed in the chapter 'Museums, Science and Material Culture'. Gell referred to objects as components of a social technology which he called the technology of enchantment.[427] His theory on objects concerns '[…] social relationships, and not anything else'.[428] What do people do with objects and what do objects do to people, and how does this reciprocity affect human interaction? He argued that the ability of artefacts to influence human behaviour is in large measure related to the way they are produced, to the shape they are given, and to the motifs and patterns that are applied onto them. From as early as 1933, J.C. Vergouwen, writing about the meaning of weaving textiles among the Batak in North Sumatra stated:

Weaving such a cloth, the artful combining of a huge number of threads into a whole, which protects the body is, from the heathen's perspective, an act strongly infused with magic. The product of this weaving, the cloth, can therefore be imagined as being charged with magical power.[429]

In the case of Indonesian textiles the materials that are used, such as cotton and indigo, and technological aspects, such as the circular warp on the loom and the *ikat* decorative technique, should also be taken into account, as is shown by M.J. Adams.[430] Adams: '[…] perhaps we should not be surprised to find that the work itself provides a structure for symbolic meanings. [...] procedures and schedules of work provide metaphoric schema for a number of symbolic systems, such as myth, ritual and other formal social patterns.'[431] She analysed the relationship between the materiality of the binding aspects of spinning, weaving and the *ikat* technique, and the spirituality of the bonding function of textiles in social and religious life.[432] Heringa related the 'inward form, i.e., the meaning of materials and techniques, to the division of labour in the textile production process and the social organisation of the Kerek society in East Java, and Hoskins studied the 'blue art' of indigo dyeing as a ritual as well as a technical process and formulated the symbolic relationship between the dyeing process and fertility.[433]

Not surprisingly, the production of textiles is mentioned in creation and fertility myths, of which a few examples are discussed. According to the Batak on Sumatra, Si Boru Deak Parujar created the earth by lowering a spun (indigo blue) thread from the sky; in Kodi in West Sumba, a blood clot (foetus) was

kept in a bundle of textiles (uterus), and grew from there to adulthood. Another Sumbanese myth states that the use of the *ikat* technique, the tying of the threads in the East and the West, preserves the fertility of the island. From Java comes the story of Nyi Pohaci (Dewi Sri), the goddess of rice and fertility from whose body the first loom was made, or as C.Tj. Bertling said: 'Thus on Java is Dewi Sri the personification of a power that is present both in the emergence and growth of the grain and in weaving. She is the rice itself, she is also the spun thread and the loom [...].'[434] The spinning of a thread, the creation of the first loom, the weaving process, woven garments and celestial materials, and the techniques and goods, are all prerequisites for the creation of the earth, life and mankind. Considering the role of these sacred textiles in ritual gift exchanges, when celebrating the attainment of the highest possible status, during birth and death rituals, and in facilitating communication with the supernatural world, they were instrumental to the regulation of social and religious life and intrinsic to the well-being of the community.

The cloths that were made to fulfil this role can be seen as Gell's 'objectified repositories'; they can be regarded as the materialisation of one of the core values of these cultures, 'fertility'. The textiles can actually only be an objectification of the fertility of mankind, flora and fauna, because life itself is potentially fertile. Gell: 'The magic just *has* to work, because the index of productivity is caused by the productivity it causes; there is a perfect, but invisible circularity.'[435] In the case of Indonesian textiles, this invisible circle becomes visible and tangible in the circular warp on the loom. Niessen:

The round warp symbolizes unbroken time, the ongoing generations, connection with the spirit world, health and well-being. Life-cycle or cyclical time, is found in the annual cycle of the patterns of stars in the skies, the cycle of the crops, the human life-cycle and their annual ritual cycle.[436]

In addition to the symbolic meaning of the circular warp on the loom, the decorative techniques that produce the complex and intriguing patterns contributed to the importance of ceremonial textiles. Holmgren and Spertus stated: 'For important

textiles women rarely employed facile techniques, […] but clung instead to difficult, time-consuming procedures, because they were sanctioned by tradition and deepened the inner quality of the pieces, and because the making of the cloth was itself a religious expression'.[437]

These complex textiles 'produced by the spectacle of unimaginable virtuosity' with patterns and motifs that exhibited 'a certain cognitive indecipherability' attained a 'magical power', a capacity to 'enchant': '[T]he power of art objects stems from the technical processes they objectively embody: the technology of enchantment is founded on the enchantment of technology' (also see Chapter 'Museums, Science and Material Culture').[438]

NOTES

Endnotes 'Museums, Science and Material Culture'

1 Tilley 2006, p. 61.
2 The term 'material archive' was coined by Susan Legêne; see Legêne 2007
3 From approximately 1600 to 1800, relations between the Netherlands and the Indonesian archipelago were entirely based upon trade. The ensuing period saw a gradual introduction of (in)direct administration until the Netherlands' recogniton of Indonesia's independence in 1949.
4 Fox 1977, pp. 94–104.
5 Rouffaer and Juynbol 1900; Jasper and Pirngadie 1916.
6 Van Brakel and Legêne 2008, p. 22.
7 Lodewycksz 1930, pp. 24.
8 For definitions of batik and *ikat*, see Chapter 'Textiles in Indonesia'
9 Appadurai 1986, p. 5.
10 Kopytoff 1986, pp. 64–91.
11 Taylor 2002, p. 198. Lou Taylor cites the work of Ruth Barnes, Joanne B. Eicher, Mary Ellen Roach-Higgins, Jane Schneider and Annette B. Weiner.
12 Roach and Eicher 1965.
13 Schwarz 1979, p. 23.
14 Lamp 2010, p. 18.
15 Weiner and Schneider 1989, pp. 1–29.
16 See Chapters 'Textiles in Indonesia', 'The Colonial Administration and the Arts and Crafts Industry' and 'Colonial Collections'.
17 Not every collection from that era was brought together in a methodological way; see Meadow 2013.
18 Hoitink 2011, p. 95. These museums' ethnographic collections were later housed in the National Museum of Ethnology in Leiden.
19 Ibid., p. 97.
20 Basu 2013 (quote from Ucko 1969), p. 371.
21 Ter Keurs 2007, pp. 1–15 (p. 3).
22 Ibid.
23 Basu 2013 (quote from Ucko 1969), p. 371.
24 Tilley 2006, p. 2.
25 C.M. Pleyte was attached to the National Ethnographic Museum in Leiden from 1883 to 1887, after which he became curator at the Artis Ethnographic Museum in Amsterdam from 1887 to 1896.
26 Boas 1927.
27 Shelton 1996, pp. 240–41.
28 Balfour 1938.
29 Henare, Holbraad and Wastell 2007, p. 2.
30 Ibid.
31 Tilley 2006, p. 2.
32 Ter Keurs 1998, p. 32.
33 Josselin de Jong 1977 (1935), pp. 231–52.
34 Ucko 1969, pp. 216, 217.
35 Gerbrands 1966, p. 9.
36 Tilley, Keane, Küchler, Rowlands and Spyer 1996.
37 Miller 2005, p. 8.
38 Miller 1987, p. 81.
39 Tilley 2006, p. 61.
40 Küchler and Miller 2005.
41 Ibid., p. 7.
42 There are too many prominent researchers to list them all here; see Chapters 'The Presentation of Textiles: Trade, Ethnology and Design'.
43 Gittinger 1979; Nabholz-Kartaschoff, Barnes and Stuart-Fox 1993; Völger and Welck 1991.
44 The results of research into textile techniques were placed at the beginning or the end of books and conference publications; see Jager Gerlings 1952; Hitchcock 1991; Gittinger 1979; Nabholz-Kartaschoff, Barnes and Stuart-Fox 1993.
45 Adams 1971, p. 322.
46 Lechtman 1975, p. 3.
47 Heringa 2010; Fox 1979; Geirnaert 1992; Niessen 2009.
48 Tilley 2006, p. 10. Such ideas were, however, not new, as already in the 1920s Marcel Maus and Bronislaw Malinowski concluded that there was an absence of a clear dividing line between people and objects in certain situations. Objects could possess human and supernatural qualities – there was no distinction between the 'material' and the 'spiritual'.
49 Ter Keurs 2011, p. 8.
50 Gell 1998, p. 7.
51 Gell 1992, p. 43.
52 Bowden 2004, pp. 309–24.
53 Gell 1992, p. 21; Bowden 2004, pp. 309–24.
54 Gell 1998, p. 74.
55 Ibid., p. 71.
56 Boas 1927.
57 Gell 1992, p. 44.

Endnotes 'Textiles in Indonesia'

58 Adapted from Jim Crace (1997, p. 74.): 'He found there was a rhythm to the bow-drill and the draw-knife and the plane which took the place of prayer. Every movement was a repetition, every repetition was a word. The timber and the tools took on new meanings.'
59 Barnes and Kahlenburg 2010; Gittinger 1998; Heringa and Veldhuisen 1996, pp. 46–69; Jasper and Pirngadie 1916; Maxwell 1990; Maxwell 2003; Rouffaer and Juynbol 1900.
60 Buckley C. *(in press)*. Among others the origin of Indonesian weaving is also mentioned in Gittinger 2005, p. 12.
61 Bellwood 1997, pp. 150, 215; Bellwood and Glover 2004, p. 1.
62 Ibid.
63 Buckley 2012, e52064, p. 19.
64 Gittinger 2005, p. 12.
65 Personal communication with Nico de Jonge.
66 Schefold 2013, p. 19.
67 Adams 1971, pp. 321–34; Gittinger 1979; Maxwell 1990; Niessen 2009.
68 Gavin 1996. p. 27.
69 Mattiebelle Gittinger mentions the different loom types in *Splendid Symbols* (1979).
70 Peranakan Chinese are descendents of Chinese immigrants who came to the region between the 15th and 17th centuries.
71 Maxwell 1990, p. 300.
72 Buckley 2012, e52064, p. 3
73 Buckley C. (in press). Buckley mentions two types of this loom: (1) The foot-braced loom in which the warp beam is braced by the feet; and (2) the externally braced loom which has the warp beam attached to an external point. The second type is still used in Indonesia.
74 Gittinger 1979, pp. 54–68.
75 Buckley C. (in press).
76 Maxwell 1990, p. 58.

77 These are not the local words for the various decorative techniques, but terms used by the Dutch. Local designations vary by region and local language.

Endnotes 'The Colonials Administrations and the Arts and Crafts Industry'

78 Groot 2009, p. 94.
79 Hoitink 2011, pp. 113, 114, 118.
80 Raffles 1836.
81 Hoitink 2011, p. 120.
82 Legêne and Waaldijk 2001, p. 36.
83 Bloembergen 2002, p. 12.
84 Ibid. While I am aware of the criticism of these forms of display as colonial violence inflicted on colonised peoples, I think a distinction can be made between these different forms of display. These representations of craftspeople were in my opinion of a different nature to the primitivisation of putting living people 'on show' that also occurred during this period.
85 Ibid., p. 65ff.
86 Ibid., pp. 87, 88.
87 Van Eeden 1883, pp. 134–40.
88 Bloembergen 2002, pp. 224, 245.
89 Jasper and Pirngadie 1916.
90 *Ethische Politiek* ('Ethical Policy'): a political movement that arose at the end of the 19th century, which called for more consideration for the interests of the population in the colonies, and would foster their eventual independence.
91 De Kat Angelino 1930/1931.
92 Motto originally from an old Dutch poem (1554).
93 Wesseling 1988, p. 38.
94 Van Eeden 1884, p. 78, pp. 1, 4.
95 Bloembergen 2002, p. 250.

Endnotes 'Colonial Collections'

96 Van Brakel and Legêne 2008, p. 22.
97 Schulte Nordholt 1997, p. 5.
98 Gelman Taylor 1997, pp. 85–116.
99 Guy 1998, p. 69.
100 Cohn 1989, pp. 312–13.
101 Schulte Nordholt 1997, p. 10.
102 Van Dijk 1997, p. 48.
103 Ibid., p. 51.
104 Ibid., pp. 54, 59, 62.
105 Ibid., pp. 39–84.
106 Gelman Taylor 1997, p. 97.
107 This group includes only those children who were officially recognised by the father.
108 Gelman Taylor 1997, p. 97.
109 Veldhuisen 1993.
110 Bronkhorst and Wils 1996, p. 29.
111 'Chinese' and 'Arab' batik styles were also developed; see the Catalogue.
112 Biographies of these batik entrepreneurs in Heringa and Veldhuisen 1997.

113 Gelman Taylor 1997, p. 108.
114 Verbong 1989 p. 51.
115 Heringa 1989, pp. 131–56.
116 Ibid., p. 140.
117 Verbong 1989, pp. 61, 65.
118 'Van Vlissingen & Co's Gedenkboek 1846-1946'. Helmond, 1948, p. 22.
119 Sorber 1989, p. 42.
120 Heringa 1989, p. 144.
121 Van Musschenbroek 1878.
122 Rouffaer 1900, pp. 26, 34.
123 Bloembergen 2001.
124 Van Eeden 1884, p. 11.
125 Simon Thomas 1989, p. 97.
126 Beelaerts van Blokland 1989, p. 151.
127 *Bulletin van het Koloniaal Museum* 24, 1901, p. 14.
128 Lion Cachet 1924, pp. 108–13.
129 Much of the information in this section is derived from Joosten 1972. This research was conducted for the exhibition 'Weltkulturen und Moderne Kunst' in 1972 in Munich.
130 Joosten 1972.
131 Wronska-Friend 2001, p. 107.
132 Joosten 1972.
133 Baanders 1901, pp. 45–87.
134 *Bulletin van het Koloniaal Museum* 30, 1904, p. 82.
135 Joosten 1972, p. 419.
136 Wronska-Friend 2001, pp. 106–23.
137 Agathe Wegerif-Gravestein was a co-founder of the Arts and Crafts art shop; see Simon Thomas 1989, p. 96.
138 'Nitik' is a way of creating patterns by applying clusters of dotted lines with a wax pen (*canting*).
139 Wronska-Friend 2001, pp. 106–23.
140 Groot 2007, p. 285.
141 Simon Thomas 1989, p. 99.
142 The National Exhibition of Women's Labour was organised in The Hague in 1898.
143 The author is indebted to Margaret Wabeke-Krijnen, the granddaughter of the Krijnen-Suries, who provided details about her grandparents. She also donated her grandparents' collection to the Tropenmuseum in 2009.
144 Bloembergen 2002, p. 69.
145 Jasper 1906, p. 32.
146 The Moluccas had already come into contact with Islam in the 14th century through Arab traders.
147 Hulsbosch 2004.
148 Thomas Cooper studied this cloth for the Tropenmuseum and translated the names and titles. The author would like to thank him for this.

149 Only a few examples of this type of cloth are known. Cohen, Beherend and Cooper (2000) describe a similar cloth, 'The Barikan Banner of Gegesik'. pp. 97–144.

Endnotes 'Collecting'

150 Legêne 1999.
151 Lodewycksz 1930, pp. 24, 58.
152 Woodward 1979, p. 20.
153 Guy 1998, p. 81.
154 Bühler and Fisher 1979, vol. 1, p. 323.
155 Van Eerde 1926, pp. 75–83.
156 Until 1836 this company was affiliated with the Hollandsche Maatschappij van Wetenschappen (Royal Holland Society of Sciences and Humanities), established in 1752.
158 Hasselman and Cremer 1910.
159 Van Duuren 1990, pp. 15, 19.
160 Van Eeden 1884, p. 10.
161 With thanks to Constance van Leeuwen, K.P.A. Koesoemodiningrat's granddaughter, who provided most of the information.
162 Van Deventer 1899, pp. 205–57.
163 *Weekblad voor Indië*, 19 August 1917.
164 Jasper and Pirngadie 1916, p. 234.
165 Van Goens 1666. Quote from: Veldhuisen-Djajasoebrata 1984, p. 124.
166 Veldhuisen-Djajasoebrata 1984, pp. 125, 126.
167 Heringa 2010 p. 173.
168 The textiles Constance van Leeuwen donated are included in the collection as Series 6435-1 and 6435-2.
169 Mehos 2006.
170 *Koninklijk Genootschap Natura Artis Magistra. 1838–1898*, Amsterdam, Van Mantgem, 1898, p. 25.
171 Ibid.
172 *De Indische Gids* 12(II), 1890, p. 1369.
173 Mehos 2006.
174 Groeneboer 2002.
175 Pleyte 1888.
176 *De Indische Gids*, 12(II), 1890.
177 Jasper 1906.
178 Mehos 2006, p. 105.
179 *Bulletin van het Koloniaal Museum te Haarlem*. Report 1912, 'Aanwinsten', 1912.
180 Van Hall p. 9.
181 Hasselman 1924.
182 Bolland, R. Unpublished manuscript. Amsterdam, n.d.
183 Some titles: Goslings, B.M. 'Het Primitiefste der primitieve Indonesische weefgetouwen', *Nederlands Indië Oud en Nieuw*, vol. XIII, 1928/29, pp. 85–96, 112–25; and 'De beteekenis der invoering van den kam in het Indonesische weefgetouw'.

Nederlands Indië Oud en Nieuw VII, 1922/23, pp. 163–80, 243–56, 275–91.

184 Goslings 1922/23.

185 Kerlogue 2001, p. 84.

186 Adam 1919.

187 Van Dijk 2011, p. 35.

188 Translation by Dr. F.H. van Naerssen, curator of the Ethnology department, March 1944.

189 Ibid.

190 Dharmowijono 2009, pp. 60–65.

191 Repertorium van Nederlandse zendings- en missie-archieven 1800-1960 Website, Huygens Instituut voor Nederlandse geschiedenis, 2011.

192 Niessen 1993, p. 101.

193 Ibid., pp. 98–112.

194 Letter 484/25 in KIT archive.

195 Drabbe 1940.

196 Frank 2012, p. 14.

197 Legêne 1999.

198 The dissertation was published as a book: *Sprekende Weefsels – Studie over het ontstaan en betekenis van weefsels van enige Indonesische eilanden.* Amsterdam, Koninklijk Instituut voor de Tropen, 1952.

199 Jager Gerlings 1952, p. 107.

200 Ibid., p. 7.

201 Ibid., p. 8.

202 From an unpublished report by Rita Bolland.

203 Van Hout 2008.

204 Jager Gerlings 1952, p. 85.

205 Alfred Bühler studied textile production techniques in Switzerland; his publications include: Bühler, A. *Ikat Batik Plangi.* 3 vols., Basel, Pharos-Verlag, 1972; Bühler, A. and E. Fischer, *The Art of the Patola.* Basel, Krebs, 1979.

206 Bolland 1991, pp. 179–84.

207 A large number of internationally known researchers visited Rita Bolland, among whom Monnie Adams, Mattiebelle Gittinger, Rens Heringa, Ruth Barnes, Anita Spertus, Jeff Holmgren, Robyn Maxwell, Brigitte Majlis, and Sandra Niessen.

208 Langewis and Wagner 1964.

209 Van Brakel, Van Duuren and Van Hout 1996, p. 12.

210 Correspondence belonging to Series 1772.

211 Van Brakel, Van Duuren and Van Hout 1996, p. 13.

212 Tillmann 1938 (a), pp. 10–16, 30–31; Tillmann 1938 (b), pp. 130–43; Tillmann 1939, pp. 16–19.

213 Information supplied during a conversation with Charlotte Tillman in 1996.

214 Schrieke 1939, p. 2.

215 Tillmann 1939, pp. 111–17.

216 Georg Tillmann's son Wolf Tilman changed the spelling of the family name. The collection is registered under this name.

217 Van Duuren 1990, p. 7.

218 Rita Bolland realised this exhibition in collaboration with Attie Tabak.

219 The author, Itie van Hout, was appointed as the successor to Rita Bolland in 1986.

220 Legêne 1998.

221 With thanks to T. Murray for his advice.

222 Gosden and Knowles 2001, p. 7.

Endnotes 'The Presentation of Textiles, Ethnology and Design'

223 Van Eeden 1887, pp. 1–11.

224 'Handelingen'. In: *Tijdschrift Nederlandsche Maatschappij ter bevordering van Nijverheid*, 1866, p. 42.

225 '[…] there were complaints about the lack of space even before the official opening in 1871, a grievance that characterises the whole history of the Museum.' Excerpt from J.T. Cremer's speech given at the transfer of the Colonial Museum to the Colonial Institute Association on 4 January 1913 (Annual Report, 1912. *Bulletin van het Koloniaal Museum*, no. 52, 1913, p. 90).

226 Van Eeden 1883, p. 134.

227 Van Eeden 1873, pp. 191–92.

228 Ibid.

229 'Plant silk or *Widoeri*, the pappus of the Crown flower (*Calotropis gigantea*), is used in the East Indies as cushion filling; attempts were also made to spin the fibres.' (*Gids voor de bezoekers van het Koloniaal Museum te Haarlem*, Amsterdam, J.H. De Bussy, 1902, p. 42).

230 'The *ikat* loom stands in the middle of the room, and a cotton mill, a yarn winder and other tools required for the weaving process are placed around it. We would gratefully receive more items from this area of expertise, such as: a spinning wheel, a spinning rod, a cotton bow, etc. Who amongst our friends in the East Indies can help the museum with this?' (*Bulletin van het Koloniaal Museum*, no. 33, 1906, p. 87).

231 *Gids voor de bezoekers van het Koloniaal Museum te Haarlem.* Amsterdam, J.H. De Bussy, 1902, p. 18.

232 This was a shift that occurred all over Europe in similar displays: for example, the Pitt Rivers Museum in Oxford – originally a taxonomic- and evolutionary-oriented museum – began focusing on anthropological studies at this time.

233 *Gids voor de bezoekers van het Koloniaal Museum te Haarlem.* Amsterdam, J.H. De Bussy, 1902, p. 19.

234 The reason for the lecture was the publication by H. Kleinmann & Co, Haarlem of Rouffaer's book *De batik-kunst in Nederlandsch-Indië en haar geschiedenis*, in 1900.

235 The 'Nederlandsche West-Indische Tentoonstelling' ('Dutch West Indies Exhibition') was held in the great hall of the Colonial Museum's new annex in 1899. Afterwards the hall became a permanent West Indies department and housed the museum's entire Surinamese collection.

236 *Bulletin van het Koloniaal Museum* 23, 1900.

237 *Bulletin van het Koloniaal Museum*, no. 11, 1895, p. 7.

238 Van Eeden 1884, p. 11.

239 These exhibitions only resulted in an expansion of the museum collection because afterwards the Dutch government made some of its exhibits available to Haarlem.

240 Van Eeden 1884, pp. 21–22.

241 Annual Report 1903. *Bulletin van het Koloniaal Museum* 30, 1904, p. 72.

242 Annual Report 1905. *Bulletin van het Koloniaal Museum* 33, 1906, p. 102.

243 Annual Report 1906. *Bulletin van het Koloniaal Museum* 36, 1907, p. 77.

244 The 1910 World Fair was held from 23 April to 7 November on the grounds of the recently opened Paleis der Koloniën (Colonial Palace) and in the Jubelpark in Tervuren.

245 Annual Report 1910. *Bulletin van het Koloniaal Museum* 48, 1911, p. 91.

246 Letter dated 16 November 1910, KIT Archive, inv. no. 3487.

247 The Artis' ethnographic collection was exhibited in three museums: from 1851–61 in the Artis' Natural History Museum, also known as the 'Groote Museum'; from 1861–88 in the Ethnographic Museum, established in the 'Amicitia' Society building, also known as the 'Kleine Museum' and the 'Museum voor Land and Ethnology'; and finally, from 1888 until the actual relocation to the new Artis Ethnographic Museum located in the building 'de Volharding'.

248 Witkamp 1869, pp. 149–50.

249 Ibid., p. 150.

250 An approach that can still be seen in the display at the Pitt Rivers Museum in Oxford.

251 Pleyte 1888, p. i.

252 Ibid.

253 Here Pleyte alludes to the Westerners' success in copying these dyes. The reaction on Java and the trading spirit that prevailed there did not escape him either: 'The attempt to sell them to the Javanese as authentic was a failure. The difference was discovered immediately, and from the very start, it was called *batik wolanda*, "Dutch batik". Because the cloths made in this fashion are much cheaper than the real ones, the Javanese set about copying the latter, and to this purpose manufactured press moulds made of wood and copper (Cabinet IV), and became so accomplished in this that recently copies of what were already European copies of genuine batiks have regularly arrived from Soerakarta on the inland markets'. Ibid., p. 14.

254 Ibid., p. 7: 'The costume in Cabinet III, which reminds one of a patchwork quilt, was received as a priest's robe from Probolingo, the veracity of which we cannot confirm'.

255 Pleyte 1888, p. 26.

256 Incorporated into the Tropenmuseum collection under catalogue number TM-A-7526. See Chapter 'Collecting', (figs. 67, 68) for a similar costume, which is from a plantation worker.

257 Pleyte 1888, p. 36.

258 Pleyte 1894, p. 2.

259 *De Telegraaf*, 22 December 1894, evening edition.

260 Pleyte 1894, p. 2.

261 Dekker replaced Greshoff who died in 1909 who previously held a chair in the committee as secretary. Dr. C. Kerbert, the director of Artis, was a member of the Dutch honorary committee for the congress and exhibition in Surabaya.

262 Included in Series TM-H-3138–3156.

263 *Het Nieuws van den Dag*, 26 December 1911, early edition.

264 Information provided at 'Inteeken-biljet voor het Vezelcongres met Tentoon-stellingen te Soerabaia', Amsterdam City Archives, archive no. 395, file 2193.

265 The exhibition in Artis did not attempt to exactly reproduce the display in Surabaya, as it was impossible to ship the industrial machinery to the Netherlands.

266 J. Dekker in *Tijdschrift der Maatschappij van Nijverheid*, January 1912, p. 35.

267 During this important meeting the actual transfer, which had already taken place in 1911, was made official by the presence of, amongst others, the responsible ministers from both institutes and the Minister of Colonies. A plaque in the museum commemorates this date.

268 The instigators were C.W. Janssen and J.C. van Eerde, repectively treasurer and secretary of the Zuid-Sumatra Instituut (South Sumatra Institute), which was part of the Colonial Institute Association. Van Eerde was also director of the Ethnology department.

269 *Nieuwe Rotterdamsche Courant*, 24 December 1922, early edition.

270 Ibid.

271 Koninklijke Vereeniging Koloniaal Instituut. 13th Annual Report 1923. Amsterdam, De Bussy, 1924, p. 26; 'Soemba-weefsels'. *Nieuwe Rotterdamsche Courant*, 22 December 1923, evening edition; and 'Tentoonstelling van Soembaweefsels'. *Algemeen Handelsblad*, 23 December 1923, early edition.

272 Ibid.

273 These were, amongst others, photographs of dances, various ethnic groups. houses, landscapes and stone tombs.

274 *Catalogus van de Jubileum-Tentoonstelling 1923, gehouden ter gelegenheid van het 25-jarig regeeringsjubileum van H.M. de Koningin in het Koloniaal instituut te Amsterdam: 3–30 September*. Amsterdam: Van Holkema & Warendorf, 1923, p. 50.

275 Ibid.

276 Ibid., p. 51.

277 *Catalogus van de Jubileum-Tentoonstelling 1923, gehouden ter gelegenheid van het 25-jarig regeeringsjubileum van H.M. de Koningin in het Koloniaal instituut te Amsterdam: 3–30 September*. Amsterdam: Van Holkema & Warendorf 1923, p. 41.

278 The 'bride' was dressed exclusively in items from Series TM-789.

279 Van Eerde 1929, pp. 48–60.

280 Goslings 1932, pp. 48–133.

281 Van Hout 1999, p. 81.

282 Ibid., p. 80.

283 Also see Legène 2009, pp. 12–22.

284 Published in the progressive cultural magazine *Links Richten*, May 1933, p. 9. Poem 'Koloniaal Instituut', by Jac van der Ster. See Van Dijk and Legene 2011, p. 18.

285 *Beknopte handleiding bij het bezoek aan het Koloniaal Museum*, compiled in 1943, p. 5.

286 Van Dijk and Legene 2011, p. 10.

287 Koninklijke Vereeniging Koloniaal Instituut. Annual Report 1939. Amsterdam, De Bussy, p. 22.

288 Among others, see inv. no. H-3301a/c, acquired from Mr. E.A. Zeylinga by W.L. Utermark during a trip to the Netherlands East Indies.

289 *Beknopte handleiding bij het bezoek aan het Koloniaal Museum*, compiled in 1943, p. 5.

290 Attempts were made to introduce this loom in various regions. Textile workshops arose in places where production was only for the market. In many rural areas, where weaving was for ceremonial purposes, the weavers continued weaving in the traditional way on the original looms.

291 Catalogue. *Arts et techniques dans la vie moderne. Les Pays Bas et les Indes Néerlandaises. Section néerlandaise à l,exposition internationale de Paris*, 1937, p. 43.

292 The attention was thus focused on several companies and industries that had either been established or had prospered over the last 40 years. The entire Atrium was made available to, amongst others, Philips, Fokker, KLM, PTT and Dutch steel producer, Hoogovens (see: *Tentoonstellingsgids Jubileum-Tentoonstelling Koloniaal Instituut (15 augustus tot 1 october 1938): 40 jaar ontwikkeling van Nederland en overzeesche gewesten onder de regering van H.M. de Koningin*. Amsterdam, Drukkerij J.H. de Bussy, 1938).

293 Ibid., p. 12.

294 See, amongst others, Frank 2012, p. 13.

295 Koninklijke Vereeniging Indisch Instituut. Annual Report 1949. Amsterdam, De Bussy, p. 35.

296 The collection was placed in the museum's care at the end of 1939 as a long-term loan; in 1947 this loan was formalised on paper and the objects were numbered and incorporated into the museum's collection.

297 It is unclear as to what exactly was wrong with the cabinet and why it had to be 'sacrificed', especially considering the large sum that was spent on it.

298 In his opening speech, Prof. Mr. C.T. Bertling called textiles a 'means of recognising culture' and specifically said about the Sumatran textiles that they 'display such clear symbols of the Cosmic order'. *De Nieuwe Dag*, 9 December 1948.

299 The quote is from the invitiation to the opening of this exhibition.

300 J.M. Prange. 'Sumatraanse weefkunst in Amsterdam.' *Het Parool*, 31 December 1948.

301 The exhibition 'Indonesian Art: A Loan Exhibition from the Royal Indies Institute Amsterdam, the Netherlands', held at the Asia Institute, New York, 31 October to 31 December 1948; and 'Exposition d'Art Indonésien ancien et moderne. Sculpture, Tissage, Peintures balinaises, Peintures d'Affandi et Barli', at the Palais des Beaux-Arts Bruxelles, 12 December 1952 to 4 January 1953.

302 'Meer dan Kinderspel! Kralen maakten verre reizen en dienden overal de schoonheid. Voorjaarstentoonstelling in Tropenmuseum'. *Algemeen Handelsblad*, 27 March 1953.

303 'Kralen schrijven geschiedenis'. In: *unknown*, no. 18, 1953, pp. 32–33.

304 'Wat met kralen is te bereiken'. *Algemeen Handelsblad*, March 1953.

305 *De Tijd*, 16 May 1953.

307 KIT Archive, inv. no. 7637.

308 Museumnota, 1965, p. 7. In this report 100m2 was initially proposed for the Textile Room.

309 Berend Jan Udink was Minister for Development from 1967 to 1971. The KIT had therefore already initiated its metamorphosis into a Third World presentation centre before his 'suggestion', in contrast to what is stated in earlier publications on the history of the Tropenmuseum.

310 Annual Report 1970, p. 14. In reaction to this, in February 1971 the institute presented the report 'Het Tropenmuseum als nationaal presentatiecentrum van de mondiale ontwikkelingsproblematiek' to the Minister.

311 Issues such as slums, health care, unemployment or the movement of people from the countryside to cities determined the structure of the temporary and permanent exhibitions at the Tropenmuseum.

312 See the report 'Het Tropenmuseum als nationaal presentatiecentrum van de mondiale ontwikkelingsproblematiek', 1971, p. 12.

313 This department was established in cooperation with Attie Tabak.

314 Departmental draft script, February 1977, KIT Archive, inv. no. 7575.

315 Mannequins: men from Peru, Burkina Faso, Sahara (Tuareg); women from: Guatemala, Jemen, Java, Japan and India.

316 Departmental draft script, February 1977, KIT Archive, inv. no. 7575.

317 'Ikat' was also the first in a series of temporary and semi-permanent exhibitions to be realised by the Tropenmuseum in collaboration with Architectenbureau Jowa.

318 Capsicum Natuurstoffen was a fabrics shop specialised in 'off-the-roll' fabrics from India and Thailand.

319 Van Hout 2006, pp. 799–826.

320 To this end, UV resistant film was applied to the Atrium's glass roof.

321 Film by Fiona Kerlogue and Itie van Hout.

322 'Batik – Drawn in Wax' closed its doors after nine months and 101,642 visitors.

323 Van Dijk and Legene 2011.

324 The installation made way for a group/ reception room in 2009.

325 Designer Daan Ament.

326 The precise figures are 119,227, with 25,000 in the first month alone. Moreover, the design of the exhibition was nominated for the 2007 Dutch Design Awards in the category Exhibition and Experience Design.

327 In 2009 and 2012, two smaller textile-related exhibitions followed, 'Culture Couture I' and 'Culture Couture II', but Indonesian textiles played hardly any role in these. The Tropenmuseum mounted these as collaborations. Both exhibitions focused on the work of students from the Antwerp Royal Academy for Fine Arts. On display was a selection of their finest creations, inspired by clothing styles from various cultures.

Endnotes Catalogue

328 Niessen 1985, pp. 47, 53; Sibeth 1990, p. 65.

329 Ibid., p. 3.

330 Ibid., p. 152.

331 Niessen 2009, p. 36

332 Ibid., p. 57. Quoted after data by Yeager and Jacobson 1996, p. 3.

333 Niessen 1985, p. 195.

334 Ibid., p. 195; Van der Tuuk 1861, plate XXIX.

335 Niessen 1985, p. 196. The warp threads on this cloth have been cut, but it was probably done in the museum a long time ago. Tropenmuseum documentation.

336 Ibid., p. 141.

337 Bakels and Annemarie 1990, p. 39.

338 Niessen 2009, p. 93. The author documented the Tropenmuseum's entire textile collection in 2003.

The information about the Batak collection was mostly derived from the *Legacy in Cloth* publication and the museum documentation.

339 Van Hout 2005.

340 Niessen 2009, p. 43. Also see the Tropenmuseum documentation by S. Niessen.

341 Niessen 1985, p. 12.

342 Niessen 2009, p. 345.

343 Ibid., p. 357.

344 Bolland 1990, pp. 24–30.

345 Niessen 2009, p. 43.

346 Ibid., pp. 361, 362.

347 De Jonge 2013, p. 87.

348 Murray 1998; De Jonge 2013, p. 81.

349 Holmgren and Spertus 1980, p. 159.

350 Barnes and Hunt Kahlenberg 2010, p. 81.

351 Alfred Steinmann, Georg Tillmann, Mattiebelle Gittinger, R.J. Holmgren and Anita Spertus, Toos van Dijk and Nico de Jonge.

352 Van Dijk and De Jonge 1980, p. 15; Steinmann, Alfred, quoted in Holmgren and Spertus 1980, p. 159.

353 Holmgren and Spertus 1989, p. 74.

354 Schefold 2013, p. 25; Totton 2009, p. 6.

355 De Jonge 2013, pp. 83, 87.

356 Ibid., p. 87.

357 Ibid., pp. 93, 95.

358 Holmgren and Spertus 1989, p. 74.

359 Ibid., p. 74.

360 Holmgren and Spertus 1980, p. 169.

361 Totton 2009, pp. xii, 6.

362 De Jonge 2013, p. 84.

363 Holmgren and Spertus 1980, p. 177. The Tropenmuseum does not have an example of this type of *tampan* in its collection.

364 De Jonge 2013, p. 89.

365 Personal communication with Nico de Jonge.

366 De Jonge 2013, p. 85.

367 Ibid., p. 90.

368 Murray 2011, p. 81; De Jonge 2013, p. 109.

369 Maxwell 2003, p. 101; Gavin 2003, p. 96, fig. 22.

370 Veldhuisen-Djajasoebrata 1984, p. 27. This myth originated in West Java. In Hindu mythology, Nyi Pohatji is Dewi Sri.

371 See Heringa 2010. p. 122.

372 In Sundanese (West Java) this technique is called '*nulis*', while on the rest of Java the term 'batik' is used; see Veldhuisen-Djajasoebrata 1984 p. 48.

373 Wisseman Christie 1993, pp. 191, 193.

374 Heringa 2010, pp. 120–31.

375 Reid 1988, 77.

376 Heringa 1996, p. 34

377 Ibid., p. 33.

378 Rouffaer and Juynbol 1900, p. 391.
379 D.C. Geirnaert and H.C. Veldhuisen have also conducted important studies in the field of batik.
380 Heringa 2010, pp. 120–31 (p. 121); also see Carey 2007.
381 Ibid., pp. 120–31 (p. 122).
382 Heringa 1996, p. 34.
383 Heringa 1989, p. 110; Heringa 1985, p. 115.
384 Ibid., pp. 106–30.
385 Heringa 2010, p. 12.
386 Heringa 1989, p. 115.
387 Peranakan Chinese are descendents of immigrants who came to Indonesia and Malaysia between the 15th and 17th centuries.
388 Heringa 1996, p. 66.
389 Ibid., p. 118.
390 Veldhuisen-Djajasoebrata 1984, p. 92.
391 Heringa 1996, p. 67.
392 Information provided by K.R.T. Hardjonogoro when the collection was acquired.
393 In addition to the tubular skirt with *ikat* motifs, Jasper and Gittinger also refer to two other types of cloth: one with stripes, and one where the decoration is applied using the warp technique. See Jasper and Pirngadie 1985, p. 199.
394 With thanks to Thomas Murray. A similar cloth is illustrated in Heringa 2010, p. 254.
395 Nooy-Palm 1969, p. 168.
396 Van der Veen 1966, pp. 19, 83.
397 Nooy-Palm 1979, p. 83.
398 Gell 1998 p. 23.
399 Nooy-Palm 1986, p. 288.
400 Information accompanying the object in TMS, recorded by the collector.
401 Jager Gerlings 1952, p. 40.
402 Ibid., p. 109.
403 Barnes and Hunt Kahlenberg 2010, p. 273.
404 Maxwell 1990, p. 41.
405 Hoskins 1989, p. 155.
406 Geirnaert-Martin 1992, p. xx.
407 See the section about FAS in Chapter 'Museums, Science and material Culture'.
408 Adams 1971, p. 322.
409 Geirnaert- Martin 1992, p. xxiii.
410 Weiner and Schneider 1989, p. 23.
411 Geirnaert-Martin 1992, p. 118.
412 Adams 1971, p. 323. Geirnaert mentions that cotton was sown on the west side of the island at the start of the dry season; see Geirnaert-Martin 1992, p. 80.
413 Geirnaert-Martin 1992, p. 57.
414 Information for this section is derived from the work of Daniëlle Geirnaert; see Geirnaert 1993, pp. 10, 15, 16; Geirnaert-Martin 1992, p. 78; Geirnaert 1993, pp. 203–28.
415 Hoskins 1989, pp. 141–73.
416 Ibid., p. 142.
417 Oei 1985.
418 Geirnaert-Martin 1992, p. 93.
419 Ibid., p. 43.
420 Ibid., p. 326.
421 Geirnaert 1993, p. 205.
422 Holmgren and Spertus 1989, p. 38.
423 Hamilton 2010, p. 305.
424 Kern 1898, p. 27.
425 Adams 1969. p. 91.
426 Holmgren and Spertus 1989, pp. 26–46.
427 Gell 1998, p. 74.
428 Ibid.
429 Vergouwen 1933, p. 68; Jager Gerlings 1952, p. 83.
430 Adams 1971, pp. 321–34.
431 Ibid.
432 Ibid.
433 Heringa 1989, pp. 106–30; Hoskins 1989, pp. 141–73.
434 Bertling 1947, p. 92. Speech delivered at his acceptance of the post of extraordinary professor at the University of Amsterdam.
435 Gell 1998, p. 108.
436 Niessen 2009, p. 41.
437 Holmgren and Spertus 1989, p. 14.
438 Gell 1992, p. 44.

Endnotes captions 'Museums, Science and Material Culture'

1 Information provided by T. Harrison, then curator in the Serawak Museum in Kuching.
2 Schulte Nordholt 1966, pp. 73, 74.
3 Maxwell 1990, p. 251.
4 Jager Gerlings 1952, p. 79.
5 Shatanawi 2009, p. 218.
6 Nieuwenhuis 1907.
7 Maxwell 1990, p. 41.
8 The forerunner to Instituut Collectie Nederland (Netherlands Institute for Cultural Heritage).

Endnotes captions 'Textiles in Indonesia'

1 Bloembergen 2002, p. 259.

Endnotes captions 'The Colonials Administrations and the Arts and Crafts Industry'

1 Bronkhorst and Wils 1996. p. 45.
2 Veldhuisen 1993, pp. 38–48.
3 Ibid.
4 With thanks to E. Seriese.
5 With thanks to the Lameijn family.
6 Cohen, Behrend and Cooper 2000, pp. 97–141.

Endnotes captions 'Colonial Collections'

1 Jasper and Pirngadie 1916, p. 237.
2 Veenendaal 2014, p. 19.
3 Rouffaer and Juynbol 1900, pp. 466, 494. Rouffaer offers no translation for 'Tunggilung'.

Endnotes captions 'Collecting'

1 With thanks to Pim Westerkamp.
2 Veldhuisen-Djajasoebrata 1984, pp. 74–77.
3 Tirtokusumo 1931.
4 Groneman 1895, pp. 23, 63.
5 Rassers 1940, p. 558.
6 Maxwell 2003, p. 148.
7 Gericke and Roorda, 1886.
8 Galestin 1939, p. 117.
9 Djajasoebrata 1993, p. 53.
10 Baker 2004, pp. 198, 223.
11 Jasper andPirngadie, 1916, p. 143.
12 Baker 2004, pp. 184, 185.
13 Jager Gerlings 1952, p. 77.

Endnotes captions 'The Presentation of Textiles, Ethnology and Design'

1 Goslings, B.M., 1932, pp. 48–133.

Endnotes captions Catalogue

1 Niessen 2009. p. 362.
2 Jasper and Pirngadie, 1916, p. 143.
3 With thanks to T. Murray.
4 Guy 1998, p. 52.

MAP

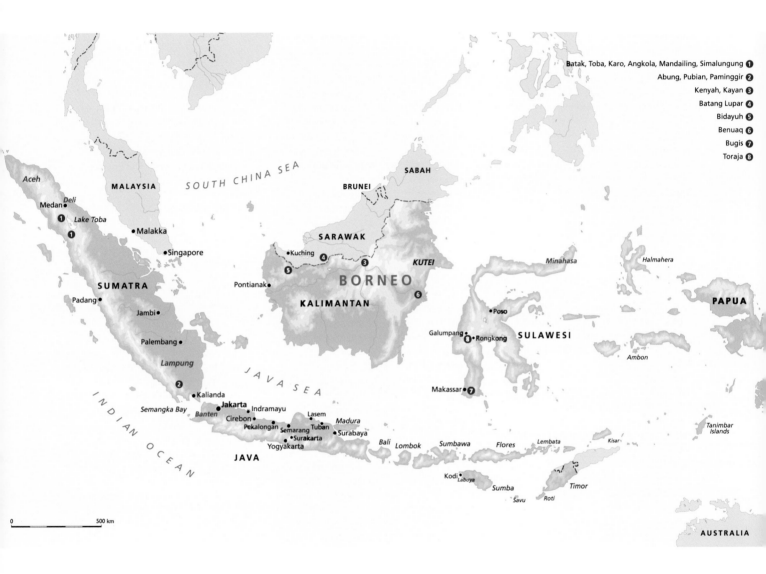

Batak, Toba, Karo, Angkola, Mandailing, Simalungung ❶
Abung, Pubian, Paminggir ❷
Kenyah, Kayan ❸
Batang Lupar ❹
Bidayuh ❺
Benuaq ❻
Bugis ❼
Toraja ❽

SOUTH CHINA SEA

MALAYSIA

Aceh

Medan • *Deli*

❶ *Lake Toba*

❶

• Malakka

• Singapore

SUMATRA

Padang •

Jambi •

Palembang •

Lampung

❷

• Kalianda

Semangka Bay

Banten

JAKARTA

Indramayu

Cirebon •

Pekalongan

Semarang • *Lasem*

Tuban

Yogyakarta • Surakarta

JAVA

INDIAN OCEAN

JAVA SEA

BRUNEI

SABAH

SARAWAK

• Kuching ❹

❺

Pontianak •

BORNEO

KUTEI

❸

❻

KALIMANTAN

Bali

Lombok

Sumbawa

Flores

Madura

Surabaya

Kodi

Laboya

Sumba

Savu

Roti

Timor

Lembata

Kisar

SULAWESI

Minahasa

Halmahera

• Poso

Galumpang ❽ • Rongkong

Makassar • ❼

PAPUA

Ambon

Tanimbar Islands

AUSTRALIA

0 500 km

BIBLIOGRAPHY

Adam, T. *Tentoonstelling van Bataksche kunstvoorwerpen*. Batavia, Nederlandsch Indische Kunstkring, 1919.

Adams, M.J. *System and Meaning in East Sumba Textile Design: A Study in Traditional Indonesian Art*. New Haven, Yale University, 1969.

Adams, M.J. 'Work Patterns and Symbolic Structures in a Village Culture, East Sumba, Indonesia'. *Southeast Asia – An International Quarterly* 1(4), 1971, pp. 321–24.

Appadurai, Arjun (ed.). *The Social Life of Things*. Cambridge, Cambridge University Press, 1986.

Arts and Crafts Kunsthandel. Capricorn, 2016.

Baanders, H.A.J. 'Studien in batik techniek'. *Bulletin van het Koloniaal Museum te Haarlem* 25, 1901, pp. 45–87.

Baanders, H.A.J. 'Over nieuwe proeven van batik-techniek in Nederland'. *Bulletin van het Koloniaal Museum te Haarlem* 24, 1901, pp. 52–62.

Bakels, J. and Annemarie Boer. *Het Wapen van de Bruid*. The Hague, Museon, 1990.

Baker, P.L. *Islam and the Religious Arts*. London/New York, Continuum, 2004, pp. 198–223.

Balfour, H. *The Frazer Lecture*. Oxford, Clarendon Press, 1938.

Barnes, Ruth. *The ikat textiles of Lamalera: A Study of an Eastern Indonesian Weaving Tradition*. Leiden: E. J. Brill, 1989.

Barnes, Ruth and M. Hunt Kahlenburg (eds.). *Five Centuries of Indonesian Textiles – The Mary Hunt Kahlenburg Collection*. Munich, Berlin, London, New York, Delmonico Books/Prestel, 2010.

Basu, P. 'Material Culture: Ancestries and Trajectories in Material Culture Studies'. In: J.G. Carrier and D.B. Gewertz (eds.), *Handbook of Sociocultural Anthropology*. Oxford, Berg Publishers, 2013, pp. 370–90.

Beelaerts van Blokland, F.W.A. [et al.]. *Paviljoen Welgelegen 1789-1989. Van buitenplaats van de bankier Hope tot zetel van de provincie Noord-Holland*. Schuyt, Haarlem, 1989.

Bellwood, P. *Prehistory of the Indo-Malayan Archipelago*. Honolulu, University of Hawaii Press, 1997.

Bellwood, P. and I. Glover (eds.). *Southeast Asia – From Prehistory to History*. London, Routledge Curzon, 2004.

'Beknopte handleiding bij het bezoek aan het Koloniaal Museum', compiled in 1943.

Bertling, C. Tj. *Sociale werkelijkheid bij primitieven*. Groningen, J.B. Wolters, 1947.

Bloembergen, Marieke. 'Nederlandse Pronk-waar – De collectie wereldtentoonstellingen in het Tropenmuseum'. Unpublished report, Amsterdam, 2001.

Bloembergen, M. *De Koloniale Vertoning – Nederland en Indië op de wereldtentoon-stellingen (1880-1931)*. Amsterdam, Wereld-bibliotheek, 2002.

Boas, Franz. *Primitive Art*. Oslo, Instituttet for Sammenlignende Kulturforskning, 1927.

Bolland, R. Unpublished manuscript. Amsterdam, n.d.

Bolland, R. 'Hoe draden trouwen'. In: Jet Bakels and Anne-Marie Boer (eds.), *Het Wapen van de Bruid*. The Hague, Museon, 1990, pp. 24–30.

Bolland, R. 'You Need a Loom to Produce a Textile'. In: G. Völger and K. v. Welck (eds.), *Indonesian Textiles – Symposium 1985*. Cologne, Ethnologica, 1991.

Bowden, R. 'A Critique of Alfred Gell on Art and Agency'. In *Oceania* 74(4), 2004. pp. 309–24.

Brakel, K. van, D. van Duuren and I. van Hout. *A Passion for Indonesian Art – The Georg Tillmann Collection at the Tropenmuseum in Amsterdam*. Amsterdam, Tropenmuseum, 1996.

Brakel, K. van and Susan Legêne (eds.). 'Collecting at Cultural Crossroads. Collection Policies and Approaches (2008–2012) in the Tropenmuseum'. *Bulletin Tropen-museum* 381, 2008.

Bronkhorst D. and Esther Wils. *Tropenecht – Indische en Europese kleding in Nederlands-Indië*. The Hague, Stichting Tong Tong, 1996.

Buckley, C.D. 'Investigating Cultural Evolution Using Phylogenetic Analysis: The Origins and Descent of the Southeast Asian Tradition of Warp Ikat Weaving'. *PlosOne* 7(12), 2012, e52064.

Buckley C. 'Looms, Weaving and the Austro-nesian Expansion'. In: A. Acri, R.M. Blench and A. Landmann (eds.), *Cultural Exchanges in Monsoon Asia*. Singapore, ISEAS (in press).

Bühler, A. *Ikat Batik Plangi*. 3 vols. Basel, Pharos-Verlag, 1972.

Bühler, A. and E. Fischer. *The Art of the Patola*. Basel, Krebs AG, 1979.

Bühler, A. and E. Fisher. *The Patola of Gujarat – Double Ikat in India*. Basel, Krebs AG, 1979.

Bulletin van het Koloniaal Museum, 'Aanwinsten'. Report 1912.

Bulletin van het Koloniaal Museum, Annual Report 11, 1895.

Bulletin van het Koloniaal Museum 23, 1900.

Bulletin van het Koloniaal Museum 24, 1901.

Bulletin van het Koloniaal Museum, Annual Report 1903, no. 30, 1904.

Bulletin van het Koloniaal Museum, Annual Report 1905, no. 33, 1906.

Bulletin van het Koloniaal Museum, Annual Report 1906, no. 36, 1907.

Bulletin van het Koloniaal Museum, Annual Report 1910, no. 48, 1911.

Bulletin van het Koloniaal Museum. Annual Report, 1912, no. 52, Sept. 1913.

Bussy, J.H. de. *Gids voor de bezoekers van het Koloniaal Museum te Haarlem*, Amsterdam, 1902.

Catalogue. Arts et techniques dans la vie moderne. Les Pays Bas et les Indes Néerlandaises. Section néerlandaise à l'exposition internationale de Paris, 1937.

Catalogus van de Jubileum-Tentoonstelling 1923, gehouden ter gelegenheid van het 25-jarig regeeringsjubileum van H.M. de Koningin in het Koloniaal instituut te Amsterdam: 3-30 September. Amsterdam, Van Holkema & Warendorf, 1923.

Cohen, M.I., T.E. Beherend and T.L. Cooper. 'The Barikan Banner of Gegesik'. *Archipel* 59, 2000, pp. 97–144.

Cohn, B.S. 'Cloth, Clothes, and Colonialism: India in the Nineteenth Century'. In: Annette B. Weiner and Jane Schneider (eds.), *Cloth and the Human Experience*. Washington, Smithsonian Institution Press, 1989, pp. 303–54.

Jim Crace. *Quarantine*. London, Picador, 1997.

Dekker, J. 'De Na-Tentoonstelling van Vezel-stoffen in Artis'. *Tijdschrift der Maatschappij van Nijverheid*, January 1912, pp. 32–35.

Deventer, C. Th. van. 'Een Eereschuld'. *De Gids* 63, 1899.

Dharmowijono, W.W. *Van koelies, klontongs en kapiteins: het beeld van de Chinezen in Indisch-Nederlands literair proza 1880-1950.* Amsterdam, Instituut voor Cultuur en Geschiedenis, 2009.

Dijk, K. van. 'Sarongs, Jubbah, and Trousers – Appearance as a Means of Distinction and Discrimination'. In: Henk Schulte Nordholt (ed.), *Outward Appearances – Dressing State & Society in Indonesia.* Leiden, KITLV Press, 1997, pp. 39–84.

Dijk, J. van. 'Ceremonial Jacket'. In: J. van Dijk and S. Legêne (eds.), *The Netherlands East Indies at the Tropenmuseum.* Amsterdam, KIT Publishers, 2011.

Dijk, T. van and N. de Jonge. *Ship Cloths of the Lampung, South Sumatra.* Amsterdam, Galerie Mabuhay, 1980.

Dijk, J. van & S. Legene (eds.), *The Netherlands East Indies at the Tropenmuseum.* Amsterdam, KIT Publishers, 2011.

Djajasoebrata, A. 'Snakeskin Motifs on some Javanese Textiles – Awe, Love and Fear for Progenitrix Naga'. In: Marie-Louise Nabholz-Kartaschoff, Ruth Barnes and David J. Stuart Fox (eds.), *Weaving Patterns of Life – Indonesian Textile Symposium 1991.* Basel, Museum of Ethnography, 1993, p. 53.

Drabbe, P. *Het leven van den Tanémbarees; ethnographische studie over het Tanémbareesche volk.* Leiden, E.J. Brill, 1940.

Duuren, D. van. *125 Jaar Verzamelen: Tropenmuseum.* Amsterdam, Koninklijk Instituut voor de Tropen, 1990.

Eeden, F.W. van. 'Kort overzigt van het Museum van Grondstoffen, Natuurvoortbrengselen en Volksvlijt uit de Overzeesche Bezittingen en Koloniën. Gevestigd op het Paviljoen te Haarlem'. *Tijdschrift uitgegeven door de Nederlandsche Maatschappij ter bevordering van Nijverheid.* Haarlem, De Erven Loosjes, 1873, pp. 191–92.

Eeden, F.W. van. 'De waarde der Indische kunst'. *Tijdschrift uitgegeven door de Nederlandsche Maatschappij ter bevordering van Nijverheid,* 1883, p. 134

Eeden, F.W. van. 'Gedenkschrift bij het Twaalf en een half-jarig bestaan van het Koloniaal Museum'. *Tijdschrift uitgegeven door de Nederlandsche Maatschappij ter Bevordering van Nijverheid,* 1884, pp. 1–36.

Eeden, F.W. van. 'De Colinderies. Herinneringen aan de Koloniale en Indische Tentoonstelling te Londen in 1886'. *Tijdschrift uitgegeven door de Nederlandsche Maatschappij ter bevordering van Nijverheid,* 1887, pp. 1–11.

Eerde, J.C. van. 'Javaansche Dansen en Europeesche Schilderijen'. In: *Gedenkschrift bij het 75-jarig bestaan van het Koninklijk Instituut voor de Taal-, Land- en Volkenkunde van Nederlandsch-Indië.* The Hague, Martinus Nijhoff, 1926.

Eerde, J.C. van. 'Kort verslag nopens de studiereis van den directeur der Afdeeling Volkenkunde naar Nederlandsch-Indië (4 April–21 November 1929)'. Koninklijke Vereeniging Koloniaal Instituut, 19th Annual Report 1929. Amsterdam, De Bussy, 1929, pp. 48–60.

Fox, J.J. 'Roti, Ndao, and Savu'. In: Mary Hunt Kahlenberg, *Textile Traditions of Indonesia.* Los Angeles, Los Angeles County Museum of Art, 1977, pp. 97–104.

Fox, J.J. 'Figure Shark and Pattern Crocodile: The Foundations of the Textile Traditions of Roti and Ndao'. In: Mattiebell Gittinger (ed.), *Indonesian Textiles.* Washington D.C., The Textile Museum, 1979.

Frank, D. *Cultuur onder Vuur – Het Tropeninstituut in oorlogstijd.* Amsterdam, KIT Publishers, 2012.

Galestin, Th.P. 'Enkele Notities in verband met de 'Kjahi Ontro Koesoemo'. *Mededeelingen van het Koloniaal Instituut,* 1939, pp. 110–18.

Gavin, T. *The Women´s Warpath – Iban Ritual Fabrics from Borneo.* Los Angeles, UCLA Fowler Museum of Cultural History, 1996. p. 27.

Gavin, T. *Iban Ritual Textiles.* Leiden, KITLV Press, 2003.

Geirnaert-Martin, D.C. *The Woven Land of Laboya – Socio-cosmic Ideas and Values in West Sumba, Eastern Indonesia.* Leiden, CNWS, 1992.

Geirnaert, D.C. *Eiland aan een Draad – Weefsels van Sumba.* The Hague, Museon, 1993.

Geirnaert, D.C. 'The Sumbanese Textile Puzzle – A Comparative Exercise'. In: Marie-Louise Nabholz-Kartaschoff, Ruth Barnes and David J. Stuart-Fox (eds.), *Weaving Patterns of Life.* Indonesian Textile Symposium 1991. Basel, Museum of Ethnography Basel, 1993, pp. 203–28.

Gell, A. 'The Enchantment of Technology, the Technology of Enchantment'. In: J. Coote and A. Shelton (eds.), *Anthropology, Art and Aesthetics.* Oxford, Clarendon, 1992, pp. 40–63.

Gell, A. *Art and Agency.* Oxford, Clarendon Press, 1998, p. 7.

Gelman Taylor, Jean. 'Costume and Gender in Colonial Java 1800–1940'. In: Henk Schulte Nordholt (ed.), *Outward Appearances – Dressing State & Society in Indonesia.* Leiden, KITLV Press, 1997, pp. 85–116.

Gerbrands, A.A., *De Taal der Dingen.* The Hague, Mouton & Co., 1966.

Gericke J.F.C. and T. Roorda. *Javaansch-Nederduitsch handwoordenboek.* Amsterdam, Johannes Muller, 1886.

Gittinger, M. 'An Introduction to the Body-Tension Looms and Simple Frame Looms in Southeast Asia'. In: Irene Emery and Patricia Fiske (eds.), *Looms and their Products.* Washington, The Textile Museum, 1979, pp. 54–68.

Gittinger, M. *Splendid Symbols – Textiles and Tradition in Indonesia.* Washington DC, The Textile Museum, 1979.

Gittinger, M. (ed.). *Indonesian Textiles.* Washington D.C., The Textile Museum, 1979.

Gittinger, M. *Textiles for this World and Beyond.* London, Scala Publishers, 2005.

Goslings, B.M. 'Weven en Ikatten'. In: A.J.L. Couvreur and B.M. Goslings, *Gids in het Volkenkundig Museum. X. De Timorgroep en de Zuid-Wester-Eilanden, en Weven en Ikatten.* Amsterdam, De Bussy, 1932, pp. 48–133.

Groot, M. *Vrouwen in de Vormgeving in Nederland 1880-1940.* Rotterdam, Uitgeverij 010, 2007.

Goens, R. van. *Javaense Reyse. De bezoeken van een VOC-gezant aan het hof van Mataram 1648-1654.* V. Caimax, 1666.

Gosden. C. and C. Knowles. *Collecting Colonialism, Material Culture and Colonial Change.* Oxford/New York, Berg Publishers, 2001.

Gosling B.M., 'Scheringtechniek in Indische Weefsels'. *Nederlands Indië Oud en Nieuw* V, 1920/21, pp. 202–40.

Goslings, B.M. 'De beteekenis der invoering van den kam in het Indonesische weefgetouw'. *Nederlands Indië Oud en Nieuw* VII, 1922/23, pp. 163–80, 243–56, 275–91.

Goslings, B.M. 'Het Primitiefste der primitieve Indonesische weefgetouwen'. *Nederlands Indië Oud en Nieuw* XIII, 1928/29, pp. 85–96, 112–25.

Goslings, B.M., *Gids in het Volkenkundig Museum XII, 'Borneo'.* Amsterdam, De Bussy, 1933, p. 113.

Groeneboer, K. *Een Vorst onder de Taalgeleerden – Herman Neubronner van der Tuuk, Taalafgevaardigde voor Indië van het Nederlandsch Bijbelgenootschap 1847-1873.* Leiden, KITLV Press, 2002.

Groneman, I. *De Garebegs te Ngajogya Karta.* The Hague, Nijhoff, 1895, pp. 23, 63.

Groot, Hans. *Weltevreden. Het Bataviaasch Genootschap van Kunsten en Wetenschappen 1778-1867.* Leiden, KITLV Press, 2009.

Guy, John. *Woven Cargoes – Indian Textiles in the East*. London, Thames and Hudson, 1998.

Hall, C.J.J. van. *Het Koloniaal Instituut te Amsterdam – Wording, Werking en Toekomst*. Amsterdam, De Bussy, 1941.

Hamilton, Roy, W. 'Textiles and Identity in Eastern Indonesia'. In: Ruth Barnes and Mary Hunt Kahlenburg (eds.), *Five Centuries of Indonesian Textiles – The Mary Hunt Kahlenburg Collection*. Munich, Berlin, London, New York: Delmonico Books, Prestel, 2010.

'Handelingen'. *Tijdschrift Nederlandsche Maatschappij ter bevordering van Nijverheid*, 1866, p. 42.

Hasselman C.J. and J.T. Cremer. *Memorie over de wording en het doel der Vereeniging Koloniaal Instituut*. Amsterdam, 1910.

Hasselman, C.J. *Het Koninklijk Koloniaal Instituut te Amsterdam – Wording, Werking en Toekomst*. Amsterdam, Het Instituut, 1924.

Henare, A, M. Holbraad and S. Wastell. 'Introduction'. In: A. Henare, M. Holbraad and S. Wastell (eds.), *Thinking through Things*. New York, Routledge, 2007.

Heringa, R. 'Kain Tuban – Een oude Javaanse indigotraditie'. In: Oei, Loan (ed.), *Indigo – Leven in een kleur*. Weesp, Fibula – Van Dishoeck, 1985.

Heringa, R. 'Javaanse katoentjes'. In: Brommer, Bea (ed.), *Katoendruk in Nederland*. Tilburg, Nederlands Textielmuseum, 1989.

Heringa, R. 'Dye Process and Life Sequence – The Coloring of Textiles in an East Javanese Village'. In: Mattiebelle Gittinger (ed.), *To Speak with Cloth – Studies in Indonesian Textiles*. Los Angeles, University of California, 1989, pp. 107–30.

Heringa, R. 'Batik Pasisir as Mestizo Costume'. In: Rens Heringa and Harmen C. Veldhuisen, *Fabric of Enchantment – Batik from the North Coast of Java*. Los Angeles, Los Angeles County Museum of Art, 1996, pp. 46–69.

Heringa, R. 'The Historical Background of Batik on Java'. In: Rens Heringa and Harmen C. Veldhuisen, *Fabric of Enchantment – Batik from the North Coast of Java*. Los Angeles, Los Angeles County Museum of Art, 1996, pp. 30–37.

Heringa, R. *Nini Towok's Spinning Wheel – Cloth and the Cycle of Life in Kerek, Java*. Los Angeles, Regents of the University of California, 2010.

Heringa, R. 'Upland Tribe, Coastal Village, and Inland Court: Revised Parameters for Batik Research'. In: Ruth Barnes and M. Hunt Kahlenburg (eds.), *Five Centuries of Indonesian Textiles – The Mary Hunt Kahlenburg Collection*. Munich, Berlin, London, New York, Delmonico Books/ Prestel, 2010, pp. 120–31.

Hitchcock, M. *Indonesian Textiles*. London, British Museum Press, 1991.

Hoitink, Mirjam. *Exhibiting the Past – Caspar Reuvens and the Museums of Antiquity in Europe 1800–1840*. Turnhout, Belgium, Brepols Publishers N.V., 2011.

Holmgren, J. and Anita Spertus. 'Tampan Pasisir: Pictorial Documents of an Ancient Indonesian Coastal Culture'. In: Mattiebelle Gittinger (ed.), *Indonesian Textiles – Irene Emery Roundtable on Museum Textiles*. Washington, The Textile Museum, 1980, pp. 157–98.

Holmgren, R.J. and Anita E. Spertus. *Early Indonesian Textiles from Three Island Cultures*. New York, The Metropolitan Museum of Art, 1989.

Hoskins, J. 'Why Do Ladies Sing the Blues? Indigo Dyeing, Cloth Production, and Gender Symbolism in Kodi'. In: Annette B. Weiner and Jane Schneider, *Cloth and Human Experience*. Washington and London, Smithsonian Institution Press, 1989, pp. 141–73.

Hoskins, J. 'Agency, Biography and Objects'. In: C. Tilley, W. Keane, S. Küchler, M. Rowlands and P. Spyer (eds.), *Handbook of Material Culture*. London, Sage Publications Ltd., 2006, pp. 74–84.

Hout, Itie van. 'Ordening in vorm en kleur. Ritmische patronen op textiel'. In: E. Den Otter, S. Legene (eds.), *Ritme, dans van de tijd*. Amsterdam, Koninklijk Instituut voor de Tropen, 1999, pp. 76–95.

Hout, Itie van. 'The Senses and Sentiments of Dress'. Paper presented at A Symposium Recognizing the Career of Regents Professor Joanne B. Eicher, University of Minnesota, 2005.

Hout, I. van. 'Dressed in Prayers – Religious Implications of Bird Motifs on Indonesian Textiles from Borneo, Sumba and Timor'. In: Pierre le Roux & Bernard Sellato (eds.), *Divine Messengers – Bird Symbolism and Aesthetics in Southeast Asia*. Singapore, Editions Connaissances et Savoirs / Seven Orients / IRASEC, 2006, pp. 799–826.

Hout, I. van. 'Curator of Textiles at the Tropenmuseum'. In: S. Niessen (ed.), *Rita Bolland – Curator of Textiles*. Amsterdam, KIT Publishers, 2008, pp. 23–39.

Hulsbosch, M. 'Pointy Shoes and Pith Helmets – Dress and Identity Construction in Ambon from 1850 to 1942'. Self-published, 2004.

Jager Gerlings, J.H. *Sprekende Weefsels – Studie over het ontstaan en betekenis van weefsels van enige Indonesische eilanden*. Amsterdam, Koninklijk Instituut voor de Tropen, 1952.

Jager Gerlings, J.H. and G.W. Grootenhuis. Museumnota, 1965.

Jasper, J.E. *Verslag van de Tweede Jaarmarkt-Tentoonstelling te Soerabaja*. Batavia, Landsdrukkerij, 1906.

Jasper, J.E. 'Bericht Vezelcongres met Tentoonstelling te Soerabaja Juli 1911'. *De Indische Gids* 34, 1912, pp. 12–15.

Jasper, J. E. and Mas Pirngadie. *De Inlandsche kunstnijverheid in Nederlandsch Indië. I Het vlechtwerk, II De weefkunst, III De batikkunst, IV De goud- en zilversmeedkunst, V De bewerking van niet-edele metalen*. The Hague, Mouton & Co, 1916.

Jonge, N. de. 'Lampung Ship Cloths: Ancient Symbolism and Cultural Adaptation in South Sumatran Art'. In: R. Schefold and Steven G. Alpert (eds.), *Eyes of the Ancestors – The Arts of Island Southeast Asia*. New Haven end London, Dallas Museum of Art, Yale University Press, 2013, pp. 81–91.

Joosten, J.M. 'De batik en de vernieuwing van de nijverheidskunst in Nederland, 1892-1905'. *Nederlands Kunsthistorisch Jaarboek* 23, 1972, pp. 407–29.

Josselin de Jong, J.P.B. de 'The Malay Archipelago as a Field of Ethnological Study'. In: P.E. de Josselin de Jong (ed.), *Structural Anthropology in the Netherlands*. The Hague, Martinus Nijhoff, 1977 (1935), pp. 164–82.

Kat Angelino, P de. 'Rapport betreffende eene gehouden enquête naar de arbeidstoestanden in de batikkerijen op Java en Madoera'. Weltevreden, Landsdrukkerij, 1930/1931.

Kerlogue, F. 'Flowers, Fruits and Fragrance – The Batiks of Jambi'. In: Itie van Hout (ed.), *Batik Drawn in Wax – 200 Years of Batik Art from Indonesia in the Tropenmuseum Collection*. Amsterdam, KIT Publishers, 2001, pp. 78–89.

Keurs, P. ter, 'W.H. Rassers and the Study of Material Culture'. In: Michael Prager and Pieter ter Keurs (eds.), *W.H. Rassers and the Batak Magic Staff*. Leiden, Rijksmuseum voor Volkenkunde, 1998, pp. 31–52.

Keurs, Pieter ter. 'Introduction: Theory and Practice of Colonial Collecting'. In: Pieter ter Keurs (ed.), *Colonial Collections Revisited*. Leiden, CNWS Publications, 2007.

Keurs, P. ter. *Materiële cultuur en vergankelijkheid*. Leiden, Leiden University, 2011.

Koninklijk Genootschap Natura Artis Magistra. *1838–1898*, Amsterdam, Van Mantgem, 1898.

Koninklijke Instituut voor de Tropen. 'Het Tropenmuseum als nationaal presentatie-centrum van de mondiale ontwikkelings-problematiek', February 1971.

Koninklijke Vereeniging Indisch Instituut. Annual Report 1949.

Koninklijke Vereeniging Koloniaal Instituut. Annual Report 1939.

Koninklijke Vereeniging Koloniaal Instituut. Annual Report 1923. p. 26.

Kopytoff, Igor, 'The Cultural Biography of Things: Commoditization as Process'. In: Arjun Appadurai (ed.), *The Social Life of Things*. Cambridge, Cambridge University Press, 1986, pp. 64–91.

'Kralen schrijven geschiedenis'. *Unknown* 18, 1953, pp. 32–33.

Küchler, S. and D. Miller. *Clothing as Material Culture*. Oxford, New York, Berg Publishers, 2005.

Lamp, F.J., 'Dress, Undress, Clothing and Nudity'. In: J.B. Eicher (ed.), *Berg Encyclopedia of World Dress and Fashion* 10, *Global Perspectives*. Oxford, New York, Berg Publishers, 2010, pp. 19–32.

Langewis, L. and F.A. Wagner. *Decorative Art in Indonesian Textiles*. Amsterdam, Van der Peet, 1964.

Lechtman, H. 'Style in Technology – Some Early Thoughts'. In: Heather Lechtman and Robert Merrill (eds.), *Material Culture – Styles, Organization, and Dynamics of Technology*. St. Paul, Proceedings of the American Ethnological Society, 1975, pp. 3–20.

Legêne, S. 'The History of the Tropenmuseum and the Colonial Heritage.' Amsterdam, Tropenmuseum, Position Paper, 1998.

Legêne, S. 'Past and Future behind a Colonial Façade – The Tropenmuseum in Amsterdam'. *Archiv für Völkerkunde* 50, 1999, pp. 265–74.

Legêne, S. and B. Waaldijk. 'Reverse Images – Patterns of Absence, Batik and the Representation of Colonialism in the Netherlands'. In: I. van Hout (ed.), *Batik – Drawn in Wax*. Amsterdam, KIT Publishers, 2001, pp. 34–65.

Legêne, S., 'Enlightenment, Empath, Retreat'. In: Pieter ter Keurs (ed.), *Colonial Collections Revisited*. Leiden, CNWS Publications, 2007, pp. 220–45.

Legêne, S. 'Refurbishment: the Tropenmuseum for a Change'. In: D. van Dartel (ed.), *Tropenmuseum for a Change! Present between Past and Future. A Symposium Report*. Bulletin 391, Tropenmuseum. 2009, pp. 12–22.

Letter 484/25 in the archive of the Royal Institute for the Tropics.

Lion Cachet, C.A. 'Voorwerpen van gebatikt perkament'. *Maandblad voor Beeldende Kunsten* 1, 1924, pp. 108–13.

Lodewycksz, W. *De Eerste Schipvaart der Nederlanders naar Oost-Indië onder Cornelis de Houtman 1595-1597*. Amsterdam, De Bussy, 1930.

Loebèr, J.A. *Techniek en Sierkunst in den Indischen Archipel*. Amsterdam, Koloniaal Instituut, 1916.

Maxwell, R. *Textiles of Southeast Asia – Tradition, Trade and Transformation*. Melbourne, Oxford University Press, 1990.

Maxwell, R. *Sari to Sarong – Five Hundred Years of Indian and Indonesian Textile Exchange*. Parkes, Canberra, National Gallery of Australia, 2003.

Meadow, M.A. 'Introduction'. In: *The First Treatise on Museums – The Samuel Quiccheberg's Inscriptiones 1565*. Los Angeles, Getty Publications, 2014.

Mehos, D.C. *Science and Culture for Members Only: The Amsterdam Zoo in the Nineteenth Century*. Amsterdam, Amsterdam University Press, 2006.

Miller, D. *Material Culture and Mass Consumption*. Oxford, Basil Blackwell Ltd., 1987.

Miller, D., 'Materiality: An Introduction'. In: D. Miller (ed.), *Materiality*. Duke University Press, 2005, pp. 1–50.

Murray, T. 'The Ship and the Tree – Adat Textiles of South Sumatra'. *HALI The International Magazine of Antique Carpet and Textile Art* 101, 1998, pp. 88–114.

Musschenbroek, S.C.I.W. van. *Iets over de inlandsche wijze van katoenverven naar Javaansche bronnen bewerkt en met aanteekeningen voorzien*. Leiden, Brill, 1878.

Niessen, S.A. *Motifs of Life in Toba Batak Texts and Textiles*. Alblasserdam, Kanters BV, 1985.

Niessen S.A. 'Waarom het garen van de godin der Toba Batak zwart was'. In: Oei, Loan (ed.), *Indigo – Leven in een kleur*. Weesp, Fibula – Van Dishoeck, 1985, pp. 137–44.

Niessen, S.A. *Batak Cloth and Clothing: A Dynamic Indonesian Tradition*. Kuala Lumpur, Oxford University Press, 1993.

Niessen, S. *Legacy in Cloth: Batak Textiles of Indonesia*. Leiden, KITLV Press, 2009.

Nieuwenhuis, A.W. *Quer durch Borneo – Ergebnisse seiner Reisen in den Jahren 1894, 1896-97 und 1898-1900*. Leiden: E.J. Brill, 1907.

Nooy-Palm, H. 'Dress and Adornment of the Sa'dan Toradja'. *Tropical Man* II, 1969, p. 168.

Nooy-Palm, C.H.M. 'The Role of the Sacred Cloths in the Mythology and Ritual of the Sa'dan Toraja of Sulawesi, Indonesia'. In: *Indonesian Textiles – Irene Emery Roundtable on Museum Textiles*. The Textile Museum Washington, 1979, pp. 81–95.

Nooy-Palm, C.H.M. 'The Sa'dan Toraja: A Study of their Social Life and Religion. Rituals of the East and the West'. *Verhandelingen van het Koninklijk Instituut voor Taal-, Land- en Volkenkunde* 2(118), 1986.

Oei, Loan (ed.). *Indigo – Leven in een kleur*. Weesp, Fibula – Van Dishoeck, 1985.

Pleyte, C.M. *Gids voor den bezoeker van het Ethnographisch Museum*. Amsterdam, Tj. van Holkema, 1888.

Pleyte, C.M. *Gids voor den bezoeker der Tentoonstelling van Geweven Stoffen, uit den Oost-Indischen Archipel*, Amsterdam. Koninklijk Zoologisch Genootschap 'Natura Artis Magistra', 1894.

Raffles, Sir Thomas Stamford. *De Geschiedenis van Java*. Translated and annotated by J.E. de Sturler. The Hague & Amsterdam, De Gebroeders van Cleef, 1836.

Rassers, W.H. *On the Javanese Kris*. The Hague, Koninklijk Instituut voor de Taal-, Land- en Volkenkunde van Nederlandsch-Indië, part 99, 1940, p. 558.

Reid, A. *Southeast Asia in the Age of Commerce 1450–1680*. Ann Arbor, Yale University Press, 1988.

'Repertorium van Nederlandse zendings- en missie-archieven 1800-1960'. Website, Huygens Instituut voor Nederlandse geschiedenis, 2011.

Roach, M.E. and J.B. Eicher (eds.). *Dress, Adornment and the Social Order*. New York, London, Sidney, John Wiley and Sons, 1965.

Rouffaer, G.P. Rouffaer and H.H. Juynbol. *De Batikkunst in Nederlandsch-Indië*. Haarlem, H. Kleinmann & Co, 1900.

Rouffaer, G.P. 'Over Indische Batik-Kunst, vooral die op Java'. *Bulletin van het Koloniaal Museum* 23, 1900.

Schefold, R. 'Art and its Themes in Indonesian Tribal Traditions'. In: R. Schefold and Steven G. Alpert (eds.), *Eyes of the Ancestors – The Arts of Island Southeast Asia*. New Haven, London, Dallas Museum of Art, Yale University Press, 2013, pp. 29–33.

Schrieke, B. 'Ter Inleiding'. *Cultureel Indië* 1, 1939.

Schulte Nordholt, Henk. 'Introduction'. In: Henk Schulte Nordholt (ed.), *Outward Appearances – Dressing State & Society*

in Indonesia. Leiden, KITLV Press, 1997, pp. 1–37.

Schwarz, R.A., 'Uncovering the Vice: Toward an Anthropology of Clothing and Adornment'. In: J.M. Cordwell and R.A. Schwarz (eds.), *The Fabrics of Culture*. The Hague, Paris, New York, Mouton Publishers, 1979, pp. 23–46.

Shatanawi, Mirjam. *Islam at the Tropenmuseum*. Arnhem, LM Publishers, 2009, p. 218.

Shelton, A., 'Predicates of Aesthetic Judgement: Ontology and Value in Huichol Material Representations'. In: J. Coote and A. Shelton (eds.), *Anthropology Art and Aesthetics*. New York, Oxford University Press Inc., 1996, pp. 209–44.

Schulte Nordholt, H.G. *Het politieke systeem van de Atoni van Timor*. Driebergen, Offsetdruk van Manen, 1966, pp. 73, 74.

Sibeth, Achim. *Mit den Ahnen leben – Batak Menschen in Indonesien*. Stuttgart/London, Hansjörg Mayer, 1990.

Simon Thomas, Mienke. 'Cretonnes – de vormgeving van bedrukt katoen voor het interieur in Nederland 1875-1940'. In: Brommer, Bea (ed.), *Katoendruk in Nederland*. Nederlands Textielmuseum, Tilburg, 1989, pp. 85–110.

Sorber, Frieda. 'Vlaanderen-Nederland: Een wisselwerking in katoendruk'. In: Brommer, Bea (ed.), *Katoendruk in Nederland*. Nederlands Textielmuseum, Tilburg, 1989, pp. 31–46.

Taylor, Lou. *The Study of Dress History*. Manchester, Manchester University Press, 2002.

Tentoonstellingsgids Jubileum-Tentoonstelling Koloniaal Instituut (15 augustus tot 1 october 1938): 40 jaar ontwikkeling van Nederland en overzeesche gewesten onder de regering van H.M. de Koningin. Amsterdam, Drukkerij J.H. de Bussy, 1938.

Tilley, C. Opening Editorial of the *Journal of Material Culture*, 1996.

Tilley, C, W. Keane, S. Küchler, M. Rowlands and P. Spyer (eds.). *Handbook of Material Culture*. London, Sage Publications Ltd., 2006.

Tilley, C. 'Introduction'. In: C. Tilley, W. Keane, S. Küchler, M. Rowlands and P. Spyer (eds.), *Handbook of Material Culture*. London, Sage Publications Ltd., 2006, pp. 1–12.

Tilley, C. 'Objectification'. In: C. Tilley, W. Keane, S. Küchler, M. Rowlands and P. Spyer (eds.), *Handbook of Material Culture*. London, Sage Publications Ltd., 2006, pp. 60–73.

Tillmann, G. 'Iets over de weefsels van de Kroë districten in Zuid-Sumatra'. *Maandblad voor Beeldende Kunsten* 15(1), 1938 (a), pp. 10–16.

Tillmann, G. 'Iets over de weefsels van de Lampong'sche districten in Zuid-Sumatra'. *Maandblad voor Beeldende Kunsten* 15(5), 1938 (b), pp. 131–43.

Tillmann, G. 'De metalen bakken van Zuid-Sumatra en de dierenvoorstellingen op de z.g. Kroë-doeken'. *Cultureel Indië* 1, 1939.

Tillmann, G. 'Het Ikatten op Madagascar'. *Cultureel Indië* 1, 1939, pp. 113–17.

Tirtokusumo, R.S. *De Garebegs in het sultanaat Yogyakarta*. Yogyakarta, Buning, 1931.

Totton, M-L. *Wearing Wealth and Styling Identity: Tapis from Lampung, South Sumatra, Indonesia*. Dartmouth College Hanover, Hood Museum of Art, 2009.

Tuuk, H.N. van der. *Bataksch-Nederduitsch Woordenboek*. Amsterdam, Frederijk Muller, 1861.

Ucko, P. J. 'Penis Sheaths: A Comparative Study'. *Proceedings of the Royal Anthropological Institute of Great Britain and Ireland*, London, Royal Anthropological Institute of Great Britain and Ireland, 1969, pp. 24–67.

Veen, H. van der "The Merok Feast of the Sa'dan Toraja'. In: Hoefte, R., and H.S. Nordholt. *Verhandelingen van het Koninklijk Instituut voor Taal-, Land- en Volkenkunde*. Leiden, E.J. Brill, 1966.

Veenendaal, J. *Aziatische Kunst en de Nederlandse Smaak*. The Hague, De Vrije Uitgevers, 2014, p. 19.

Veldhuisen, H.C. *Batik Belanda 1840–1940 Dutch Influence in Batik from Java*. Jakarta, Gaya Favorit Press, 1993.

Veldhuisen-Djajasoebrata, A. *Bloemen van het Heelal – De kleurrijke wereld van de textiel op Java*. Amsterdam, Sijthoff, 1984.

Verbong, Geert. 'Katoendrukken in Nederland vanaf 1800'. In: Brommer, Bea (ed.), *Katoendruk in Nederland*. Nederlands Textielmuseum, Tilburg, 1989, pp. 47–68.

Vergouwen, J.C. *Het Rechtsleven der Toba-Bataks*. The Hague, Martinus Nijhof, 1933.

'Van Vlissingen & Co's Gedenkboek 1846-1946'. Helmond, 1948, p. 22.

Weiner, A.B. and J. Schneider, 'Introduction'. In: A.B. Weiner and J. Schneider (eds.), *Cloth and the Human Experience*. Washington and London, Smithsonian Institution Press, 1989, pp. 1–29.

Wesseling, H.L. *Indië verloren Rampspoed geboren*. Amsterdam, Bert Bakker, 1988.

Wisseman Christie, Jan. 'Texts and Textiles in "Medieval" Java'. *Bulletin de l'Ecole Française d'Extreme Orient* 80(1), 1993, pp. 181–211.

Witkamp, P.H. *Amsterdam in schetsen*. Amsterdam, G.W. Tielkenmeijer, 1869, pp. 149–50.

Woodward, H.W. 'Indonesian Textile Patterns from a Historical Point of View'. In: Mattiebelle Gittinger (ed.), *Indonesian Textiles – Irene Emery Roundtable on Museum Textiles*. Washington, The Textile Museum, 1979, pp. 15–35.

Wronska-Friend, M., 'Javanese Batik for European Artists: Experiments at the Koloniaal Museum in Haarlem'. In: Itie van Hout (ed.), *Batik Drawn in Wax – 200 Years of Batik Art from Indonesia in the Tropenmuseum Collection*. Amsterdam, KIT Publishers, 2001, pp. 106–23.

Yeager, R. and M. Jacobson 'Traditional Textiles of West Timor: Regional Variations in Historical Perspective'. *Studies in the Material Cultures of Southeast Asia* 2, 1996.

INDEX

LM Publishers
Parallelweg 37
1131 DM Volendam
The Netherlands
E-mail: info@lmpublishers.nl
www.lmpublishers.nl

The publisher gratefully acknowledges the support of the BankGiro Loterij and the Prins Bernhard Cultuurfonds

© 2017 LM Publishers – Volendam, The Netherlands

Nationaal Museum van Wereldculturen
Nationaal Museum van Wereldculturen was established on 1 April 2014 through a merger of the Rijksmuseum Volkenkunde (1837, Leiden), the Tropenmuseum (1859, Amsterdam) and the Afrika Museum (1954, Berg en Dal). Now one museum spread over three locations, the former names will continue to be used for the public: Tropenmuseum, Afrika Museum and Rijksmuseum Volkenkunde. The new museum has a collection of over 400,000 objects and ranks among the top 10 most-visited museums in the Netherlands. Research activities are concentrated in the Research Centre for Material Culture. The museum's mission remains as relevant as ever, namely contributing and promoting a broad outlook on the world.

Translated from the Dutch and edited by
Stefan Osadzinski & Mark Poysden

Photography (unless stated otherwise)
Irene de Groot (Tropenmuseum)

Design
Studio Berry Slok, Amsterdam, The Netherlands

Production
High Trade BV, Zwolle, The Netherlands

Printed in Slovakia

Cover illustration: detail fig. 203

ISBN 978 946022 3907
NUR 640